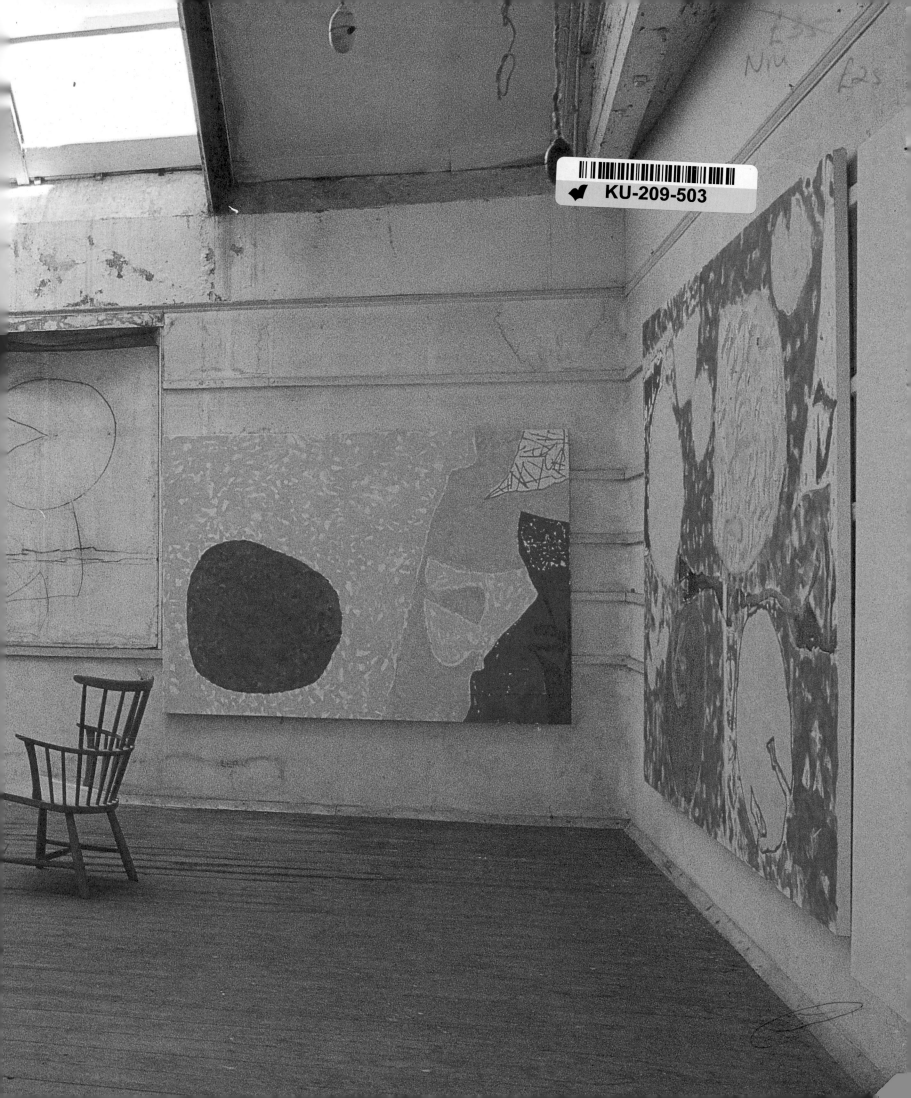

PATRICK HERON

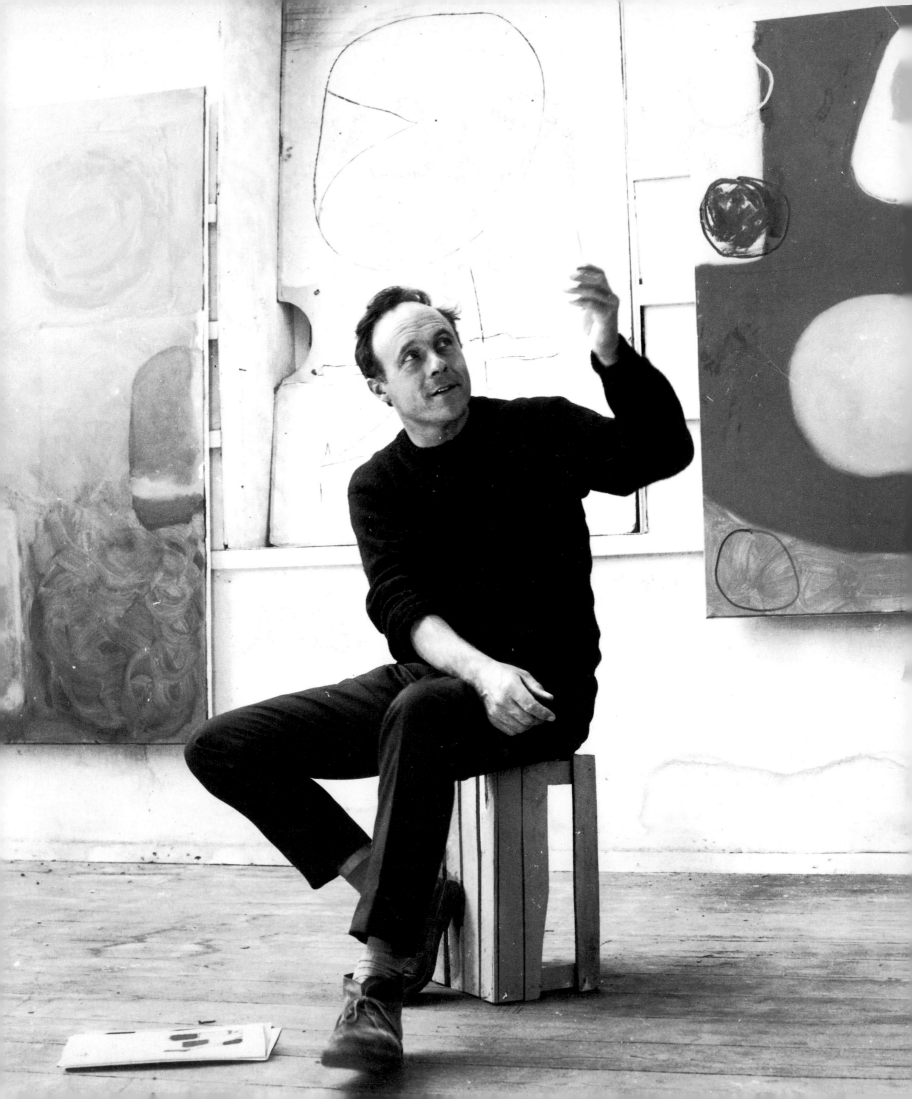

PATRICK HERON

MEL GOODING

Φ

THIS BOOK IS DEDICATED TO
KATHARINE, JULIAN, AND SUSANNA

← FRONTISPIECE
Patrick Heron in his studio, 1963

ACKNOWLEDGEMENTS

Special thanks are due to Katharine
Heron, Susanna Heron, Julian Feary,
David Thomson, Anne Dolan,
and Andrew Wilson. I acknowledge
the indispensable assistance, the
endless patience and the unfailing
good humour of Janet Axten. I owe
a special debt of gratitude to Rhiannon
Gooding. Above all, I am indebted
to Patrick Heron, for friendship,
conversation, and generous and
tactful assistance at every stage of
the making of the text.

Phaidon Press Limited
2 Kensington Square
London W8 5EP

First published 1994

© 1994 Phaidon Press Limited

ISBN 0 7148 2926 9

A CIP catalogue record of this book
is available from the British Library

Printed in Hong Kong

PHOTOGRAPHIC
ACKNOWLEDGEMENTS

The publishers wish to thank the
museums, galleries and private owners
who have provided photographs or
given permission for works in their
possession to be photographed.
Photography of works of art by Bob
Berry, Prudence Cuming Associates
and John Riddy.

Additional photographs by
Alec Bangham 47, 25B; Julian Feary
10BL, 19, 246T, 246B; Patrick Heron
7, 8, 9, 10TR, 10TL, 12, 13, 14, 15, 16,
17, 18t, 18b, 254; Susanna Heron
201B; Ida Kar 53; Anne Kelley 211;
J.S. Lewinski 2, 25T, 201T;
Roger Mayne 105, 121; Dennis
McCarthy 66; F.E. McWilliam 145,
175; John Riddy 10BR, 11;
James Scott 111; Brian Seed 189;
Tim Street-Porter 194B;
David Ward 18C, endpapers

1 PATRICK HERON: AN ARTIST IN HIS TIME

→ Eagles Nest, from rocks above,
looking northwest *c*.1985

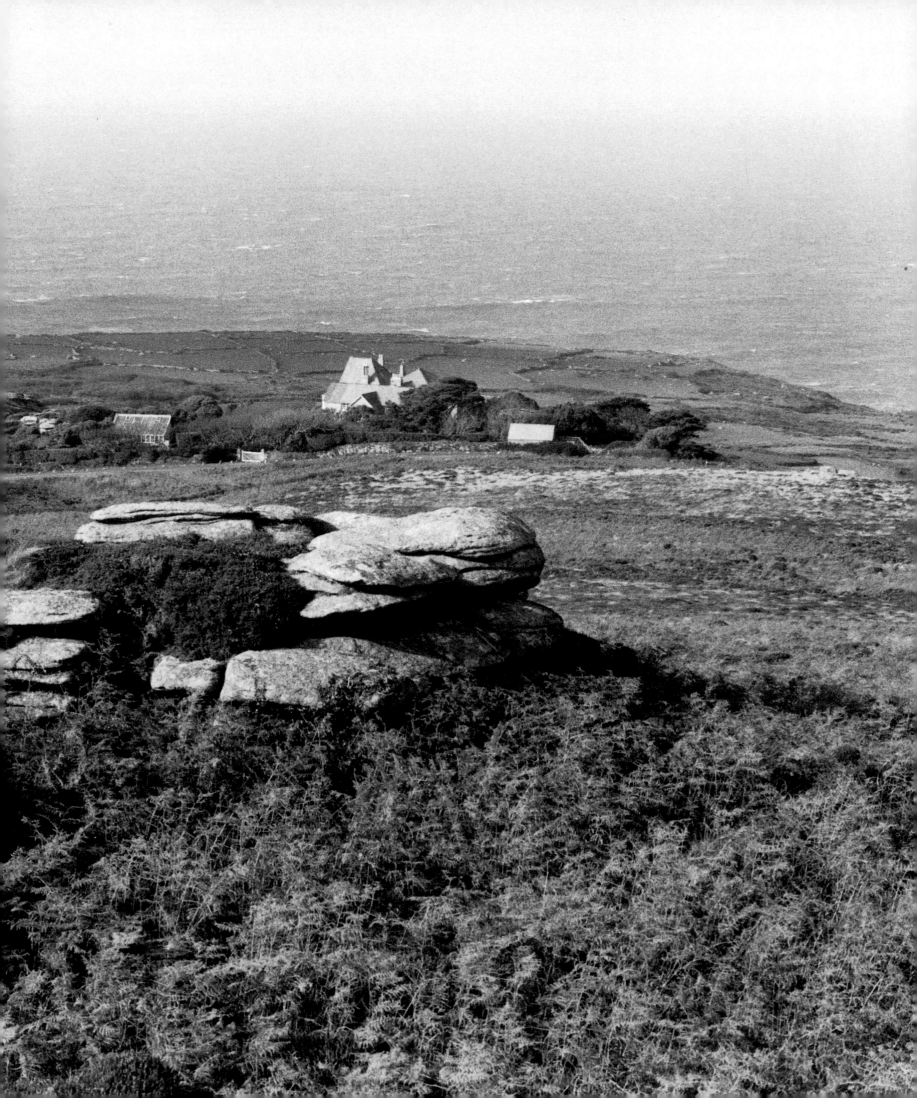

↑ View of Tregerthen Farm from
Eagles Nest, c.1960

⇒ View of Eagles Nest from the southeast

From the kitchen window the skies over the distant-seeming sea are bright, milky opalescent; the view, framed by the window's rectangle, is shaped dramatically by the great boulder behind the house that is this morning a dark curved mass intruding from the left, and the opposing outline, similarly curved, of a shrub to lower right. Between and below, the grey reticulations of the stone walls enclose emerald green fields in ancient configurations, a passage in the picture that appears to tilt up towards the vertical, Braque-like. Its upper edge is the limit of land to the eye, the sign of a precipitous drop to an invisible rocky shore, six hundred feet below the house; between this irregular line and the sky the pale shimmer of the sea rises to the dividing horizon. The night's gale has blown itself out, the beating rain has stopped. What is seen composes itself to the eye, as the ear registers the after-storm quiet.

Outside, this calm, perceived by contrast to the violent clamour of the night's racket as the house took the broadside of the Atlantic gale, is quickly dispelled: the air is never silent around Eagles Nest, and in the garden the evergreen shrubs and windbreak escallonias and senecios catch the fresh rush of the morning's light wind from the rising moor to the landward side. The air is cold, the light clear as crystal on 'a lawn floating in air high above the sea'.

On the other side of the grey house, with its 'strangely Cubist complexities', is the azalea garden, with its winding pathway passages, the darknesses of its secret places intensified by the gloss of the evergreen leaves. The paths lead through to miniature glades, and pass between massive boulder-like outcrops of granite, their outlines rounded and roughly smoothed by the winds of countless million years, their dull grey surfaces, where the sun strikes them, pitted and glinting with quartz, where shade prevails, mossed and lichened in the pure marine air. At any moment from the shadows of this garden, leaf mould and moss underfoot, you may be amazed by a spectacular view through pine trees and shrubs to the brilliant blues, cerulean, cobalt, turquoise, of distant sea and sky: shadow and light, near and far, brought together in a single complex experience.

Eagles Nest is where Patrick Heron has lived and worked since 1956, when he arrived in early spring with his wife Delia and two daughters, to catch the April brilliance of the azaleas, and to find his work immediately take on a new spirit and new forms. It was a house of special significance, for he had lived there for some time as a child, and had dreamed of returning. In shaping and re-shaping the house and its unique garden, he has been shaped by it; in occupying it, it has come to occupy him; it has become the ground of his creative being, the very centre of his vision and his imaginings. Here at the land's western edge the rock-strewn brackened moorland slopes steeply down to the green domestic shelf of farmlands which ends in cliff-top middle air. Stretching beyond are the great sea and the sky. On a moorland promontory is the house and garden from which Heron has watched their infinite variegations of light and colour, from white dawn mists to multichromatic sunset splendours, in the ceaselessly changing peninsular weathers of West Penwith. It is, he has written (with a typical precision), 'clearly very nearly the greatest passion of my life'.

Patrick Heron is a visual inventor of the first rank, an originator of images, and a colourist of genius. His work has the continuity of a consistent and coherent vision served by technical gift and an unceasing discipline of looking: 'Seeing' he wrote, a few weeks before moving into Eagles Nest in 1956, 'is not a passive but an active operation. We see what we are capable of reconstructing in the scene before us – and no more … all art is a convention, an invention. Painting may literally claim to alter the look of the world for us. We only see nature through a system of images, a

configuration which painting supplies.' (We shall get used to the habitual emphatics of Heron's style, the characteristic *drama* of his utterance: it is the man himself.) His work is indeed instantly recognizable, in the profoundest sense of the word: looking at it, we see in it aspects of the world we know; turning back to the world we find ourselves reconstructing in it what his art has invented for us, those configurations that derive from his own distinctive system of images.

Heron's paintings are at once evocations and celebrations of the visible: they proclaim seeing as a primary human experience. His work has been a deliberate and courageously sustained effort to reclaim for painting as its true subject the complex actuality of visual reality, 'the reality of the eye'. The 'anciently valid response of the painter to the world around him', he once wrote, '… is one of delight and amazement, and we must recapture it.' This commitment to an art of direct engagement with the visible world in its sensational aspect, to the record on canvas and paper of a purely sensuous apprehension of colour, space and shape as such, has animated Heron's work as a painter from its first maturity in the mid–1940s, and its beginnings can be traced in his first professional work, undertaken for his father ten years before that.

A principle of delight informs all his work, confers upon it its singing colour, sometimes high-keyed and chromatic, sometimes sonorous and tonal, and determines its surprising variations of texture across the surface. It determines, too, the outlines of its forms and the dynamics of their spatial relations across the picture's vertical arena, and also in the purely imaged space behind that physical plane. Heron has been constant to a decorative art of expressive *image* rather than of programmatic *symbol* or descriptive *mimesis*, to a mode of painting whose primary intent is the evocation of space and depth achieved through dispositions of colour shapes across a flat plane. 'It is enough to invent signs' said Matisse. 'When you have a real feeling for nature, you can create signs which are equivalents to both the artist and the spectator.'

'I love all images and hate all symbols' has long been a Heron watchword: concepts and symbols '… are the enemy of painting, which has as its unique domain the realm of the pure visual sensation', what he calls 'the world of the eye'. 'For me painting deals with images. An exclusive concern with the image – this is the realm of the painter. Each painting both contains images, interlocking and mutually definitive, and is itself a single, total but exceedingly complex image in its own right.' The central concern of this account of Heron's work is to trace the implications of this view of painting through the many changes of manner that mark its progressions and recapitulations through the modalities of figuration, abstraction and non-figurative invention.

Heron's apparently simple insistence upon the primacy of optical sensation, and his emphatic delineation of the boundaries of painting's domain, seem to demand a reaction articulated with equal clarity and sharpness of definition. What is required is a description of the work that will discover its meanings, or define its purposes, as a unique *pictorial* expression of a particular and inimitable visual apprehension of the world. For behind the making of the work, and the famously vehement utterance which sometimes accompanies it ('It is obvious that colour is now the *only* direction in which painting can travel.'/ 'Art is autonomous.'/ etc.) is a complex sensibility and a restless intelligence, informed alike by a passionate response as much to the morphologies and configurations of the physical world as to its light and colour. These components of a forceful artistic personality have cohered around an assiduous and prolonged contemplation of the painting of the great moderns, disciplined, at various times, by the requirement to write for publication.

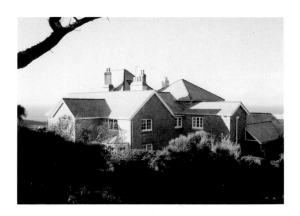

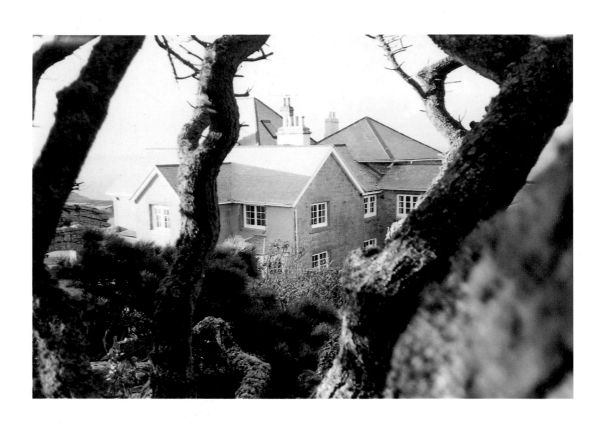

↑ ↗ Views of Eagles Nest from the
 southeast, from the pine, 1992

 →→ View of the bay window on south side
 of the sitting room

↓ ↘ Views into studio and study from the
 sitting room, 1993

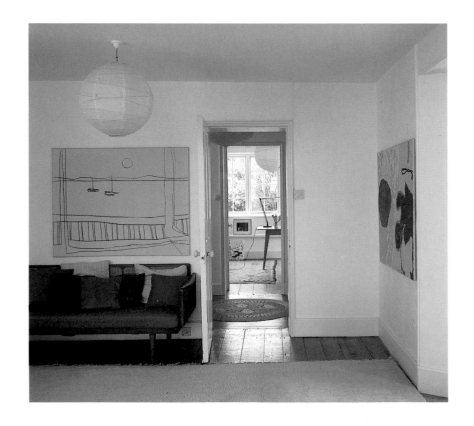

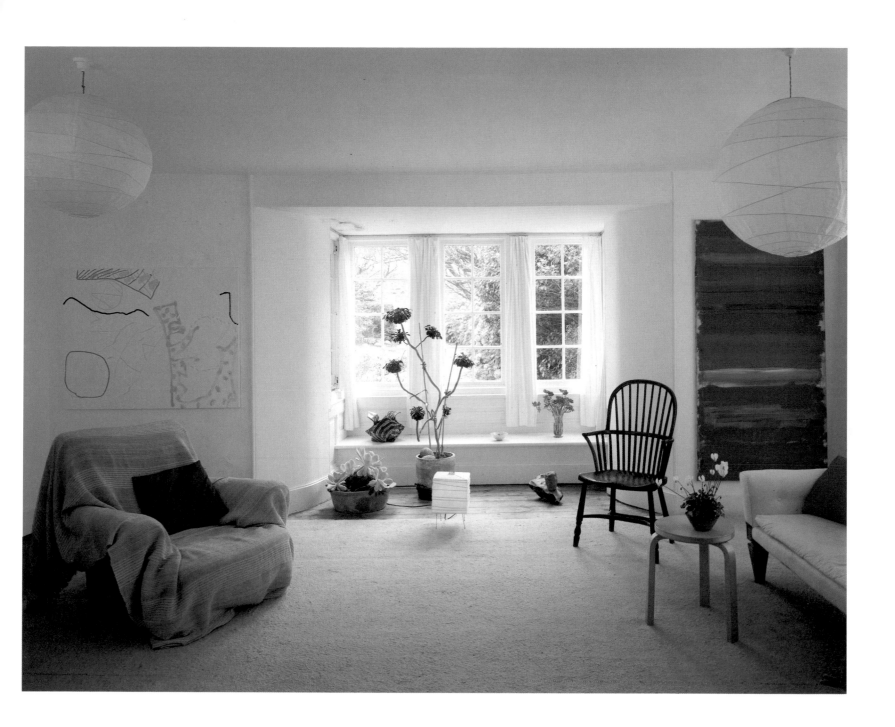

↑ 1964 painting in the Emperor's Room

⇒ View from PH bedroom across landing
to corner bedroom

⇒ View across landing to PH bedroom
from corner bedroom

↓ 1956 garden painting in corner
bedroom

At its best, Heron's writing, on his own work as well as that of others, has an energetic exactitude of observation that is virtually unique. He is a remarkable, and sometimes great, critic.

The frequency and intensity of his critical attention to certain of the masters of the School of Paris, especially to Braque, Matisse and Bonnard, on each of whom he has written with the eye and the insight of an artist, is a measure of their importance to Heron as a painter. In the first place it was a matter of empathetic response to their shared obsession with plastic and spatial values, and with colour as space, this latter preoccupation being in itself a defining characteristic of their essential modernity, as Matisse acknowledged when he spoke of the 'rehabilitation of the role of colour, and the restitution of its emotive power'. It was to do also with their modern pre-eminence in that tradition in art which profoundly emphasizes the sensuous, the purely visual. ('Sensation, revelation', said Braque in his old age.) It is to do, finally, with the specifically *compositional* genius which distinguishes each of these great modern painters, that quality which prompted Heron to cite Bonnard in particular as '*utterly relevant* to living abstract artists, impinging with inescapable force upon our pictorial thought processes at this very moment'. It was the 'apparently unending, allover nature of Bonnard's design … the distribution of accent and pictorial stress' that gave Bonnard his crucial importance, his capacity to compose an '*abstract music of interacting form-colour.*'

Heron's own painting in all its phases has aspired to such a music. It is significant that when he invented this phrase (probably in 1947, just after Bonnard's death, which he felt as 'a personal shock') he was wholly committed to representational modes, and in the process of finding a style of his own under the potent influences of the recent (mostly wartime) still life and interior paintings of Picasso and Braque, which he had seen (and reviewed) in London. In the essay on Bonnard (significantly entitled 'Pierre Bonnard and Abstraction') he was in no doubt of the connections of such abstract patternings to things, 'even particular things', observed in the external world, and distinguished it from the 'consciously sought Abstract product' of the time, which he felt to be synthetic (in the sense of made-up or artificially contrived) and intellectually willed rather than a function of the aesthetic faculty, an expression of the whole sensibility.

At the time, and for some years to come, Heron's painting still admitted the scrutiny of actual objects as the starting point for the intuitive discovery of purely formal configurations. In turning later to abstract and non-figurative modes he was to maintain an unswerving allegiance to that great trio of French painters, whose essential abstracting tendencies (each different from the others) he had so quickly and precisely identified, and described with such awesome exactitude. Indeed it may be seen that each of them has occupied a pre-eminence in his creative imagination at particular times in the course of his progress as an artist: Braque (the later Braque of the mid-war years) was without question the predominating influence upon the work of his early maturity; Matisse (especially the late Matisse, whose interiors of the mid-1940s he had first seen in Paris in 1949) exercised an imperious hold on his imagination, shaping his thought and his practice, through the years of his obsession with colour as space; and Bonnard is the star ascendant over the brilliant garden paintings of this most recent decade of his work. This is to over-simplify and exaggerate, perhaps absurdly. What remains true is that Patrick Heron is, before and after anything else, and at all times, a painter of European sensibility, working within a European tradition.

In this he shares affinities with a number of his near contemporaries in what has been termed the 'middle generation' of British artists, significantly younger than

that of Paul Nash, Ben Nicholson, Henry Moore and Barbara Hepworth, who had established their artistic personalities and their critical reputations before the war, but older than the cohort of the high-profile British artists who came to critical (and public) notice in the 1960s, who had entered the art schools in the post-war period. The early professional years of this middle generation were crucially interrupted by the war itself, and their formative contact with living European art, especially with the painting of the School of Paris, had been terminated abruptly in 1939. For almost all of them, the immediately post-war London exhibitions of recent work by Picasso and Matisse (at the Victoria and Albert Museum in December 1945) and Braque (at the newly re-opened Tate Gallery in the spring of 1946) were events of special, almost symbolic, significance: they represented the re-establishment of a vital relation. Heron's writings on these exhibitions articulated and focused the response of a young practising artist, the more intense for it having come from one who for over four years had been forcibly engaged in other pursuits.

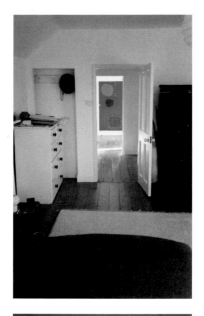

Several important painters of this generation, including William Scott, Roger Hilton, Bryan Wynter, John Wells, Peter Lanyon, Alan Davie and Terry Frost, all a few years older than Heron, were close friends, and in the post-war period his associations with these and other artists were to be consolidated by shared creative connections with West Penwith and St Ives. Heron had worked in St Ives, as an assistant at the Leach Pottery, for 15 months towards the end of the war, and from 1947 he was to spend several months each year, living and working at 3 St Andrew's Street, on the sea wall, before finally moving to live at Eagles Nest in 1956. Ben Nicholson and Barbara Hepworth had been living in Carbis Bay, a little to the East of the town, since August 1939, staying first at Little Park Owles (a house later owned by Peter Lanyon) with Adrian Stokes and Margaret Mellis, who had moved there earlier that year. A month later they had been joined in Cornwall by Naum Gabo. These, and other older artists important to post-war developments in British art, such as Victor Pasmore (whose move into the St Andrews Street studio Heron arranged in the autumn of 1950), and Ivon Hitchens, were also to be counted among his friends. Bernard Leach he had known since childhood, when the Heron family had lived near or in St Ives during the years when his father had run Cryséde Silks in the town.

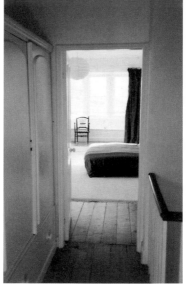

During his two sustained periods as a critic, for the *New English Weekly* and the *New Statesman and Nation* in the late 1940s, and for the New York magazine *Arts* in the late 1950s, Heron wrote on many occasions on these artist friends, in many cases (Lanyon, Hilton, Scott, Wynter, Wells, Frost, Davie among them) being the first critic to pay close attention to their work. This descriptive and analytic effort was of crucial importance in defining the particular character and qualities of the work of several of these artists, and in Heron they had a formidable champion, critically generous and passionately articulate, clear-eyed and unsentimental. For many of them he was instrumental in introducing their work to the American art public, through the pages of the influential New York magazine Arts, to which he was invited to contribute as London correspondent by the redoubtable Hilton Kramer in 1955. Heron's writings were never programmatic, and the promotion of his own work was no part of a hidden or even unconscious agenda. They were animated by his passions and enthusiasms: his sympathies were remarkably broad; his antipathies expressed without disguise. What he despised he ignored. There was no artist-critic comparable to elaborate the case for his own work, to which he rarely referred in the years between 1945 and 1958.

It was in *Arts* in March 1956 that Heron wrote the celebrated article that recorded the first collective showing in London of the painters of the post-war New York

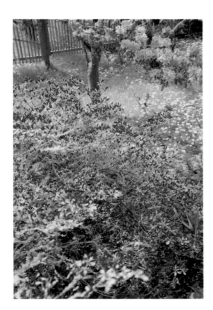

School (as the final section of the MOMA New York travelling exhibition, *Modern Art in the United States*), and which provided for its American audience a sharply turned and at times hilarious account of the London critics' reception of the new American painting. It is relevant at this point to remember that Heron was alone among his contemporary critics in treating the abstract expressionists in depth, with enthusiastic respect and a graceful lack of condescension, and, most significantly, in making critically useful distinctions between them. He was writing, of course, as a painter himself, and he chose to concentrate on the New York artists because they were 'the centre of interest with our forward-looking painters', a point he returned to in the specific emphasis of his final paragraph:

… I would like to end by insisting that to me and to those English painters with whom I associate, your new school comes as the most vigorous movement we have seen since the war … We shall now watch New York as eagerly as Paris for new developments (not forgetting our own, let me add) – and may it come as a consolidation rather than a further exploration.

In fact the representation of the abstract expressionists was not at all substantial, being confined to the last gallery of an exhibition that occupied six, and including no more than one painting each by a number of the artists, including Kline, Still, Motherwell, Hartigan and Tomlin, and two only of Rothko, Pollock and de Kooning. Among significant omissions were Newman, Gottlieb, Hofmann, Tobey and Reinhardt. Tobey, considerably older than any of the New York artists in the show, had recently shown a group of his works at the Institute of Contemporary Arts in London. Again at the ICA, a large painting and two small works by Pollock had featured in a mixed exhibition in 1953. Apart from that there had been no exposure whatsoever of post-war New York painting in London.

Alan Davie had seen paintings by Pollock (as well as by de Kooning, Motherwell and others) from Peggy Guggenheim's collection at the Venice Biennale in 1948, a fact remarked by Heron in his next article for *Arts* in April 1956, and William Scott had met several of the New York painters in the Summer of 1953, the year in which he appeared in Heron's exhibition, *Space in Colour*, and later represented Great Britain, with Heron, at the São Paulo bienal. He had been teaching at a summer school in Banff, Alberta, and was invited to New York by the American critic James Johnson Sweeney, to meet Martha Jackson, who was to become his American dealer. There he met Rothko and Kline whom he found to be 'Anglophile, and very curious to hear about the art situation in England'. On a visit to Long Island he met de Kooning and Pollock. (He was, he recalled later, the first European artist to visit Pollock.) 'I returned convinced that the Americans had made a great discovery and that the mood in England – a longing for a nice comfortable realist art would not last much longer. When I got back I found that Patrick Heron was particularly interested …' Scott's reaction to this experience, however, was typically independent: he determined 'to discontinue my pursuit of abstract art and try to put my earlier form of symbolic realism on a scale larger than the easel picture, with a new freedom gained from my American visit'. What had really impressed Scott was not so much the 'originality' of the painting he had seen in New York as its 'scale, audacity and self-confidence'. The 1956 exhibition, he believed, 'had the effect of expanding our scale of painting in England'.

'At last we can see for ourselves what it is like to stand in a very large room hung with very large canvases by Jackson Pollock, Willem de Kooning, Mark Rothko, Clyfford Still, Franz Kline and others', wrote Heron at the beginning of his article. 'I think it is true to say that the fame of these painters just managed to precede the

arrival of their canvases in London: in other words, the exhibition has come at "the psychological moment" – the moment when curiosity was keenest.' Heron was, clearly, positively primed to receive the impact of the new American painters; for some time it had been clear that something exciting was indeed happening in New York, and no one in England was more attuned, positively, to the vibrations emanating from there. Heron had great admiration for Scott, and confidence in his judgement; he had good reason to anticipate the Tate exhibition with some excitement.

In the summer of 1954, in fact, the American critic most closely associated with the critical promotion of the new American abstraction, Clement Greenberg, had visited him in London and spoken at length about Pollock. In his introduction to *The Changing Forms of Art*, written in October of that year, Heron was to refer to Pollock in the same paragraph as Picasso and Moore, with the clear implication that the American was to be considered a modern master; based on limited experience of Pollock's painting in the flesh, it was a premature commitment in print he was later slightly to regret. It was on that visit that Heron had introduced Greenberg to Scott and Hilton, and alerted him to the originality and power of the best contemporary British painting. Greenberg, however, had a critical agenda whose imperatives were not likely to incline him to be especially impressed.

It was all the more remarkable, then, that Heron's 1956 review, for all its generous enthusiasm, and written in the knowledge that it was for an American audience, should scrupulously register certain doubts and disappointments, and that it should record in so direct a personal tone the shifts and sways of his response. In the troubled wake of his later polemical writings on the relations between New York and British painting in the 1950s and 1960s few commentators have recalled the careful evaluations and critical distinctions of Heron's *Arts* review, its deft analyses of the specific qualities of the paintings by de Kooning, Pollock, Motherwell and Rothko, or remarked on the carefully qualified enthusiasm for Rothko, Kline, Pollock and Still of his 1958 review of the ICA exhibition of the E. J. Power collection. Hilton Kramer, Heron's editor at *Arts*, writing in 1971 in critical response to the 'political' tenor of Heron's essay 'Two Cultures', well remembered the intelligent sympathies of his London correspondent in the mid-1950s:

Mr Heron was then one of the very few critics in London from whom one could expect an informed, disinterested, esthetic analysis of painting, American or otherwise. I considered him then the best art critic to have emerged in London since Roger Fry, and I think his writings of the period … still make his claim to that position unassailable.

The mix of critical subtlety and sympathetic discrimination that informed Heron's response to the new Americans should have surprised no one who had read *The Changing Forms of Art*, the edited selection of his critical writings between 1945 and 1954, which was published in London in 1955 and New York in 1958. Heron was deeply knowledgeable about the painting of his friends and contemporaries in England, much of it abstract or near-abstract, and of its creative and artistic sources. He knew also of the new painting in France, of the vitalities of *tachisme*, of the grandly beautiful later manner of de Staël, and of its powerful impact upon himself and others of his generation. In the May 1956 issue of *Arts*, two months after his review of the Tate show he was to report on the memorial exhibition of late paintings by de Staël in London, remarking their re-introduction of the 'figurative function: *figuration in abstraction*'. Heron was himself, of course, acutely aware of the abiding significance of Matisse, Braque and Bonnard to the painting of his time. In short, his reaction to the new American painting was that of a sophisticated practitioner and an acute and knowledgeable eye.

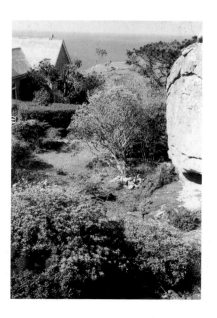

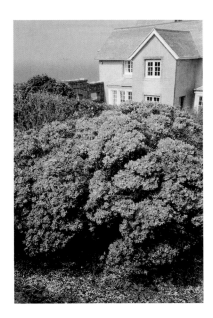

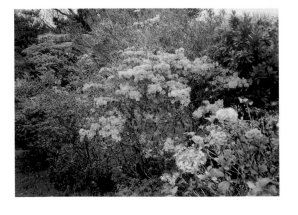

Heron had made it a condition of his contributing to *Arts* that he would write only when he felt that his primary commitment, to painting, was satisfied. In November 1958 he resigned as London correspondent to the magazine, privately determined 'never again to write criticism'. It is proper to remember at this point that his writing has always been a secondary and complementary activity: his true *vocation*, one might almost say from childhood on, has been to painting and only to painting, and the essential story of his life is the history of his painting.

The mid-1950s was a period of extraordinarily intense activity and phenomenal development for Heron. His sharply focussed experience of the American painters at the Tate, the impact of which should not be exaggerated, fed into a complicated set of creative–critical relations of thought and feeling with which he had been wrestling for some time. These ambivalences had been touched upon with considerable psychological subtlety in his Introduction to *The Changing Forms of Art*, written in October 1954, where he spoke of 'renouncing a more abstract for a more figurative mode' in his own painting, and described the complex contradictions that attended upon his sense of a duty, *as critic*, 'to elucidate and champion the works of the most uncompromisingly non-figurative painters to be found on the scene'. A possible explanation might be, he wrote, 'that having 'failed' to create a non-figurative art of my own I wished to demonstrate that I was nonetheless in possession of its secrets; and so wished to act as an initiate–interpreter of the non-figurative mystery'. In terms of a negative compulsion that itself suggested irresolution, he wrote that he had found himself '*compelled* … to refrain from jettisoning the figurative function entirely'.

In the winter of 1955–6 Heron moved, in fact, with dramatic decisiveness, from a stylized figuration with clear links to the later work of Braque and Matisse to a radical abstraction that had much in common with what had come to be called *tachisme*. Within 10 months of acquiring Eagles Nest, in a spectacular creative outburst he produced a remarkable body of purely abstract work in a variety of modes. The production of paintings in those various modes overlapped in time, and there were clear and coherent inter-relations between them. At last Heron had been able to kick away the figurative scaffolding of allusive line and referential forms and move into the space of colour. It was a visual universe that he was to explore for the next 20 years, in successive styles of lyrical abstraction.

The history of Heron's painting is that of a constant and complex development, a continuous process of discovery and consolidation, of renewal and recapitulation. Its progress has been eventful and unpredictable, marked at moments by apparently sudden intuitive breakthroughs to new formal possibilities, new ways of registering a vital apprehension of the world, such as that which led to the invention in 1957 of the abstracted stripe as an expressive 'sign' (in Matisse's sense of the term). At other times it has been characterized by a systematic and wilful exploration over many years of an over-riding compositional idea, producing a dazzlingly virtuosic series of variations on a theme like the paintings in his 'wobbly hard edge' style made through the late 1960s and the 1970s. At times, as with the abstractions of early 1956 and of March 1957, and the Sydney paintings and gouaches of 1989-90, there has been a sudden explosion of original work.

Underlying each movement, each phase, has been a set of wholly consistent, even obsessive, preoccupations. Colour as space; line as the demarcation between colour spaces, and the determinant of their optical effect; the dynamic contradiction, by colour relations, of the flatness of the canvas: these have been for Heron the inescapable thematic and formal desiderata. Behind these considerations lies the deeper thought: that these pictorial dynamics are epiphanies and signs; and that

painting is uniquely capable of their declaration. Heron's work has been dedicated to the revelation of the secret structures of form and colour that inhere in Nature, to making visible in the material disposition of paint on canvas the hidden linear rhythms and lucent harmonies by which those structures are shaped.

For all the the lucidity and formalist rigour of his own writings on art, he has always acknowledged 'the essential element of the mysterious', finding it in figurative and non-figurative art alike, and tracing it, as the vital content, in the purely pictorial architectonics of painting. These abstract forms, divisions and arrangements of colour and texture on the flat surface of the canvas, are, in Heron's own metaphor, *crystallizations* of the realities immanent in the physical world that surrounds the artist. That image comes from Heron's first published article, on Ben Nicholson, written in October 1945:

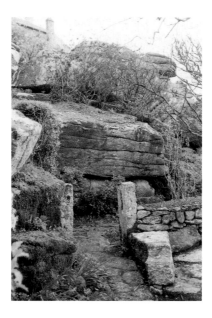

In art, forms crystallise in the consciousness only after a prolonged agitation at what we might call the level of life itself. And if one seeks these forms, the forms which life alone conceals, one will not be content to manipulate an existing currency of crystals, so to speak. Rather one sets one's face towards the incoherent, vast and vastly intricate anonymities of Nature; towards the faceless and baffling but rich-to-infinity fields of Nature herself – which exist for the painter's purpose, in whatever surrounds his physical frame by day, by night, on the moors of Celtic Cornwall and by the sea-sucked rocks, or in the lemon lamplight upon a stained and flaking city wall; in the lichen covered stones of Zennor, or across the glittering surfaces of a Euston ABC's glass tables. New crystallisations are latent everywhere.

Syntactically stretched as that may be, it remains a remarkably prescient début statement, a powerful manifesto from an artist in his mid-twenties, just starting out properly at last. Heron knew already that those forms that crystallize in art are precipitates not of an objective programme but of subjective intuitions; the outcomes of unpremeditated acts within a deeply considered process. They are not accidental, but neither are they designed: they are discovered. Eleven years later he was to come to live on those very moors of Celtic Cornwall, in a house set among the lichen covered stones of Zennor, a place inscribed with cultural and personal memory, whose setting determined that every day from window and garden he would look out upon 'the incoherent, vast and vastly intricate anonymities of Nature'.

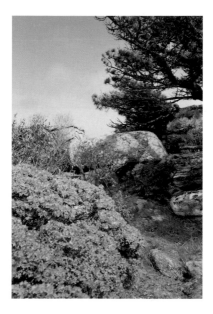

→ Pebble path running down to house
past Big Rock

⇒ Balancing rock with pool above azalea
garden, 1993

↘ Azalea garden showing balancing rock
containing pool, 1993

↓ View of the Big Rock with *Senecio
Rotundifolius,* pebble path and azaleas

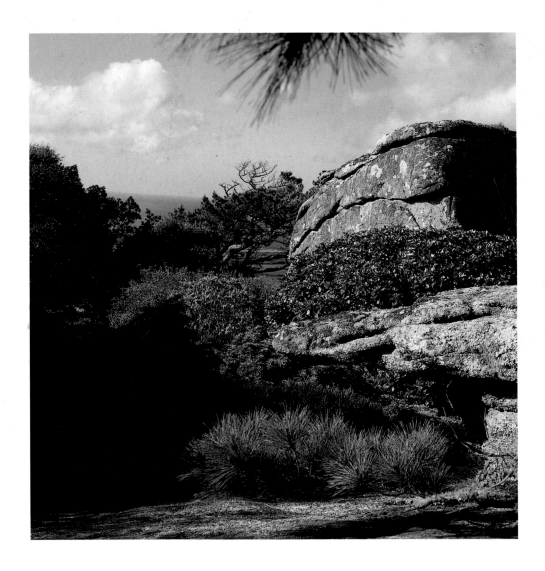

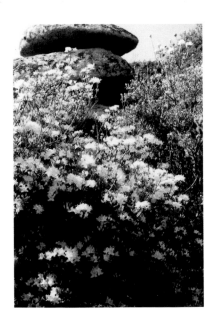

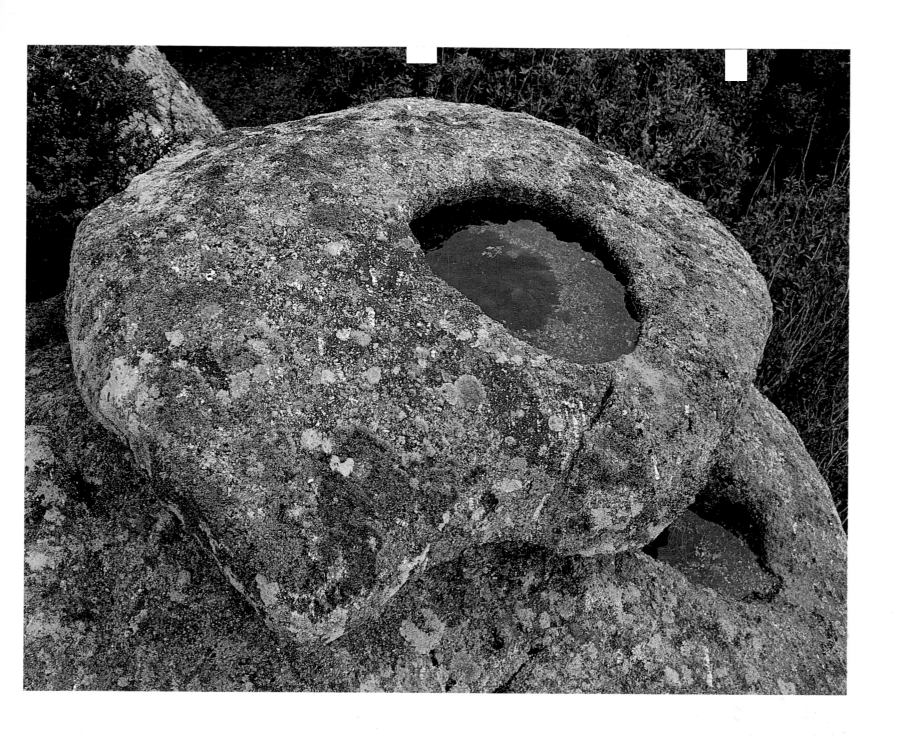

2 THE MAKING OF A PAINTER

1920–45 The permanence of childhood

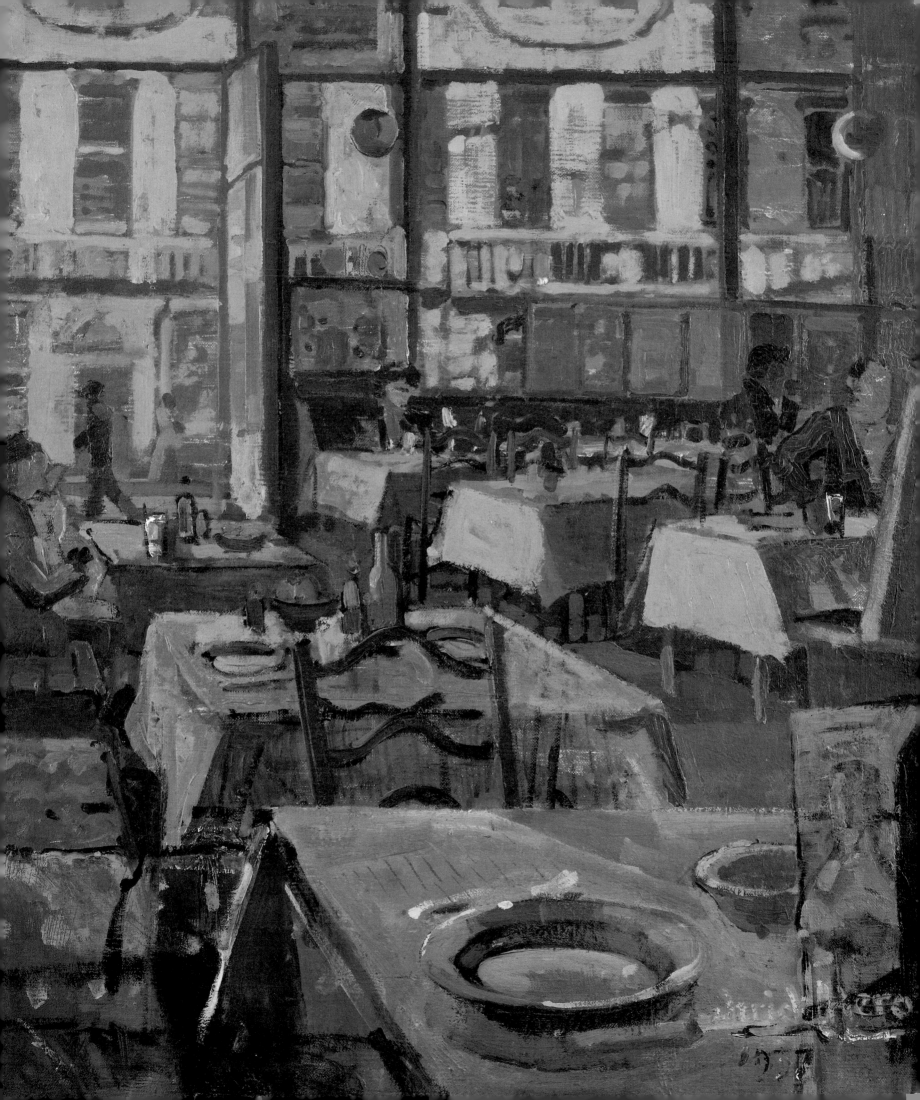

It is not uncommon for artists to show signs at an early age, usually through a compulsion to draw, and an ability to do it unusually well, of a specially creative disposition; it is not unknown for perceptive parents to recognize and encourage it. There are many records of such precocity in the lives of artists, great and minor alike (going back at least as far as Vasari's touching account of Giotto's childhood), and testimonies to their early awareness of an artistic vocation. As the predestined artist grows older the certainty of calling is usually attended by an impatience with orthodox education, sometimes indulged by an enlightened parental disregard of academic conventionality. Such was the case with Patrick Heron, whose fortune it was to be born to parents of quite remarkable independence of mind and generosity of spirit.

Patrick's childhood drawing was encouraged with great seriousness from the moment he could hold a pencil. From the beginning his efforts were carefully kept in folders and buff envelopes, in which many of them have survived. Heron refers to them, without affectation or ironic distance, as 'early drawings'. He has no sense of a discontinuity between work done in childhood and youth and the painting of his maturity. As in those later paintings in which there is reference to an interior or exterior topography, a recollection, as it were, of things seen in the external world, these childhood drawings were done always from memory, away from the motif. It was as if he were concerned from the outset to be faithful not to appearances but to the register of those appearances upon the inner eye. An unconsidered but intense fidelity to a personal truth of perception is the essential affecting quality of all children's drawings and paintings done from an inner compulsion. What is remarkable about Heron's 'early drawings' is the degree of self-consciousness that informs them, even as they catch the impress on a child's mind of a sharply perceived and clearly remembered fact.

Heron speaks of having known from the age of three that he would be an artist. His memories of the topographies of his childhood have an unusual clarity and exactitude, and he has lived always with an extraordinary intensity of visual and affective relation to place. He learned early that to draw from memory or imagination was to imbue visual experience with feeling and form, and to define a relation to the subject. The constant discipline of drawing from memory was a crucial aspect of his visual development. The sense of its deep and continuing significance as an act of self-definition, of discovering identity in the world, was necessarily heightened by the context of a lovingly non-judgemental but actively expectant parental audience.

There is about the childhood drawings a true discipline of attention, and they are conscientiously worked to a completeness of presentation that is touchingly solemn, and that anticipates an attentive response. They are often carefully titled, and almost every one is signed and dated. (Sometimes they are annotated for the benefit of the viewer: '*drawn* perppesly bad Heddingly Leeds by P. Heron'; '*IN PENSEL*'.) It is clear from these drawings that Heron was precociously aware of himself *as artist*, which is not to suggest that they lack the charm of innocence, or that they are in any way inauthentic as productions of childhood. It is, rather, to accept the view that a particular kind of realization, a specific externalizing of insight, is possible in childhood drawing (or painting, or modelling, or in a child's making of music as executant or composer); that, at the moment of making, the child's imaginative engagement with reality has the essential characteristics of artistic production. That this is known to the child is manifested in the creative deliberateness of the act.

Perhaps it was his recognition of this lively authenticity that prompted Ben Nicholson to remark of the Wallis-like drawing of a three-master, *Schooner in Storm:*

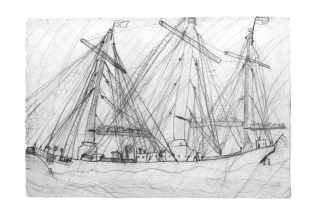

1925: 'I rather *tend* to like this as much as anything you've done'. (It is possible to detect a skittish irony in this, which is consistent with a genuine truth: one can see why Nicholson *would* like this drawing.) Nicholson would certainly have appreciated *HAYL. DOCS. FROM LELANT* ('*By Patrick Heron 1927*'), which depicts the same view from a point just outside the churchyard of St Uny, Lelant, as that of one of his own drawings, which it anticipates by 21 years, *Two Gravestones. Hayle Estuary* of March 1948. Both drawings notice the aerial linearities of the power cables, and the receding curving parallels by which the distance is defined. That is merely coincidence, but in *Coniston Old Man and Wetherlam: 1925,* drawn whilst on holiday in the Lake District in 1925, there is a remarkable anticipation of the economy of line and spatial composition of one of Heron's own works of many years later, the fine charcoal drawing on canvas, *Balcony Window with Moon* of 1954. This and other formal and compositional anticipations, such as that which may be discerned in the linear configuration of the outline of the St Ives promontory, Man's Head, in the drawing of 1928–9, suggest an underlying signature, a habit of gesture, the beginnings, in the earliest drawings, of the 'invention' of a characteristic 'system of images'. In art as in life, the child is father of the man.

In these drawings we find the earliest symbolic representations of what might be called 'the matter of place', the creative matrix composed of deeply assimilated topographical recollections, continuously modified by the recurrent return, actual and imaginative, to *familiar* sites (and sights), and by emotive associations. This aspect of Heron's experience, of seeing or recollecting a room, a view, a topography of forms, colours, and colour shapes, and of recognizing its affective associations, has been active at the centre of his creative life. The specifically local actualities of what 'is seen and known and felt along the heart', are the constant source of his imagery, the activating prompt to imaginative discovery and plastic invention. Whilst this may seem to be obviously true of the figurative paintings of his early career, with their constant reference to familiar objects in known rooms and places – 'chairs or tables, eyes or roses, chimneys or the sea' – it is no less true of his later abstract and non-figurative work. This is not intended to suggest that the categorical commonplace 'landscape-based abstraction' is critically adequate to the description and analysis of Heron's later work.

The matter of place: the term conflates two distinct and equally pertinent definitions of matter. Firstly, the matter which, in Kantian terms, is 'that element of knowledge that is supplied by sensation' and that is separate from and precedes its formal constitution in painting; and, secondly, matter as the imaginative mix, the cultural and phenomenological *materia* out of which meanings are made, and values ascribed to the persons, places and things we encounter in everyday life. The underlying patterning and structures of an artist's work, and the recurrent themes and preoccupations that are expressed in the work, must have their origins in the artist's uniquely individual experience of the world, and that experience is continuous. In the case of certain artists, and Heron is among them, it includes a self-conscious effort of creative response that begins in early childhood.

The crucially formative years of Heron's childhood were spent in West Penwith, to which 'magic ground' he was removed in 1925, at the age of five. Here, in Penzance, he first went to school. From the Herons' first house in Cornwall, just above Newlyn, he was walked to school through hedgerows, then down the hill, the sea-town, the harbour, the high-masted sailing ships spread before him, the high Cornish sky above, salt in the clear air. It was an excitingly different world from that of his birthplace, Headingley, Leeds, the Victorian industrial suburb he had recorded in those earliest drawings of its traffic, its heavy Victorian churches

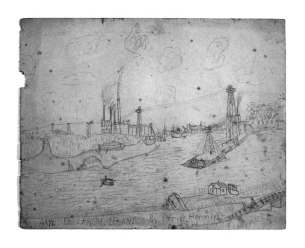

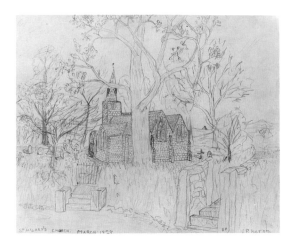

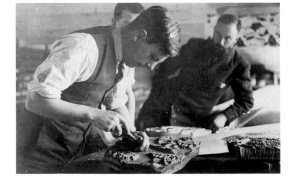

and tall factory chimneys, one of which, 'drawn purposely bad', gave an unintended hint, perhaps, of an attitude to its smoky streets.

Patrick's father, Tom Heron, a successful young entrepreneur originally from Bradford, was a pacifist who had been granted absolute exemption as a conscientious objector during the war, and a radical socialist, though not of an orthodox kind. He had come to Newlyn to join a friend, Alec Walker, in a modest business venture, Crystéde Silks, which at that time consisted of a garment 'factory' set up in three converted fisherman's cottages overlooking the harbour, and three or four shops in Cornish towns. Heron, who had set up his first business on his twenty-first birthday in 1911, had met Walker as a member of a family firm which had supplied his own blouse company with silk. Both of them were artistic and ambitious, believing that developing a chain of high-quality silk garment shops, modelled on what Jaeger had achieved for woollen ware, would enable them to beat the slump of the early 1920s by providing retail outlets for their own beautifully designed and finely made products. Impatient of family opposition, Alec Walker had gone off to Cornwall and set up his own firm, for which he alone made the designs. Walker was a brilliant textile designer, and that was what he could do best; he was less able as a business man. When Tom Heron arrived in Newlyn to manage Crystéde, Alec was freed to devote himself to design and to travel.

The four and a half years Tom Heron spent in Cornwall as managing director of Crystéde Silks was a period of astonishing business success for the firm. Within months he had moved the hand-block printing and the dressmaking works to a large complex of fisherman's lofts over a two-acre site on the Island at St Ives, and before long he was employing over a hundred local people and opening several shops a year all over the West Country. Heron was the energetic director of every stage of the production and trade distribution of the beautiful hand-block printed pure silk dresses that were the firm's product. By 1929 there were over twenty Crystéde Silks shops, the latest, in Cambridge, having been designed by the architect Wells Coates, as his first significant commission. Loathing the ordinary shop-fitters' style of the time, Heron had invited Wells Coates to St Ives in 1928, to undertake the design of the Crystéde shops. It was typically constructive of Tom Heron to respond to the enthusiastic commitment of an unknown designer so generously. He was to be rewarded by the brilliantly innovative shop designs Wells Coates made in the next couple of years for Cresta Silks, the firm Heron set up in 1929, whose famous frontages and distinctive lettering were to make Cresta a byword for stylish modernism in the 1930s.

He was less well-rewarded for his commitment to Crystéde and the extraordinary success he had made of it. In 1929 there was a disagreement with Walker, whose first marriage was breaking up, and whose behaviour had become unstable and unpredictable. The partnership ended unhappily, and Heron was on his own. Crystéde struggled on, but Walker sacked most of the skilled and energetic design and managerial staff that Heron had appointed, and the business in St Ives faltered and finally collapsed. Cresta ultimately bought the firm, and acquired the printing blocks that were left. The break-up was to be Tom Heron's making. Moving to a factory in Welwyn Garden City he set up Cresta Silks, commissioning Wells Coates to design the factory interior and the shops, and McKnight Kauffer to design the Cresta stationery and boxes. Like those of Wells Coates for the shops, these latter designs are classics of applied modernism.

The move to Welwyn Garden City was not entirely unpremeditated, though the break with Walker had not been foreseen. In 1928 Tom Heron had moved his family from the small cottage at Lelant that they had occupied since the move from

Newlyn in late 1925 to a grander, double-fronted Victorian villa above Porthmeor beach. Heron had become a figure of some importance to St Ives, though his artistic interests and political attitudes were hardly likely to endear him to the stuffy local middle class in a town which had been a Liberal stronghold for as long as could be remembered. His most sympathetic local friends were Bernard Leach, who had set up his pottery on the outskirts of the town on his return from Japan in 1920, and Will Arnold-Forster, the Labour luminary who had distinguished himself in the administration of the League of Nations after the War. In 1921 Arnold-Forster had settled at Eagles Nest (it was he who restored its original name to the house), and with the zeal of a visionary had set about the creation of its amazing garden. Tom Heron was an energetic supporter of his unsuccessful election campaign in St Ives in the General Election of May 1929. Labour's national success was partly attributed to the so-called 'flapper vote' created by the lowering of the female voting age from thirty to twenty-one, a fact which gave Heron, who had been an active and brave supporter of the suffragettes, great satisfaction.

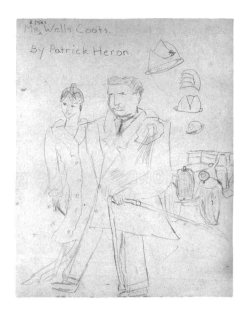

In St Ives, Patrick, after a brief spell at St Ia's school, where his closest friend, Edward Cothey, had lived in the tiny court immediately behind Alfred Wallis's cottage at 3 Back Road West, was sent to 'Sunnycroft', another private school set in the fields above the town, with a view down to The Island, harbour and bay. Here he first met Peter Lanyon and his sister Mary, and the two Leach daughters, Eleanor and Jessamine. Peter and Patrick formed the 'Golden Harp Club: Society for the Preservation of Culture in England', with rubber-stamped headed note-paper: *President* Peter Lanyon; *Chairman*, Patrick Heron; *Treasurer*, Michael Heron. Of its proceedings nothing is recorded; but its title alone signals the seriousness of its concerns, and the precocious solemnity of its founding, and only, members.

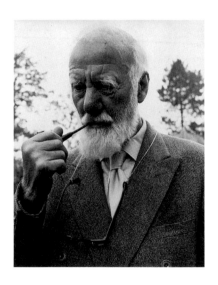

Heron was never to forget the impressions of the light and landscapes of West Penwith that streamed in upon him at that enchanted time: the inland hills capped with great boulders and earthworks, with their prospects across intricately patterned field systems; the coastal coves with curved rock pools; the great bright sweep of the beach, and the strangely configured headlands, of Porthmeor; the curving rhythms of tide-lines in the sands of Hayle estuary; the blazing colours of the bulb fields near the cottage at Lelant, approached through a dark thicket under great Cornish elms; the pale grey-greens of the links around St Uny, Lelant; cerulean days, violet nights.

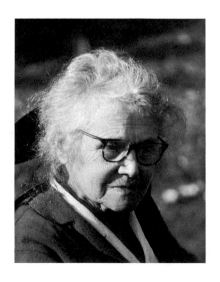

The young Patrick experienced these things with an intensity that he inherited from his mother, whose ardent response to natural objects was often expressed not so much in words as in a rapt attention to their distinctive radiance, to what Hopkins called their *inscape*, 'the dearest freshness deep down things.' Many years later, Heron wrote of Herbert Read's 'gift of pure taste, of a pure aesthetic judgment which extended right across the world of things seen …'. In words remarkably close to those by which in conversation he still remembers his mother's similar gift, he continued: 'If you were with him at the moment he noticed a gentian on a granite wall, you shared the electric shock of the pure pleasure the actual sight of the flower's colour aroused in him. His response to visual beauty, in the natural world or in a painting, was immediate and visible, however quietly indeed silently – it was experienced'. If Patrick inherited something of his political idealism and his fearless activism from his father, he owes no less of those aspects of his character to his mother, Eulalie, and her extraordinary family. And growing up in the

↑ MAN'S HEAD, PORTHMEOR, ST IVES: 1928/9
Charcoal on paper 24.8 × 32.4 cm

⇢ ZENNOR NEAR ST IVES: OCTOBER 1938
Conté on paper 27.9 × 38.1 cm

↓ THE NORTH COAST OF CORNWALL, NEYR ZENNOR: 1928 MARCH 9TH
Pencil on paper 17.6 × 23.5 cm

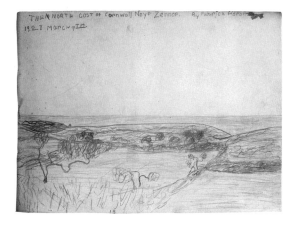

presence of her intense wonder at the visual world, he got from her his passionate eye for natural phenomena and his pure delight in the world of things seen.

What persisted especially from Heron's Cornish childhood was the experience, through the five winter months of 1927–8, of living at Eagles Nest. The Arnold-Forsters were away, and it was thought that staying there might be good for the chronic asthma from which he suffered as a child, from which he has never been free, and which has been a crucial influence upon his life. Asthma induces a solitude of spirit, an inwardness that encourages reverie. The aesthetic intensities of Patrick's childhood, and the parental protectiveness that encouraged their artistic manifestations, can be traced to that condition in which the breath of life itself is constantly threatened.

The interior of Eagles Nest was gloomy, the furniture heavy and dark, the entire woodwork painted black. The garden was at this time like a giant rockery; Arnold-Forster's ambitious programme of planting was already well under way, but nothing was taller than the stocky bush heathers, and the shrubs and trees were no bigger than lavender clumps. Whilst staying there that winter Patrick was given a magnificent box of French pastels by a friend of his father, John Park, a St Ives painter of neo-Impressionist harbour-scapes, a modest man and a true artist. With these Patrick made his first excursions into colour, *Wicca Cove (From Eagles Nest): 1928*, a view of the gorse-covered slopes below the house, with a distant prospect of the sea.

After leaving St Ives in 1929 Heron was next to see Eagles Nest on a three-day visit to Cornwall in 1938. With Eleanor Leach in her Austin Seven he made a tour of the beloved peninsula. Approaching Zennor on the road down from Eagles Nest they stopped, and Heron made a drawing of the village. Taxed on the inclination of the church tower in his drawing, Heron points out, accurately, that by an optical chance the tower from that point on the road, and indeed from other vantage places, truly appears to incline. In 1943 he again spent a brief holiday in St Ives, with Francis Davison, staying in a cottage rented by the Leach pottery. An outcome of this renewed contact with Bernard Leach was Heron's return to St Ives in 1944, to work at the pottery. But this is to anticipate: it is necessary at this point to take up again the story of his father's fortunes, and to trace their influence upon Heron's early career.

Tom Heron had been interested for some time in the garden city movement, more than once visiting Welwyn Garden City and watching its progress since 1920. The optimistic projections of a new quality of life for workers in a light industrial city, where people would have gardens to relax in, allotments in which to grow their own food, and would be able to walk to their work through green streets, breathing clean air, were entirely consistent with Heron's life-long belief in the possibility of a humane and fair social and economic system. Heron's politics were anything but vaguely idealistic, having been shaped in the robust discussions of early Fabianism, and sharpened in the Social Credit debate in which he had played a national role. He had become a friend and ally of Major Douglas, the proponent of Social Credit (and incidently a profound influence on Ezra Pound), through his involvement with A.R. Orage and *The New Age*, the intelligent and influential journal which mixed political and economic analysis with art, literature and matters spiritual.

The editorial programme of *The New Age*, and its anti-dogmatic politics, appealed to Tom Heron as a man of strong social conscience but lacking any narrow ideological rectitude. Possessed of a subtle and flexible mind, with broad interests, and a lover of art, he had sometime around 1921 joined the Anglican communion, and his socialism had been tempered by a Christian conviction. He

was by nature a thoughtful *doer*, a courageous activist, rather than an intellectual. Such men and women are indispensible to the defence of the good against the bad, in life, politics and art alike. Patrick was deeply influenced by his example; just as his commitment to art was valued and encouraged by his father, so were his political and ethical attitudes shaped in an atmosphere of benevolent tolerance and high expectations.

Against the delusions of freedom promised by a political system inherently unjust Tom Heron proposed something more real, the freedom to make and do, and thereby to create a personal identity: 'You are free when you are doing a good drawing,' he wrote in a letter to Patrick at school in 1934, the year in which he commissioned the first designs from his fourteen-year-old son:

You are not free when you are mooching round saying 'Curse it what a bore. Theres nothing to do' when all the time no one is preventing you from doing anything you wish to do!! ... 'The truth that maketh Free'. Finding freedom in creative work – this idea of freedom is what we have to carry into our social organisation. Compared with a society based on this idea of Freedom, Fascism is a DISEASE. But then so is INDUSTRIALISM, & so is SOVIETISM.

Enclosed with the letter were 'particulars of two ART competitions.' A parental economy that seems characteristic prompted the final word: 'Let Micky [Patrick's brother Michael, also at the school] see this letter if you can. He might be interested'.

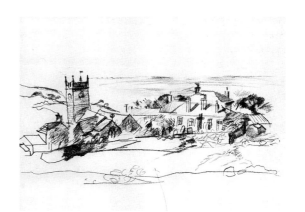

Tom Heron's vital sense of the centrality of art and imagination to the truly experienced life ('You are free when you are doing a good drawing') could be traced back to his young manhood when he had been a leading member of Leeds Art Club. He was 20 when he had joined in 1910, and the ambit of the club's concerns went well beyond any narrow definition of 'art'. A.R. Orage was the President and there were talks by Annie Besant on theosophy, by G.K. Chesterton on the relation of art to life, by Edward Carpenter on socialism and art, discussions of philosophy, socialism and mysticism, and, of course, art. In 1911 Michael Sadler (who was later to translate Kandinsky) became Vice Chancellor of the University, and shortly after, President of the club. Members visited his home to see his Cézannes, Van Goghs and Kandinskys, and paintings from his collection were lent to the club for discussions; at one of these Herbert Read, an undergraduate at Leeds, first encountered modern art and became a lifelong friend of Tom Heron. Orage left to found *The New Age* in London, and quickly became the centre of a regular Café Royal soirée of artists and writers at which Heron, on his frequent business trips to London, became a regular. Ginner, Gilman, G.D.H. Cole, Epstein, Gaudier-Brzeska: all became friends. His life in business was devoted to the practical integration of the aesthetic into the commercial, with the ideal that the beautiful and the fine could enter the lives of ordinary people through the clothes they wear, their furniture, and the houses in which they live. It is not surprising that Heron was the motivating force (being a conscientious objector, he worked from behind the scenes) behind the idea and development of Utility clothing in the 1939–45 war.

Immediately upon setting up Cresta Silks in Welwyn Garden City in late 1929 Tom Heron turned for textile designs to Cedric Morris, whom he had met and admired in Newlyn. It was an inspired choice: the outcome was a series of brilliantly extravagant floral silks. Equally inspired was his commissioning, slightly later, of Bruce Turner, a friend from Leeds days, a remarkable but reclusive painter, whose complex and beautiful all-over designs for Cresta were utterly original: they were the product of a genuine artist with no ambitions as a designer, and no experience,

→ ROCKS IN A COVE: FEBRUARY 4, 1928
Watercolour and Chinese White on paper
25.4 × 31.1 cm

⇒ WICCA COVE (FROM EAGLES NEST):
1928
Pastel on paper 22.8 × 30.5 cm

↓ NIGHT LANDSCAPE NEAR ST IVES: 1928
Charcoal and fixative on paper
17.8 × 22.8cm

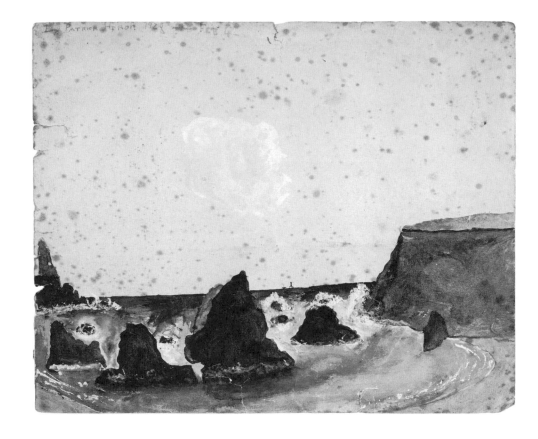

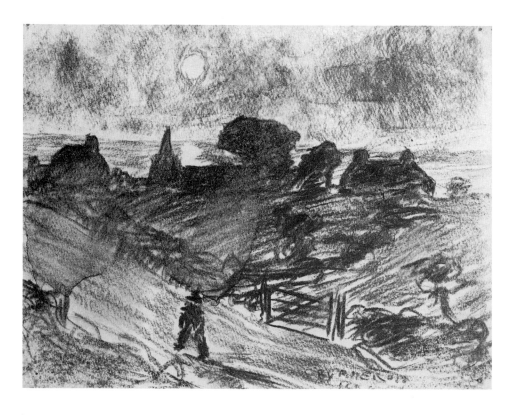

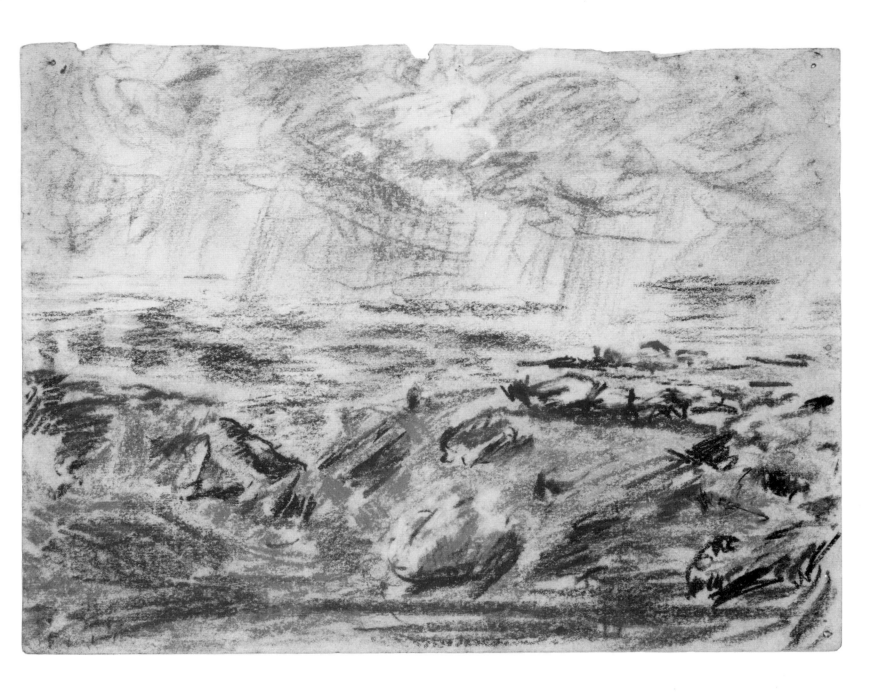

until and apart from his work for Cresta, of the complicated techniques of block printing. At the outset he also approached Paul Nash, whose reluctance to allow Cresta a free hand in deciding colourways and recurrent dissatisfaction with those they came up with, delayed production of his designs until 1932. Heron's tireless patience in his dealings with Nash reflected his respect for the artists with whom he collaborated.

It was into this aesthetically advanced and highly professional set-up that Patrick was invited by his father in 1934, to make his first designs, for silk scarves. Later, in 1936, he made *Amaryllis*, his first all-over design for block-printed silk. *Melon: 1934* is clearly indebted to French decorative styles, derived most significantly from Dufy and Matisse, although it seems unlikely that Heron would have seen much by the former, and certainly not his textile designs, or anything but black and white reproductions of work by the latter. But the French style was in the air, and its decorative flatness and linear vitality was decisively appealing to the young artist: his predilection for the decorative was at once active in these designs.

A combination of proper professionalism and a sweet-natured paternal care is clearly manifest in a letter from Tom of November, 1935:

Thank you very much for the two additional colourings which I am getting tried out at once. You will be glad to hear that the first scarf we sent to Bond Street [where Cresta had a Wells Coates-designed shop] – the sample printed on Crêpe de Chine – sold the second day it was in the shop … I am now printing 50 scarves in your original colourings and hope to sell most of them for the Christmas trade. Mrs. van der Straeten has written me a very nice letter full of appreciation for the scarf you gave her so altogether this is a most satisfactory start with your practical work. I am glad you had a long talk with Mr. van der Straeten about your future. You shall tell me about it when I see you.

Ludvig van der Straeten ('Vandy' to his pupils) was the art and craft master at St George's School, Harpenden, the co-educational boarding school to which Patrick had been sent in 1932. 'I hope you won't try to teach my son Art' wrote Tom Heron, protective of Patrick's native talent, and anxious that he should not be inculcated into a conventional academicism. 'I wouldn't dream of it!' returned van der Straeten. In fact he was to have an enormous influence upon Heron, but not in any academic direction. He was positively encouraging to Patrick, allowing him to paint in the afternoons, when other pupils were playing compulsory games, teaching him to make and decorate original frames in the arts and crafts tradition, and introducing him to Sickert and Cézanne. With the peremptory command 'Get into the car, Heron!' one day in early 1933, he announced a surprise journey: driving his Ford V8 up to London, he parked outside the National Gallery and walked his precocious pupil to the gallery where the Courtauld *Mont Ste Victoire* was then hanging. Heron was exhilarated by this dramatic encounter. In such ways Vandy went against Tom Heron's injunction, and did indeed teach his son art *and* Art.

Heron made a number of paintings at St George's that have survived. Two of these, in their handling and treatment of space, testify to the impact that Cézanne made upon him. He still remembers the moment of 'realization', on a spring day in 1936 in the orchard at Lower Slaughter, in the Cotswolds, when the scene focused and the elements of the picture, paint and perception, fused into a coherent image. *Fête at Hatfield House*, painted in the same year, 1936, is at once an essay into comic *genre* and a subtle spatial exercise. The bow tie of the bowler-hatted moustachioed gent at foreground left is at the focal junction of a right angle which begins its movement at a point two thirds across the lower horizontal and ends where the top of the house façade meets the picture frame. A diagonal passage of recessed space is layered away from the figure towards centre right where it

meets the diminishing perspective of the building. It is an accomplished and witty performance.

St George's School Chapel, Harpenden: 1936 with its Edwardian tones, blue-greys and Indian reds, and its theatrically angled light from the big windows at the right, is a conscious exercise in Sickertian moodiness. *Bogey's Bar: February 1937* was painted in van der Straeten's newly fabricated studio in the garden of Digswell Lodge, just outside Welwyn Garden City, in 1937, the year Heron left school without academic qualifications. Both pictures were painted from memory, and in the latter the space of a modest tea room in Woburn Place has been expanded to create the impression of a French café. Its tonalities have nothing about them of the literal atmospherics of Euston Road: its space and light derive from Vuillard and Bonnard, as does its slightly angled perspective, the bright slabs of light catching the tablecloths, and the essentially decorative backdrop of the façade opposite, the parallel lozenges of which anticipate compositional devices in Heron's paintings of twenty years later.

These paintings were shown to Randolph Schwabe at the Slade, who offered him a place to study there. Heron took up the offer and began attending, two days a week, in the autumn of 1937. He kept this up for two years, but in truth it was of no benefit to him. He made no work of note in that period, travelling home to Welwyn Garden City each evening after classes, and having little contact with fellow students. Many years later, at William Coldsteam's instance, *Bogey's Bar: February 1937* was featured in the Slade centenary exhibition; Heron could find nothing of consequence from his time at the Slade to offer for the show. Indeed his time at the Slade was a period of artistic uncertainty from which little has survived.

Table, Window and Chair of 1937, also painted before his attendance at the Slade, is interesting in that its composition of subject matter, and its spatial ideas are exactly those of a number of paintings of the early 1950s. Though it lacks the spatial sophistication and the abstract tension of those later works, it registers for the first time in Heron's painting a consciousness of Matisse: its stark architectural vertical divisions and interior/exterior subject derive directly from the *Quai Saint-Michel* paintings of 1916–17, which Heron had seen in black and white reproduction. Its colour is English tonal, but the leaves of the plant are of a fresh pure green, and the sky being grey, the clear blue of the table top is a sharply perceived effect of reflected light rather than of colour.

The war came. In spite of his asthma, which would have earned him exemption from service anyway, Heron, true to the principles of a family whose pacifist opposition to war went back as far as the Boer War, registered as a conscientious objector. Like so many artists of his generation his development was abruptly interrupted, and it was impossible to think about any consistent effort of creative work 'for the duration'. Heron worked for nearly three years as an agricultural labourer for the Cambridgeshire War Agriculture Committee, digging ditches and clearing fields in frequently appalling conditions, especially in winter, and lodging for most of that period in Cambridge. The Committee's labour gangs were composed of pacifist scholars, foreigners caught up by the war, and other individuals of distinction, whose company relieved the boredom, but could not alleviate the physical miseries. He later worked on a chicken farm at Codicote, near Welwyn, where conditions exacerbated his asthma to the extent that he was ordered by doctors to rest. So it was that in August 1943, with Francis Davison his friend from school days, Heron was freed to visit West Penwith, and renew again his connections with the 'sacred land' of his childhood. When, five months later, he went to work with Bernard Leach at the St Ives Pottery, it was a return not only to a loved place, but to a life in art.

↠ FÊTE AT HATFIELD HOUSE: 1936
Oil on primed plywood 57.2 × 68.5 cm

↓ ORCHARD, LOWER SLAUGHTER: 1936
Oil on canvas 41.3 × 55.2 cm

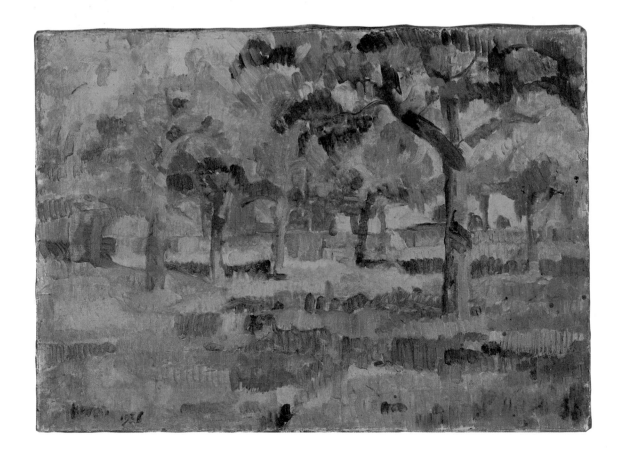

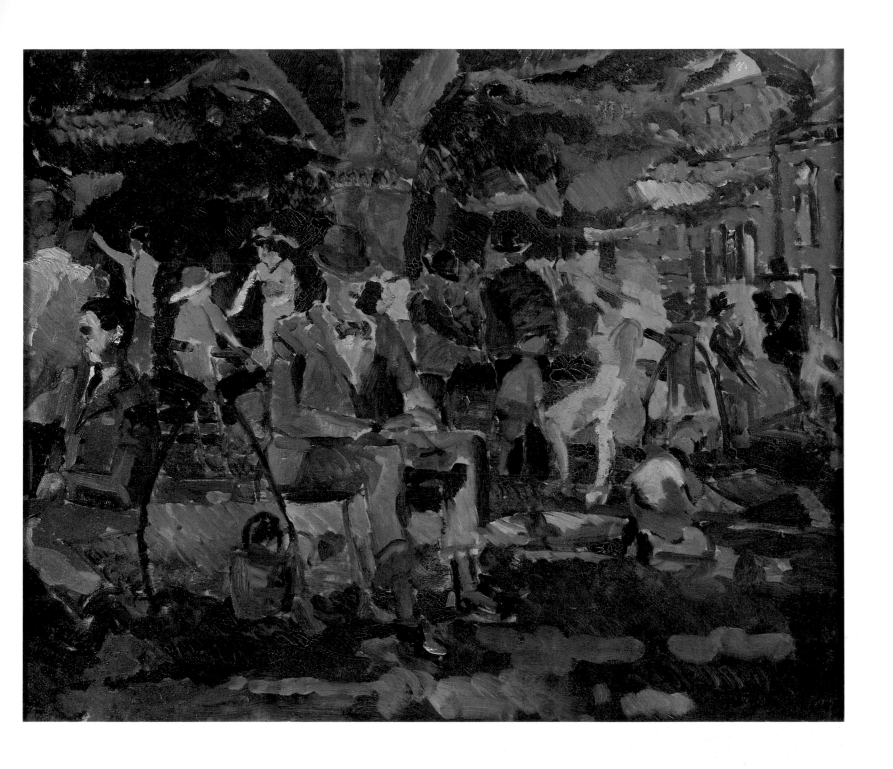

TABLE WINDOW AND CHAIR: 1937
Oil on canvas 76.2 × 50.8 cm

ST GEORGE'S SCHOOL CHAPEL,
HARPENDEN: 1936
Oil on canvas 77.5 × 50.8 cm

BOGEY'S BAR: FEBRUARY 1937
Oil on canvas 91.4 × 71.1 cm

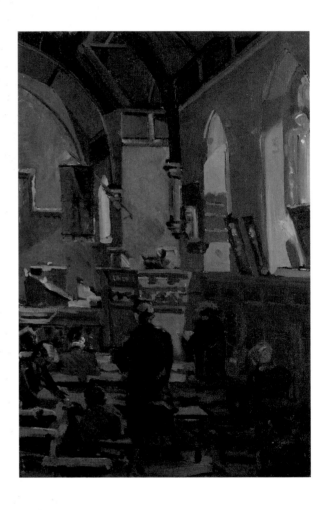

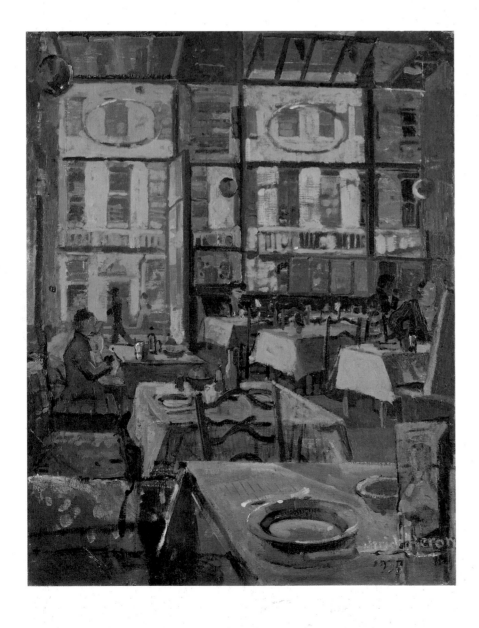

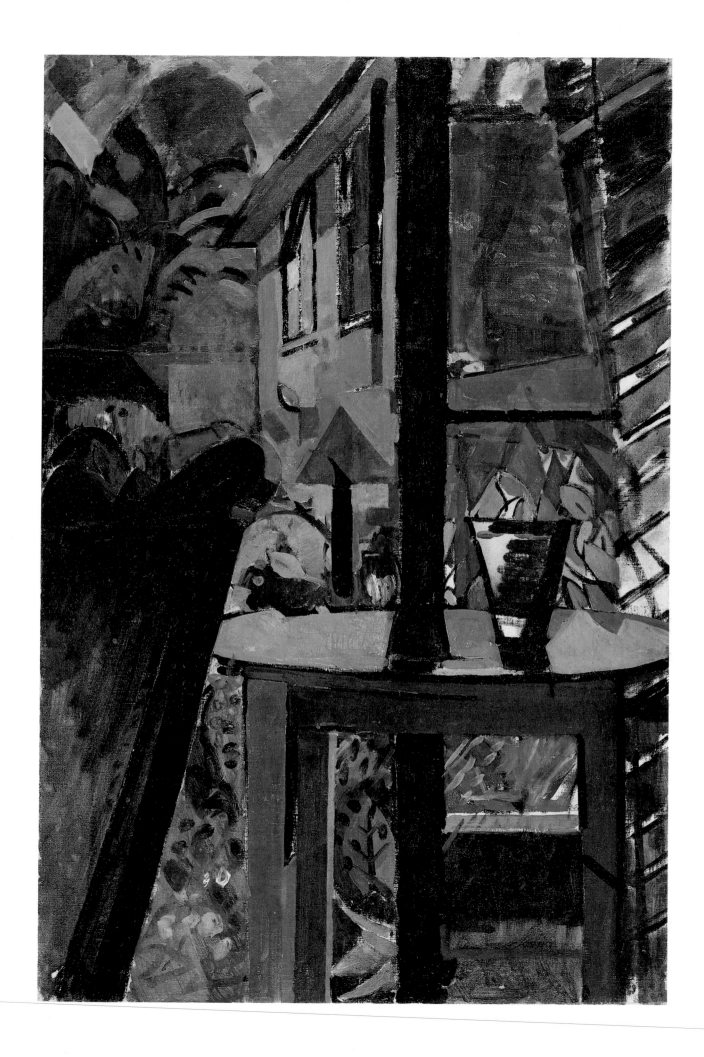

3 CREATING AN IDENTITY: POST-WAR BEGINNINGS

Tradition and the individual talent

Pottery is an ancient form of non-figurative art.' With these words Heron opens his classic essay on the significance of Bernard Leach, 'Submerged Rhythm *A Potter's Aesthetic*'. He immediately quotes Leach himself: 'A single intuitive pressure on the spinning wet clay, and the whole pot comes to life; a false touch and the expression is lost.' Heron comments revealingly on this: 'And this criterion, 'life' … is the right one, though a volume might be devoted to its elucidation as it applies to pottery.' That informing vitality, as the essay itself so brilliantly elucidates, is something Heron defines as 'rhythm', and it is to be found in painting as well as in pottery. It is an inner pulse of expressive energy which 'pervades a picture or a pot, dominating its forms, dictating its character, and above all, determining its intervals.' It 'cannot be pinpointed'; in painting it is 'that logical force which suddenly gives the subject – whether still-life, landscape or figure – its new identity as a pictorial … image.' It is, of course, the essentially *abstract* configuration of elements that composes a picture to which Heron is referring in this: those dispositions of colour shape whose interrelations determine the spatial dynamics of the picture, its visual effect and affective impact, whether it is figurative or non-figurative in intention.

What Leach had done was to rediscover 'an ancient formal rhythm which precisely coincides with the formal rhythm of certain modern painters; and notably those of Braque'. In particular it was the 'submerged rhythm' of Chinese Sung pottery and Japanese eighteenth-century stoneware, whose inner aesthetic identity, he had recognised, had much in common with the *'blunt, full'* rhythms of early English pottery and English country slipware, that had entered into Leach's own style. Leach had effected 'a genuine East–West synthesis' and, in doing this, he had created 'a ceramic idiom very much in accord with aspects of modern art.' In going back to formal models outside the classic European Renaissance and post-Renaissance canons, in adopting an approach in which 'intuitive pressure' and authenticity of 'touch', and truth to the nature of the materials to hand (to use an apt phrase) were essential to the shaping of forms, Leach had much in common with his contemporary, Henry Moore. Both emphasised 'the generous pulse' of 'massive, blunt forms'; both were preoccupied with the making of an object whose 'volumes, open spaces and outlines', in Leach's words, 'are parts of a living whole', and which is itself *a form in space*.

Much of 'Submerged Rhythm' was written in 1952 as a lecture, which Heron delivered at the International Conference of Craftsmen in Pottery and Textiles at Dartington Hall in the July of that year. It represents a summary, up to that time, of his thought on Leach and his achievement, that of 'a very subtle artist', whose work was 'utterly contemporary: the exact counterpart, in ceramic terms, of the sculpture of Henry Moore or the painting of Braque.' It is also an exploration, in some respects overt, in some disguised, of the significance of Leach in his own creative evolution: 'I have often wondered,' he wrote, 'to what extent I have myself been influenced, as a painter, by the fourteen months I spent at the Leach Pottery at St Ives in 1944 and 1945.' The influence that Bernard Leach may be thought to have exercised on Heron's artistic development, and that of the experience of working at the Pottery when he did, was no less decisive for being necessarily indirect. That period at St Ives was idyllic; after the miserable discomforts of his previous war service as a labourer, it was not only restorative but formative.

The influence upon Heron of working with Leach was in the nature of an affirmation: it was a matter of a prevailing spirit and feeling, an atmosphere of creativity, the implications of which went beyond matters of *métier* and style:

'… I believe that the potter and the painter … have one thing in common, above all else. Both are dedicated to perpetuating the *creative act* in an age which is increasingly dominated by inhuman mechanistic processes'. Leach, as we know, had been a friend of Tom and Eulalie Heron from the mid-1920s in St Ives: the congruity of the ideas so emphatically elaborated in the Dartington lecture with the practical philosophy of Heron's father, and of their descent from Ruskin and Morris, is clear. Leach was the most distinguished living proponent, in his writings and in his practice, of this philosophy. What he preached most eloquently he practiced with a technique of genius, the unparalleled ability as a potter to convey an 'intuitive apprehension of *life*' through form. Technique could not be separated, wrote Heron, from the thought and feeling, the idea and emotion, that its exercise made visible: it was '*the power to materialize a concept*'.

Heron moved to St Ives to work at the Pottery, at the invitation of Bernard Leach, in January 1944. The end of the war was over a year away. He was still officially a conscientious objector and this was an approved work placement, considered suitable for someone with his medical background. Already working there was Dick Kendall, a friend from Slade days, who had been given total conscientious exemption at the beginning of the war, and had become, in the interim, Leach's principal assistant, and Frank Vibert, a pacifist from St Ives. Under the tutelage of Leach they engaged in prolonged and intense discussions of matters philosophical, ethical and aesthetic. Heron was essentially a journeyman potter at the Pottery, and he had no ambitions to be anything more than that; his future as a painter was determined. In such circumstances, however, constantly in the company of an artist as complete as Leach, it was inevitable that he would consolidate an approach to art and life that had been developed with such rigour at home and at school.

Heron's philosophical and critical coherence, as artist, writer, polemicist and political campaigner, that single-minded conscientiousness which has marked his actions in each of those incarnations, was forged, albeit out of a mettle already formed, in those months at the Leach Pottery. The potter and the painter, the craftsman and artist, are equally aware of 'immense dangers inherent in the very nature of our civilization': the dangers of encompassing mechanistic technologies that threaten to dominate humankind and place it at the mercy of the 'mere processes' of technocracy. 'Our work', the work of the artist and the craftsman, he wrote in 1952, 'is not only an affirmation – an affirmation of our deepest, instinctive awareness that the very texture of life is dependent more upon organism than upon mechanism. It is also a protest.' This goes to the heart of Heron's philosophy as an artist and as a man. It is in the *making* of the work that the artist engages at the profoundest level with the ethical: the individual creative act is itself the decisive political act. The created work exists, *in itself*, as a challenge to those forces in modern civilization that seek to dehumanize and devitalize us. The essay ends with a memorable formulation: '… for me, the moral and the aesthetic have a single identity. Ethics are the aesthetics of behaviour'.

Love – of places no less than of persons – also plays its part in this richly imagined politics. The continuing significance of West Penwith to Heron's artistic imagination is something to which it will be necessary to return, but it is pertinent here to refer to his tenacious and effective campaigns over many years to protect the landscape of that 'final knob of the long, westward-yearning peninsula of Cornwall' and its ancient coastal road 'that slips, folds and slides around rocks, under crags, past lonely huddles of granite farms, past the mines of the past.' Heron has written of this landscape with a poetic precision:

↠ ACROSS THE TABLE: 1946
Printed crêpe de chine scarf for Cresta
91.4 × 91.4 cm

↓ ON THE TERRACE: 1944
Printed scarf for Cresta 66 × 66 cm

Stop anywhere on this road and climb to the rock-crowned crest of any hill – Trevalgan, Trendrine or Carn Galva – or halt in a church-crowned village – Zennor, Morvah, St Just. You are in a world of viridian greens, of a multitude of greys, soft ceruleum blue, indigo, black, khaki, and Venetian red. A worn asymmetric rectangle, a lopsided disc, an uneven triangle of smooth stone, inlaid in the field-path at your feet, are echoed precisely, it seems, in the boulders of the hedge by the stile, in the wall of the ancient church tower, in the configuration, half a mile away, of pale giant rocks balanced in an intricate chaos on the dark bracken slopes above you – among the badgers and the magpies.

In *Hills and Faces*, the essay from which this passage is taken, Heron muses on the possibilities of a modern portraiture and modern landscape painting. The success of such painting depends upon the quality of the artist's engagement with the subject: 'we must not forget that the artist is also an ordinary man; and every one of his faculties is relevant to the problem of the direction his art will take.' This engagement comprehends more than the passively visual, it is a 'subtle act of empathy at every stage'; its purpose is the realization of the complex experience of the moment of painting, which concatenates sensation to memory, thought and feeling. And the primary sensation of painting, which distinguishes it from other arts, from poetry and music, is visual. Painting, it may be said, is the translation of the visual from the reality of the world to the parallel reality of the canvas.

The subject matter that Heron found most congenial to his own concerns in the mid and late 1940s was that of the still life in a domestic interior. There had been and would continue to be occasional efforts in other directions: small Derain-inspired landscapes, one painted in 1941 at his digs in Cambridge, another three years later in Welwyn Garden City, both done from memories of Swaledale in Yorkshire; a romantic imaginary *Church on the Sandhills: 1944*, whose creamy tonalities and flowing brush strokes seem at odds with Heron's predilection for pure colour and characteristic impulse to compose and structure the pictorial surface. The war made sustained creative research impossible, and the pictures that survive from those years are, by and large, isolated experiments, often significantly unfinished.

Closer to the direction his art was to take, in fact, is *On the Terrace*, the scarf design he made in 1944 for Cresta. From this time on Heron was to be the principal designer of printed textiles for Cresta, creating a remarkable body of work. *On the Terrace* with its decorative deployment of bright colour in disparate patches across the surface, its playful corner-to-corner compositional axis and off-centre diagonal divisions, in short, its spatial *rhythm*, anticipates many of Heron's later pictorial concerns. The demands of design as such seem to have freed him from the preoccupations of a young artist self-consciously seeking a style through a fitful engagement with the major painters of his time. (Bonnard, Derain, Vlaminck, Picasso among others had featured in his experimentation during these years.) The requirement of a directly decorative impact with no specific point of focus, no compositional centre, accorded precisely to the internal impulse that was to shape the forms of Heron's mature painting, changing forms indeed, but absolutely consistent in exemplifying the abiding qualities of the decorative. Its flat colour derives directly from Matisse, whose marvellous selection of his own paintings, published by Braun and Cie (Paris 1939), Heron had bought at Zwemmers in 1940; in its multi-directional compositional dynamic he had learned from Bonnard. In working as a designer Heron began to define himself as a painter.

The point may be made with even greater force in reference to a slightly later design for Cresta. The vital edge-to-edge design of *Across the Table: 1946,* with its linear verticals enclosing dabs and dashes of colour, discrete 'square round' strokes,

and its arbitrary dispositions of abstract colour shapes that make jug, plate, cup and saucer, flowers, window ledge and girl all equal elements in the composition, clearly prefigures the compositional devices of the Braquean still lifes of the later 1940s and, even more so perhaps, the dazzling interiors with figures of the early 1950s.

There is an instinctive predisposition to certain formal devices, particular gestures, recognisable forms and configurations, the product of 'certain reflexes of eye, arm and hand', which is personal to the work of any original artist. Persisting through changes of manner and subject, it may be defined as *the impulse to style*, where what is indicated by the term style is the expressive ideolect of the individual artist, in circumstances where many artists share an idiom. At a certain moment in the artist's development, in a particular work, this impulse finds its proper expression, and at that moment a personal style announces itself. It is, to paraphrase Heron's own words, the instant at which *technique* matches vision in relation to the individual artist's unique aims: '… once we know or can recognize these aims, we have already passed, at a bound, from a consideration of means to a consideration of ends.'

The Piano: 1943, which preceded *On the Terrace* by a year, marks such a moment, though this was not fully recognized by Heron for many years: 'I have come, with hindsight,' he wrote in 1978, with a typical declarative emphasis, '(and by hindsight I literally mean thirty years) to recognise that this picture marks the greatest step forward in my whole life, in the sense that it is visibly related, in shape after shape and colour after colour, to works typical of my production at point after point in time from the Fifties on.' In a somewhat more guarded tone he added: '… I think I believe it would be true to say that the basic rhythms, the fundamental patterns which link all the colourshapes we eventually recognize as being most typical of a painter are possibly established – even if they're somewhat disguised – at a very early stage in his career.'

What makes *The Piano: 1943* remarkable in Heron's development, in spite of its diminutive size (roughly 19 × 28 cm), is its abstract clarity, its deliberate division of the picture surface into a configuration of shapes whose relations are determined by an inner logic, by that very *rhythm* defined earlier. It is that impulse not amenable to purely conscious intention which creates on the canvas or paper (as in this case) an autonomous reality. Its operation confers on the picture an identity of its own as an object whose relation to the visible is neither mimetic (or photographic) nor wilfully personal and private in its significances, though mediated through an individual and unique sensibility. *The Piano: 1943* discloses concerns that have pre-occupied Heron forever after: space, colour and colour shape; the relations of direct visual experience to the created forms of art.

The Piano: 1943 is the first painting of Heron's that has stylistic autonomy, French as it is in feeling. Its subject is immediately recognizable: a grand piano with a vase of flowers on it, in front of a window through which the light falls to catch its curving top at the right. This light is the untouched support, the paper left visible: at once a flatly objective actuality and a fiction of the moment's reality. The picture is dominated by a shape whose rhythmic surge into the foreground gives the work a dramatic presence out of all proportion to its scale; the fullness of the piano's *form* in real space here becomes a flat *shape* that is its effective embodiment in pictorial space. The spiralling rhythm of the picture as a whole, which continues the swelling curve of the piano into the leftward scatter of green leaves across the centre top, and homes to bottom left through the same green zigzag of the piano leg, is countered by a succession of vertical planes, and by the rectangular forms of

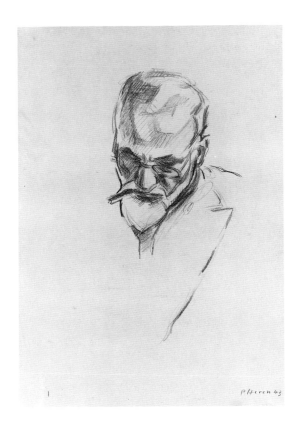

THE PIANO: 1943
Oil on paper 19 × 27.3 cm

SWALEDALE LANDSCAPE:
JANUARY 1944
Oil on cardboard 13.3 × 16.5 cm

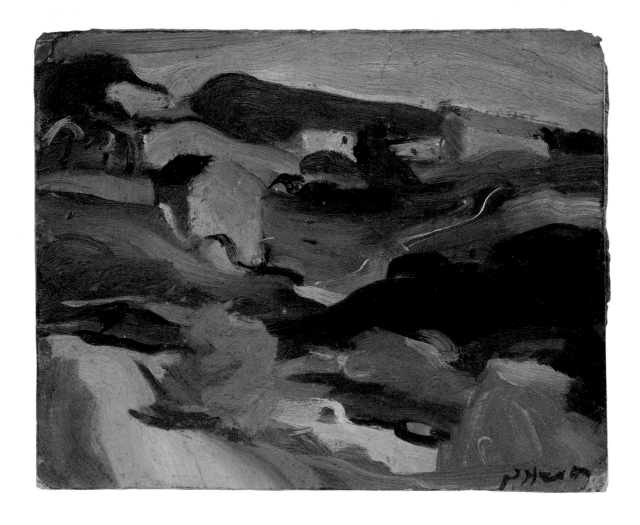

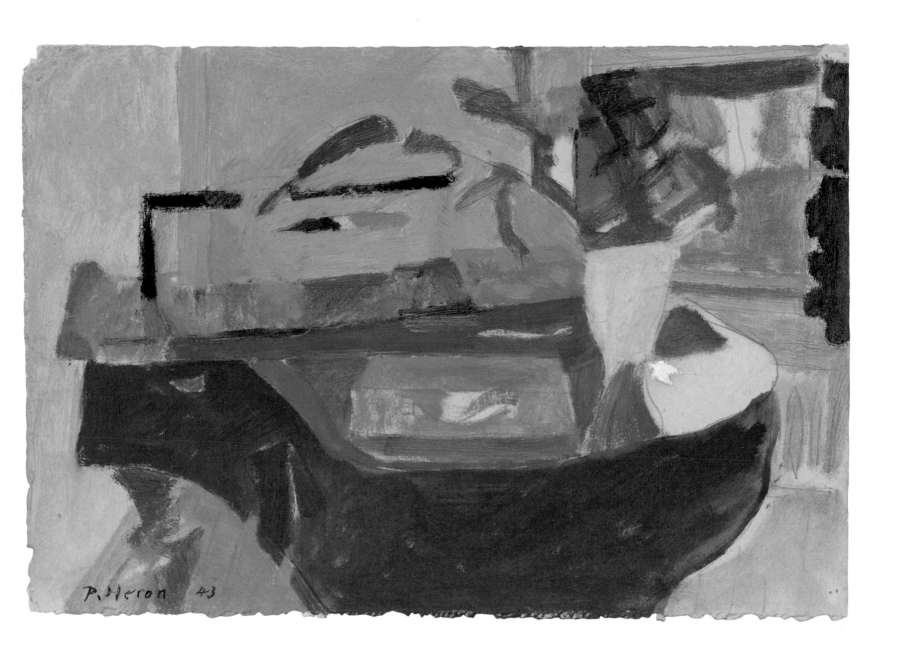

→→ Wedding photograph in the Reiss's
 garden at Welwyn Garden City:
 17 April 1945

↓ Delia Reiss, c.1940

the window and the upright music holder. The hot orange and violet stripes of the sill that signal the transition from inside to outside (a device found in both Matisse and Bonnard) irresistibly tug the eye to the right edge of the picture, where the outline of the purple curtain, and its compositional effect, prefigure those of similar vertical edge shapes in the 'wobbly hard-edge' paintings of over twenty years later.

This little painting was made early in 1943, at the family home in Welwyn Garden City; in the April of that year it was chosen by Delia Reiss as her twenty-third birthday present. Heron had met Delia almost immediately on arrival in Welwyn in 1929, when they attended the same school. In 1931, her father, Dick Reiss, had decisively intervened to help Tom Heron to maintain Cresta's independence in a crisis. Reiss had been a co-founder of Welwyn Garden City and was keen to see Cresta stay there in business. There were, then, long term connections between the families, and Patrick and Delia were friends at first in childhood. In 1932 they were prizewinners in a local children's art exhibition, and Patrick's first press notice was shared with Delia: 'A very feeling study of a horse's head, by May Robinson, and a frieze depicting submarine life, by Delia Reiss ... were awarded prizes. A special prize, given by Mr M. Herbert, was secured by Patrick Heron with two watercolour sketches revealing strength of portrayal and remarkable observation.' Tom wrote to Delia: 'There was brave colour in your frieze, and you are the richer for having done it. Do another!'

Delia was a remarkable person, intelligent, artistically gifted, spirited and beautiful. After seeing little of each other during later schooldays, she and Patrick had become friends once more in the months just before the end of the war. When Heron went to work in St Ives in 1944 Delia visited him on several occasions, staying at the nearby Veor Farm. Coming to the Pottery, she sat for the first time in her life at a potter's wheel and at once, effortlessly, threw five perfect small pots, each different from the other: a feat unprecedented in Bernard Leach's experience, and which he never forgot. One day, after she walked alone to Zennor, she said to Patrick, 'I've just seen your Eagles Nest at last.' In the April of 1945, together with Tom and Eulalie, they visited the house that eleven years later was to become their home, and Patrick made a drawing of the azalea garden. That month they were married. In Delia Patrick found the perfect companion, whose feeling for art and nature answered precisely to his own. Her commitment to his work was tempered by an absolute independence of spirit: she was his 'best and most essential critic.'

On their honeymoon, at Love's Farm, near Easebourne in Sussex, Heron made a series of drawings from memory of St Ives and its environs, of Penbeagle Hill behind the Pottery, and of Lelant Church. These are sparely evocative, and in their conviction of line and instinctive feel for the character of the landscape and its buildings they recall the style of Christopher Wood, whose drawings Heron had seen at the retrospective exhibition at the New Burlington Galleries in 1938, and whose own associations with St Ives were well known to him. During his period at the Pottery, Heron had become friendly with Ben Nicholson, whose friendship with Wood had led to his first visit to the town in 1928, and with Barbara Hepworth. He had also made friends with Adrian Stokes and Margaret Mellis, living at this time at Little Park Owles, and with Naum Gabo, whose modest bungalow was nearby.

The war being over, living with Delia in a flat in Addison Avenue, Holland Park, Heron was at last free to paint. He had at last to become a serious painter, and he had little doubt about those modern artists to whom he would look for

inspiration and influence. Neither the currently fashionable figurative melodrama of the mostly London-based neo-Romantics, nor the muddy tonalities of Euston Road realism held the slightest appeal for him. And in spite of the admiration he had for its greatest proponents, he was not tempted by the cold clarities of English abstraction, exemplified above all by Nicholson's 'measured squares and circles, overlaid with a paint as smooth and innocent as ether', or by the constructivist austerities, however brilliant, of Gabo. He was not interested in an art from which 'all hint of human furniture is emptied, all echo of familiar, long-loved forms removed – chairs or tables, eyes or roses, chimneys or the sea ...': such art, he wrote in that first essay on Ben Nicholson, represented 'the conclusion of a logic ... at a tangent to the mainstream of art.' That mainstream, he had no doubt, flowed through Paris.

Within months he would be able to see and study in depth the recent painting of those whose work he knew would do most to nourish his own artistic imagination. His attention to major exhibitions of Picasso and Braque was intensified by a commitment to write about them; but his address to them, and to Matisse, who was also shown in London in 1945, was in the first place, and most importantly, as an artist. He was keenly aware of a precedent in this: Heron had not read widely (and never has) but he had read deeply, in Lawrence, Joyce and Eliot. From the criticism of the latter, whose poetry he revered, and whose example as a practitioner-critic encouraged and justified his own writing, he had learnt that the emotion whose expression was found in art is 'impersonal', and that the artist 'cannot reach this impersonality without surrendering himself wholly to the work to be done. And he is not likely to know what is to be done unless he lives in what is not merely the present, but the present moment of the past, unless he is conscious, not of what is dead, but of what is already living'. For Heron in 1945 the most vital locus of the 'present moment of the past', a moment fraught with an extraordinary historical intensity, was in France: 'When France disappeared into silence in 1940 we knew that somewhere or other nine men lived on whose artistic achievement already ensured a position in history for each and all of them. The glory of permanent achievement rested, in 1939, on Picasso, Matisse, Bonnard, Vuillard, Braque, Rouault, Derain, Utrillo and Maillol ...'.

That note of Eliotic *gravitas* is sounded in the first paragraph of Heron's 1946 essay on Braque, written for *The New English Weekly*. It marks the beginning of a long and complex engagement with the work of the great French master: Heron continued to write about Braque, always with a special intensity of admiration, up until 1958, when he contributed the text for the Faber Gallery Series *Braque*; his own painting through the 1940s and the first half of the 1950s constitutes a prolonged creative dialogue with the artist whose 'permanence, grandeur, deliberation, lucidity and calm' he recognised as representing the 'paramount virtues of the art of painting.' By the time he came to write the important essay for *Arts* (New York) in February 1957, and the Faber text in 1958, Heron had moved decisively away from figuration; '*experience*' of Braque's paintings had given way to '*knowledge*'. He could write of Braque now with a certain detachment, as one of a generation 'occupied in new pursuits having apparently little connection with this great painter's life work ... a non-figurative art [seeking] a spatial freedom and certainty in the interaction of colours at once harsher and brighter than Braque's ...'. Even so, he acknowledged essential continuities in a critical manner that derived directly from Eliot: '... Braque is become 'the very near past' ... but we are only who we are and where we are because, in large measure, Braque is who he is and where he is.'

→ EMPREINTES: 1945/6
Printed crêpe de chine for Cresta
16.5 × 22.5 cm (repeat pattern)

I no longer walk about London literally *seeing* Braque's stringy lines of drawing in the lines of the panelling on the interior partitions of Underground trains; or his gritty, dull-toned surfaces – his khakis, walnuts, or *café-crèmes* – in the nicotined dados of pubs; or his flat, leaf-balancing pot-shapes in the window-boxes just off the King's Road – thin iron railings sliding up in front of them (a black grille), and behind them and *through*, the silhouetted forms of an 'interior' seen through half-open French windows.

This vivid evocation of Braque's vision, mediated through the remembered consciousness of the young painter in his late twenties, provides a startling insight into the vital way in which a great artist's influence may animate the imagination of one involved in the process of finding a style of his own.

To some extent Heron's identification of affinities between Bernard Leach and Braque, in those passages from *Submerged Rhythm* discussed at the opening of this chapter (and which are not to be found in the earlier pieces on Leach, written in 1946 and 1952 respectively, and incorporated into the Dartington lecture), must be attributed to Heron's deep preoccupation at the time of writing, and for some years before, with the problematics of pictorial space, and with the crucial part the still-life painting of Braque had played in the making of his own style during that period. The essay acknowledges this, to some extent implicitly, in the manner in which Heron develops his argument that 'certain parallels ... exist between contemporary pictorial and ceramic aesthetic.' It is a complex aesthetic, this, being a synthesis of structural pressures (the 'generous pulse' from within, the 'interior thrust' that gives shape to form) and compositional rhythms (the dynamic *relation* of forms in space) whose outcome is a quality of presence in the created object that can only be called 'life'.

In figurative painting this quality of presence animates the depicted objects themselves:

... the kind of life which he bestows on his coffee-pot or coffee-grinder, his table, his chair and window, is just the sort of life we feel these things are really living! The personality with which Braque invests his jug is something that the jug really possesses in its own right. In other words, Braque divines the essential spirit – one might almost call it the 'soul' – of each object that he paints.

It is hard not to see in this some reference to the artistic ambitions of Heron himself. Its vehemence of utterance (a tone that can be traced back to Lawrence's writings on art) gives the clearest expression to the impulse behind his continuing commitment to figuration at a time when some of his closest artist friends were turning to abstraction. Heron had no doubt that Braque was the 'the greatest living master of still life', his manner radically distinct from that of Picasso's, whose 'fantasy ... shows scant respect for the subjects of his pictures'. In Braque he found a magisterial modern precedent for his own passionate apprehension of familiar things in known rooms, and for his celebration of them in paint. His commitment to figuration, with one or two brief deviations, persisted until late 1955, and is the subject of the next chapter.

4 THE FIGURATIVE PAINTER

1945–55 Interior and window

→ CHRISTMAS EVE: 1951
Detail

Visiting Braque in his Paris studio in 1949 Heron had spoken of the non-figurative painting of the younger French painters. Braque had exclaimed: 'Ils sont trop cérébraux. L'objet, c'est tout!' Recalling this later Heron also remembered a *Cahier* maxim of the master: 'Let us forget things and consider only the relationships between them.' Braque's care for the real objects that filled his studio was conditional upon their transmutation into pictorial form. 'I do not have to distort; I start from formlessness and create form.' Writing in 1955, John Richardson described this studio, as represented in the great crowded *Atelier* pictures, as 'a microcosm of the painter's professional universe', where current paintings, finished and unfinished, were carefully displayed, with sketchbooks, canvases and frames, and 'small tables are neatly piled with artists' materials, while others are covered with pots, vases, musical instruments, pieces of sculpture, *objets trouvés*, plants, flowers, and the like, which the painter uses, without actually copying, in his still-lifes. The total effect is that of an elaborately arranged composition waiting to be incorporated into a picture.' All those things to be 'forgotten' in the creative alchemy of object into pictorial essence!

There is something profoundly French in this, something that derives essentially from Mallarmé whose influence upon the artists of this century in France is incalculable (Matisse was his most magical illustrator-interpreter), and from Cézanne: *everything exists to end up in a picture.* 'In a typical Braque interior,' wrote Heron in 1951, thinking of his visit to that marvellous studio, 'the girl sitting among the uprights of easels, nursing a guitar as tenderly as a baby, is only one more object … among many other objects … Perhaps it is *because* human beings appear in his works on more or less equal terms with pianos, easels, palettes, guitars, climbing indoor plants and garden chairs or tables of ornate iron-work, electrically tense, that all these objects are invested with life and dignity?' Certainly, there was in Heron's own figurative painting always an impulse towards the realization of an *abstract* energy that would hold all the elements of the picture in tension, transforming the objects and figures into formal elements of a total composition, charged with a life that is contained within the picture and not to be separated from it.

To succeed required an essential clarification of aims, as well as an assiduous attention to the work of those who had most triumphantly achieved such realizations. During 1945 and early 1946 Heron painted feverishly in several idioms. Among the most notable pictures made in this period were a number of stove-top still lifes, directly inspired by the wartime paintings of Picasso on that theme, which he saw at the Victoria and Albert exhibition in December 1945: Picasso, Heron has said, 'made the gas stove into a sacred object.' Recently married, and domestically settled in the London flat, it is not surprising that Heron should have been inspired by the dynamic animism of Picasso's wartime paintings of kitchen objects, even if their expressive function was that of symbolic disguise for the artist's feelings rather than the affectionate discovery of their 'personality'. The components of the domestic interior comprised precisely the known loved things whose successful translation into a purely pictorial reality would invest them with a life and dignity that was utterly without sentimentality.

The primary problem that Heron had set for himself was certainly not one of pathetic personal expression; neither was his painting to be construed as a form of affective autobiography. 'Twentieth century Expressionist painting', he wrote in his essay on Vlaminck in 1947, 'is defective as art because it is painting in which the formal means at the artist's disposal are insufficient or inappropriate as a vehicle for the emotion he is trying to express.' Vlaminck's greatness consisted in his ability to increase intensity of effect with a masterly economy: in the use of pure and

primary colours within a minimal tonal palette; in his repertoire of distinctive strokes, slab, impasto and scribble; and in the formal logic of his design. In Vlaminck's best paintings the emotion is never sentimental, morbidly in excess of its object; it is genuine and specific to a place and to a time of day. It is the purpose of a Romantic art such as Vlaminck's to effect a poetic transmutation of what is seen and felt into a formal arrangement that will release an equivalent feeling in the spectator. Admiring Vlaminck, Heron had no strong impulse to emulate him, though he did make one or two essays in that direction whilst he was working on the Vlaminck text, on a holiday in North Wales in 1947. Such efforts, like those in homage to the more severely classical Derain, may be seen as a kind of creative criticism, a means to *discover* the inner structural dynamics that give their work its formal strengths.

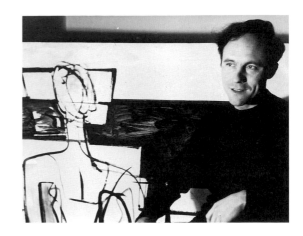

Picasso, for all the *furore* of his personal presence in his work, his 'imposition of his own meanings upon objects', was recognised by Heron as 'the only painter who compares at all with Braque in … *animating the inanimate*.' Picasso is portrayed in Heron's writings on him as if possessed by a daemon, rapt in a powerful 'fantasy'. 'But it is never … manifested in terms which violate plastic unity. The perfect marriage of fantasy and reality, the co-existence of the poetic and the purely pictorial in a single gesture of paint – that is everywhere the miracle of Picasso …'. Heron, in fact, recognized those starkly figured candles, coffee pots, saucepans, empty mirrors, writhing plants, etc., as examples of an 'objective correlative', the finding of which is 'the only way of expressing emotion in art', and which Eliot had defined in terms that might be closely applied to the drama of Picasso's painting: 'a set of objects, a situation, a chain of events which shall be the formula of that *particular* emotion; such that when the external facts, which must terminate in sensory experience, are given, the emotion is immediately evoked.' In his 'Changing Forms' essay on Picasso, Heron was to speak of the 'Picassian ambition to find a pictorial equivalent for *every* experience of mind and spirit', contrasting it with Braque's striving after 'a refinement, a quiet advancement of the the means of painting'. Objects in Picasso's paintings are vehicles for the conveyance of an awesomely powerful vision in which things are bent to his expressive will and purpose; in Braque they are transformed by a mode of contemplation into elements of an abstracted pictorial harmony.

Heron was predisposed by both temperament and taste to this latter mode. And it is not surprising that he should turn quite consciously to the example of painters whose work exhibited that tendency towards an ordering of the observed world, a rhythmic formalizing of sensation to create an art that is, in Cézanne's words, 'a harmony *parallel* to Nature.' This is something very different to that sort of naturalistic 'realism' that seeks to imitate or record nature, whether it be that of the Euston Road painters or that of the social realists that came to prominence (and into conflict with Heron the critic) in the 1950s. He was not interested in what he called 'the *camera eye*' that simply registered the visual appearance of things. Sensation as such was merely the beginning of the process of a *composing* transformation. That such a phrase invokes music is perfectly appropriate: the greater part of Heron's figurative painting in the 1940s and 1950s could be described best as a series of variations upon a theme. That innate predisposition towards the discovery of an abstract visual music was equally to inform the development of his work after his momentous move into non-figurative painting in the mid–1950s.

The artists he found most sympathetic to his purposes were precisely those for whom subject matter was the pretext for formal invention and design: those painters whose work achieved an equilibrium of form and content, an expressive

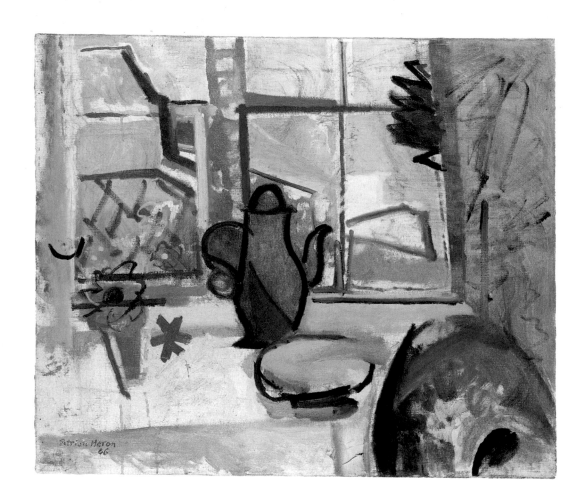

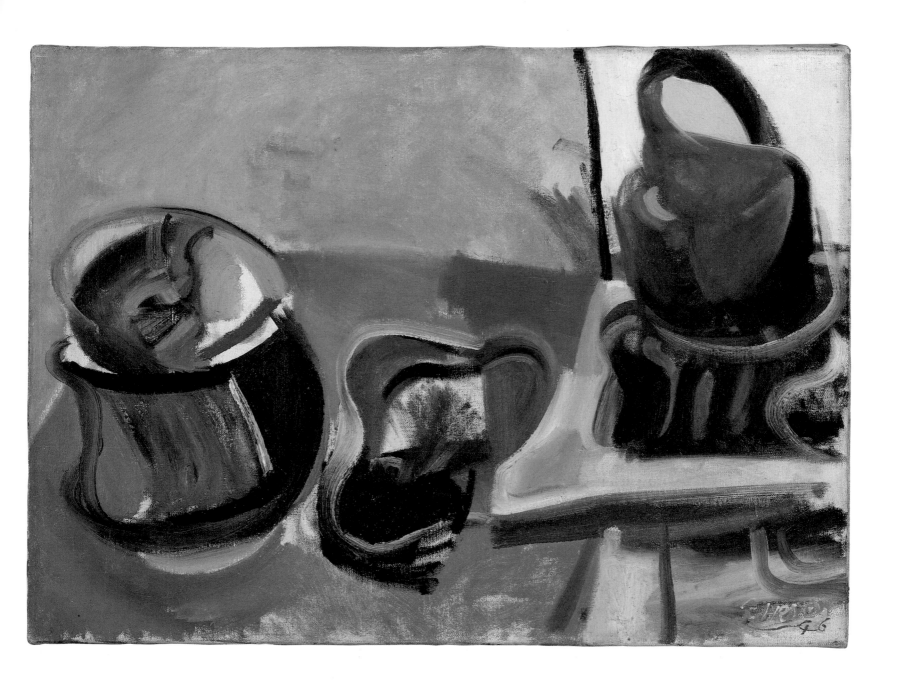

tension between the subjective and the objective, expression and impression; those caught between the impulse to abstraction and the requirement to keep an eye on the world. In short, Heron looked to those modern artists most decisively inclined to the *decorative*, in the profound sense implicit in Matisse's definition of *composition* as 'the art of arranging in a decorative manner the diverse elements at a painter's command to express his feelings.'

As a young and impressionable artist of acute visual sensibility Heron had eagerly grasped an extraordinary opportunity to study at first hand in the master's own work the implications of Matisse's emphasis on the decorative aspect of art. In the latter half of 1943, after his discharge from work on the chicken farm, and before his invitation to the Leach Pottery, Heron had encountered Matisse's stupendous *Red Studio* of 1911, which had for many years, more or less unseen, adorned the walls of a smoky Soho nightclub, and which was now hanging at the Redfern Gallery. *The Red Studio* is a *tour de force* in the decorative deployment of the 'diverse elements' of colour, line and form, and above all it is revelatory in its discovery of space in pure colour, of depth in pure flatness. Much was to be made of Heron's stylistic debt to Braque in his paintings of interiors and still life arrangements, but looking into *The Red Studio* it is possible to find many of the formal elements and devices that recur in Heron's figurative paintings: the transparency of objects (such as that of the chair at bottom right, and of the glass on the table lower left); the creation of space in planes of pure chromatic colour; the ambiguity of perspective which flattens out the corner angles in the interior space depicted; the edge to edge compositional rhythm, centrifugal rather than centripetal as in Braque. '… I paid endless visits to the Redfern Gallery', Heron wrote many years later, 'simply in order to absorb, in every detail, the revelations of this great masterpiece. It was … by far and away the most influential single painting in my entire career.' It is a presence in the work that has persisted through every change of mode to the very latest paintings.

Artists are drawn to what most closely answers to their own needs and disposition. A commitment to the decorative as a value in art, perhaps the highest value, since it has to do with the central problem of expression, that of organizing the picture to maximize its autonomy of meaning and its impact upon the spectator, has been central to Heron's practice as an artist, and is the animating principle of his critical insight. 'As in the music of Bach,' he wrote in 1955, at a time when his painting was still figurative, 'the grandeur of spirit of a great painter is transmitted directly out of the vibrant heart of the formal complex of abstract forms. It is precisely in the abstract harmony of colour and form that the profoundest human thought and feeling finds direct expression. *And this is true whether the work be abstract-figurative or non-figurative*' [my italics].

To achieve that quality demands a particular kind of attention to the formal means of painting, not in the sense of an acquired technique, but rather as an essential element in the process of transformation, in which the instinctive impulse to style is matched by an imperative to expression in the medium of paint itself, beyond any conscious communicative intention of the artist. It is not that the artist has no intentions; it is that those intentions count for nothing in the finished work, which is an independent entity whose essential relations are with the spectator, and whose energies work upon the spectator's mind and feelings. It is the work which gives off those energies, intellectual, emotional, spiritual; and its efficiency in doing so is a function of its technical sufficiency, its formal dynamics. It is the work, not the artist, that communicates.

The history of Heron's figurative painting is the history of his successive

efforts to achieve that completeness of expression which issues in work that is self-sufficient, independent of its author. Such a painting, to borrow a figure from Valéry, 'is really a kind of machine for producing the poetic state of mind'; not, as in a poem, by words, but by means of paint on canvas. 'The effect of this machine is uncertain, for nothing is certain about action on other minds. But whatever may be the result, in its uncertainty, the construction of the machine demands the solution of many problems.' Those problems are technical, their solutions formal. Heron's criticism articulates a vision of art that is wholly coherent with this rigorous aesthetic; it is the principle behind his brilliant formal analyses of the work of artists as diverse as Braque and Bonnard, Vlaminck and Scott, Leach and Hilton.

Heron's painting in this phase is varied in manner, and there are moments of indecision, crises of style. The variations and experiments reflect a restless creative temperament acutely aware of what was happening in some of the best art of his time, and prepared to turn to his own expressive purposes the formal architectonics and technical device of those whose work he most passionately admired: Matisse, Braque and Bonnard above all others. This is to consider his work in terms other than those of simplistically perceived stylistic 'influences'; it is to trace affinities and assimilations that operate in his work at a deeper level than surface feature, and to recognize that Heron was prepared to undertake the challenge presented by those indisputably great masters. His figurative painting represents a sustained effort to find in a *conventional* subject matter that complex of abstract forms that would effect the dynamic expression that is the purpose of art. There were false starts and failures; but there is a musical vitality of form and radiance of colour in much of his painting of this period that places it amongst the best British work of its time.

The first summer of their marriage was spent by the Herons at Carbis Bay, St Ives, where they were close neighbours of Margaret Mellis and Adrian Stokes. From this time on, until the summer of 1955 when they bought Eagles Nest, they were to spend part of each year in Cornwall. In the summer of 1946 they stayed at Mousehole, and from 1947 onwards at 3, St Andrews Street, directly on the sea wall in St Ives. The front room, looking out across the bay to Godrevy lighthouse, with the far distant Hayle Sands to the right of the picture, became Heron's studio. This was the interior and window that was to be a primary subject of his painting, including many paintings made in London, for the next eight years. Heron got into his stride remarkably quickly, and his first London exhibition, at the Redfern Gallery in October 1947, consisted of paintings, varied in manner, from this early period of inspired experiment.

It included still lifes, landscapes and interiors painted at Mousehole the previous summer, gas stove paintings made at the Holland Park flat, and other works made during the Herons' stay in North Wales in the August of 1947. One of these, *Sunset Abersoch: 1947*, painted from the motive, has something of Derain to it, in the deliberately structural facetting, each a single decisive horizontal stroke of a laden brush, across the central passage: light caught against hard surfaces in a field of more diffuse haze, created of looser brushwork and scribble. More characteristic of the direction Heron's art was taking at this decisive time was *The Boats and the Iron Ladder: 1947* in which the tracery of the brown planking and purple-blue ladder is at once a complex pattern on the surface, and descriptive of the objects. Its presence as a configuration of pure paint is emphasised by the fact that the lower rung of the ladder actually disappears behind the downstroke of the boat's stern, just as

THE BOATS AND THE IRON LADDER: 1947
Oil on gesso wood panel 30.4 × 60.9 cm

SUNSET ABERSOCH: 1947
Oil on canvas 31.75 × 63.5 cm

HARBOUR BOTTOM: 1948
Oil on panel 26.9 × 58.7 cm

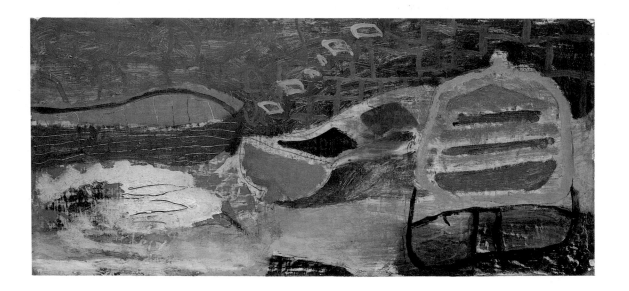

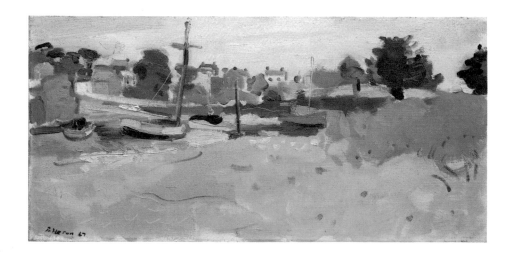

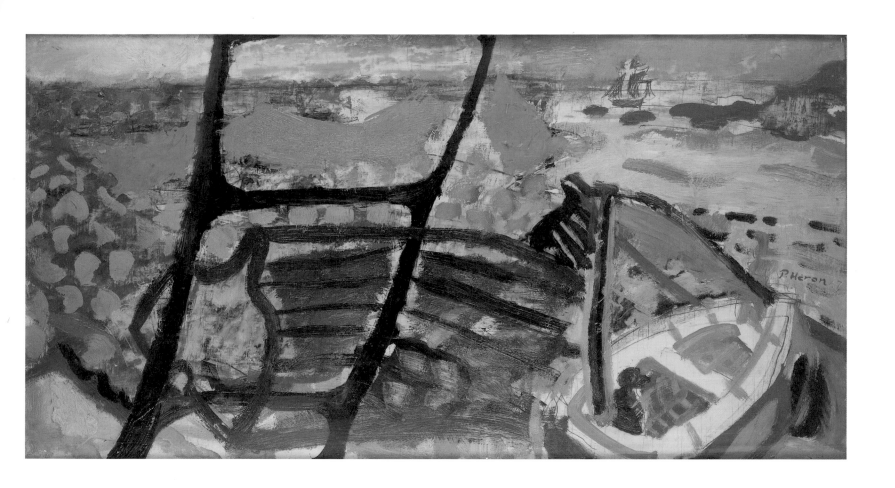

→ STILL LIFE WITH RED FISH: 1948
Oil on canvas 63.5 × 76.2 cm

→ NIGHT STILL LIFE: 1948
Oil on canvas 50.8 × 91.4 cm

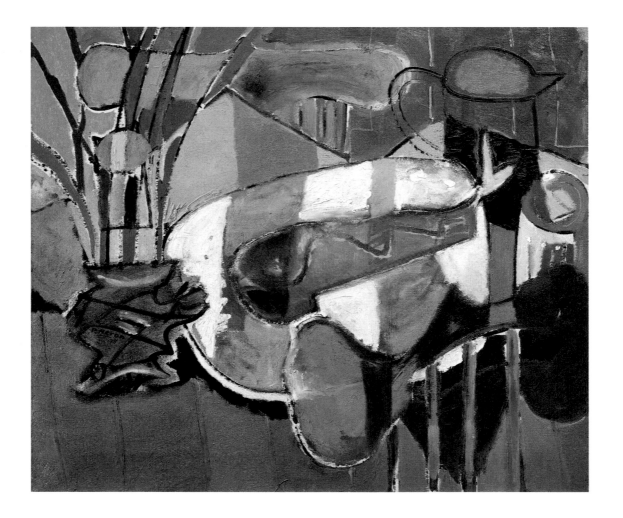

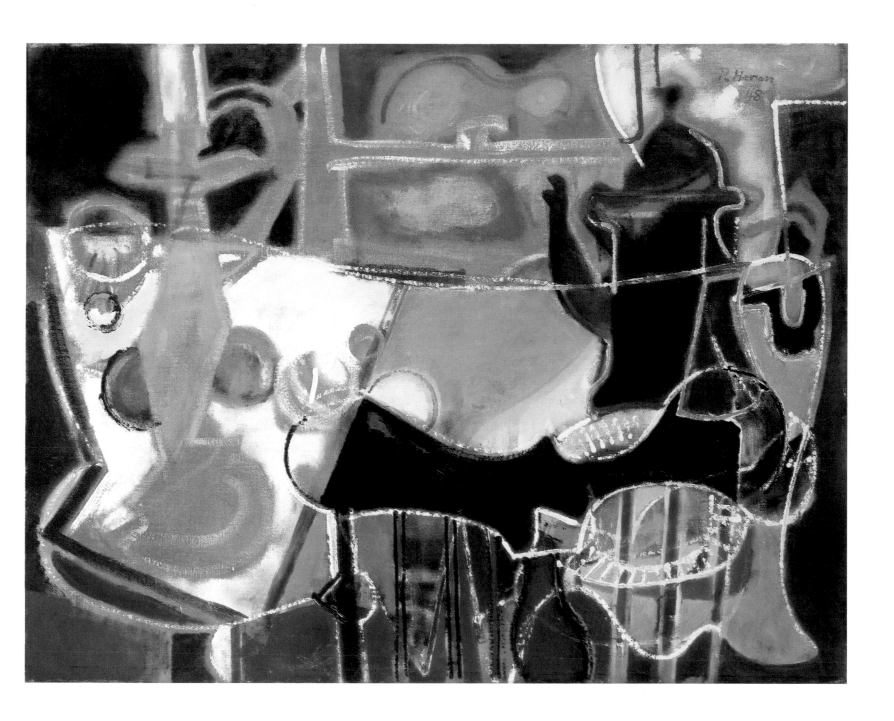

the roughly horizontal parallels of the boat's bottom end on either side of the ladder's vertical, leaving visible an undescriptive halo of primed board. These linear elements are equal in value and weight to the pink lozenges to the centre left, which are purely abstract ciphers for pebbles on the beach, to the dark mauve mast of the boat in the foreground, and to the dark diagonals of the blue boat's planking. All of these features are in stylistic contrast to the vaguer paintwork that describes the distant sea, horizon and sky.

In *The New English Weekly* a sympathetic Hugh Gordon Porteus referred to the 'bold open cages and bars of brushwriting' of Heron's drawing in paintings like this, and noted also 'the spontaneous and rapid notations of a fleeting mood in *Sunset Abersoch: 1947,* where the dying light is caught without fuss and melodrama.' Responding to the stylish objectivity of much of the work, other critics noticed what Gordon Porteus called a 'French accent' to the work in general, its emphatic colourism and its taste. But the most perceptive of commentaries came from Robert Melville, one of the best critics of the day, who was by disposition more sympathetic towards symbolic and surrealist tendencies in art, and towards their psychoanalytic interpretation, than to what he described as the 'diluted cubism' of the 'Paris movement' to which he felt Heron was inclined.

Melville recognized that the young Heron was 'a remarkably sophisticated painter.' He saw, correctly, that there was 'scarcely any of Picasso in his work,' and that the cubism in it came 'directly and obviously from Braque', adding that there was 'a breaking up of colour that comes … partly from the later Hitchens, partly from Bonnard'. (In fact, Heron was unaware of Ivon Hitchens at this time, first encountering his work in the following year.) Most remarkably, Melville instinctively perceived the true nature of the aesthetic impulse behind the formalistic experiment and varied output, the deliberate limitation of the work to conventional subject matter, and its lack of narrative drama: 'The objects in his still lifes are gifts from Braque … He doesn't pretend he discovered them himself. Appropriately … he allows them to become remote and phantasmal. One day they may float entirely out of sight, behind an exquisite little cloud of paint. By that time Heron probably won't notice they are gone.' Leaving aside the irritating preciosity of phrase (Melville's review was written for a BBC radio programme), this is uncannily prescient of the fate of the object in Heron's painting.

Heron's next one-man show at Redfern, a year later in the autumn of 1948, contained a number of paintings which registered an assured clarification of purposes, a confident assumption of a more personal manner. Nevile Wallis in *The Observer* (7 November 1948) remarked this and identified its source: 'Paint, which he handles with spirit and increasing assurance is … the chief concern of Patrick Heron, whose collection at the Redfern shows he is shedding some of his earlier French influences and developing a more personal style and outlook'. Generous as it is, this is typical of critical responses to Heron through the late 1940s and early 1950s: it misses the point that it is precisely in his attention to the deployment of paint itself, that is to say, to colour, texture, form and rhythm, those abstract formal elements particular to the art, that Heron most deeply acknowledges, in creative terms, his debt to the great French modernists. What such critics saw was superficial stylistic derivation; what they often failed to perceive was the deeper tendency.

Harbour Bottom: 1948 handles a subject, three boats in the deep shadow of a harbour wall at low tide, not unlike that of *The Boats and the Iron Ladder: 1947,* but in a less wilful, more relaxed manner. There is a similar subordination of the observed objects to a play of forms, in this case within a wave-like motion that begins with the line that describes the farther gunwhale of the grey boat at left, and

PH, Peter Lanyon and Giles Heron
at San Gimignano, 1953

which turns under itself in the pink outline of the boat at the right and returns to the left under the grey hull. Within and around this double movement there are colour forms: the bright blues of the centre boat, the pinky greys and browns enclosed in the pink flattened ellipse at the right, the two greys of the boat at the left. The descriptive graphic motives (the steps down reduced to a diagonal fall of grey diamonds, the fishnet pattern of the stonework, the plank lines) are brushed on to or scratched into a busy variety of paint surfaces: washed and brushed, scraped and blotted, evocative markings. All these are aspects of an *undisguised* facture: these brushstrokes and sgraffito incisions, paint and marks on canvas are also signs to be read as things in an identifiable space.

Still Life with Red Fish: 1948, one of his best paintings of the period, reveals most clearly the debt to Braque in Heron's work at this moment in his development. Even so, the visual music of the picture is beautifully contained within a formal rhythm that is quite unlike that most characteristic of Braque, being diagonal and spiral where he is most often four-square and vertical. It is in the first place a brilliant presentation of facts: an ensemble of objects – the plant in its pot, the table top with two chairs facing across it, the jug and pot to the right, the vivid red fish inert on a bright white plate; a light, falling in stripes from a window *behind* the viewer; a space, perceived as receding into the top left corner from an angle of view that is diagonal, and emphasised by the sharp upward pointing angle of the table corner. The eye bounces across the fish to top left and back to bottom right, then up to centre top and down again to lower centre, in a ping-pong motion between the bat-like lugs of the chair tops, compelled to register the space across the top of the table in the centre of the picture. And then, like the ball hitting the net, it is arrested by the fish itself, with its zigzag, exactly at a right-angle to its movement, and directed towards the edge, the foliage exploding out of the picture to upper left, the jug pointing out to the right, the ellipse of the pot top just cut off at centre right. All this is formally determined by a rhythmic rhyming of curves from bottom right to top left, traversed vertically by the stripes of light and shade, the uprights of the chairbacks, the upward thrust of the plant stems, dynamically diverging at top left, and by the edges of the jug and pot. The picture's design is thus a disposition of abstract shapes across the plane, and an interplay of counterpointed chromatic and tonal colour. In pictures like this Heron was moving towards a more schematic complexity, a greater formal complication. Meeting him in 1948, William Scott remarked: 'Your paintings are as full up as mine are empty!'

A more purely sensuous response to the visible world and its objects is to be found in two table top still lifes done in 1948. In both *Still Life with Black Bananas: 1948* and *The Long Table with Fruit: 1949*, the essential compositional dynamic is horizontal; we are presented with a sumptuous procession of forms across the canvas in brilliantly celebratory colour. In the first of these paintings, the colour is orchestrated in the high key of a rich orange, punctuated by the focal rhythms of deep bottle green of the leaves in the jug at the left, which, as they project against the light become pure black notations, directing the eye rightwards to the 'blunt fullness' of the black Hamada bowl and its grey bananas, and then onwards, through a scatter of fruit to the homely Leach jug, part obscured, with its curved handle echoing the outline of the bowl and reversing the configuration of the jug handle and cakes at the other end of the table. This pulsing curvilinear rhythm is countered by the grid of the tablecloth pattern and of the red tile floor: those horizontal parallel lines act as a visual stave, along which is written the music of the dark curved shapes.

The Long Table with Fruit: 1948 (bought by Herbert Read from the Redfern

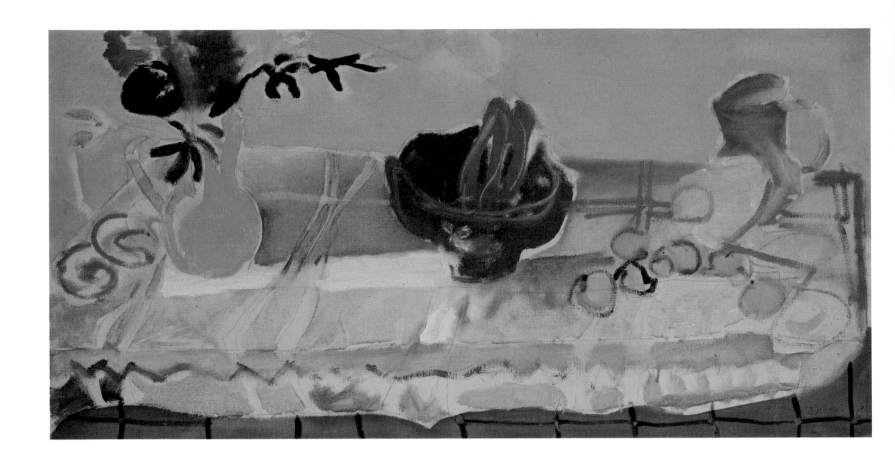

↑ STILL LIFE WITH BLACK BANANAS: 1948
Oil on canvas 45.8 × 91 cm

→ THE LONG TABLE WITH FRUIT: 1949
Oil on canvas 45.8 × 91.4 cm

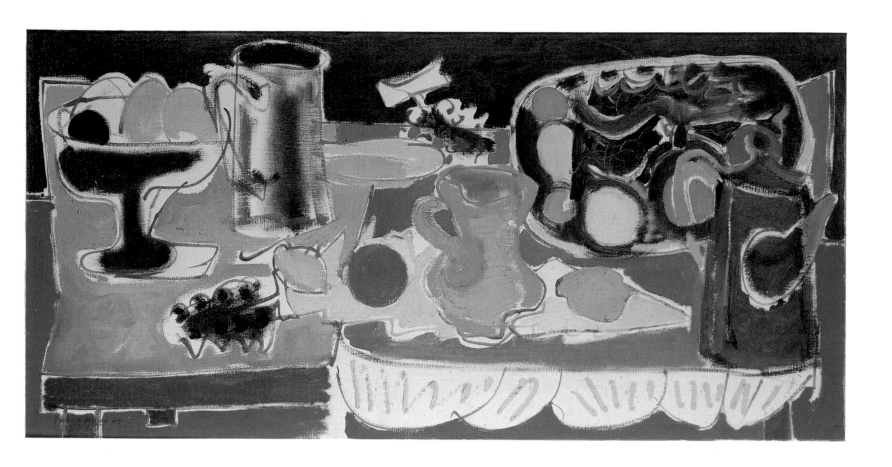

T.S. ELIOT: DRAWING: TUESDAY
AFTERNOON MARCH 4, 1947
Conté on paper 50.8 × 91.4 cm

Katharine Heron on Porthminster
Beach, St Ives, wearing Cresta print by
PH, 1954

exhibition in 1950) is an image of plenitude even more crowded than *Still Life with Black Bananas: 1948*. It too presents its objects against a Matissean up-turned table top in a simple processional configuration, with a minimal gesture towards perspective. Its bright primaries and pure colours against a black light suggest the intensity of the morning sun, where the earlier painting seems saturated in the orange yellow light of late afternoon. There seems nothing in these paintings of the anxiety of influence; they have about them a spontaneous gaiety and an unabashed enjoyment of colour as light, colour released from description, colour shape as a determining dynamic in the formal organisation of the picture. In both a lucent clarity is achieved by the direct laying of pure colour on to the primed canvas.

Heron experimented with high-key Fauvist colour during a visit to Provence in late 1948 and early 1949, when he and Delia stayed with Francis Davison and Margaret Mellis at Le Château des Enfants, on the tip of Cap d'Antibes, where Davison was temporarily occupying a family home. In the autumn of 1946 the Herons had introduced Margaret, whose marriage to Adrian Stokes had come to an end, to Francis, Patrick's close friend, and they had married in 1948. At Antibes Heron made a number of paintings, including *Juan les Pins From Cap D'Antibes: December 1948* and *Cap D'Antibes: Xmas 1948,* both of which are painted in hot dark colours, blues intensified with accents of magenta, violet and pink, yellow heightened by dabs of orange; a palette of unprecedented sonority and richness. But these remain untypical in their thickness of paint, chromatic opacity and agitated brushwork: *Courtyard, Antibes: January 1949* with its lighter touch and paler registers of mauve and grey-blue, in single layers laid on white ground, its linear grid and Matissean distribution of forms, its irregular shapes hugging the edge, is rather more characteristic of the way in which Heron's work was moving at this time.

Courtyard, Antibes: January 1949 was shown at Heron's show at the Redfern in 1950, along with the splendid *The Round Table: 1950* (which was bought by the Arts Council), and the serenely cool *Crambe Vicarage: York: 1949*. In these latter paintings and certain others, notably *Round Table against the Sea: 1949* and the later *Balcony Window with Green Table: St Ives: 1951*, Heron was at last consolidating a decisively personal manner in which the primary influences on his approach to figurative presentation were integrated into a style indisputably and unmistakeably his own. Their subjects, interior and window, the table with still life, lamp, jug, flowers and fruit, (to which may be added the figure in a room, Heron's other most favoured motive), are important in this: they are the familiar materials for visual variations, presenting a repertoire of known forms to be translated into the abstract configurations that will give the painting its own pictorial felicity, its own musical dynamics. They are in this respect Heron's version of the 'humble pretexts' of classic Cubism, those pipes and glasses, jugs and guitars whose shapes, and relations in space, are the true subjects of an art devoted to the magical transformation of familiar things into poetic relativities – 'the relationships between things' in the parallel reality of the painting. Such objects and figures are likewise the obsessive subjects of Matisse and Bonnard.

Basil Taylor, who had replaced Heron as the critic for *The New Statesman and Nation*, and who was to contribute a perceptive introduction to Heron's Wakefield retrospective catalogue in 1952, quickly identified the formal element that gave these new pictures their distinctive clarity: '… their much greater coherence … [is achieved] through line, a line which gives a stronger definition of his forms and ties them, like ligament, into a spatial order.' A rhythmically intervalled

drawing in paint was indeed the organizing principle of the best work of this period, describing objects with an insouciant freedom whilst following its own linear logic across and up and down the surface of the canvas. The white spaces are filled in with planes of pure colour, quickly and spontaneously brushed, and directly applied to the primed surface, rarely over-painted, and independent of the outlines, which often trace their ways through channels of still-exposed canvas.

T.S.Eliot

Heron had used this new-found freedom of relation between colour and line in two remarkable portraits also shown at the Redfern in the spring of 1950. These were of T.S. Eliot and Herbert Read. The former was the outcome of a prolonged effort to arrive at a satisfactory formal resolution in the portrayal of a formidable subject. This had begun on a bitterly cold Tuesday afternoon on March 4, 1947, when Heron made his first pencil study of Eliot in his office at Faber and Faber in Russell Square. (It is extraordinary that only Heron and Wyndham Lewis had made portraits of the great poet by that date.) The finished portrait (now in the National Portrait Gallery) is problematic. Using the Picasso/Braque device of the double head, whereby the face is presented semi-frontally and in profile, the left eye serving a double function, Heron has achieved an unsettling likeness at the same time as subordinating the figure to the over-all design of the picture. 'No head, I felt,' wrote Heron many years later, 'even in a painting which called itself 'a portrait', should have more (or less) importance in plastic terms than any other part of the painting – a Cézannian principle of the essential *equality* of parts, which must always and forever prevail.' But the space around the figure seems vague and unresolved, something noticed by David Sylvester in his review of the show in *Art News and Review*: '… the head floats among weak and inarticulate forms, for here Heron's capacity to sustain the rhythms of a picture throughout its dimensions has for once deserted him. Perhaps he has laboured too hard at this portrait.' But paintings make their own history: it is possible now to read the odd stylistic uncertainty of the 1949 portrait as reflecting truthfully the complex and troubled man behind the mask, as does, in quite another way, the grave drawing of a man with a faraway look in his eyes, made on that wintry day two years before.

The Herbert Read portrait (painted at Eliot's suggestion), with its emblematic flowers in bright light, surely catches with an affective quickness the character of its subject, the sensitive face and clear eyes, and the alert intelligence of Read's manner, the slight nod of the head, the quietly emphatic gesture. David Sylvester preferred its more assured and lighter touch, with its 'anti-classical freedom, diffuseness and vibration', the qualities that characterized 'most of the latest – and best works in this exhibition with their labyrinths of stringy lines twisting among the planes and wandering through space.' Heron was, Sylvester added, 'becoming less dependent upon the Master. If [certain of the paintings] are still dominated by Braque's idiom, they have a peculiarly astringent intensity that is quite foreign to Braque.' Borrowing an image from Eliot he concluded in terms that suggest an important breakthrough: 'So far, we have known Heron as one of those rare English painters who can assume the manner of a French Master without provoking comparison with a Bradford millionaire in a silk hat. Now it seems that we may know him in the future as an artist with a personality of his own.'

The astringency noted by Sylvester in Heron's painting at that pivotal moment could surely be attributed to the use of pure colour, to the restless, nervous linear rhythms, and to that openness of the composition which refuses to let the eye settle, insisting on its constant adjustment to the contrasts of recessional illusion and decorative flatness, of pictorial space and surface pattern. These were elements of a style that achieved its most complete expressive potential in two major paintings

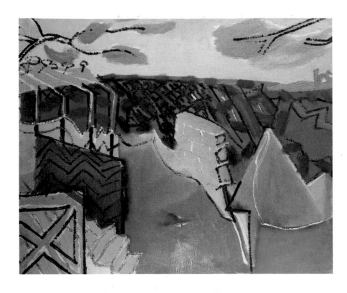

↑ LA GAROUP, CAP D'ANTIBES:
 JANUARY 1949
 Oil on canvas 63.5 × 76.2 cm

→ JUAN LES PINS FROM CAP
 D'ANTIBES: DECEMBER 1948
 Oil on canvas 31.75 × 63.5 cm

⇒ COURTYARD, ANTIBES: JANUARY 1949
 Oil on canvas 63.5 × 76.2 cm

↘ CAP D'ANTIBES: XMAS: 1948
 Oil on canvas 40.6 × 50.8 cm

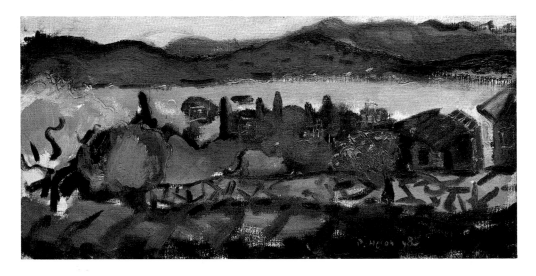

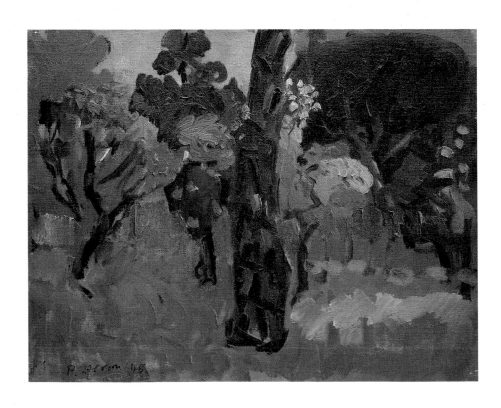

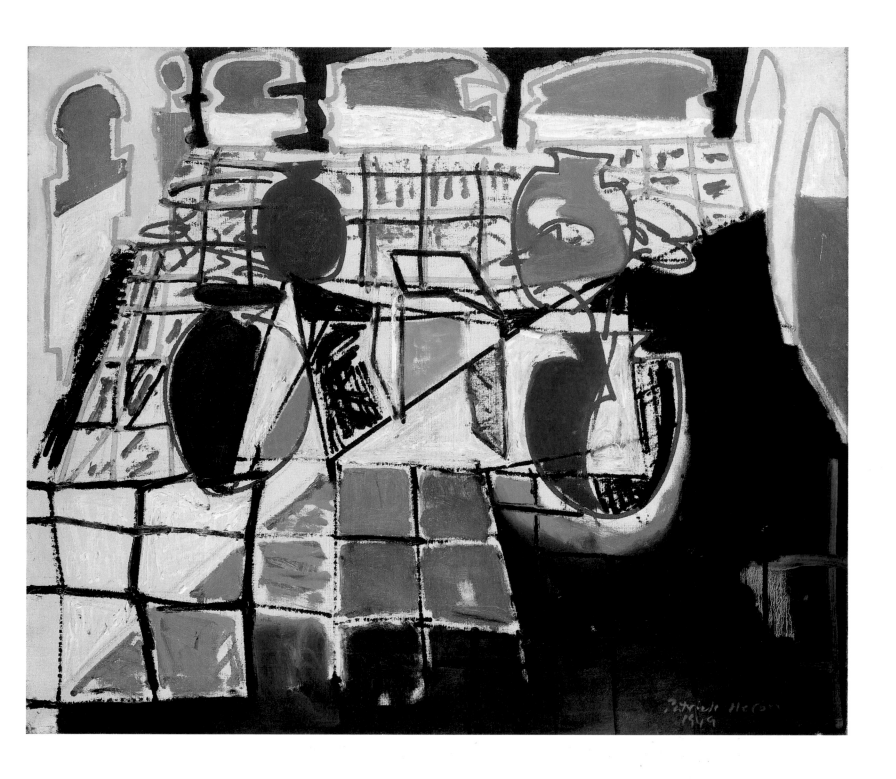

BALCONY WINDOW WITH GREEN
TABLE: ST IVES: 1951
Oil on canvas 91.4 × 45.8 cm

CRAMBE VICARAGE: YORK: 1949
Oil on canvas 91.4 × 71.23 cm

THE ROUND TABLE: 1950
Oil on canvas 91.4 × 45.8 cm

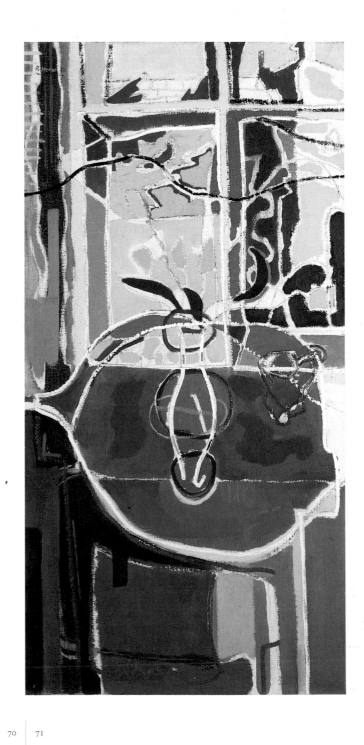

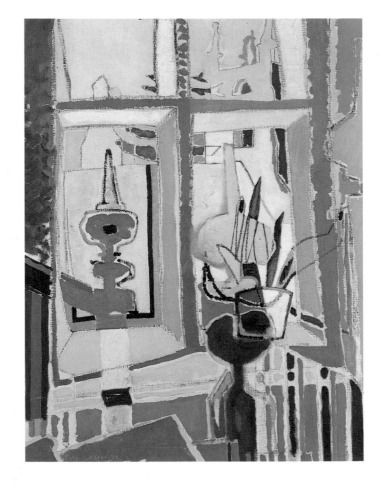

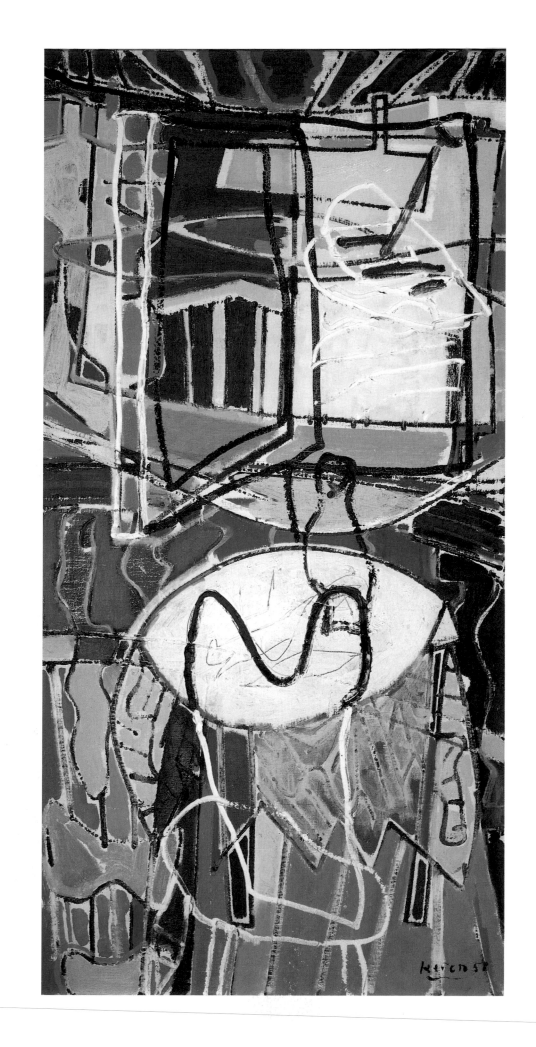

PORTRAIT OF T.S. ELIOT: 1949
Oil on canvas 76.2 × 63.5 cm

PORTRAIT OF SIR HERBERT READ: 1950
Oil on canvas 76.2 × 63.5 cm

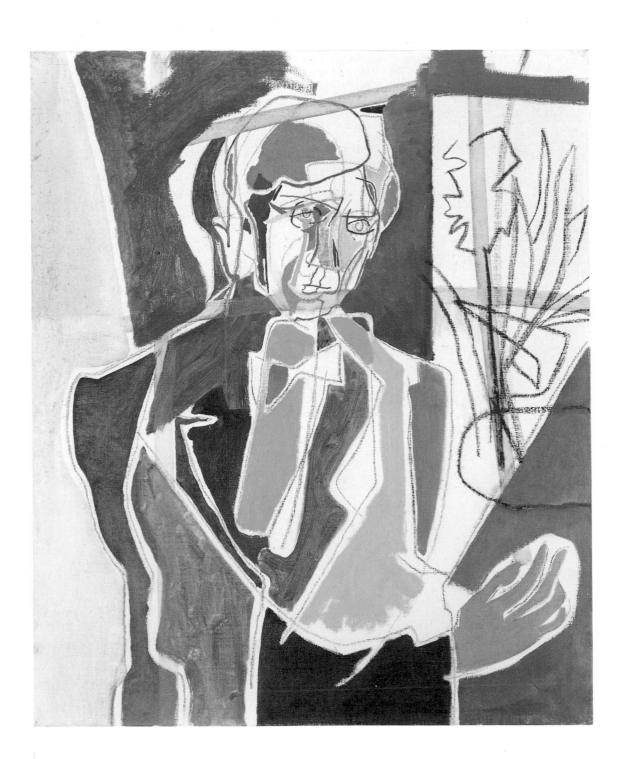

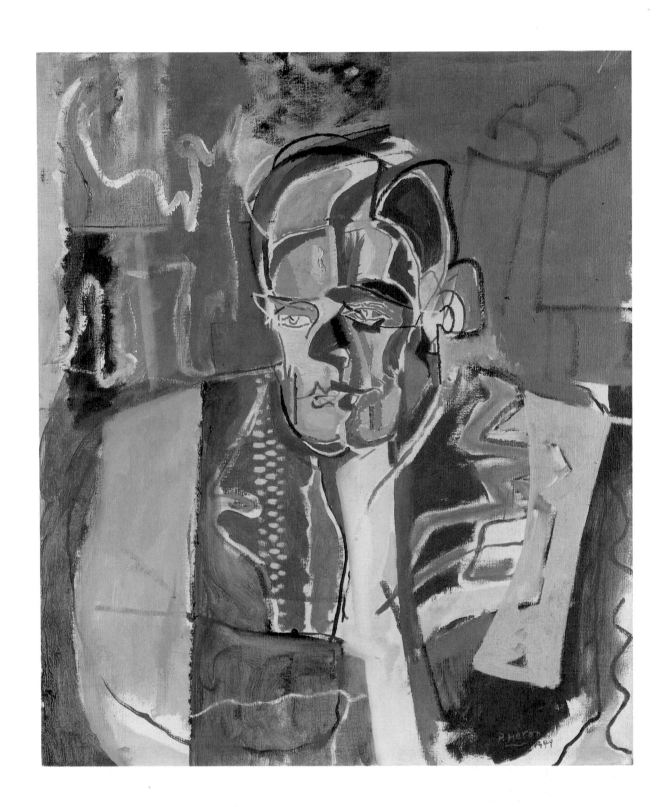

made soon after: *Harbour Window with Two Figures, St Ives: July 1950* and *Christmas Eve: 1951*.

Harbour Window was the largest and most ambitious painting in Heron's 1951 Redfern show, from where it was removed temporarily in order for the Trustees of the Tate Gallery to consider it for purchase. (It was in fact bought by the Tate thirty years later.) *Christmas Eve* was painted at the invitation of the Arts Council for the Festival of Britain exhibition *60 Paintings for 51*, which was devised to provide an opportunity for artists to make paintings on a large scale, in most cases for the first time since the war. Canvas was supplied free of charge; the only stipulation was that the pictures should measure at least forty-five by sixty inches; remarkably, there was no upper limit. (That the minimum dimensions stipulated should be regarded as those of a large painting is revealing of attitudes to scale in the early 1950s; the response to the abstract expressionist paintings at the Tate in 1956 was largely conditioned by such attitudes.) In the event, Heron took full advantage of the Arts Council's enlightened generosity: *Christmas Eve* is on what was considered a mural scale at seventy-two by one hundred and twenty inches. Heron was also invited to design a mural for the Festival restaurant, to measure ten by forty-three feet: several exciting studies were made for this, but the project was aborted at the last moment. (Had it been installed it is likely in any case that it would have been destroyed in the malevolent vandalism that accompanied the premature closure of the Festival Exhibition on South Bank by the newly elected Conservative government in late 1951.)

Both paintings are of interiors with windows, though *Harbour Window* is the most typical, in that its theme is the relation of inside to outside space: 'The feeling of a sort of marriage of indoor and outdoor space, through the aperture of the window frame, itself roughly rectilinear and parallel to the picture surface, was really the main theme of all my paintings – or nearly all – between 1945 and 1955.' This, as we have seen, is not entirely true of Heron's production in that period, but it is certainly true of almost all his successful paintings from this time, 1950, up to 1955. The passage comes from an informative letter written to the Tate after its acquisition of the painting in 1980, and it bears further quotation:

... the window in the vast majority [of paintings on this theme] was this harbour window, looking out across a balcony over the harbour and bay from the studio cottage, perched right on the sea wall itself ... I shall never forget the immense sensation of space the first moment we entered that room, at the end of our journey from London: it was an October night and a full moon was rising over Godrevy. [*Balcony Window with Moon: 1954*] was a memory of this moment – it consists of a black and white drawing in charcoal on primed canvas, but this was the window occuring over and over again in my paintings of that period, whether we were actually in St Ives when I painted them, or at home at Addison Avenue, Holland Park. I probably painted more St Ives harbour window paintings in London than in Cornwall. [*Harbour Window*] which I think is the best of the entire series, was actually begun in St Ives and three-quarters finished, and was then taken to Addison Avenue to be completed. My habit of drawing in charcoal on a white ground, and then slotting planes of colour in between the grid of charcoal drawing, was still the procedure followed here ... Also established at the time I painted it was my habit of only applying one coat of colour over the white ground, which seems to be responsible for the brilliance of hue – there are one or two areas, very noticeably, where I have applied more than one colour – on the side of the armchair to the left, on the wall under the window just over the table, and in the sea in the middle of the right-hand window panel.

In spite of its subject, Heron was at pains to point out, with that characteristic emphasis, that the idiom of the painting,

and of all my paintings then and later, was totally unrelated to any painting ever made in Cornwall. It was largely based on the French masters I so admired, and which I was alone (with William Scott) in England, let alone Cornwall, in being influenced by at that time ...

[he might at least have added the name of Ceri Richards here] … From Braque came the idea of the 'transparency' of the objects: for instance the line of carpet flows right through both the armchair, the legs of the nude figure (Delia), the table, as well as the near chair-back, and the figure of my daughter Katharine … On the other hand, the nature of my charcoal drawing is far removed from Braque; for instance, there is not a single rigidly straight line, nor a pure arc or circle; in their loose and speedy linearity these charcoal grids are, therefore, if anything, nearer Matisse – though I would have thought they are perhaps personal and rather English.

This is so accurate and interesting a formal analysis that it hardly required re-inventing for the benefit of this text. What Heron leaves out, however, is as interesting as what he describes. There is the extraordinary spatial freedom of the picture, by which the exterior is as immediate a *presence* as the interior, so vitally a part of the space within the picture that we might by some sort of visual paradox be looking *through* it into the room: the line of the window frame runs through the right shoulder of the standing figure; the balcony balustrade is drawn to overlap the chair at upper left; the outline of the quay runs through the double portrait of Delia's head. The total impression is of the very dynamics of space, of space as a continuum, containing simultaneously stillness and movement, the far and the near (and this within the interior as well as between it and the outside), and of space as a representation of *time*, for movement within space is movement within time, and the painting demands the imagining of movement.

The theme of the picture, and its recurrence in Heron's paintings at this period, brings to mind the answer of Matisse to the question, 'where does the charm of your paintings of open windows come from?' 'Probably from the fact that for me the space is one unity from the horizon right to the interior of my work room, and that the boat that is going past exists in the same space as the familiar objects around me; and the wall with the window does not create two different worlds.' It might be added (and that Heron worked mostly away from the motif is very much to the point here) that painting is invention, a thrilling fiction by means of which that consciousness of the artist, of space, of colour, of form, through technique acting upon material, finds an expressive equivalent that itself opens a window upon that subjective world. It is something beyond the representation (*always* conventional) of external appearances.

Christmas Eve is a *tour de force* in Heron's mature figurative manner. Painted at the Addison Avenue house, but set in the drawing room of his parents' home in Welwyn Garden City, it is an evocation of that magical day in the lives of children. The artist's daughters are portrayed at centre foreground and centre right, a third (fictional) child at lower right, all entranced by music and light. Their grandmother plays the piano, whilst their mother arranges the Christmas Tree; Christmas candles illuminate the space around them, in rings or puddles of lemon yellow paint squeezed directly from the tube. All colour in this dizzying space is purely chromatic, singing in stripes and planes, contained in linearities that dynamically play across the surface: in parallels that turn at angles flattening the space of the room into a decorative unity; in arabesques and zigzags; in curves and ellipses. No object, floorboard, carpet, chair, piano, tree, figure, but demands its own visual rhythm. Nothing is still in this space but the spellbound children, three focal points to which the eye is irresistibly drawn and by them momentarily stopped: the room enters our head as it enters theirs, a dizzying enchantment of sound and colour. An abstract rigour maintains the poise of this marvellous image, its tension keeping at bay any element of sentimentality in its magical evocation: it is the equilibrium of Valéry's 'poetic machine'.

CHRISTMAS EVE: 1951
Oil on canvas 182.9 × 304.8 cm

HARBOUR WINDOW WITH TWO
FIGURES, ST IVES: JULY 1950
Oil on hardboard 121.9 × 152.4 cm

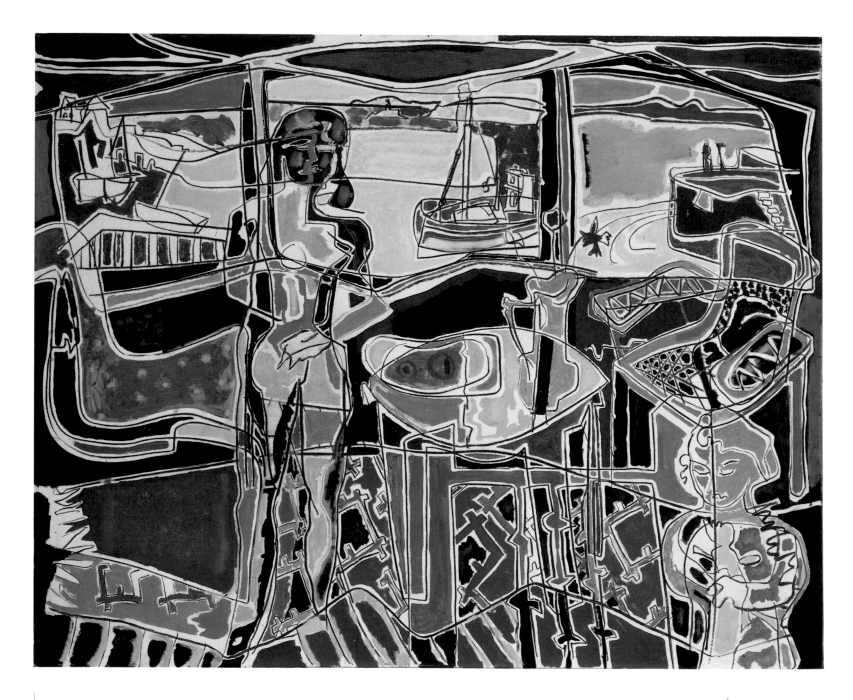

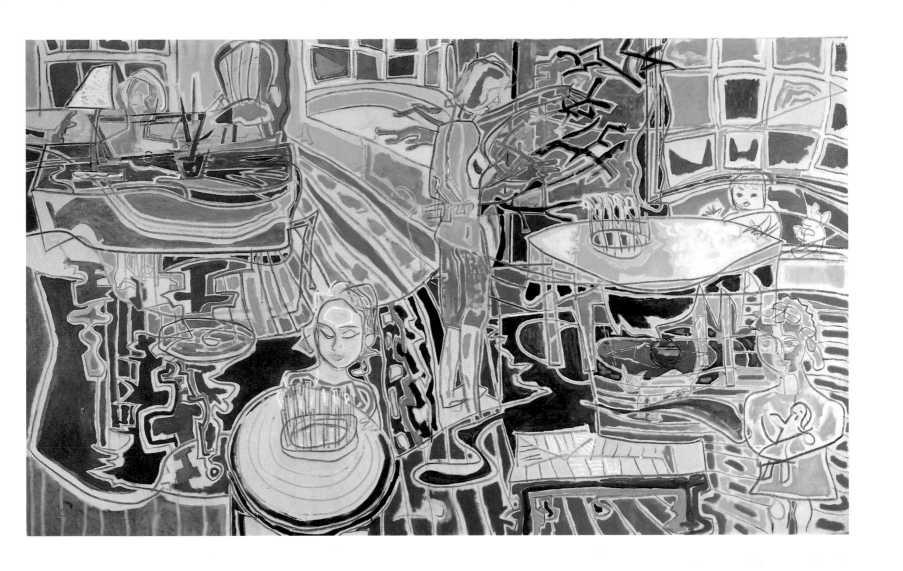

→ GIRL IN A WICKER ARMCHAIR: 1950–51
Oil on canvas 76.2 × 63.5 cm

↓ Clockwise from top left
ASSISI: APRIL 1953
ASSISI: COURTYARD 1953
ASSISI: 1953
ASSISI: APRIL 1953
All four drawings, 6B pencil on paper 27.3 × 32.7 cm

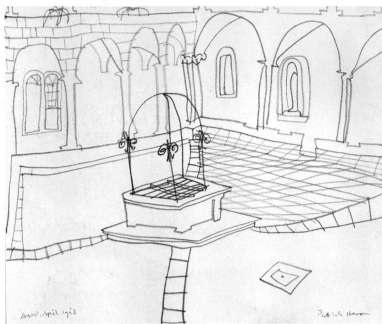
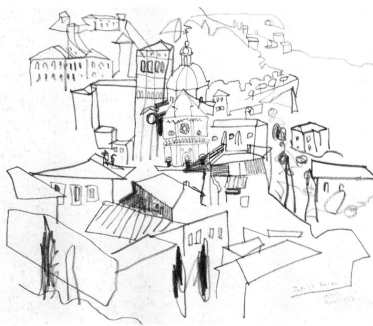
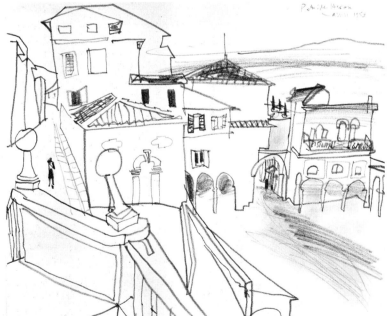

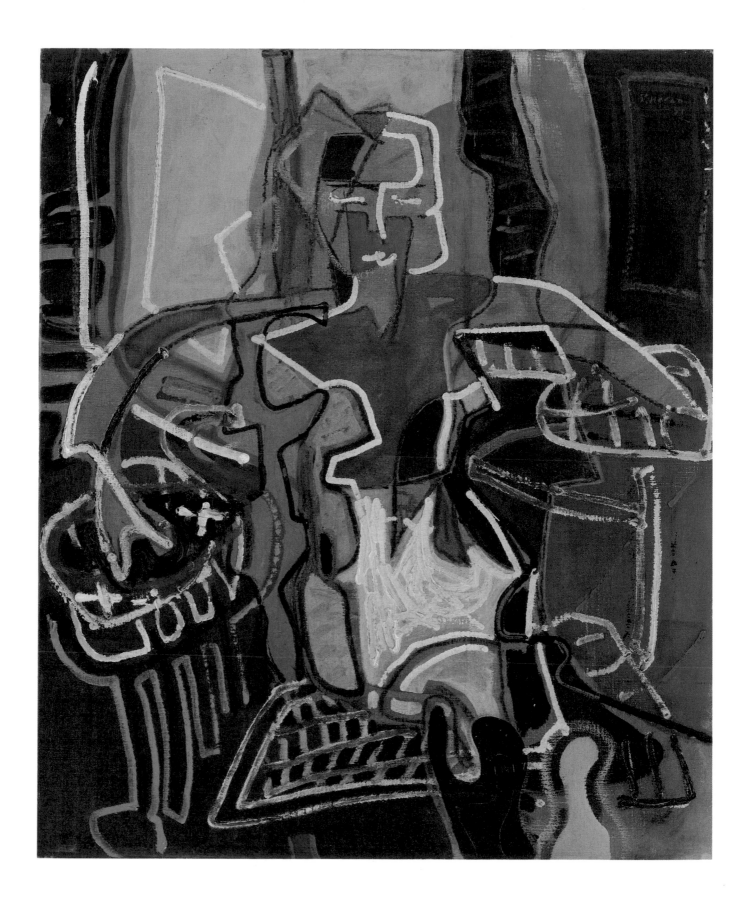

⟫ INDIGO BAY: 1952
Oil on canvas 45.1 × 121.9 cm

↓ BRYHER, ISLES OF SCILLY: 1951
Oil on canvas 50.8 × 91.4 cm

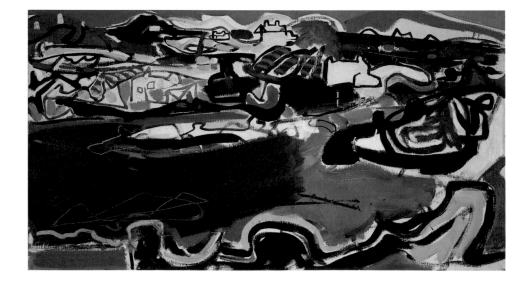

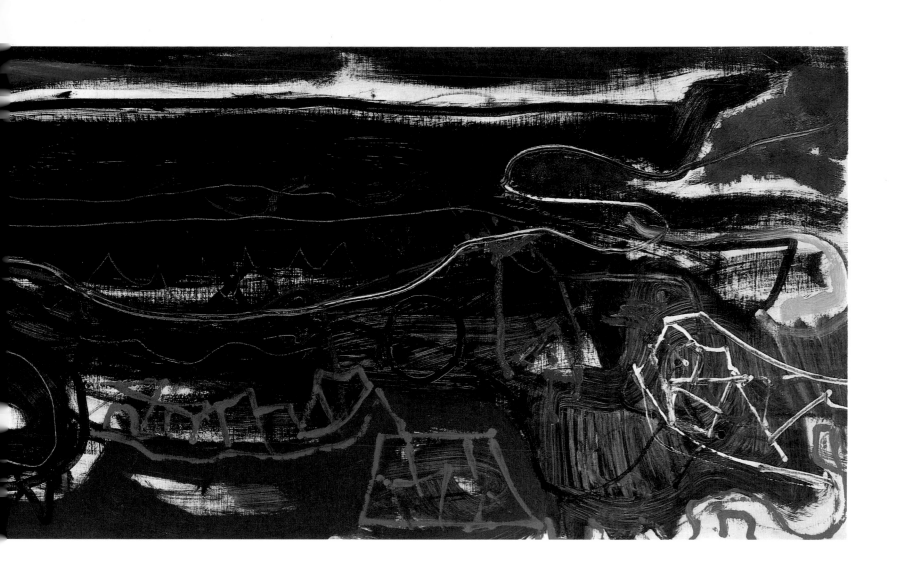

→ FIGURE IN HARBOUR ROOM
(ORANGE & GREY): 1952–54
Oil on canvas 91.4 × 45.8 cm

↘ THE BLUE WINDOW: 1952
Oil on canvas 91.4 × 45.8 cm

↓ ST IVES WINDOW WITH SAND BAR: 1952
Oil on canvas 91.4 × 45.8 cm

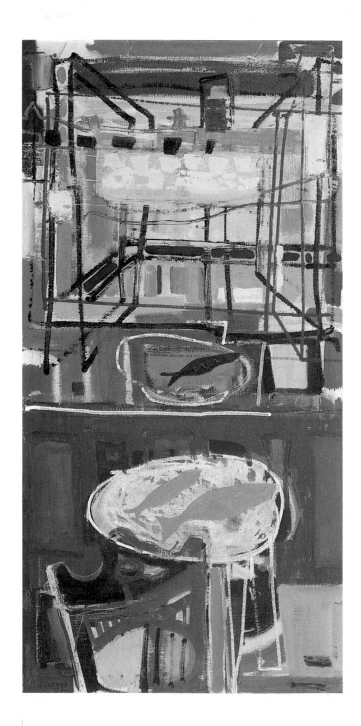

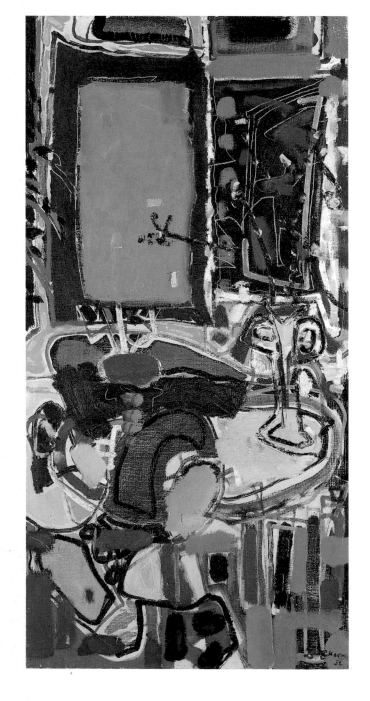

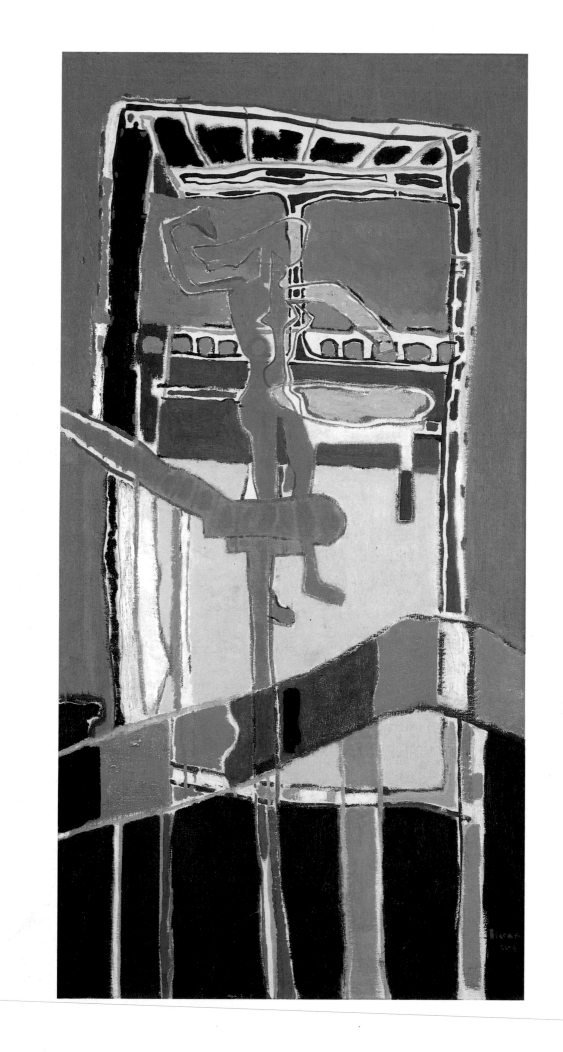

THE STAIRCASE: 1954
Oil on hardboard 182.9 × 121.9 cm

GIRL IN HARBOUR ROOM: 1955
Oil on hardboard 121.9 × 182.8 cm

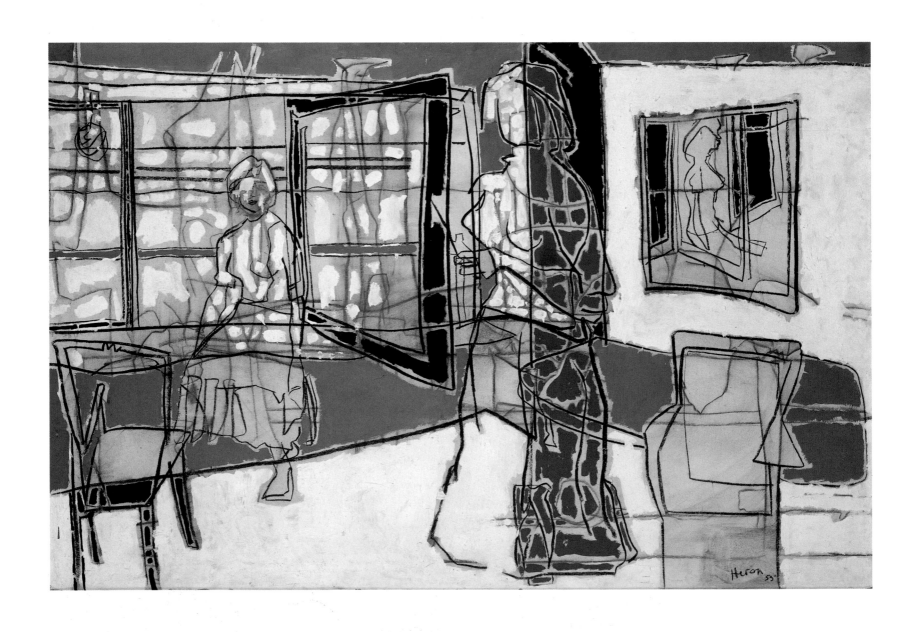

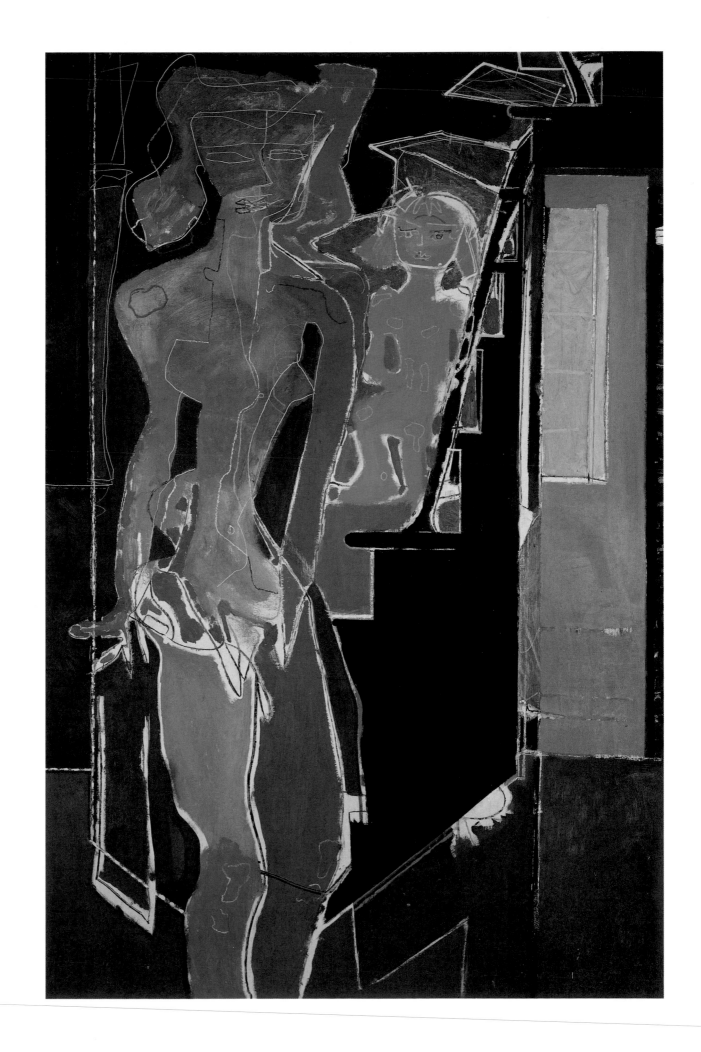

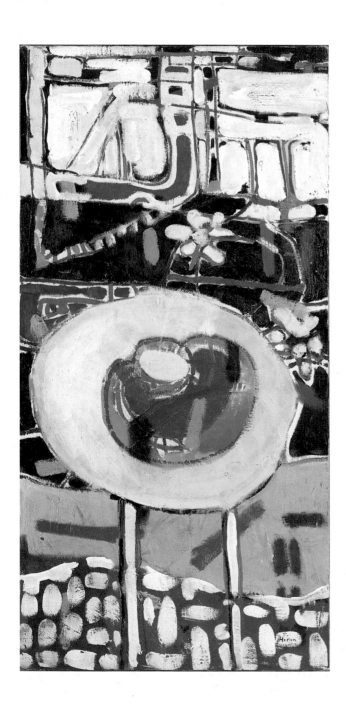

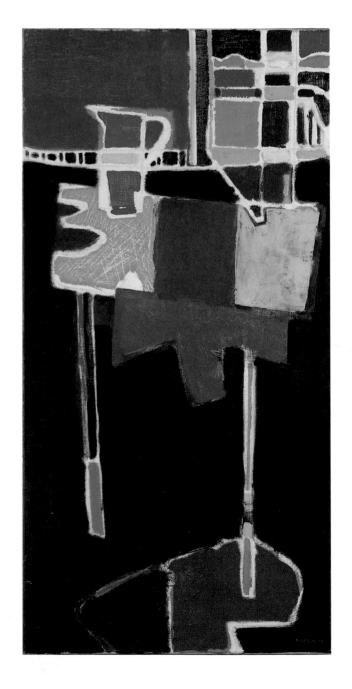

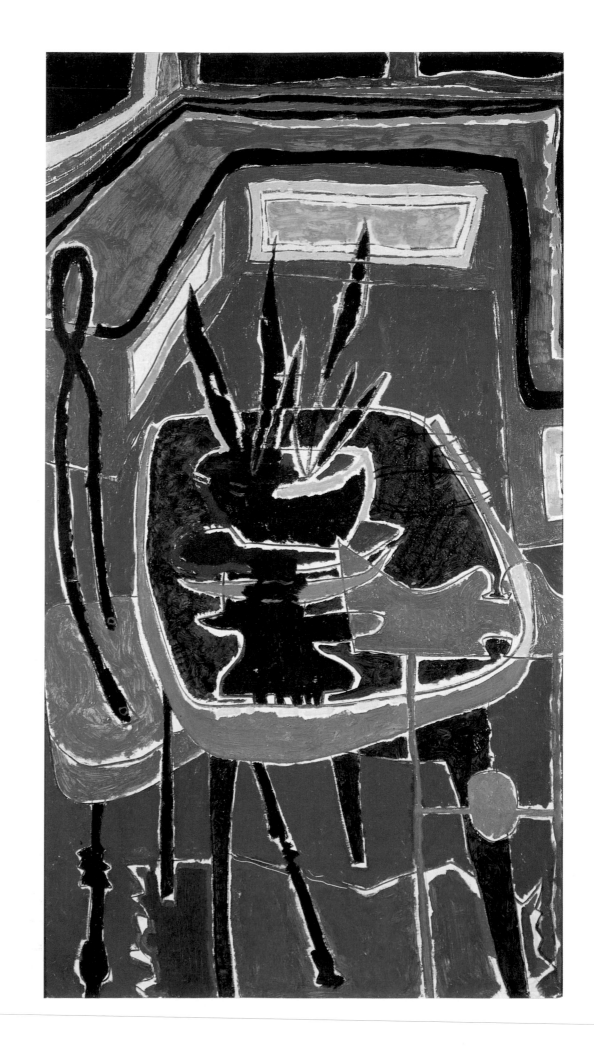

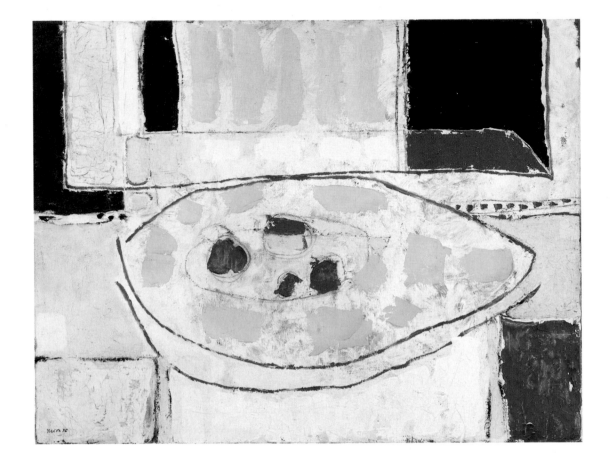

→ THE WHITE TABLE: 1955
Oil on canvas 71.1 × 91.4 cm

⇾ INTERIOR WITH GARDEN WINDOW:
1955
Oil on canvas 121.9 × 152.4 cm

↓ THE RED TABLE: 1954
Oil on canvas 101.6 × 127 cm

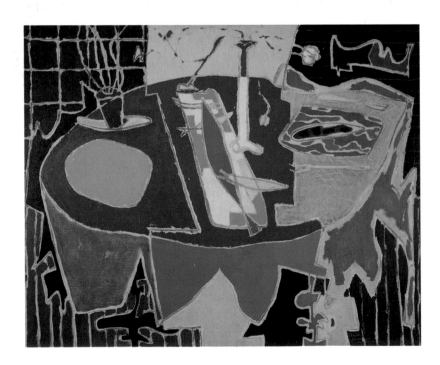

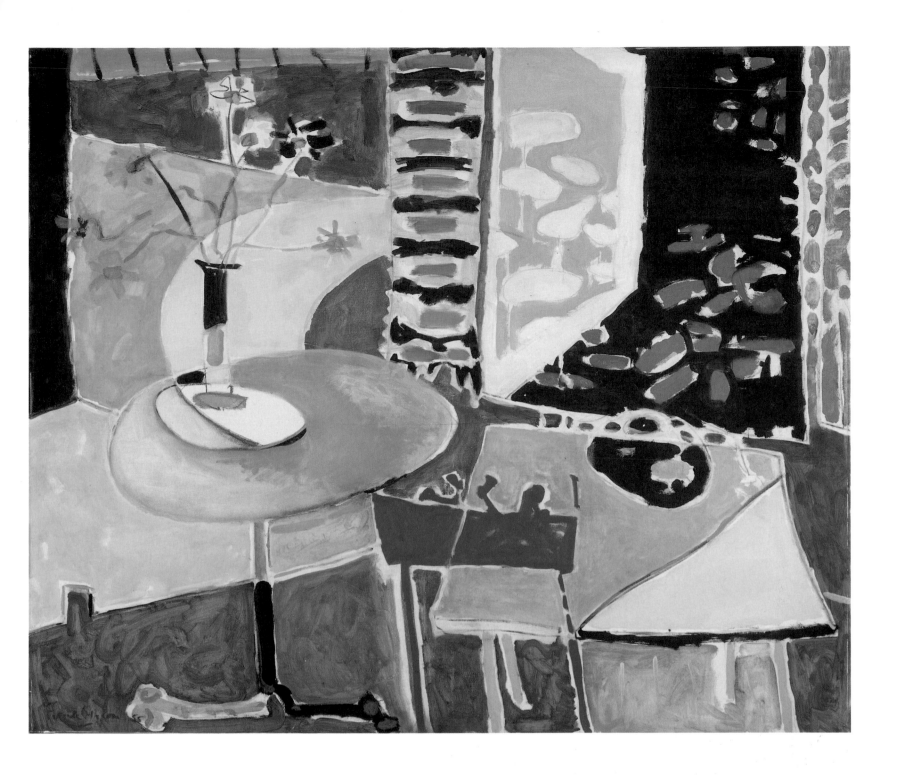

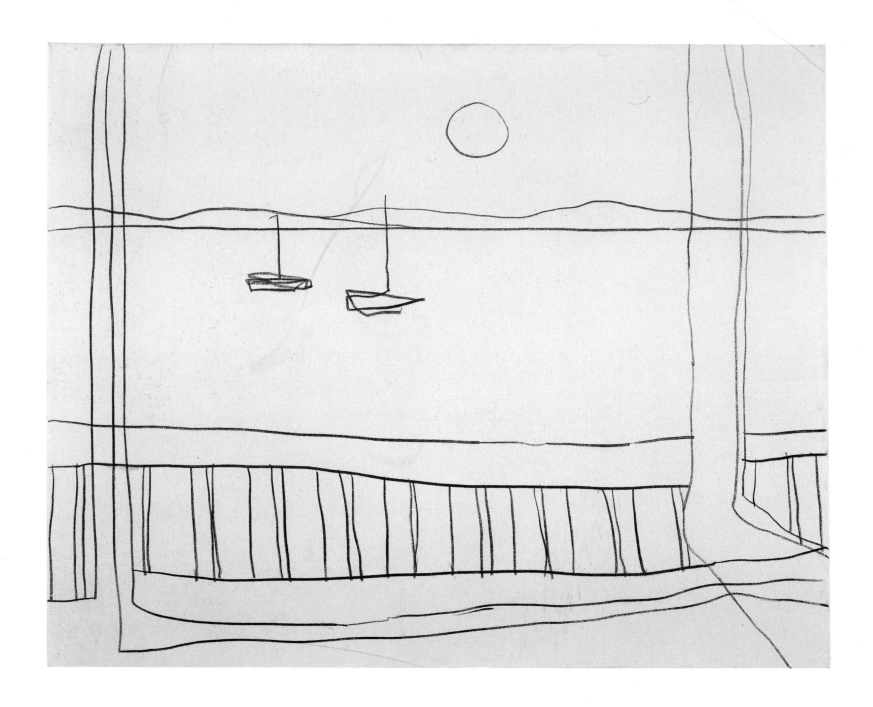

↑ BALCONY WINDOW WITH MOON: 1954
Charcoal on canvas 101.6 × 127 cm

⇥ WINTER HARBOUR: 1955
Oil on canvas 101.6 × 127 cm

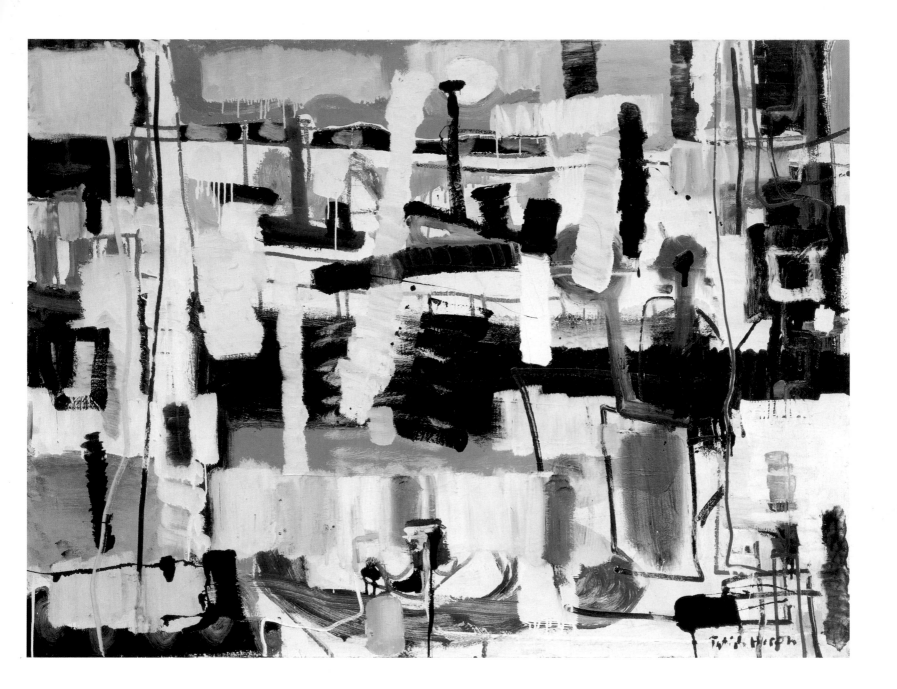

5 THE RETURN TO EAGLES NEST

1956–58 Garden and horizon

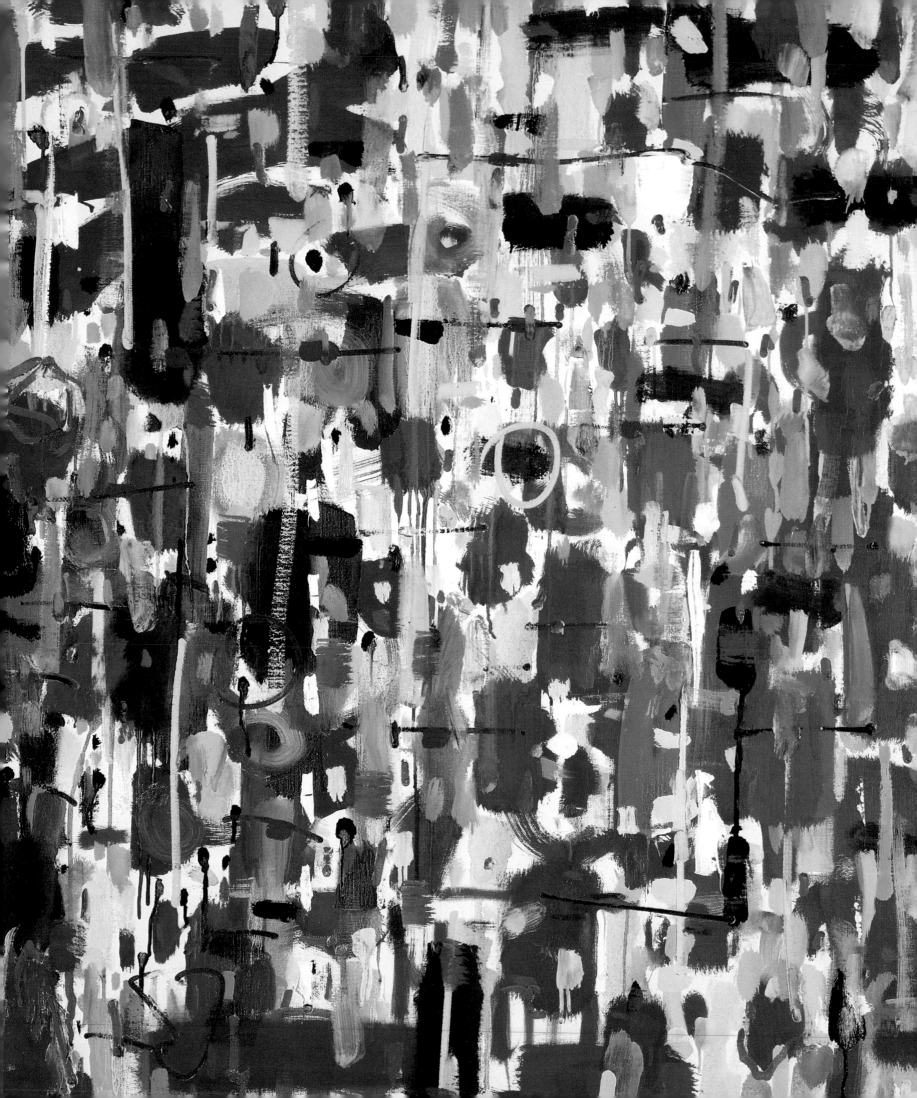

THE LAMP: AUGUST 1955
Oil on canvas 101.6 × 76.2 cm

PH, Ernst Gombrich and Renato
Guttuso debating at the Italian Institute,
Belgrave Square, 21 March 1955

'Here at last! I wish you could see the place today in its Mediterranean brilliance of light and colour! Yesterday, though, we were wreathed in mist all day: hot, steamy stuff which made the rocks and bushes into grey Chinese silhouettes ...' Heron's letter to Herbert Read, written in July 1956, catches something of the excitement of the first months at Eagles Nest. Patrick and Delia, and their daughters, Katharine and Susanna, had finally moved into the house in April, having bought it from Mark Arnold-Forster, Will's son, the previous summer. The house had been neglected, the woodwork throughout was painted a gloomy black, and much work needed to be done, so during the winter the family had remained at the London house. For Heron it was a dream realized: the house and its garden had haunted his imagination since the childhood winter he had spent there almost thirty years before, but he had never thought it possible that he might one day own the house. Now by an extraordinary chance it was his home and workplace. Exactly forty years before D. H. Lawrence had moved into Higher Tregerthen, the tiny group of cottages at the bottom of the hill below Eagles Nest, visible from its windows, with a similar sense of excitement: 'At Zennor one sees infinite Atlantic, all peacock-mingled colours, and the gorse is sunshine itself ...'. Zennor, he wrote to Middleton Murry and Katherine Mansfield in the spring of 1916, 'is a most beautiful place: a tiny granite village nestling under high shaggy moor-hills, and a big sweep of lovely sea beyond, such a lovely sea, lovelier even than the Mediterranean ... It is the best place I have been in, I think'.

Once there Heron had immediately started work on a series of small vertical paintings that carried forward a programme of radically abstract experimentation that had begun in earnest in late 1955, with *Winter Harbour: 1955*, in which a figurative treatment of the subject had been virtually obliterated by a curtain-like succession of laterally brushed rough verticals. (When this was shown in the Contemporary Art Society's theme show 'The Seasons' at the Tate in March 1956, William Coldstream had remarked 'Un petit peu de tachisme, Heron, n'est-ce pas?') *Red, Black and Grey* of December 1959 was another figurative painting similarly over-painted with a wilful chaos of brushed patches and diagonals. These paintings have the feel of transition about them, even of crisis. Their apparently arbitrary disposition of rough and inconsistent brushmarks, paintlines, dribbles and splashes activate the surface of the painting, denying spatial depth and insisting on texture. The smaller paintings made in the first weeks at Eagles Nest, mostly in the dimensions of the double square (90 × 45 cm), are more formally ordered: taking their cue from the format they are mostly composed of vertical strokes parallel to the canvas edge. They are painted in a variety of methods, each one different: in some the canvas is completely covered, with thickly opaque slab-like strokes laid over a painted base; in others the verticals are more lightly laid on with a turpentine-wet brush, leaving trails of vertical dribble, to create a kind of veil over the white primed canvas; in some there are horizontal marks across the verticals.

This programmatic diversity of attack, the uniform dimensions and the unusually small scale of these works, suggest a more systematic approach to formal problems than is characteristic of Heron; these exercises suggest that he was, for once, deliberately experimenting with variations of technique, rather than making technical discoveries in the intuitive process of painting. It was not that there was anything premeditated about the dramatic changes through which the work was moving at this time: '... the fact is that all transitions strike one at the time as being wholly chaotic and terrifying', Heron wrote many years later, apropos this very moment in his career, 'one seems, at the time of change, to be jeopardising one's entire art and the difference is seen as very extreme indeed'. Until now, formal

94 | 95

THE RETURN TO EAGLES NEST

invention and stylistic discovery had been outcomes of an engagement with an external reality; the image had always an objective visual referent in the world, however transformed, distorted or disguised it may have been in the painting. With this decisive move into non-figurative abstraction Heron was having to do without the pretext provided by a subject: the image was the painting itself, its form invented, and its manner of presentation discovered, in the act of its making.

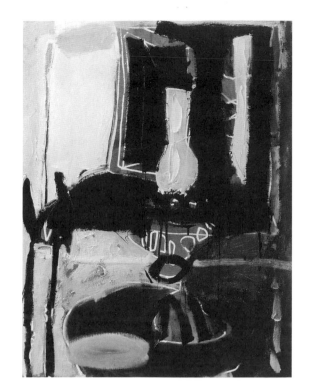

In retrospect it is possible to see Heron's arrival at non-figuration in the winter of 1955–6 as the logical culmination of a long process: it seems in certain respects to have been inevitable. Even its forms can be recognized as having been anticipated directly in certain paintings made in the year or so before. Heron has himself pointed out such anticipations in the 'Tachist blobs' used to 'infill between the charcoal lines of drawing … in the big largely black and white painting called *Girl in Harbour Room: 1955* or *Round White Table (St Ives): 1953–4* which was a London memory of the St Ives window'. Certainly the crucial formal move towards his first distinctive abstract mode was the abandonment of the charcoal linear scaffolding of his figurative work. The drawn line had carried the bulk of the descriptive burden in the best paintings after 1950; the paint itself had long achieved an expressive autonomy, functioning both as a means to propose space and as a component of an all-over decorative design. For this reason, a painting such as *The Lamp: August 1955*, with its emphatic vertical paint rhythms and minimum linearity can also be seen as anticipatory of the 'tachist' paintings of early 1956.

Heron had, of course, been thinking and writing about the nature of abstraction since his very first published article in 1945; apart from Herbert Read, who admired his writing and his painting in equal measure, and whose deepest critical concerns were with British and European artists of an older generation, there was no other critic in this country who had engaged so deeply with the problematic relations between figuration and abstraction. He had close critical knowledge of the variously abstract and non-figurative painting of Scott, Hilton, Lanyon, Pasmore, Wynter, Frost and Davie, among other British artists of this period, and he enjoyed friendships with these artists, and with Ben Nicholson and Barbara Hepworth, though he was not involved to any great extent in the groupings and counter-groupings of the St Ives artists. Neither had he taught at the Bath Academy of Art at Corsham, where Scott, as Head of Painting there until 1955, invited like-minded artists to teach and exchange ideas. Heron championed the abstract painting of his contemporaries in England with an enthusiasm of the eye and generosity of spirit, supporting his judgements with sensitive and subtle formal analysis of their work, throughout the period when he had remained convinced of his own need, as a painter, of 'that troublesome entity, the subject'.

That revealing phrase had occurred in Heron's most recent writing on those 'middle generation' painters, in his first article for Hilton Kramer's *Arts Digest* (soon to abbreviate its title) in March 1955. In it he re-stated the arguments for his choice of artists for the *Space in Colour* exhibition he had organized in 1953: 'In a climate dominated by literary values and where, for instance, "abstract art" is still the *bête noire* of the majority of critics, the object of that exhibition was to demonstrate that the fundamentals of good painting – of different styles – are abstract'. Later in the same piece he refers to the persistence of a symbolic imagery in Roger Hilton's most rigorously non-figurative paintings. 'The fact is, probably, that *every* type of figure, sign, image or symbol cannot be excluded or chased away. Non-figuration is merely an unattainable ideal. *All* configurations take on, with time, overtones of meaning alien to the pure ideal of non-figuration.' That insight had prophetic implications

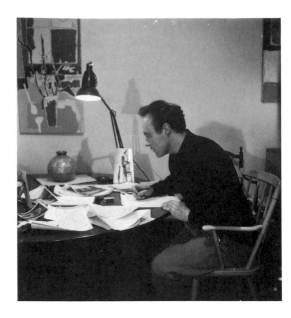

for Heron's own non-figurative work, as he was to recognize many years later.

For Heron himself at this time it continued to be true that the example of the great French painters were of the greatest significance, and Paris was still the centre of the artistic universe. His visit to Paris in June 1949, as critic for *The New Statesman and Nation*, was the second of several over the next few years, and it is clear from his reports that he knew the work of many of the younger French artists, was keenly knowledgeable of the various abstract and non-figurative tendencies in Paris during this period, and was capable of making decisive critical distinctions between them. In 1951 and again in 1952 he noted with satisfaction that it was 'Bonnard alone of the "old masters" who now influence the best of the youngest painters'; 'Estève, Singier, Manessier, or such very young artists as Rezvani and Arnal, all owe much to the abstract elements in Bonnard'. Nobody had written with such penetration of the relevance of Bonnard to the painting of the time: 'He forged a conceptual imagery out of perceptions …', Heron had written as early as 1947, an 'alloverness' in which 'the form of objects in a picture … hardly exists in isolation from the total configuration'.

'I believe that it still holds true that French painting is the best in the world: it still holds the centre of the stage. Indeed, it *is* the stage. There are still a great number of intensely professional painters of many nations living and working in Paris. And from the ranks of these there may spring at any one moment an individual artist who will give that extra twist to the material that is now the common property of perhaps a hundred very intelligent artists – who are still only intelligent, and not geniuses.' To the painter, as opposed to the critic, the very air of Paris in the early 1950s seemed more transparent than that of London, the light more even, calm and pervading, bestowing on the dingiest of surfaces a luminosity; everywhere he looked he saw painting. So many great painters had worked there in the past that the atmosphere was pervaded by their spirit; and among their younger successors working in Paris now there was a community of spirit and sophistication of discourse lacking in London.

What Heron called 'the power of Paris' continued to exert its magic upon him through the mid–1950s and beyond. The urgency and commitment of the younger painters – ('the painters are *obsessed* by painting') – seemed to him continuous with the spirit of the masters he revered, including Braque, who still lived and worked in the magic city. In a personal postscript to his February 1957 *Arts* essay on Braque, Heron was explicit on this continuity:

The non-figurative art of today seeks a spatial freedom and certainty in the interaction of colors at once harsher and brighter than Braque's – and through formal gestures and statements that are controlled, not as his are, by either rectilinearity or curvilinearity – but by a *new* feeling of formal coherence and consistency which depends on neither. The apparent accident of handling, the natural energy of dripping pigment almost imperceptibly guided by the artist's hand – this new art is apparently far removed from that of the master of cubist collage. *Yet there is always continuity, at one level or another, between the best of one generation and the next* [my italics].

Heron went on to find a kind of 'figurative tachism' in the late Braque landscapes. Heron's inner ruminations, as a *painter*, on the problematics of non-figurative painting, and the pressures within that led him to his own forms of abstraction in 1956 and beyond, were most powerfully conditioned, then, by his knowledge and experience of French post-war abstract painting, and especially in the first place by the more freely painted stroke, splotch and blob all-over painting for which the French critic Michel Tapié had in 1952 coined the term *Tachisme*.

This freely gestural painting, with an accompanying rhetoric that extolled abso-

lute spontaneity of execution in the service of pure emotional expression, had quickly become an 'international style', and by the end of the 1950s it had the status of a new academicism. The process was hastened to some extent by the romantic legend of Pollock, and by a widespread misunderstanding of his work, which emphasized the chance elements and the lack of conscious control in his painting. It was a misunderstanding not shared by Heron. Writing, in *Arts*, April 1956, about Alan Davie, who had acknowledged the liberating impact of Pollock in the late 1940s, and making an essential distinction between Davie's work and that of the famous American, Heron wrote:

Pollock is widely held to have occupied an extreme pole of artistic style – he is thought to have demonstrated the ultimate limit in spontaneous execution. Yet this is far from true. In fact Pollock is of a classical frame of mind, it seems to me … The beauty of a Pollock of, say, 1950, is the beauty of a supremely architectonic, cool, minutely precise design. In all of which he is the opposite of Davie who is, by comparison, an intuitive romantic.

'As a rule', Clive Bell once wrote, 'the recognition of a movement as a movement is its death'. By the later 1950s the label '*Tachisme*' had become critically meaningless, being used interchangeably with the term 'action painting' to describe any freely or thickly painted abstract or symbolic painting. In his contribution to *Art Since 1945*, a major international survey of the art of this period, Herbert Read provided a loose listing of names of British painters 'of this school' which actually included figurative painters like Frank Auerbach, and referred to Alan Davie, who was represented by a reproduction of *Sacrifice*, an overtly symbolic painting of 1956, as perhaps the only British artist who could 'be regarded as a consistent Tachiste'. In an essay in which he saw no reason to mention a single American painter Read continued: 'It seems likely that, though belated, the Tachiste tornado will sweep over the country in the immediate future, leaving its colourful wreckage on a thousand canvases'. Driving into London on an evening in late May 1956, over two years before Read's account was written, the contents of his forthcoming Redfern show in the back of his Dormobile, Heron had turned to Delia and exclaimed: 'Here comes London's first exhibition of *tachiste* paintings!' In using the French term (then and since) he was indicating something exactly definable in relation to *method*, and deliberate in its definition of the provenance of his own abstract manner.

It seems likely that the limited revelation of the abstract expressionists at the Tate in the January of that year had some impact upon Heron the painter, though it was not registered stylistically in the paintings he was making at that time in preparation for his Redfern exhibition. The American show had arrived, as he remarked, '"at the psychological moment" – the moment when curiosity was keenest'. And some part of the enthusiasm of his general response can be put down to the anticipatory excitement that had made the show as a whole 'undoubtedly "the talk of the town".' As we know, Heron himself was particularly well prepared to receive the show with the open responsiveness which distinguished his reviews from the reactions of the London critics. There was nothing comparable to his appraisal, in critical depth or in the subtlety of its distinctions; and at Hilton Kramer's request, Heron devoted the first part of his essay to a devastating survey of other reviews.

Writing for an American audience, he was, nevertheless, gently ironic about the claims already being advanced for the American influence on European art: 'I think it is true to say that the fame of these artists [the New York painters] just managed to precede the arrival of their canvases in London …'; he noted, with a hint of scepticism, the idea gaining currency that 'this new school of American

→ SQUARE LEAVES (ABSTRACT):
JULY 1952
Oil on canvas 76.2 × 50.8 cm

painters has become an international force, capable, even, of exerting an influence on Paris … even *The Times* can explain, in its review of this exhibition, that [these] painters have "gained for the United States an influence on European art which it has never exerted before".' Referring to Meyer Schapiro's tactful reserve, in a BBC broadcast, about the extent of 'this influence on European art', Heron remarked that professor's inability, nevertheless, to conceal a 'fervent enthusiasm'.

As for himself? Heron was impressed but not overwhelmed. 'My own feelings have shifted one way, then another, since my first sight of them … a month ago. [Heron was writing in February, the article appeared in March.] I was instantly elated by the size, energy, originality, economy and inventive daring of many of the paintings. Their creative emptiness represented a radical discovery, I felt, as did their flatness, or rather, their spatial shallowness. I was fascinated by their constant denial of spatial depth, *which goes against all my own instincts as a painter.*' [my italics]. This goes at once to the heart of the matter, being perceptive about the original qualities of New York painting, about *what made it new*, and at the same time registering a personal note of doubt. Heron's separation of his critical and his creative activities was habitually strict, and it was rare indeed for him to make reference in his writing to his own practice as a painter. (This does not mean that what Heron wrote as a critic did not throw a revealing light on the aesthetics of his practice as a painter.)

There is no further reference to his own work in the piece, but what follows the passage just quoted has behind it a personal feeling that relates directly to his own creative predilections:

Also there was an absence of relish in the *matière* as an end in itself, an absence of worked-up paint quality such as one never misses in the French (sometimes a superbly manipulated surface texture is all one can find in Paris). These American painters were so direct in the execution of the *idea* that their paint-gestures, their statement on the canvas had an almost over-dry immaculateness – and I mean this even in connection with such wet-paint canvases as Pollock's.

Heron's critical misgiving about the Americans' *colour* surprised himself, (and was also revealing of his own preferences as a painter): 'There is always, however, a lack of resonance in their color … it was, for me, the great surprise of the show. I had always thought that these painters … must use colors of the utmost strength and brightness: I had thought de Kooning, for instance, who is so weighty, severe and dramatic a designer, seen in black-and-white reproduction, would be at least as drastic *in color* as Soutine. But not a bit! His color is all ladylike, gossamer, pastel tints! Very beautiful, very delicate, very rich in a muted way. But surprisingly feminine and impressionist, with white in all his charming pinky-green mixtures'. (Heron was referring to *Woman 1* of 1951–2.) Pollock's *Number One 1948* was 'as silvery-white-gray as a Monet of snow – but less substantial and, *as color,* less plastic …'. Neither Pollock or de Kooning, Heron felt confident enough to observe, 'fully understands the pictorial science of color as yet'.

As always in Heron's thinking, this concern with colour in painting is related to his preoccupation with pictorial space. The finest painting in the exhibition he considered to be Motherwell's *Granada 1949*. ('Of course', he wrote, 'it is nearer to the French in some ways … his brush is wielded with a dry opulence which rivals the rich discipline of Soulages, for instance'.) This painting had 'twenty times the spatial punch of a Pollock or a de Kooning', and its spatial evocation was 'dependent upon a positively scientific awareness of the operation of tone-color'. Kline, on the other hand, 'avoids the sense that color is present in his black-and-white compositions', whereas 'the feeling of full color somehow pervades any Hartung or Soulages or

William Scott which has the same black-and-white limitations'. Compared with Motherwell, Heron felt Rothko 'probably is the more important explorer. Like others in this group, he is discovering things never before known. I would say that his apparently supreme concern for *surface* was in fact a concern for the exact opposite: his exquisitely powdery horizontal bands of colour in *Number 10, 1950,* bulge forwards from the canvas into one's eyes like colored air in strata-form. He evokes the layers of the atmosphere itself'. After reference to similar evocations in the rhythmic marks of ripple and wave patterns in Clyfford Still's *Painting 1951,* Heron concluded (anticipating, with unintentional irony, precisely the objections to the St Ives abstractionists made later by Americanophile critics like Lawrence Alloway): 'Yet the emulation of nature's own forms and forces is not quite enough. The American abstract expressionists are possibly still concerned too much with such an emulation'.

As a critic Heron was clearly impressed, but sceptical as to the magnitude of the American achievement up to that moment. He was aware that he had only a handful of pictures to go on. Admiring these paintings, and having no truck with the shallow and foolish reactions of the majority of the British critics, he demonstrated a sturdy disinclination to be overawed by the new-found 'fame' of their authors, and looked at their work as an artist whose confidence in the international centrality of European painting was unaffected by the brilliance and vigour of this new school. ('We shall now watch New York as eagerly as Paris for new developments …') He had, for once, perhaps unconsciously but significantly, relaxed the vigour of his self-imposed separation of critic from artist; notwithstanding the warmth of his critical welcome, itself expressed with careful reservations, as a painter his admiration was qualified. Impressed by their energy and scale, he continued to go his own way. In certain respects his reaction to the American phenomenon was parallel to that of his close friend William Scott, who wrote many years later of his own first encounter with New York painting: 'I felt now that there was a Europeanism that I belonged to, and that many qualities of painting which were possessed by my friends might elude an American – i.e. our disregard for technical "know how" and the quality the French call "gauche".'

His articles for *Arts* over the next months continued to reflect Heron's abiding critical preoccupations with French and British art and their creative inter-relations: he wrote of Terry Frost, comparing him favourably with the French abstractionist Jean Bazaine; of William Gear, remarking his affinities with de Staël and Soulages; of the controlled 'accident' in the painting of Paris-based Riopelle; of the eclectic French-inflected but personal idioms of Ceri Richards. Later in the year he contributed major appraisals of Renoir and Cézanne. In London, in March, just before the removal to Eagles Nest, Heron wrote on the de Staël memorial exhibition at Tooth's, remarking the pervasive influence on British *avant-garde* painting of 'this very French artist who was not, in fact, a Frenchman'. (This appeared in the May issue.) Already embarked upon a series of large vertical paintings more radically non-figurative (and genuinely *Tachiste*) than any he had made before, Heron must have recalled his own first experiments in abstraction, made in 1952, under the spell of de Staël, whose first exhibition in London was held in that year.

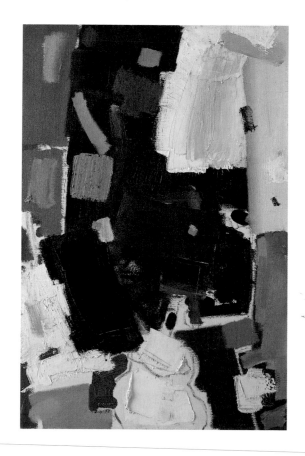

Of these perhaps the most successful was *Square Leaves (Abstract): July 1952.* Like much of the painting at this time of de Staël himself, on second sight this turns out to be a disguised figurative picture, an example of what Heron was to describe in his 1956 tribute to de Staël as *figuration in abstraction*; it is in fact a window still life. At lower centre is a white jug on a brown table, its solidity of form proposed by three palette-knifed slabs, its outline by a tenuous grey line; to its right is a cup, similarly described in paint and line. In the jug are flowers and foliage (the square

→ BLACK AND WHITE VERTICAL I:
MARCH 1956
Oil on canvas 182.9 × 91.4 cm

⇉ VERTICAL: JANUARY 1956
Oil on hardboard 243.8 × 121.9 cm

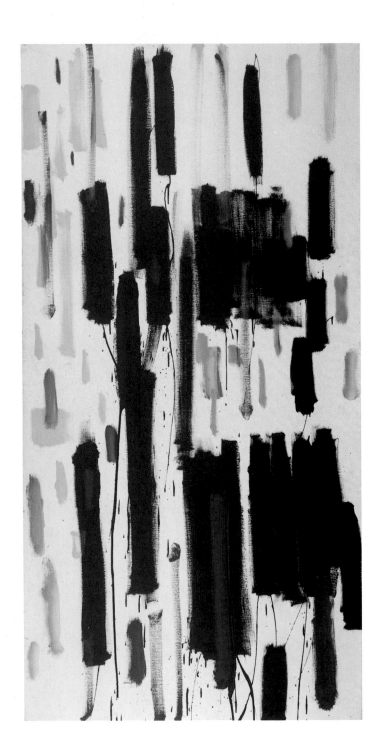

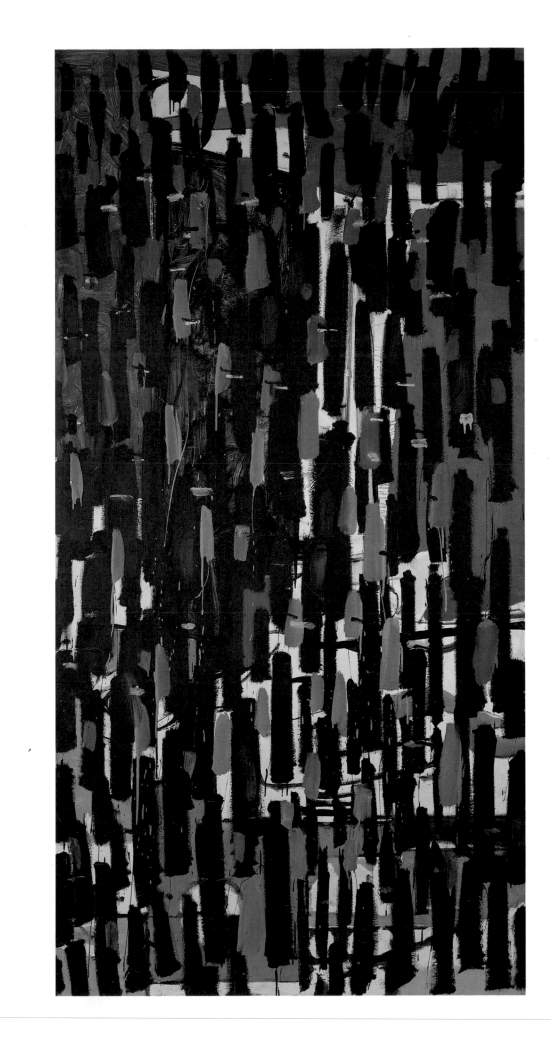

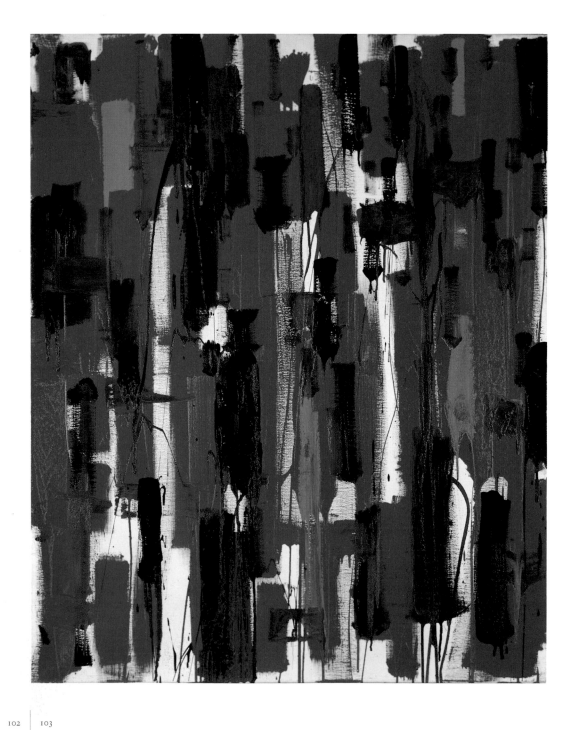

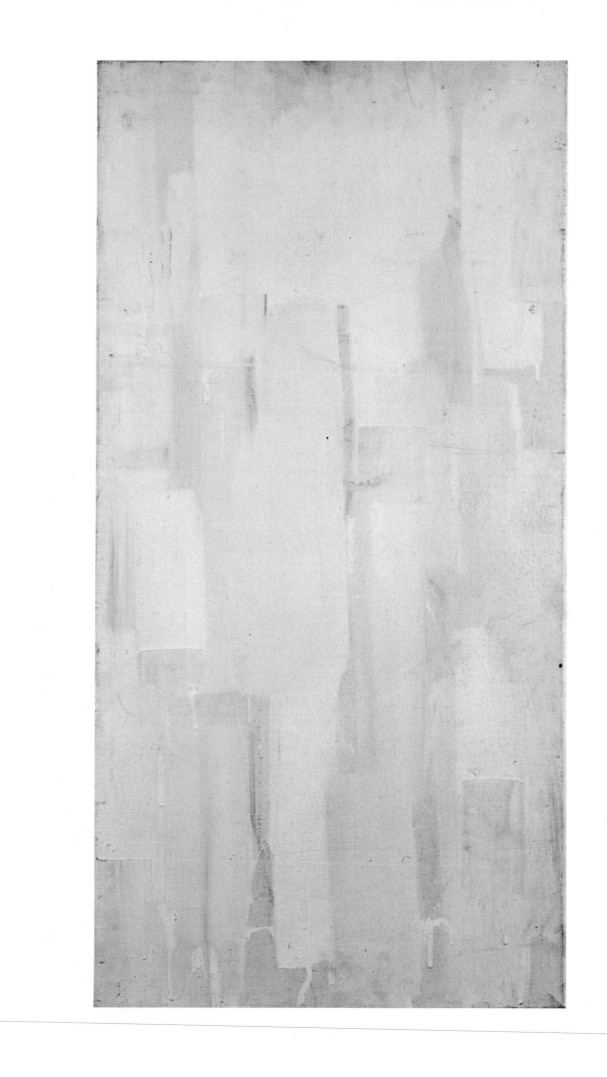

leaves of the title), stylized to pure rectangles of slabby paint, set against a window giving on to darkness (the bright lightness of the jug in the foreground suggests an artificial light in the interior space). *Square Leaves (Abstract): July 1952* is one of several stabs at abstraction made at this time, but the experiment lacked conviction, and Heron was to wait for over three years before once more turning to non-figuration, this time once and for all.

All painting arises out of a continuous dialogue with other painting; to paraphrase Valéry, *art feeds on art*. But all good painting is, in some profound way, also a response to the reality of the artist, to specificities of time and place and situation; art grows out of the artist's life. The crucial event in Patrick Heron's life in early 1956 was the April removal to Eagles Nest; this was to be the central event in Heron's life as an artist. The impact upon his painting was immediate and dramatic: within a month he had laid the non-figurative bases for a series of formal developments that have continued to this day. The upheaval of the removal of family and furniture from the smoke and fog of London to the coastal clarities of Zennor took place a few weeks before the opening of his Redfern exhibition in early June. In a period of intense excitement and intensive activity, which included writing articles for *Arts*, Heron completed the transition of his painting to a fully resolved expressive abstraction. Elated by the success of these new paintings, and conscious of a connection between their radiance of colour and his exhilaration at the effervescence of the spring-flowering azaleas and camellias at Eagles Nest, Heron titled them 'Garden' paintings.

The series of small paintings described at the beginning of this chapter were essentially experiments in structuring the picture by means of painterly *strokes*: economic in scale, limited in colour range (mostly blacks and whites), and within a predetermined formal frame, they were essays in *Tachisme*, strictly defined. Heron was working on the problem of colour and space in relation to a mode of pictorial construction which was purely painterly, having no subject, and depending on no linear framework, being 'controlled … by a *new* feeling of formal coherence and consistency …'. This element of *control* is psychologically necessary to Heron's practice as a painter, but his conception of its operation within the process of making is complex and dialectical: 'The only rule I follow in painting is this; I always allow my hand to surprise me … : also, I always follow impulse – for instance in the choice of colours; deliberation is fruitless. But this does not mean that every act connected with the painting of a picture is not deliberate; it is.' The objective expression of the new feeling of formal coherence, of the 'spatial freedom' that he sought, could not be premeditated or conceived independently of the action of painting; hence the pivotal significance of the small vertical pictures of early 1956.

The first painting of this period that is totally assured in its assumption of a non-figurative manner was, however, painted in London at the very beginning of that extraordinary year. This was the magisterial *Vertical: January 1956*, which was not only the first, but also the largest of a group of related paintings made in the first four months of 1956. In common with most of the others its format is the double square, which provides a steep vertical face down which falls a multitude of stark black broad strokes, parallel to the vertical edges, and more or less evenly distributed from top to bottom, and from edge to edge. Behind this screen the support is painted white, and over the white, but behind the black strokes, are irregular areas of primary colour and grey. The ambiguous space of the late figurative

works, with its reference to actual spatial experience in the external world, the world our bodies inhabit, is here realized entirely in terms of relations within the picture: it is imagined space, inhabited only by the eye. It exists not only behind the 'screen'; for the presence of smaller grey vertical bars, and of tiny yellow horizontal strokes on top of the black and grey verticals, suggest recessive relations *between* the bold blacks. Thus a purely textural dynamic, paint laid in a dramatic downward configuration of strokes on a rectangular plane, is countered by the sensation of space in front of and behind that surface, and of space between the marks that configure to create the image.

Black and White Vertical I: March 1956, painted in London in March, is altogether more aerial. Instead of the complex space behind the black strokes of *Vertical: January: 1956*, complicated by colour and texture, in this painting there is a bright white light created by the luminosity of the untouched primed canvas. Recessive space is a function of the relations created between the vertical blacks and greys by the various weights of their application, whether or not they are over-laid, and the relative sizes of the strokes. These are freely distributed, bunching slightly to lower right, a vitally asymmetric aspect of the composition. The graphic simplicity of this image, the undisguisedly spontaneous application of the downward strokes, the limitation to black, grey and white (which nevertheless succeeds in creating an impression of colour): these are elements in a marvellously assured performance that formally anticipates Heron's first vertical stripe paintings of exactly one year later.

Black and White Vertical II: Granite: April 1956 was started in London in March, and completed the following month in Cornwall. Though it is clearly related to its immediate predecessor, its mood is very different. Much over-painted in bituminous blacks and thick whites, the space in this picture is at the front, or in front, of the canvas, which presents the spectator with an opaque wall, a solid facework of impenetrable paint. This forbidding surface, as slow in its effect as in the previous painting it was quick, is lightened by tiny accents of emerald green. Some time after its making, Heron realised that it resembles a tarred granite-block wall at the disused Levant tin mine, on the cliffs about six miles along the coast from Zennor. Between the great blocks sprout diminutive emerald ferns. In its slightly claustrophobic opacity this painting has much in common with the small-scale *White Vertical: May 1956 (Black),* and with *White and Green Upright: August 1956*, which being painted in August, suggests that Heron was still prepared to try out the effects of a more thickly applied and over-painted manner *after* the exhibition at Redfern.

In the event it was not something he would pursue. *Red Painting: April 1956*, the format of which, though still vertical, is less extreme than the double square, was painted at Eagles Nest. Like *Black and White Vertical II* it is a picture which crowds to the edge, its crimsons, blacks and blues distributed over the whole surface, but in this case applied direct to the primed canvas with little over-painting, giving it a back-light, and with a decidedly upward pictorial dynamic created by the bunching strokes at the top and the downward trails and trickles of running paint. Such dynamics inevitably give a painting a more openly spatial, atmospheric or aerial feeling, and it was this lighter, quicker texturing that Heron adopted for the brilliant 'Garden' paintings which are the climax of this phase of his work.

The earliest of these is *Camellia Garden: March 1956*, which was followed by *Garden (Mist): 1956* and by *Azalea Garden: May 1956. Camellia Garden* is a complex and crowded canvas, its dazzling effects achieved by a virtuosic variety of *Tachiste* marks and motives, and by a radiance of colour that is unprecedented in this first phase of abstract painting. The downward strokes which predominate are of differing strength, width and length; touched over by dabs and splotches, trickles,

↠ BLACK AND WHITE VERTICAL II:
 GRANITE: APRIL 1956
 Oil on canvas 182.9 × 91.5 cm

↘ WHITE VERTICAL: MAY 1956 (BLACK)
 Oil on canvas 91.4 × 45.8 cm

↓ WHITE AND GREEN UPRIGHT:
 AUGUST 1956
 Oil on canvas 91.4 × 50.8 cm

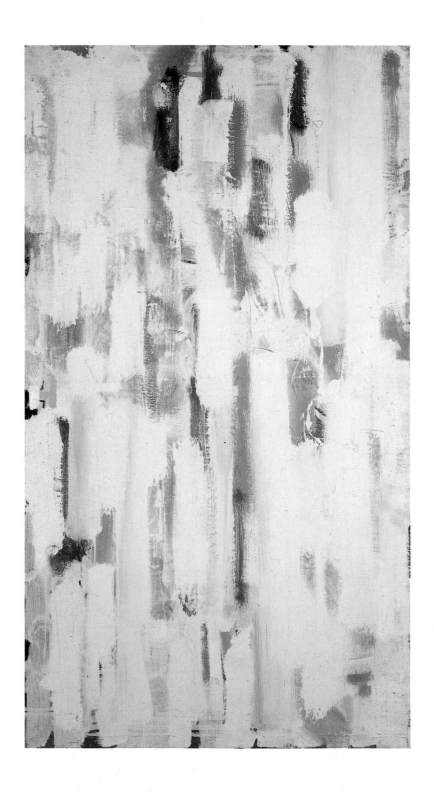

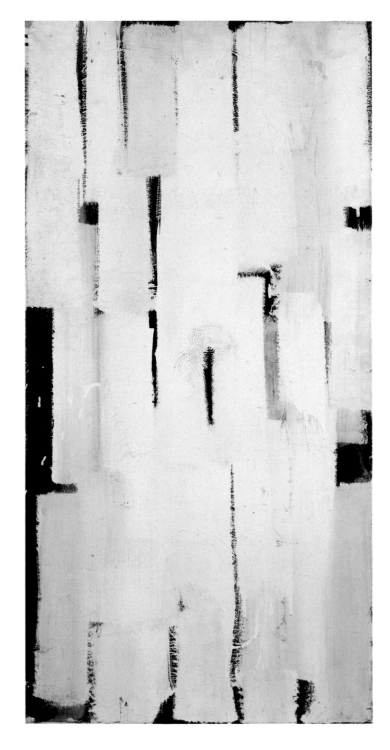

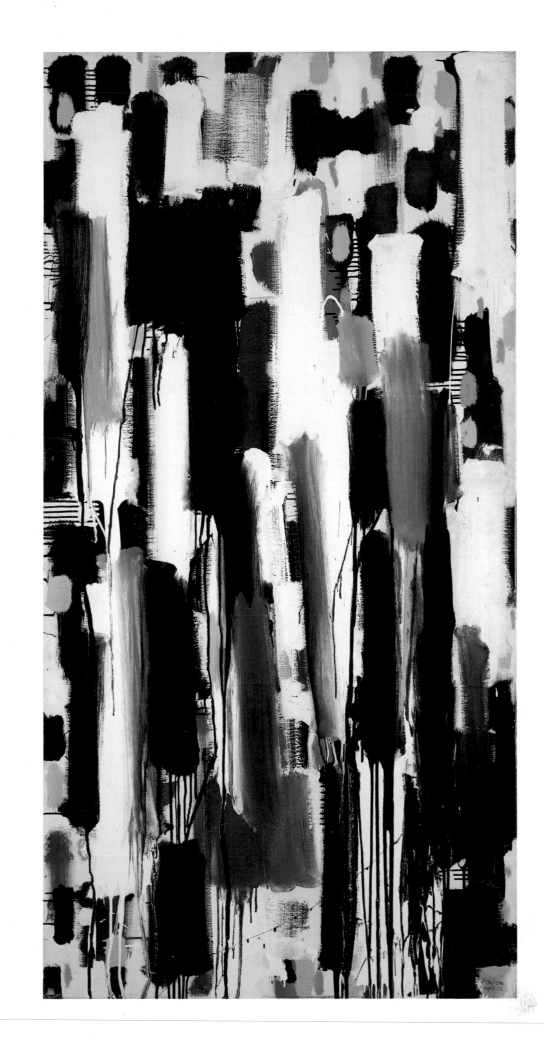

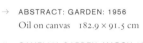
ABSTRACT: GARDEN: 1956
Oil on canvas 182.9 × 91.5 cm

CAMELLIA GARDEN: MARCH 1956
Oil on canvas 182.9 × 91.5 cm

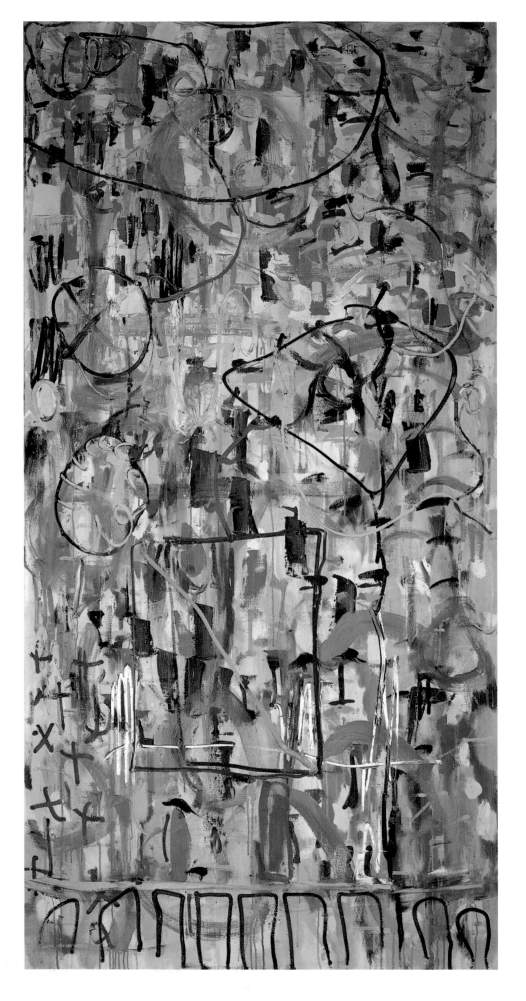

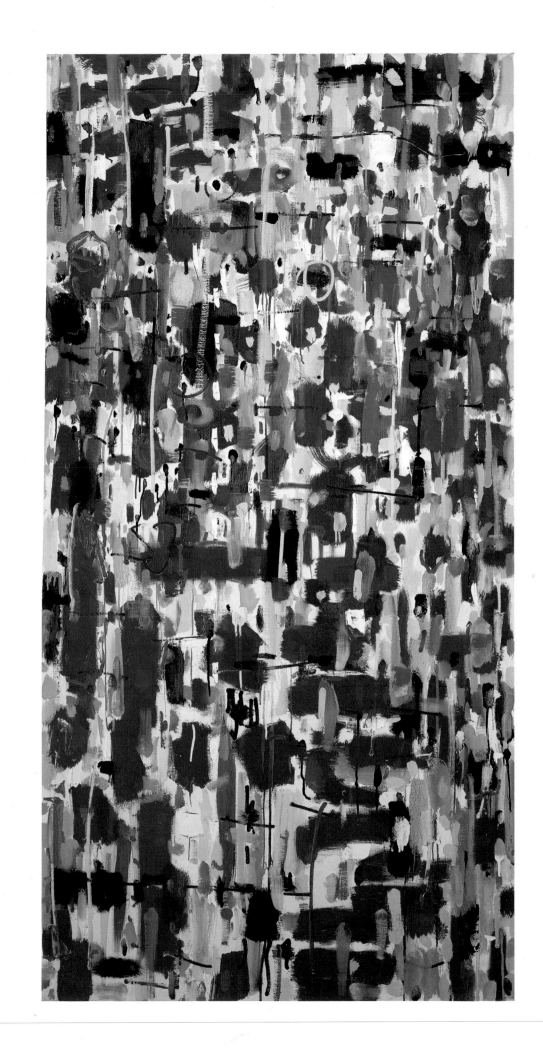

drips, calligraphic squiggles, they appear to recede or push forward as the eye moves between them and behind them. This spatial effect is complicated further by the presence of broad-brushed horizontal bars that appear to overlap and underlap the verticals, and by thin lateral paint-lines, squeezed directly from the tube, whose spatial role is ambiguous. The painting's all-over distribution of graphic stress, its surface flicker, gives it a Bonnardian richness and density. As in Bonnard this busy surface resolves into a complex spatiality which is a function of the eye, a matter of perception, rather than of a conceptually ordered visual convention. The eye is presented not with a window on to the garden but with a spatial sensation such as it registers in the world. The true subject of the picture is not the simulated sensation of seeing camellias, but the actual sensation offered by the painting, analogous to that of being among camellias.

Garden (Mist) and *Azalea Garden* are less dense in texture, quicker and less complex: they are more aerial, the former with the milky opalescence suggested by its title, the latter brilliant and chromatic, sunlit in its intensities of colour. (These are indeed the 'exquisite clouds of paint' predicted by Robert Melville in 1947!) Both are constructed of lightly brushed downward strokes applied direct to primed canvas: in *Garden (Mist)* the brush is lightly loaded, with more turps, and many of the strokes have a translucence which emphasises the atmospheric tonalities of the soft greys, yellows, pinks and mauves which predominate; in *Azalea Garden* a crystalline brightness of light is created by the massing of the pure white blobs and sharper-edged lozenges towards the top and the right of the picture, and the scatter of white accents across the whole surface area.

The titles of these paintings invite a reading of them as essays in a kind of late-Monet-like impressionist evocation, replete with ambiguities of surface and depth, exploiting the subtle interplay of the reflective light on the skin of things and the light that shines through them or surrounds them, registering the subtleties of the changes of light at different points in a field of vision, here shadowy, there lucent. And no small part of the pleasure they give is of such impressions of the light of nature, reflected by dark leaves, absorbed and intensified by flowers, refracted through a dawn mist; of its morning glitter, afternoon shimmer, evening glimmer. The titles of the later paintings in the series, *Summer Painting: 1956*, *Garden Painting: August: 1956* and *Autumn Garden: 1956*, imply that it is seasonal variations that condition their changes of key in light, colour and tone. But the visual impressions they create are associative rather than pictorial, the outcome of analogy rather than of description. And they begin with the purely painterly facts: of surface texture; of the distribution of strokes across a plane, and of their densities and weight, opacities and translucencies; of colour and tone, and of the spatial illusion they create. At no moment do these various pictorial elements coalesce into an image that can be separated from their operation as a configuration of marks: our sensation is of the painting.

Heron was concerned now to make paintings as rigorously free of reference as was possible. He had no metaphysical pretentions and no expressionist intention upon the spectator's emotions. Above all he had no ambition to describe natural phenomena or record his sensations of them. He had finally made the transition to non-figuration, which now seemed to have been inevitable, and the work he showed in June, notwithstanding its inclusion of paintings which were essentially experimental, was stylistically coherent if varied in its means and effects. The exhibition was a bravely unequivocal statement of his commitment to an autonomous and objective abstract art, intuitive and authentic: '… a false touch and the expression is lost!'

Critical reaction was generally imperceptive and condescending. There was frequent slighting reference to the 'decorative' quality of the paintings: 'A girl could make them lovely as a summer dress.' wrote John Berger; Mr. Heron had contrived 'decorations that could be translated into the most beguiling wallpapers' opined Nevile Wallis. The titles of the 'garden' paintings invited (as they were bound to do) the unexamined assumption that Heron was still working in some way *from* nature, though the terms used to convey this view were vaguely imprecise as to *how*: 'The riot of azaleas and other blossoms … *inspires* one of his more sensuous abstractions,' wrote Wallis, 'though there is no evident *starting-point* in nature in some other recent paintings'; Basil Taylor observed that Heron had 'at last if not finally abandoned the object, although such titles … suggest that his work continues to be *occasioned* by natural appearances.' Would Heron 'deepen and clarify those intimations of the natural world which are *implied* in these pictures, or … try to discover within himself a gift for non-figurative painting'? ('I hope he will undertake the former struggle' he concluded); '[each] canvas is an overall pattern of loose brush jabs, marks and drips *deriving from* a kind of Impressionist memory of flower beds and sunshine … the sensations they convey could only have been *recorded* by a trained and sensitive eye', wrote Berger [my italics in each case].

There was also some predictable reference to American painting. The ignorance displayed by the British critics in response to the Tate exhibition in January was by June (without benefit of any further exposure of New York painting in London in the interim) transformed into knowledge confident enough to perceive the influence of Pollock in paintings which bore no resemblance to his work, and which had their stylistic origins (unnoticed by the same critics) in Heron's experience of European, specifically French, traditions and tendencies. There was in fact one American painter, unmentioned by the critics, with whose work some of Heron's new paintings had a genuine affinity. This was Sam Francis, whose beautiful atmospheric paintings of the early 1950s Heron had first seen, though not particularly liked, in the 1953 ICA exhibition, *Opposing Forces*, arranged by the French painter Mathieu, which had included among others Riopelle, Michaux and, for the first time in London, Pollock. Heron visited Francis's studio in Paris in 1957, by which time he had become a warm admirer of his work. 'I make the late Monet pure,' Francis had replied, when asked (in 1950) by the German *Tachiste* painter Bernhard Schultze 'what he painted, what direction he followed.' Some years later, referring to Francis's Paris paintings of the early 1950s, the American critic James Johnson Sweeney spoke of their 'French palette' and of the artist's affinities with Bonnard: 'Bonnard and Cézanne, particularly Cézanne in his watercolours and late oils, are possibly his two closest kinsmen or exemplars in this Paris period …'. It is not surprising, then, that Heron should have found Francis sympathetic. Whilst the more thickly-worked small 'garden paintings', and the larger black and white *Verticals* have little in common with his work, either in technique or feeling, the more lightly painted and atmospheric large 'Gardens' are certainly close in spirit to it.

In contrast with the general critical response to the new work, Herbert Read, in selecting *Black and White Vertical I* and two of the later 'Gardens' (*Garden Painting: August 1956* and *Summer Painting: 1956*) for his Critic's Choice exhibition at Tooth's in September, observed that Heron had 'experimented with the same kind of passion as Davie' but that he was 'far more conscious of tradition, of continuity'. He continued: 'I have chosen "within" his work and what I have chosen is not representative of the whole: but it does express a tendency which I find full of promise and excitement.' As we have seen, Read was not without his own confusions about the non-figurative painting of the time, but he was, as ever,

AZALEA GARDEN: MAY 1956
Oil on canvas 152.4 × 127.6 cm

GARDEN (MIST): 1956
Oil on canvas 182.9 × 91.5 cm

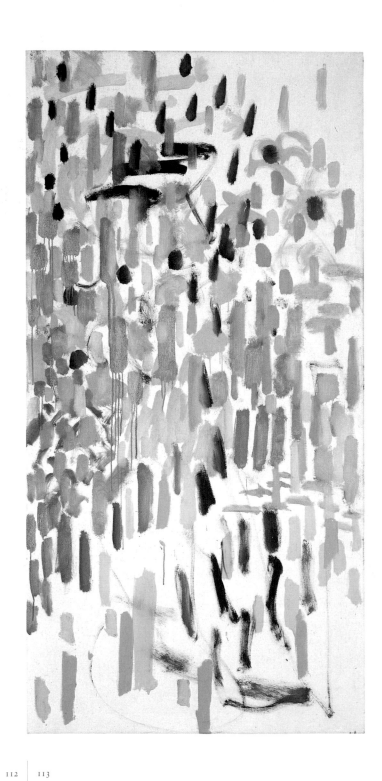

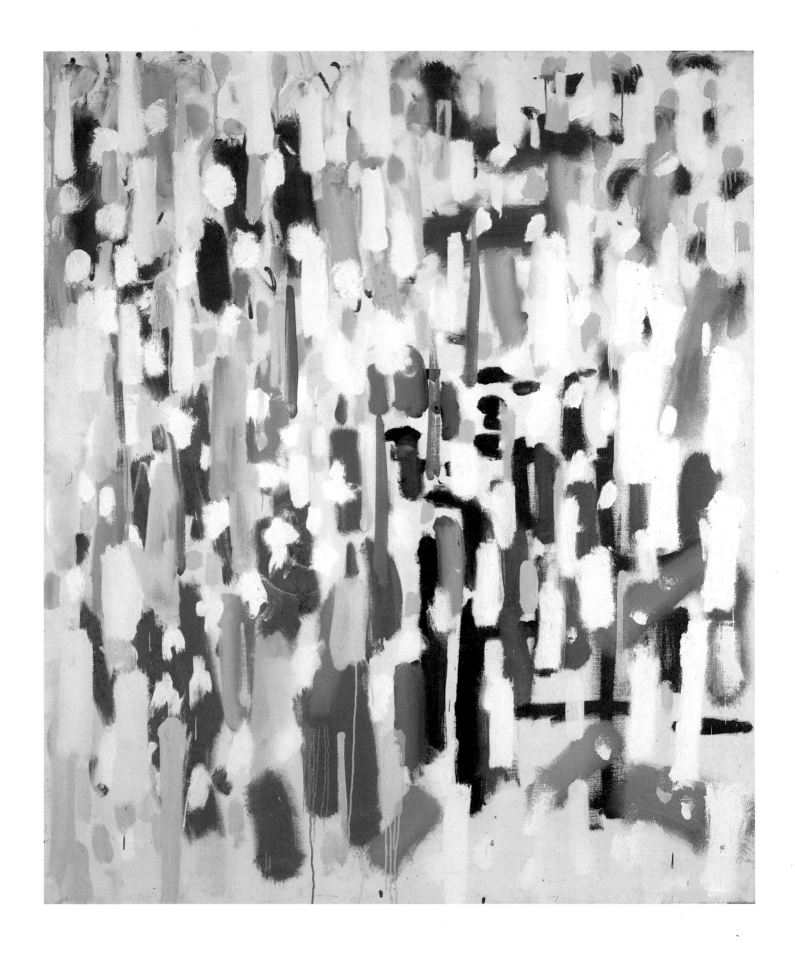

Eagles Nest Little Lawn, *c*.1957
(l–r) Agnes Lepeltier, William Scott,
Caroline Holmes, DH, KH, PH

critically generous and open to the new spirit: '… I am determined to take the opportunity to make an abstract demonstration,' he had written in a letter to Heron in February, apropos the invitation to select the Tooth exhibition. 'I shall begin with Ben – that's easy! and then ??? … I want very much to make a very unified show, and no compromises. I don't mean an academic abstraction, as the names Scott and Davie will indicate. How abstract have you become?' This was before Heron's June exhibition at the Redfern, but as the letter clearly suggests, Read had perceived the essentially abstracting tendency in Heron's painting up to that moment. The excitement registered in his Critic's Choice Introduction was a response to its resolution in the paintings of early 1956.

Read's sense of the promise inherent in Heron's new non-figurative mode was soon to be abundantly justified. The later *Gardens* of 1956 were his last in an overtly *Tachiste* manner. There followed a pause in Heron's output. Such a break is not unusual in his career; a burst of creative activity stimulated by a new set of circumstances, a new setting, a specific demand, is followed by a fallow period, a breathing space for reflection, a re-charging of energies. As Alan Bowness remarked in 1968, it is characteristic of Heron after such a pause to make a sudden shift in manner: '… Heron has never stood still – in fact his temperament compels him to look always for the contrary of what he is doing as a means of furthering his progress, or if you like to work from thesis to antithesis to synthesis in an everlasting sequence.' (This distinctive pattern of behaviour is reflected in Heron's manner of working in the studio: periods of inactivity and procrastination are followed by explosive bouts of activity; after hours, or even days of waiting, he may attack the canvas and lay down within seconds, and once and for all, the basic design of a picture.)

Having made a personal breakthrough Heron wanted to move on to an exploration of what now seemed an infinite universe of new expressive possibilities. He was keen to leave behind what was already becoming a new international academicism, the busily worked, all-over surfaces of *Tachisme* or action painting. The textures and tonalities, and the form-in-space problematics of St Ives abstraction did not interest him as a painter, though he continued to be committed critically, and influentially so, to the work of Hilton, Scott, Lanyon, Frost, Wynter, Wells, Davie and others. He was temperamentally averse to the measured squares and circles of Nicholsonian neo-cubism, and the poetic geometrics of British constructivism. What he sought was a painting in which chromatic structure was an image in itself, conterminous with the painting as an independent, autonomous object. It was in respect of this ambition, and in this liberation from the requirement to convey a pre-determined 'meaning', that the 'creative emptiness' of the new American painting, or such of it as he had seen, was to influence Heron's practice in the next eighteen months.

'To me, something called *good painting* is all that matters' he wrote for *Statements*, an exhibition of British abstract art in 1956, selected by Lawrence Alloway for the ICA in January 1957. It is a remarkable manifesto, the first statement about his own work that Heron had ever written, and bears extensive quotation at this point in the story:

… admittedly, I do not believe that there is any figurative painting being done today by painters under fifty or sixty which can compare with the non-figurative work of similar age-groups. But I do not, on the other hand, necessarily believe that the future belongs to non-figuration. On the contrary: I think a brand-new figuration will emerge, but emerge *out of* our present non-figurative thought and practice … The pictures I have painted since last January have much in common with my figurative paintings: but they lack the linear grid of figurative drawing. This has freed me to deal more directly and inventively (I hope) with every single aspect of the painting that is purely pictorial, i.e. the architecture of the

canvas, the spatial interrelation of each and every touch (or stroke, or bar) of colour, the colour-character, the paint-character of a painting – all these I now explore with a sense of freedom quite denied me while I still had to keep half an eye on a 'subject'. Just what it is in such pictures that one comes to regard as their 'content' (and it is an unmistakable entity) is certainly mysterious. But its mystery does not invalidate its reality: quite the contrary, in fact. Thus, exclusive concentration upon the palpable facts of colour and form and spatial illusion does not oust, but actually introduces, the essential element of the mysterious.

The observations with which John Berger concluded his review of the 1956 Redfern exhibition could not have been wider of the mark: '... the trouble with these paintings, though it would shock Heron to know it, is that they are too literal ... They try to reproduce not the subject but the sensation of it too faithfully ... Heron should remember Monet's advice: 'No one is an artist unless he carries his picture in his head before painting it.' These have only been carried on the retina.' In fact, the last thing Heron wanted was to begin painting with an 'idea': his objection to the late Monet (against the fashion for seeing a proto-non-figuration in the *Water-Lilies*) was precisely that those paintings lack 'abstract *content*', that they 'really represent a distended representational idea'. ('In them Monet pointed to the future; but he did not enact it.') To render an idea of things perceived, an impression of sensations, was not what Heron was concerned to do. He was seeking, rather, to *create* sensations by manipulating 'the palpable facts' of the painting itself. In the very month in which he painted *Vertical: January 1956* he had written an essay on 'the seeing eye', which opened with the words: 'Seeing is not a passive but an active operation'; and ended: 'For the painter, *the vital transformation* of visual things occurs in his eye – not in his brain' [my italics]. Freed from responsibility to 'that troublesome entity, the subject' he could keep that eye on the painting itself, and *without premeditation* discover that abstract content, that 'unmistakable entity'.

With the exception of the handful of paintings already mentioned Heron made virtually no work in the latter half of 1956 or the first couple of months in 1957. There was much else to occupy him. This was the first summer and autumn of the garden at Eagles Nest. 'Delia was the expert who nursed and doctored and understood the hundreds of flowering shrubs and trees ... But it fell to me to cut the windbreaking hedges, as well as the lawns and paths ...' Here in what Will Arnold-Forster, its creator, had described as 'what must surely be the windiest garden in Britain' the Herons began the task of consolidating and extending the work of that remarkable man. As a gardener and plantsman Arnold-Forster was something of a genius; his knowledge was encyclopaedic, his mastery of detail astonishing. His energetic vision, exercised in collecting the shrubs, from Chile, Australia, New Zealand and South Africa, and in shaping the garden as a whole, did not preclude an aesthetic that could thrill to minute particularities of sight and smell, or a poetic descriptive gift. Working in the garden Heron would have recognized Arnold-Forster's *senecio rotundifolius*: 'Its large round leaves are tough as leather, polished green above and a pale gilt underneath when young. It has no beauty of flower; but the firmly drawn leaves are beautiful in pattern, and the golden shine of their undersides can make a sunlit sea look deeper blue by contrast.' The painter of *Garden Painting: August 1956* and *Summer Painting: 1956* knew by then 'the white flowers in August' of *eucryphia cordifolia*, 'like single white roses, with fluted petals and a ring of tawny anthers ... so freely borne when the tree is well established that the whole plant is whitened', the 'starry white flowers' of *hoheria populnea*, 'a lovely sight against the dark green [of their leaves]', and 'the *metrosideros lucida* in July, whose shoots that have not borne new leaves end in cymes of scarlet flowers – a scarlet with more crimson in it than that of *m. robusta* – each flower

→→ AUTUMN GARDEN: 1956
Oil on canvas 182.9 × 91.5 cm

↘ GARDEN PAINTING: AUGUST 1956
Oil on canvas 121.9 × 91.5 cm

↓ SUMMER PAINTING: 1956
Oil on canvas 182.9 × 91.5 cm

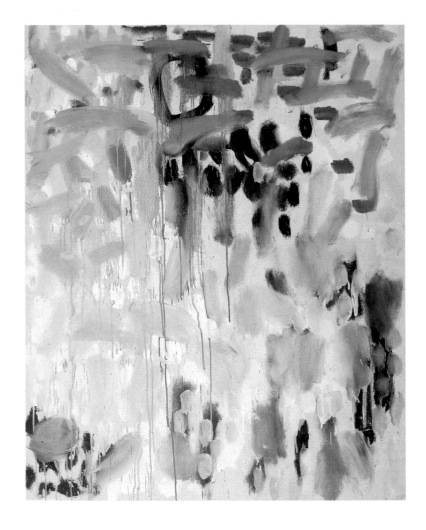

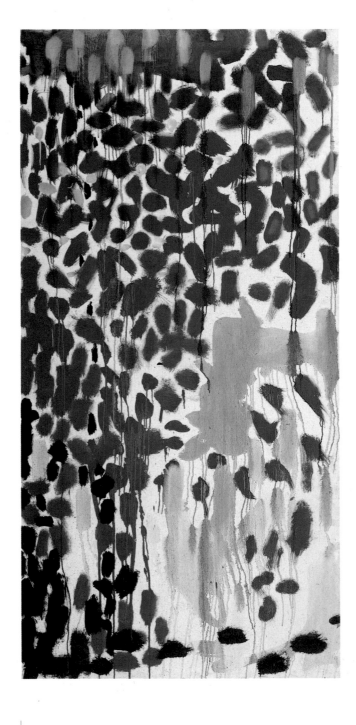

having a brush of long red stamens round a central saucer glittering with honey'. In Delia Heron the garden found another genius, her natural empathy here remembered many years later by her daughter Susanna: 'There was often evidence of the garden clinging to my mother, mimosa flowers, spiny leaves, falling sepals in her hair'.

Living at Eagles Nest has profoundly influenced Heron's art. 'This is a landscape which has altered my life' he has written; 'the house in its setting is the source of all my painting'. As we have seen, the change from London to Zennor was registered immediately in the bright colour, loose structures and atmospheric translucencies of the 'garden' paintings, in contrast to the last London paintings with their wintry blacks and greys. Heron more than once remarked of Braque that he was a 'metropolitan painter', and that Cubism was a metropolitan idiom: its characteristic planes, 'parallel to the picture frame', reflected the visual realities of urban confinement, imitating the limited visual field of the city, composed of just such planes. In terms that might describe *Vertical: January 1956* he wrote (in his 1958 essay on Braque) of the 'geometry of vertical screens [that block] the horizon-seeking eye: in every direction that eye encounters vertical screens, geometric planes, of varying opacity or transparency'. Now Heron was himself one of those painters who, living by the sea 'take the same sort of obsessive interest in the texture of a horizon or a layer of sky that the metropolitan painter takes in the combination of colours he suddenly notices in a façade … For me, a cobalt or indigo horizon now replaces the horizontal moulding in the stucco wall across the street'.

Heron had long loved Cornwall, but his paintings of the room and window at St Ives had been done from the experience of a sea-level interior in a town; his habitual view, and his memory of it in his London studio, where many of those paintings had been made or completed, was from inside out on to a harbour itself enclosed by quay and jetty. That interior/exterior, near/far spatial interplay had been, moreover, his principal *subject*, with objects and figures to catch in its compositional net. But now he had experienced the turning seasons of a year's intense activity in the garden at Eagles Nest, high above Lawrence's 'great peacock-iridescent sea', looking westward to a stupendous horizon, into skies of perpetually changing light and colour, from mother-of-pearl gleam at dawn, through the daylight intensities of blue, grey and gold, to sunset incandescences. This had been an experience of the *all-roundness* of elemental nature. In the garden all is air, light and shadow, circumambient: 'All day there is the sound of the wind in the trees that is so like the sound of the waves of the sea … Wind that blows away the light of day and reason with it'. Inside the house it is no less possible to be unaware of its site on the high promontory; of the moor rising behind to a strangely configured skyline of granite outcrops and boulders which sweeps round and down towards Zennor Head; of the hill falling away below to the farmland shelf, with the sea beyond, its reflected light shimmering on the ceilings of the house in the evening.

After the break in output in the autumn and winter of 1956/1957, Heron returned to painting in March 1957 with an astonishing burst of creative activity. He had been deeply pondering his direction as an artist, thinking about non-figuration and its implications for his painting. This we know from his ICA 'statement', written at the turn of the year. What was remarkable about the paintings he produced in early 1957 was the coherence of their continuity with the abstract work of the year before, and the decisiveness of their break with its surface features, and the manner of their disposition across the canvas. What was effected

in March 1957 was a simultaneous clarification of the role of colour in his painting, and of the image it carried: for colour in these pictures is indeed the prime mover, the 'indispensible means for realizing the various species of pictorial space'. This was achieved, it might be said, at a stroke, in the 'stripe' and 'horizon' paintings of that spring of 1957, in a period of intensive productivity even more remarkable than that of exactly one year before.

Heron had waited for the moment; which is not to suggest that he had been thinking about his next move in a schematic way. He has never anticipated his own work programmatically; he has no theory before the event of painting (or, indeed, after). His approach to the making of painting is intuitive and its outcomes unpremeditated, discovered in the physical action: in the line left by the unpredictable twists and turns of the wrist, in the unforeseen effects of placing one colour next to another, or enclosing one in another, in the light that reflects off or sinks into an area of colour, whether heavily brushed or lightly scribbled, and so on. For all the intelligence and generalizing *bravura* of his critical writing, Heron is not an aesthetician so much as an empiricist of the eye: what he looks at demands visual analysis, provokes thought, association and comparison. This is true of his writings about his own paintings. Since he never knows what he is going to paint next, how could it be otherwise? When he describes his own paintings, it is because they exist in the world, as objects for his contemplation and analysis. (He can speak also, albeit subjectively, of the circumstances and history of their execution.)

The larger *Tachiste* works of 1956, including the 'Garden' paintings, had been composed principally of short downward strokes and patches of colour, flat blobs and lozenge shapes, and occasional lateral bars and touches, disposed as a kind of screen across the surface of the canvas, these component strokes being unmodelled and parallel to the plane, but recessing variously into space behind that surface. It was as if the Braquean structural discipline that had informed so much of the figurative work had been relaxed to allow an all-over distribution of colour shapes not unlike that which Heron had perceived to underpin Bonnard's compromise with appearances. But now it was as if Heron wished to escape altogether from such links, however tenuous they may be, with the spatial actualities of the perceived world. In the new paintings Heron set off on what Matisse had called 'the path of colour'.

In Matisse's brief autobiographical essay of that title, written in 1947, he remembers the revelation, in his discovery of Japanese *crêpons* (brightly coloured reproduction prints on crêpe paper), of the expressive power of colour freed of descriptive function: 'Colour exists in itself, has its own beauty'. To follow this path, according to Matisse, was not a matter of choice but of necessity, part of the 'inescapable fate' of modernity. 'I had to get away from imitation, even of light. One can provoke light by the invention of flats, as with the harmonies of music. I used colour as a means of expressing my emotion and not as a transcription of nature. I use the simplest colours … nothing prevents composition with a few colours, like music which is built on only seven notes …' This 'expression of emotion' is for Matisse a function of *art*, a matter of *objectifying* feeling in the painting, which becomes a correlative for it: an image in the world, independent of the artist. As his account makes clear, it is a quality he found most purely realized in those traditions of art in which a formularized imagery allowed colour to work expressively: the painting of the Italian Primitives, Oriental, Persian and Byzantine art. It is in this essay that he writes: 'It is enough to invent signs. When you have real feeling for nature, you can create signs which are equivalents to both the artist and the spectator.'

PH and Ben Nicholson on the moor
above Eagles Nest (BN wearing sweater
borrowed from PH), c.1957

The absolute directness of Heron's paintings of 1957, and their use of a strictly limited repertoire of forms, arbitrarily arrived at, constitute just such an invention of expressive signs. The simple radical gesture that Heron employed to create these images was the single stroke, vertical or horizontal, of vibrant oil colour, usually unmixed and direct from the tube, greatly thinned with turps. This ensured a double effect: the colour is at full chromatic brilliance at the same time as the turpentine thinning creates a translucent luminosity. They have no subject but light, and this is mediated through shape and colour. The impact of this radiant light upon the spectator – and these are among the most spectacularly beautiful paintings made anywhere since the war – is a phenomenon of art, by means of which nature finds an equivalence in the created object, and becomes its mysterious content. It is the very phenomenon of which Matisse spoke (the country is Provence; it might be West Penwith): 'Here is a country where light plays the leading role, colour comes second; it is with colour that you put down this light of course, but above all you must feel this light, have it within yourself; you can get there by means which seem completely paradoxical, but who cares? It's the result alone that counts'.

The strokes of colour in these paintings were quickly laid in parallel bands of different width, sometimes overlapping; mostly they are horizontal, in which cases thin downward runs of colour complicate slightly the lateral dynamics of the colour bands. The images created by this procedure are both strikingly simple in the means of their realization, and complex in their effects. In almost every case the format is that of a dramatically extended rectangle: *Scarlet, Lemon and Ultramarine: March 1957* is a landscape format triple square; the width of *Vertical Light: March 1957* is over twice its height; *Horizontals: March 1957* is over twice as high as it is wide. The elongated landscape-format paintings confound expectations by presenting the spectator with a procession of verticals; the eye travels from left to right and back again seeking the space through which it may penetrate to the non-existent horizon. The extended vertical-format paintings at first seem to demand a lateral scanning; the eye moves across and back as if reading a page of print or music, and then begins to run up and down the steps of colour, its rhythm and speed complicated by their irregular height. The decisive handling, that quick gestural repetition and directness of touch that characterizes all of these paintings creates an image that is vitally kinetic, the *equivalent* of that presented by the ceaseless change and indeterminancy of elemental light, the dramatically variegating and attenuating layerings of sunset and dawn light.

Beyond these generalizations there is little else that is true of all the 'stripe' paintings. They are different, one from another in numerous ways: in scale, from the small *Atmospheric Paintings* of early 1958 to the grand *Horizontal Stripe Painting: November 1957 – January 1958* which was painted to an architectural commission, and is nine feet tall; in the extent to which strokes are over-painted or overlap; in their colours' range and registers; in the degree to which they leave the primed canvas to act as a backlight. In some the stripes extend to the edge of the support, becoming a total, or near total, ground of colour bands; in others they remain a series of deliberate brushed *strokes*, the self-declarative evidences of gesture. Because each of these paintings was begun without preconception as to what its effects would be, together they constitute *a series without a programme*, beyond that of making an impulsive choice of a sequence and prevailing register of colour, and the adoption of a specific compositional structure and manner of application.

'I thought I was making the most extreme paintings in the world', Heron has said; and the stripe paintings did seem to reduce to the bare minimum the formula

for the making of pictures. The expressionist gesture, the existential spontaneity of touch so beloved of *Tachisme* and action painting, seemed neutralized by the deliberate stretching and repetition of such strokes according to a *formula* of vertical or horizontal parallels; and yet their intuitive structuring, vigorously unpredictable handling and the potent colour placed them completely outside any strictly formalistic or constructivist aesthetic. Their reductive compositional dynamic has reminded some critics of Rothko, though there is no more visual evidence of any such influence upon the compositional structure, the handling or the imagery of these paintings of 1957, than there was of Pollock in the *tachiste* paintings of the previous year. The principal determinant of their form is clearly found in the inner logic of Heron's own stylistic development: they are precipitates of temperament.

Writing of Rothko's *Number 10 1950* in early 1956, Heron had been critical of its colour, which for all its 'misty beauty and subtlety' lacked the 'positively scientific awareness of tone-colour' that distinguished Motherwell's painting; '… his exquisitely powdery horizontal bands of colour … bulge forwards from the canvas into one's eyes like colored air in strata-form. He evokes the layers of the atmosphere itself … Yet the emulation of nature's own forms and forces is not quite enough.' This characterization of Rothko's work, and its description of his colour, indicate clearly that Heron was not looking to learn from Rothko in his own painting at this time. Two years later he was to return to the theme: 'Although I think Rothko a very fine colorist indeed, it still strikes me that his color is *too* muted; I long for stronger contrasts and a sharper vibration'. These responses are separated by the two hectic phases of non-figurative work at Eagles Nest in early 1956 and early 1957, and by a further development in Heron's work through 1957 and early 1958.

The 'stripe' paintings, with their vibrantly chromatic colours, un-mixed and declarative, and their spontaneously kinetic handling, bear so little resemblance to Rothko's mature work, with its symbolic soft-edged, cloud-like forms, and its rarified colours, (as represented by *Number 10, 1950*, which was until early 1958 the only painting of Rothko's that Heron had actually seen), that it is difficult at this distance to see what prompted the comparison. This was before the rhetorical orthodoxy of the later criticism of Rothko, encouraged by the quasi-visionary utterance of the artist himself, had begun to gather apace, and rather than attend to its spiritual and tragic implications, the critical response to his work here still tended to emphasise those formal aspects, especially colour and composition, which, in referring to the *reception* of his pictures, Rothko was at pains to discount: 'My new areas of color are things,' he told an interviewer in 1952, 'I put them on the surface. They do not run to the edge, they stop before the edge … These new shapes say … what the symbols said … Abstract art never interested me. I have always painted realistically. My present paintings are realistic.' In 1957, in conversation with Selden Rodman, he was emphatic on this issue: 'I'm interested only in expressing basic human emotions – tragedy, ecstacy, doom … and if you, as you say, are moved only by their color relationships, then you miss the point!' The radical *formal* reduction of painting to a succession of parallel strokes, parallel to the plane, in which the facts of paint-colour create what he has called a 'purely visual experience', a complex harmonic visual sensation, was *precisely* what Heron was seeking: image, *not* symbol; 'sensation, revelation', *not* evocation; expression, *not* communication.

The 'stripe' paintings at the time were in fact *sui generis*, though the line of development from Heron's painting of a year before (especially from *Black and White Vertical I*) is clear, and can be seen even more obviously in a picture like *Scarlet Verticals: March 1957* painted in the same month as *Vertical Light*, but in which the weight *and* length of the vertical bars varies, and several of them are fused laterally to form solid blocks,

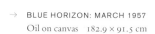

→ BLUE HORIZON: MARCH 1957
 Oil on canvas 182.9 × 91.5 cm

↠ RED HORIZON: MARCH 1957
 Oil on canvas 182.9 × 91.5 cm

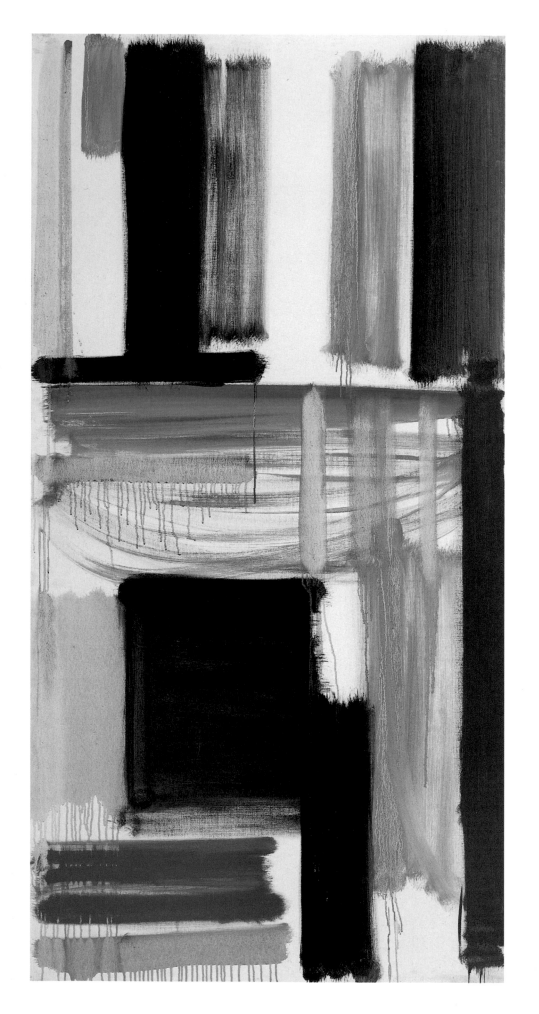

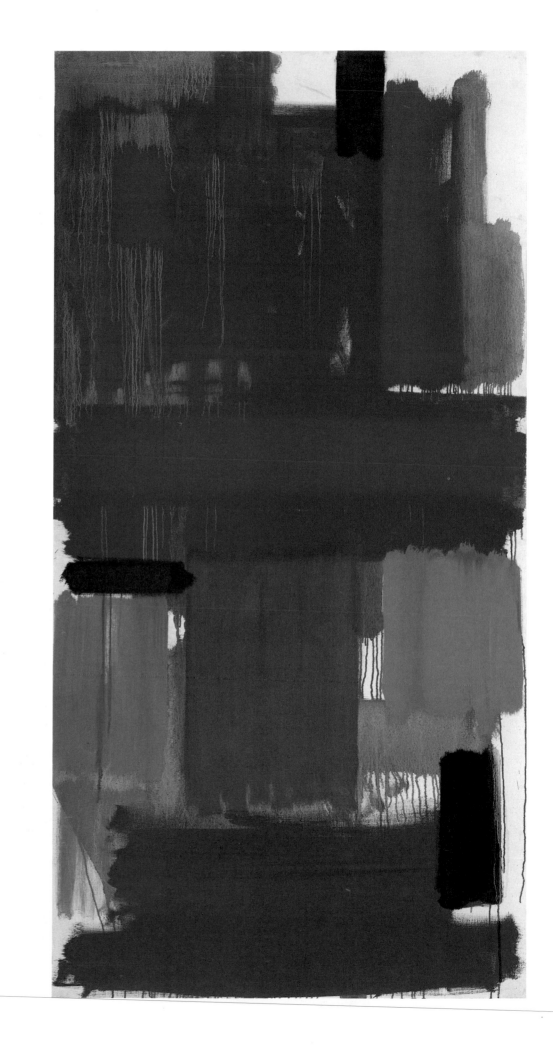

and others stretched from top to bottom of the canvas to create a continuous stripe. *Vertical Light* was the first achieved painting in the new manner. Its 'extreme' clarity (the term is especially appropriate) can be defined in terms of its absolute simplicity of image, its emphatic directness of utterance, its 'creative emptiness' of any content that is not intrinsic to its medium: its space is an aspect of 'light'; light is a function of colour, and colour of paint. For Heron in 1957 its radical credentials were to be found in this irreducible selfhood of the painting as painting.

Vertical Light, and the other paintings in the series, without symbolism and offering no compromise to the conceptual, enter directly what Heron, in his 1973 Power Lecture, called 'the world of the eye' – 'the realm of pure visual sensation' that is painting's 'unique domain.' The very simplicity of their forms was a means to purity of expression, a step towards 'the rehabilitation of the role of colour, the restitution of its emotive power' that Matisse had called for. 'Painting,' Heron had continued, 'should start in that multi-coloured, and at first amorphous, texture of coloured light which is what fills your vision, from eyelid to eyelid, when you open your eyes. The finished painting should also end in pure sensation of colour – having passed into the realm of the conceptual in the process, and come out again at the other side.'

There is no sure way of knowing which of the paintings of March 1957 came first, or in which order they were painted. All we can know is that at the moment of discovery, so to speak, of the 'stripe', Heron also painted both *Red Horizon: March 1957* and *Blue Horizon: March 1957*. These are more complicated, both being large double-squares across which are distributed, in asymmetrical configurations, different-sized roughly rectangular blocks of pure colour, and expanses of thinly-painted wash. These elements are laid down directly on to the primed canvas in broad turps-laden strokes, with an expansive gestural freedom. The washes create translucent veils of colour against which the more opaque darker blocks appear to float. Speed of execution and immediacy of attack are evidenced by the vertically trailing runs of turps, both within colour areas, as at the top left of *Red Horizon*, and across areas of primed canvas, where they trail a diminished colour, as at lower right of the same painting, or centre left of *Blue Horizon*. In their clarity and open-ness, and their high-key lucidities of pure colour, these paintings, and others, such as *Yellow and Black: May 1957*, are, like the 'stripe' paintings, wonderfully atmos-pheric and fresh in feeling. They are unlike anything else being painted in England at that time.

'Clarity and openness', 'freshness' and high key and lucid colour are the terms, of course, in which Clement Greenberg famously characterized those works he selected for his Post Painterly Abstraction exhibition at the Los Angeles County Museum of Art in the spring of 1964. The earliest paintings in that show were made in 1960, with the significant exception of two by Sam Francis dating from the early 1950s, whose 'liquefying touch' in the paintings of that period Greenberg remarked, 'somehow conveys light and air.' So far from emulating American painting in the late 1950s Heron's 1957 paintings can be seen, rather, to have anti-cipated in certain respects the American reaction to the heavily-accented gestur-ality, the painterly mannerism into which abstract expressionism had degenerated, and that Greenberg's show set out to document seven years later. In acknow-ledging that the 'tendency' towards 'physical openness of design or towards linear clarity … began well inside Painterly Abstraction itself', in the work of virtually all the major New York abstract expressionists (somewhat perversely he included Mathieu as the only European artist in his list), Greenberg adumbrated the oper-ation of a complex stylistic dialectic. Heron himself had never developed the

mannerism that Greenberg in his introduction to the exhibition calls the 'Tenth Street touch', and had moved quickly beyond the 'density and compactness' of his earliest *tachiste* pictures. No fewer than three of Greenberg's post-painterly abstractionists asserted their freedom from the gestural stroke by making large parallel-stripe paintings; two of them, Gene Davis and David Simpson, adopted a ruled (or taped) hard-edge; the third, Morris Louis, used the pour-and-stain technique which was to be so influential in American painting in the 1960s. None of them exhibited stripe paintings before 1960.

Heron's decisively brushed 'stripe' paintings, however clear and open in their manner, were actually quite different in feeling to those later works, and as we have seen they were arrived at spontaneously and without programme. He continued, sporadically, to make spectacularly beautiful paintings within that description until mid-1958, when with *Lux Eterna: May – June 1958* the series came to an end. This was the only 'stripe' painting in which the bars of colour are laid consistently on to a painted ground, and in which passages were scraped down and over-painted: and its richness of texture and sonorously beautiful deep tonalities mark it off from the rest. By this time Heron was already making paintings that were significantly different in mode and manner from the 'stripe' and 'horizon' pictures of 1957. *Cadmium Scarlet: January 1958* and *Squares in Deep Cadmium: January 1958* were both painted just after the glorious *Incandescent Skies: December 1957* and *Red Layers with Blue and Yellow: 14 December 1957*, and within weeks – possibly days – of the small format 'stripe' *Atmospheric Paintings* of February, the month in which he also painted *Yellow and Violet Squares in Red: February 1958*. These paintings, in which soft-edged squares of a colour are enclosed within larger areas of another colour, are the beginnings of an exploration of new possibilities of expression in composition, colour and colour-shape. They were anticipated, even so, as early as May 1957, by the seminal *Red Ground: May 1957*, the most complex painting of this entire period, in which are incipient almost all the formal elements of Heron's style over the next five years.

Heron has said that he stopped making the 'stripe' paintings when he realized that they resembled the sunset skies over the sea at Zennor. The impulse behind these paintings had been towards the most extreme non-figurative *formality* of utterance: '… the reason why the stripes sufficed, as the formal vehicle of the colour, was precisely that they were so very uncomplicated as *shapes* … the emptier the general format was, the more exclusive the concentration upon the experience of colour itself. With stripes one was free to deal *only* with the interaction between varying *quantities* of varied colours, measured as expanses or areas'. The congruence between the 'formal vehicle', the *sign*, and what is overwhelmingly present in the natural environment, is inescapable: the horizontal is an abstraction, the horizon is a fact; our eyes are flooded with the colour *of things*, of leaves and flowers, seas and skies, and colour is a function of light on and within those things. Every abstraction, in every kind of language, verbal, gestural, visual, musical, is an abstraction from nature. Heron's radical pictorial simplifications, vertical and horizontal parallel strokes, brilliant fields of translucent colour-light, were those very 'forms [that] crystallize in the consciousness only after a prolonged agitation at what we might call the level of life itself … the forms which life alone conceals.' Heron had entered painting's 'unique domain, the realm of pure visual sensation', and 'come out again at the other side': in arriving at these abstractions, 'by means that seem completely paradoxical', he had arrived home – 'here at last!' – in the sensational world.

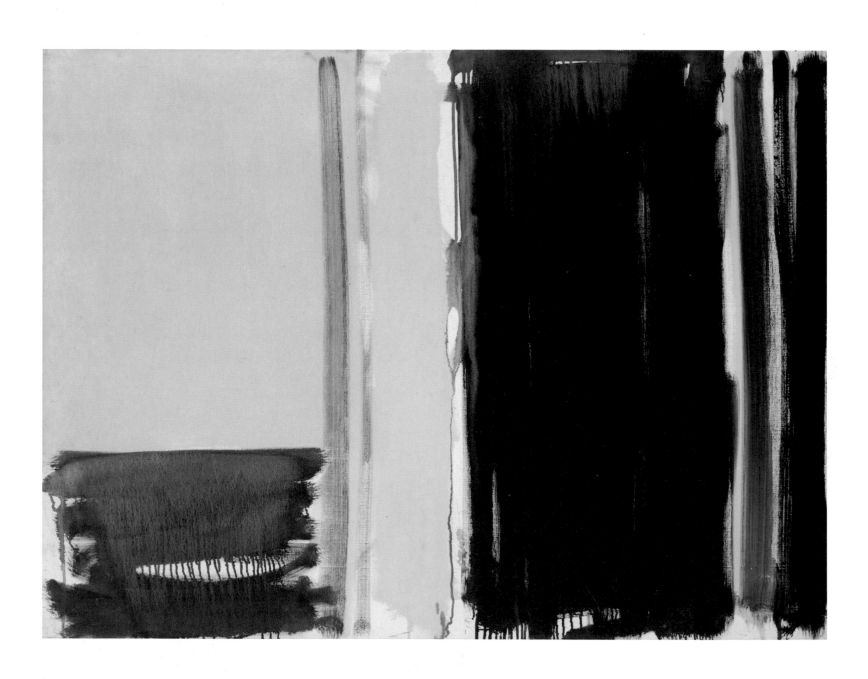

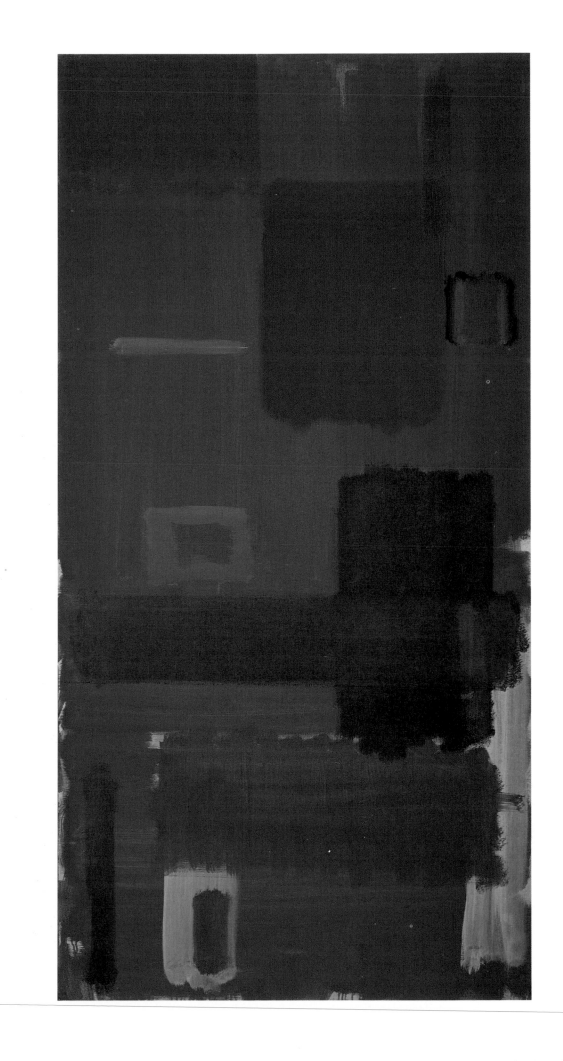

→ HORIZONTAL STRIPE PAINTING:
NOVEMBER 1957 – JANUARY 1958
Oil on canvas 274.3 × 152.4 cm

↘ INCANDESCENT SKIES:
DECEMBER 1957
Oil on canvas 182.9 × 91.5 cm

↓ RED LAYERS WITH BLUE AND
YELLOW: 14 DECEMBER 1957
Oil on canvas 182.9 × 91.5 cm

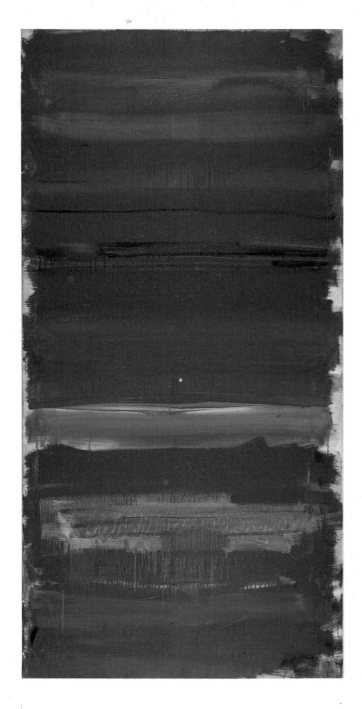

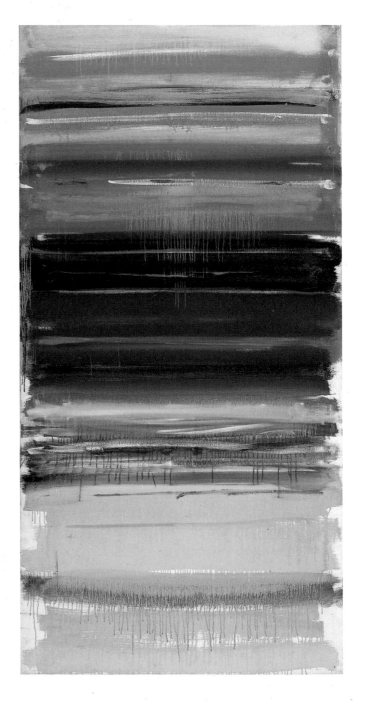

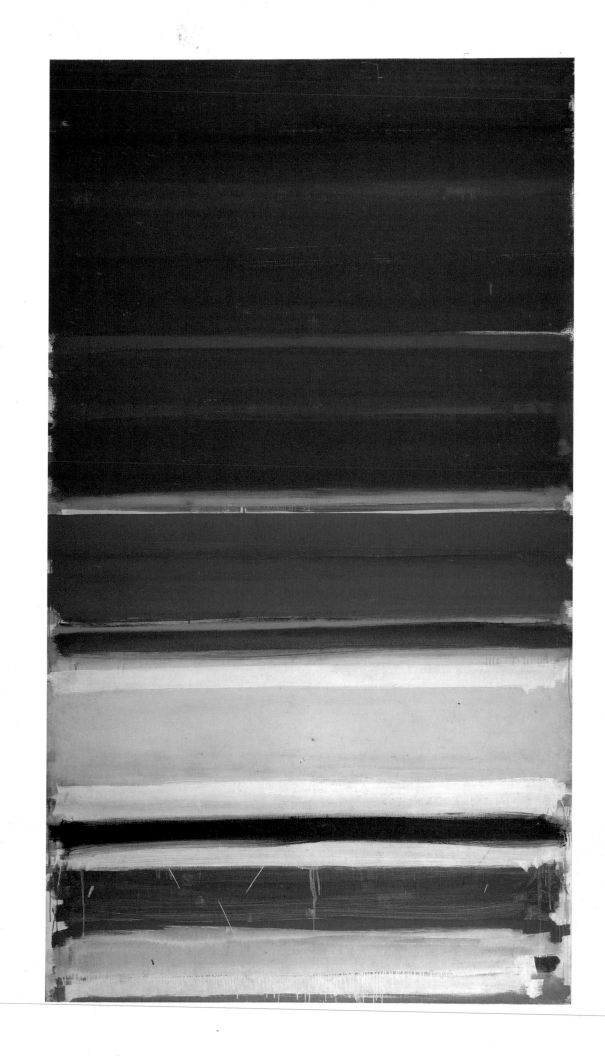

→ SCARLET VERTICALS: MARCH 1957
Oil on canvas 102 × 127 cm

↓ RED PAINTING: JUNE 1957
Oil on canvas 127 × 102 cm

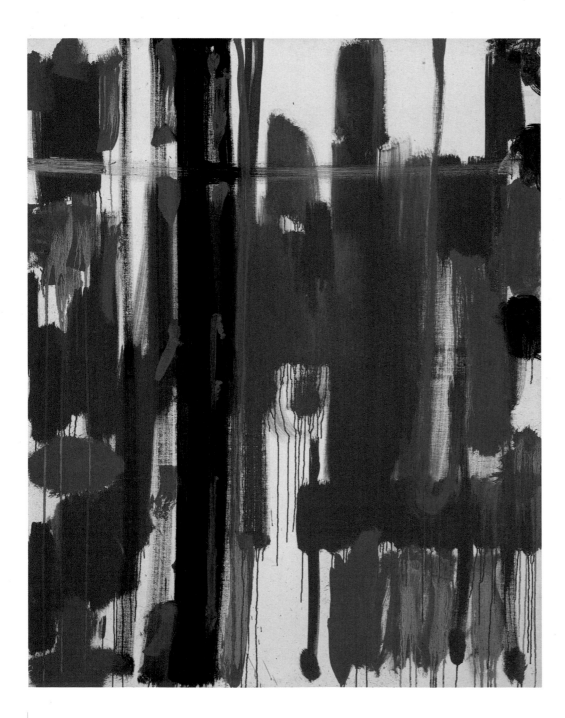

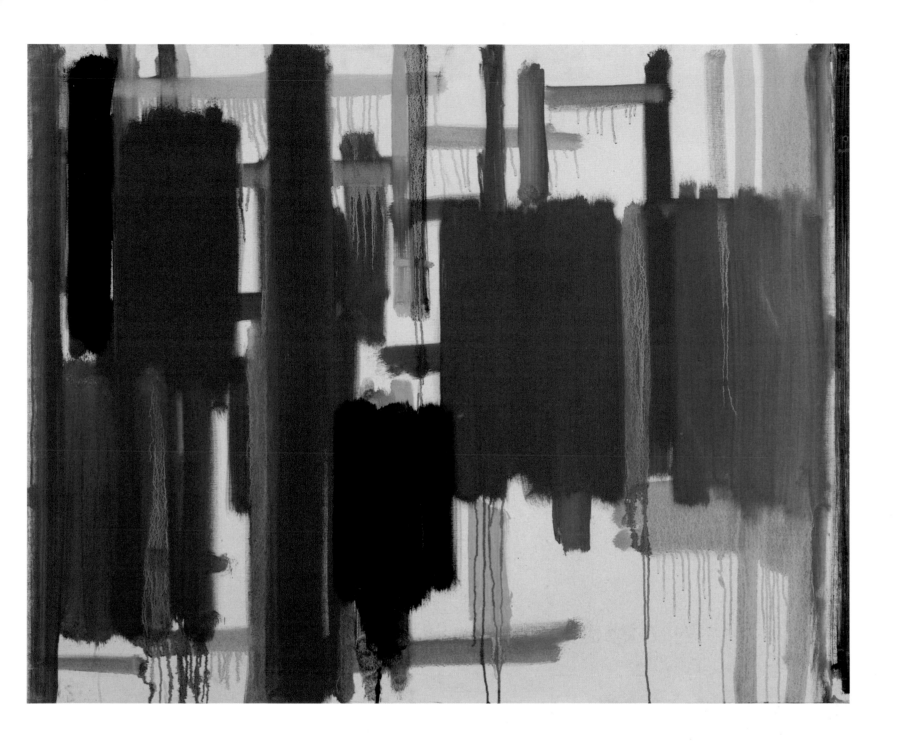

6 FROM ABSTRACT TO NON-FIGURATION

1958–62 The deliberateness of a dance

→ BLUE PAINTING WITH DISCS:
SEPTEMBER 1962
Detail

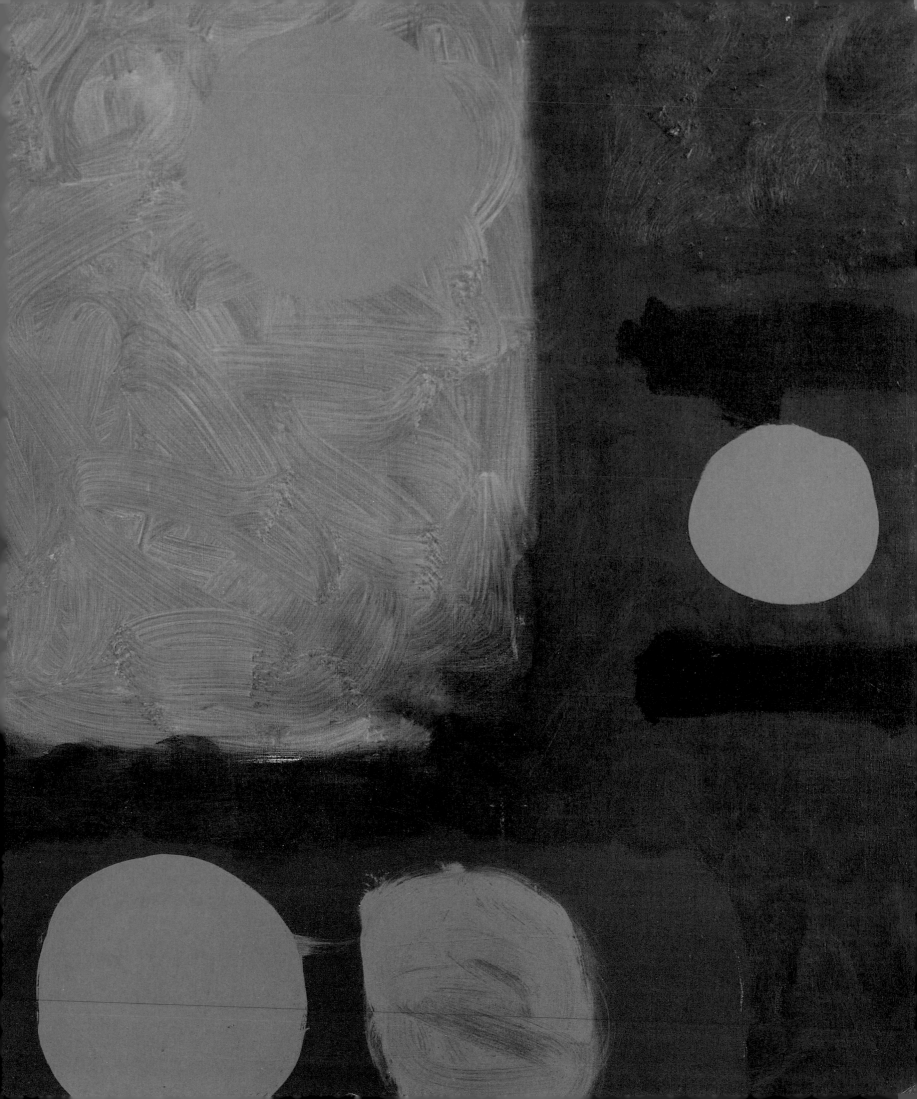

The first of Heron's 'stripe' paintings to be seen in public was *Horizontals*, one of those made in the extraordinary burst of March, 1957, which was shown at *Metavisual Tachiste Abstract: Painting in England Today*, an exhibition of non-figurative painting put on at the Redfern in April of that year. The progress of modern art is punctuated by exhibitions notable for having brought about some kind of critical clarification, whether by defining a new style, identifying a group of artists with a common programme, or proclaiming a new movement or philosophy. *Metavisual Tachiste Abstract* was not one of them. It contained works by no fewer than twenty-nine artists and appeared to have no coherent rationale beyond bringing together as many non-figurative artists as the gallery director, Rex Nan Kivell, could muster. Delia Heron had proposed 'metavisual' as a catch-all adjective that might cover all non-figurative tendencies, and replace the confusing diversity of current terms. By retaining 'Tachiste' and 'Abstract' in the title, Nan Kivell succeeded in merely perpetuating the confusion.

Heron himself pointed out in an essay for *Arts* (June 1957) which referred to the show, that the 'international Tachist movement … is so widespread and possesses so many adherents that it already presents us with a vast new academicism'. The task of criticism was now to sort out the good from the bad, and to recognize and define the distinctions between the different species of non-figuration and the proliferating names attached to them. Terminological exactitude was called for. Tachism, as Heron defined it, extended the possibilities of image-making by its specific emphasis upon the fluidity of organic *matter*, 'the dripping, sliding interpenetration of different pigments weaves webs of design which end as a sort of revelation of the natural laws involved in the movement of matter.' This was to be distinguished from the expressive inflections of a descriptive imagery, even where these are the outcome of natural dynamics. Heron's example of the latter was the accidental drips and marks left by the spontaneous rapidity and certainty of Picasso's vigorous brushwork.

The tendentious exclusiveness of this definition is typically exact, and the exemplary distinction sharply observed and personal, and his definition, though incomplete, is emphatically consistent with Heron's use of the term 'Tachism' in relation to his own work. If the term 'metavisual' did not successfully enter critical discourse it was because it was vague and comprehensive, when what was needed were just such precisions of definition and differentiation. By mid-1957, Heron's own practice had gone beyond the 'touch' or fluidity of Tachism so defined, and he was embarked upon an exploration of atmospheric colour and light using the minimal means of the pure colour 'stripe', or of juxtapositions of horizontal and vertical blocks of colour and clear thin-washed areas of translucence. In the pictures of this period, as with the properly-termed tachist paintings of the year before, image and painting are one, and the natural properties of the medium and of the pigments it conveys on to the canvas – drips and runs of colour, opacity and transparency – are visibly evident, and integral to the image. In these most recent paintings of Heron, the image is revelatory not only of the mobility of *matter*, but of the dynamics of *light*.

The stripe, horizon and squares-in-colour paintings of 1957 and early 1958 are remarkably cool and unemotive: they have no determining intent upon the viewer. Like the natural phenomena to which their dispositions of matter and colour may be seen as analogous, or the natural dynamics that they exemplify or demonstrate, they move us with the force of the revelation that springs from sensational apprehension. The artist is no longer present: the runs and drips are not those of an expressive Picassian vigour of execution which have a communicative power of personal utterance; the colours have no symbolic or evocative import.

They are the visible traces of actions that are spontaneous and unpremeditated, but structured deliberately to facilitate the visibility of natural process as such. Heron's definition of Tachism was, then, entirely characteristic of his own concentration upon the physical and phenomenal, and its emphasis coherent with his preoccupations as a painter, even as he moved beyond the specific aspects of Tachism he had identified as definitive, towards a new style of his own in which colour shapes and their relations were a central concern.

As might have been predicted, the general critical response to Heron's 1958 exhibition at the Redfern, his seventh and final one-man show with the gallery, at which he showed the 'stripe' paintings together with a number of more recent works, such as *Squares in Deep Cadmium: January 1958; Black, Green and Red: February 1958* and *Cadmium Scarlet: January 1958*, was at once uncomprehending and condescending. It served no doubt to confirm Rex Nan Kivell's worst misgivings about the direction of Heron's work. (On taking delivery of the 'Garden' and 'Vertical' paintings in 1956, he had remarked that he was 'just beginning to find a market for the still lifes'.) His confidence in this new batch was demonstrated by his decision to take the entire show off the walls for a week whilst the gallery was repainted, an action which had prompted Bryan Wynter, with a typical quickness of integrity, to cancel his own forthcoming exhibition at the gallery and to introduce himself to Victor Waddington, who had just opened his first gallery across the street.

It was precisely the self-declarative simplicity of the paintings, their avoidance of the deliberately emotive expressionist gesture, that troubled the reviewers. The problematic relation of the random painterly stroke, or of a configuration of such strokes, marks or dribbles, to a specific expression of feeling or thought (that is to say, *the problem of meaning* in gestural abstraction or Tachism) was something generally obscured by a vaguely rhetorical phrase-making which took the relation for granted, as a critical given: vigorous mark-making was revelatory of personality, 'expressionistic', urgently subjective. The abstract clarity of Heron's new paintings, the apparently formulaic ordering of what John Russell called 'the isolated chords of colour which he has struck in his new canvases', seemed merely demonstrative of some idea or principle, perhaps 'scientific', lacking the power or interest of personal expression.

Denys Sutton, bewildered some months before by the diversity of expressive modes he was required to introduce in his preface to the *Metavisual Tachiste Abstract* exhibition catalogue, had written there of the 'the lyrical emotionalism of *Tachisme*', contrasting it to 'the mathematically precise "architecture" of Constructivism', as if those terms were part of an agreed currency (indicated by the knowing quotation marks). In his review of the 1958 show he complained that Heron's paintings possessed 'his customary subtlety, yet they [lacked], all the same, that larger more allusive suggestiveness of his mentor, Mr Rothko, the American painter', and lacked, moreover, 'an individual tang.' Russell teetered on the edge of insult: that the 'tyranny of illusionism' no longer existed was something to be celebrated, but 'it is undesirable, all the same, that a tyranny of fatuity should take its place. We know from his writings that there is nothing fatuous about Mr Patrick Heron.' That his new canvases 'contain nothing but these bands of colour,' he continued, 'seems to me to poise them on the very edge of the absurd: or is it that they should be seen as illustrations of an unwritten article … ?' Nevile Wallis considered that they 'made no noticeable advance on this science [of colour relations], but have rather the air of deft exercises designed to demonstrate some points of colour vision.' The critic of *The Times* was sympathetic but unmoved, remarking that the

paintings were 'organized like diagrams of the spectrum: colours progress in ordered sequences of vertical or horizontal stripes from one side of the canvas to the other. Luckily the progressions are enchanting, or their diagrammatic quality would be even more pronounced than it is … [their] artful proportions and sequences sing round the gallery, but they remain demonstrations of colour harmony and colour opposition waiting to be put to a purpose – objects, in fact, of some beauty but of mainly scientific interest.'

In an article for *The Listener* Andrew Forge praised Kline and Rothko, on the basis of pictures then on show at the ICA (in Rothko's case two paintings separated by seven years of work and stylistically quite distinct), as painters 'able to make highly particular statements within a limited repertoire', contrasting them with Soulages and Heron as painters who '[seem] to be making the same generalized statement of mood with each picture'. In a paragraph whose emphasis on the lack of personal expressiveness was typical of the general response, Forge remarked that Heron's recent pictures ('in a style which owes a certain amount to Rothko, painting simple bands and rectangles of colour side by side') failed to detach themselves one from another and 'come at you': '… one is aware of a sensitive eye, of original colour juxtapositions, of an outstanding decorative unity, yet one misses the sense of a particular statement, an unhesitating will to make the particular picture expressive in a certain way.'

The diversity, in scale, manner, colour and device, of the 1957–8 paintings, to say nothing of the radical departures that they make from the equally diverse but very different paintings of 1956, make this assessment of them as lacking particularity and difference incomprehensible. It is perennially true that the new is difficult to see, and that neologisms and namings intended to help the eye to focus upon the unfamiliar may actually hinder that process. It is perhaps not surprising, then, that the cool rigour and impersonal beauty of Heron's new paintings were difficult to appreciate for those whose eyes were as yet barely accustomed to the various new painterly abstractions, and for whom a plethora of terms – 'abstract expressionism' (applied to paintings absolutely different in mode and manner), 'action painting', 'Tachism', etc. – had served to obscure distinctions and muddle definitions. What these paintings lacked was inchoate 'expressiveness', or the suggestions of an existential angst; their spontaneity of execution was compromised by an implicit programme: their very strengths as paintings, the demonstrative architectonics of colour and light that brought nature directly into the ambit of art, were seen as weaknesses of artistic conception.

Not surprisingly, in spite of television coverage in which the work was defended by William Scott and praised by Winifred Nicholson, the exhibition lived down to Nan Kivell's expectations and hardly a painting was sold. In his introduction to a retrospective exhibition of Heron's paintings held at the Oxford Museum of Modern Art in 1968 Alan Bowness recalled the nature of the challenge presented by these paintings:

Looking at them again ten years later one can understand why they were so upsetting. At that time qualities of paint texture and touch and expressive brushwork seemed to matter very much – indeed they were the things one looked for first in abstract painting. What was one to make of these parallel stripes of colour? Admittedly the structure reflects the movement of the painter's hand, and one could relate the brushstrokes to other pictures (including Heron's own garden paintings of 1956) which have a certain calligraphic quality. Yet this was all done with such lack of deliberate concern for texture and matière: the paint was so thin, and applied immediately to the canvas in a single stroke. All the artist seemed to be interested in was the relationship of these bands of colour, echoing chords across or up and down the picture plane.

In 1972, introducing Heron's Whitechapel retrospective, Bowness referred again to the critical reception of the 1957–8 paintings (which had been 'about as derisory ... as any twentieth century artist has had to face'):

At the time one was told that Heron was simply following Rothko. Now if this means that he was exceptionally quick to appreciate Rothko's quality and his importance, it is true, and there are indeed a few pictures which show the absorption of this influence. But the striped paintings of 1957 and the open paintings that immediately succeeded them are not really like Rothko at all, and the American paintings they do now recall are later in date.

What Heron was actually thinking about Rothko and contemporary American painting in early 1958 was revealed in the review he wrote for *Arts* of an exhibition in March at the ICA of works from the collection of E. J. Power, the most distinguished collector in this country of American and European abstract painting. Heron's exhibition at the Redfern had opened a week earlier, and it is evident from the *Arts* piece that his own situation as a painter was at the front of his mind. Recalling his 'exhilarating' encounter with the Americans at the Tate two years previously, Heron reflects that their greatest innovative achievement had been the abolition of the image as a 'single complex of forms, that exists on two levels simultaneously: i.e., as a purely formal fact, there on the surface of the canvas; and, secondly, as the visual *evocation* of a fact (or facts) that is *extrinsic* to that canvas.' European non-figurative painters in the early 1950s had still placed forms inside a recessive pictorial space. 'Inside the pictorial architecture of a Manessier, a Soulages or even a de Staël of 1950 ... there are, so to speak, *nests* of more complicated form which are lodged *within* the all-over nonfigurative structure of the composition. In this sense most European nonfigurative painting of the period 1945-50 was still figurative.' It was the Americans who had 'finally insisted, with a vehemence that has since converted almost everyone everywhere, that the total painting itself is the only image involved in a painting. Today, a painting is not the vehicle of an image (still less, of a symbol). Today, the painting itself *is* the image. Anyone who cannot accept that has not begun to understand the art of the present moment.'

The implications of his own vehemence here are unequivocal: Heron was of the converted. In the clearest terms possible this is a critical acknowledgement of the significance at that moment in history of New York painting. But they are terms whose emphatic focus upon a formal fact might have surprised several of the Americans to whose work they refer (notably Rothko and Newman, although it is true that at that point in time Heron had never seen a painting by Newman), and who would have found what followed impossible to accept, if not incomprehensible: 'Again, a painting is not something which exists in order to convey meaning; on the contrary, 'meaning' is something which attaches itself to that independent, autonomous object which is a picture.' Heron is, in fact, writing out of his own experience as an artist whose most powerful creative impulses were towards a painting free of communicative clutter and personal expression, of extraneous subject or imported symbol. He had recognized in the New York painters the formal confidence, generosity of scale and directness of attack that met his purposes – purposes that, as it happened, differed radically from theirs. He wanted, above all, painting that was pure of intent, that freed the imagination of the spectator as music does, and, like that of Matisse, offered a profound delight to the senses.

The reservations that had modified Heron's enthusiasm in 1956 were compounded in 1958, and were expressed in terms that provide a perfect insight into Heron's own criteria for 'good painting'. No fewer than four of the five Americans in the ICA exhibition were found wanting: the paintings of Pollock, Kline, Still

→ CADMIUM SCARLET: JANUARY 1958
Oil on canvas 182.9 × 106.6 cm

↘ BLACK, GREEN AND RED: FEBRUARY 1958
Oil on canvas 182.9 × 91.4 cm

↓ YELLOW AND VIOLET SQUARES IN RED:
FEBRUARY 1958
Oil on canvas 121.9 × 76.2 cm

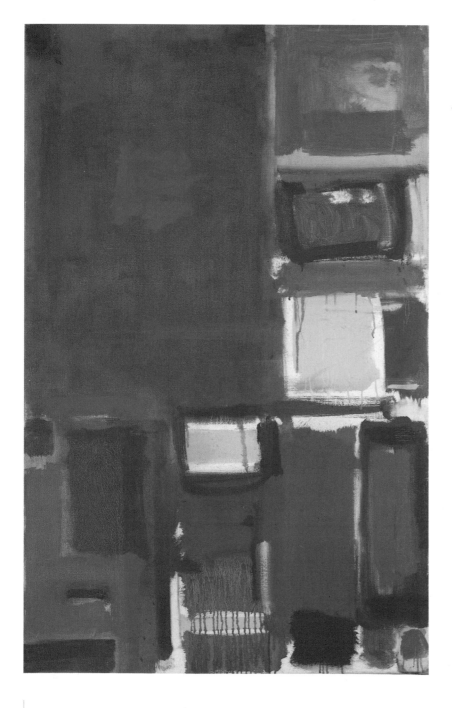

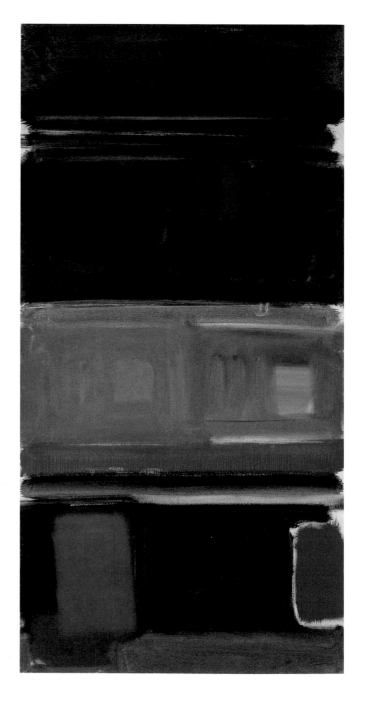

FROM ABSTRACT TO NON-FIGURATION

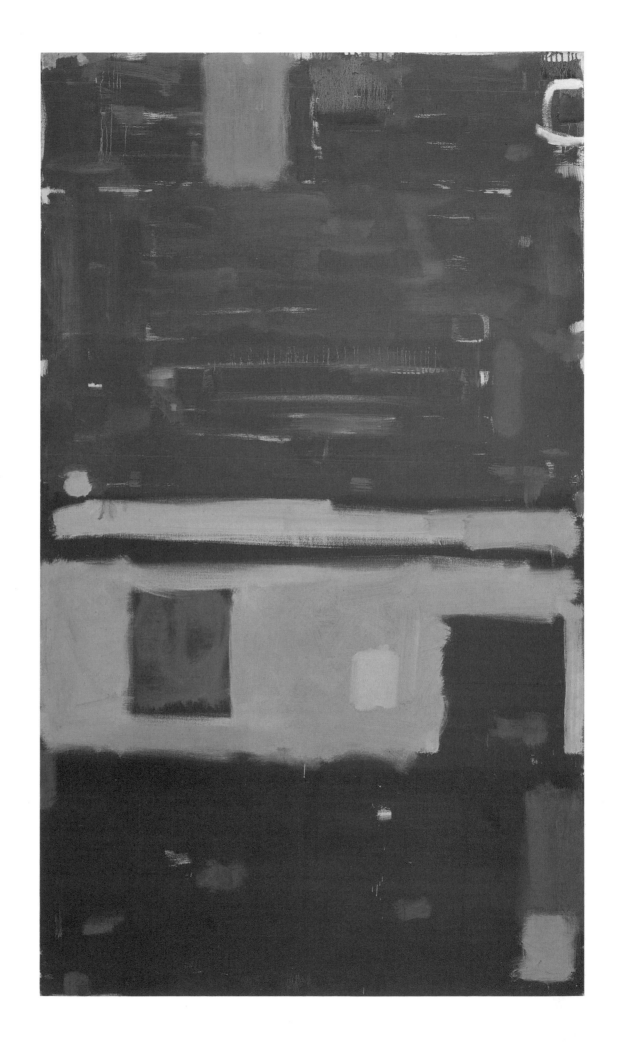

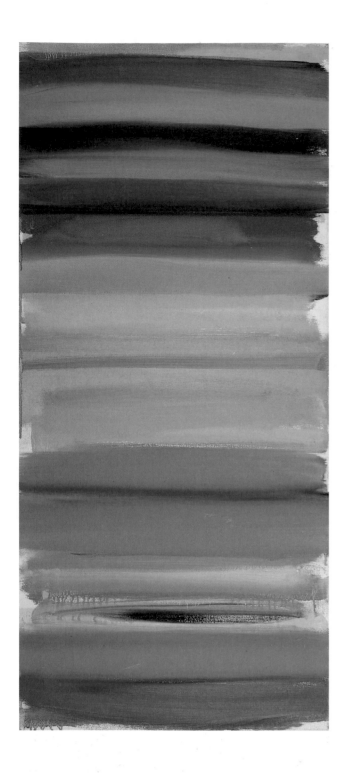

↑ GREEN AND MAUVE HORIZONTALS:
JANUARY 1958
Oil on canvas 121.9 × 55.9 cm

» SQUARES IN DEEP CADMIUM:
JANUARY 1958
Oil on canvas 182.9 × 106.6 cm

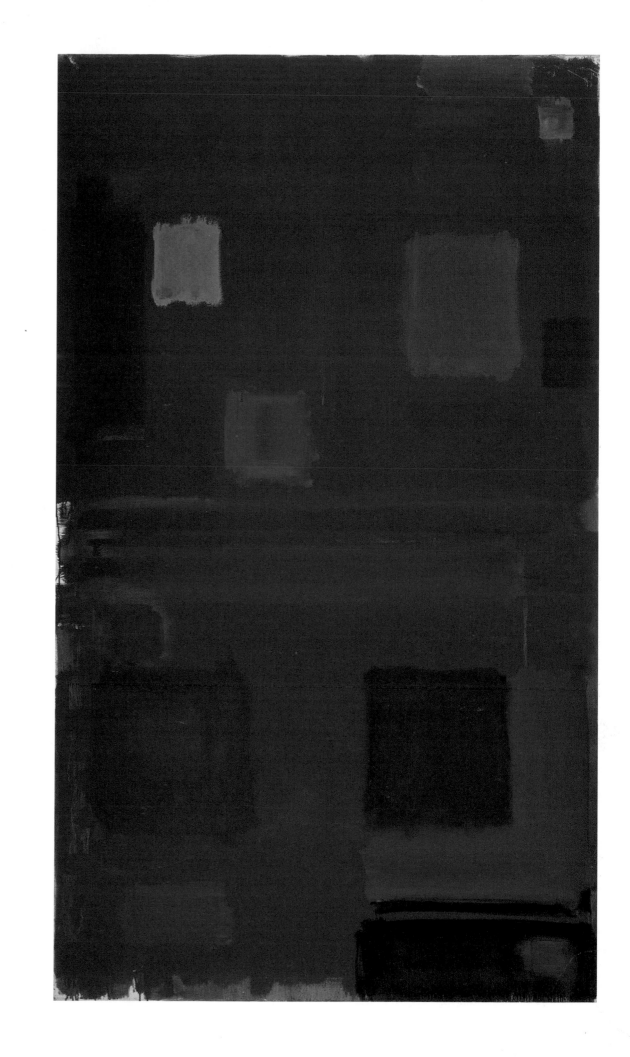

and de Kooning lacked 'a sensuous subtlety of tone color, a subtle asymmetry of shape, a varied tempo of working …'. At a time when any 'mode of figuration [was] retrogressive in some way or other', those good painters who incorporated images (which 'are always figurative') were to that extent relinquishing 'the exploratory function of painting and … elaborating on something already understood and then embellishing their art with this elaboration of a known theme' (this is the maker of 'extreme paintings' speaking): on this account he did not greatly admire de Kooning. The separate strands and strokes of colour in Pollock's painting failed to 'flood together' in 'harmony'; Kline's blacks were more positive than his whites, and contributed to a minimal 'image'; in Still what was missing was a 'caressing subtlety of color.'

The exception was Rothko. In spite of misgivings about his 'muted' colour, he now seemed to Heron to be 'the best of living Americans, and better than Pollock.' Heron described both of Rothko's paintings in the exhibition, the first, *White Cloud* of 1956, being of the classic format of the mature Rothko, 'that limits itself to that minimal horizontal oblong of atmospheric color floating on a ground of one single tone-color' with another rectangular area of colour below it. But it was the second Rothko which especially caught Heron's attention; he described it as 'the most beautiful picture in this show,' and he reproduced it with his article. *No 14* (1949) 'is composed,' he wrote, 'of a number of rectangles, of very different shapes and sizes, which loom out of a soft ground of yellow-orange, and is the first painting by him that I have seen that is not cast in the same pattern as *White Cloud*.' It was not surprising that this picture should strike so resonant a chord: one of a group made nine years previously by the American artist he admired with least reservation, it was remarkably similar in some respects to some of the recent paintings at the Redfern, notably *Red Ground: May 1957*, *Squares in Deep Cadmium: January 1958* and *Yellow and Violet Squares in Red: February 1958*.

In the previous two years Heron had clarified his purposes as a non-figurative artist and was in the process of defining his own course; he was already embarked upon his own exploration of the continent of colour. This involved something more now than the 'mere quickness in actual execution' that was supposed to validate the authenticity of 'action painting' or its cognates. The 'visible speed with which Pollock registered an impulse has proved a feat as infectious as anything from the hand of Picasso. And it has served to jog Western painting out of its post-Picassian coma'. But such spontaneity (which at times in Pollock and de Kooning registered in a 'forced violence' of touch) was a false criterion of 'something called good painting' (a phrase Heron had first used in his January 1957 'statement'). What was needed now were 'examples of a new and fine *deliberateness*; a more fully conscious and considered mode of action, which will embrace the static and fundamentally architectural elements in painting at the same time that it displays the fluent and spontaneous.'

If this prescription fits Heron's stripe paintings, in which a succession of spontaneous and vigorous applied strokes, with natural consequences of drip and flow, are constrained by a premeditated architectonic, then it applies even more exactly to those recent paintings characterized by openly-organized intuitive placements of soft-edged squares, lozenges and rectangular apertures. For in these paintings, and in those that succeeded them over the next four years, Heron moved beyond the rapid summary strokes and washes of the 'stripe' and 'horizon' paintings towards what he described as a 'true spontaneity', a manner of working that demanded 'an infinitely varied tempo – slow finickiness *allied* to swift and broad movements.' Towards, in fact, a worked-for sensuous variegation of surface

texture and an intuitively *composed* pictorial organization of colour field and colour-shapes. These were the two principal formal considerations that were to preoccupy him from now on as the means to explore what he had now clearly identified as the *subject* of his painting: colour, space and light. 'My interest is in fact always in *space in colour* and space in colour is the *subject* of my painting today to the exclusion of everything else.'

These words come from a short statement Heron wrote later in 1958 for the October issue of *Architecture and Building* apropos the installation at the London offices of the publishers Lund Humphries of *Horizontal Stripe Painting: November 1957 – January 1958*, which had been newly designed by the architect Trevor Dannatt. The dimensions of the painting were precisely related to an architectural space to which the work was integral, and the deepening red and broadening gradations at the top of the nine-foot canvas were created with a specific spatial effect in mind. A lowered ceiling of parallel wooden slats obscured the upper third of the painting, appearing, as it were, to run into the painting at right angles to its own horizontals: 'The top yard is thus designed,' wrote Heron, 'to be read *through* [the] slats of the hanging ceiling.' Heron's response to the commission, and his commentary on it, are a confirmatory indication of his clarity of purpose and creative self-confidence in early 1958. *Space in Colour* was, of course, the title he had invented for the exhibition he had organized in 1953. The difference was that by now he had resolved once and for all his uncertainty vis-à-vis figuration and non-figuration: 'Allusions, overt or not, to external facts', he had written in the review of the ICA show, '… are almost inevitably clichés. There simply is not available at the present moment, it seems to me, a valid figure, or mode of figuration …'.

Heron had, then, by this time arrived at a kind of programme; or rather he had come to an understanding of the direction his own painting must take in respect of his own deepest feelings as an artist. There is a fertile contradiction here: a programme is a willed thing; what is imperative is not a matter of choice. Heron has never been a programmatic artist, but his best work has come out of his recognition of what is necessary to the realization of his own distinctive vision, and his commitment to what most deeply obsesses him. The emphatic prescriptions of the *Arts* review are clearly rationalizations of a personal position, *obiter dicta* extrapolated from his own case. And as with the equally revealing 1956 review of the New York painters at the Tate, it was against the challenge presented by an exposition of the newly-dominating American painting that Heron defined, this time consciously, his own preoccupations in contradistinction to those that had shaped abstract expressionism in both its painterly and non-painterly manifestations.

This is the true significance of his preference for the earlier of the Rothkos in the ICA show: it was both more painterly and more complicated in its image; it was, moreover, asymmetric in its arrangement of colour forms, its disposition of colour and shapes exhibiting that intuitive 'true spontaneity', varied in its operations and various in its effects, that Heron had defined as the proper criterion for good painting. In short, it was a beautiful exemplification (achieved ten years previously!) of the 'fine deliberateness' to which painting needed now to aspire; Heron's tribute to Rothko was an acknowledgement of this. In the case of the other painters in the show, Heron's newly-confident definition of his own position was registered in terms of negative response: he was no longer really interested, in relation to his own development, in what these painters were doing: '… this time I do not react with enthusiasm to the shallow space; nor to the overt speed of the muscular brushwork; nor to the harshly brittle paint; nor to the lack of subtle resonance in color. In fact, I felt again and again what I can only describe as

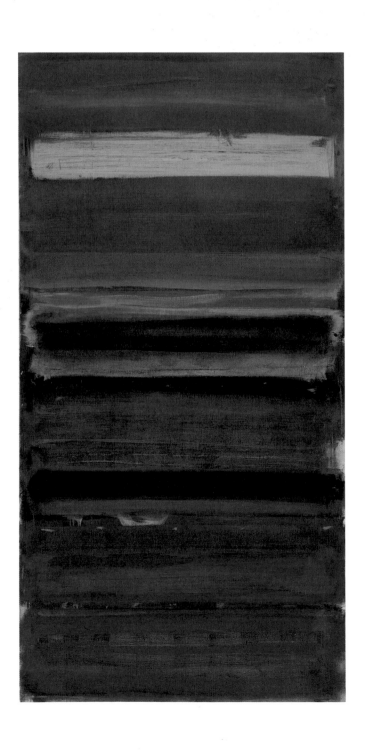

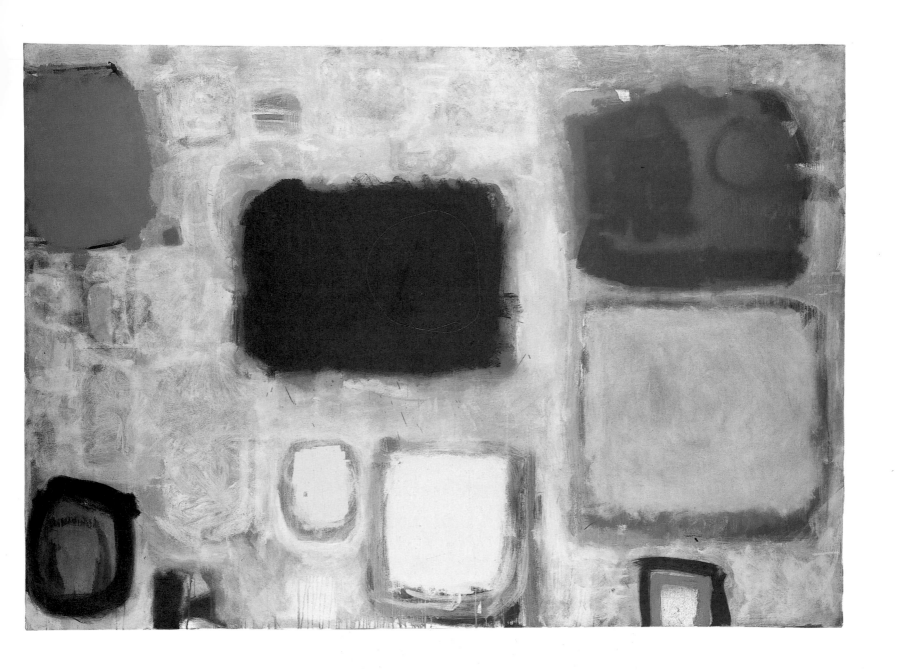

» GREY AND YELLOW (WITH CIRCLE):
OCTOBER 1958 – FEBRUARY 1959
Oil on canvas 152.4 × 121.9 cm

↓ VIOLET AND DULL GREEN: JULY 1959
Oil on canvas 121.9 × 152.4 cm

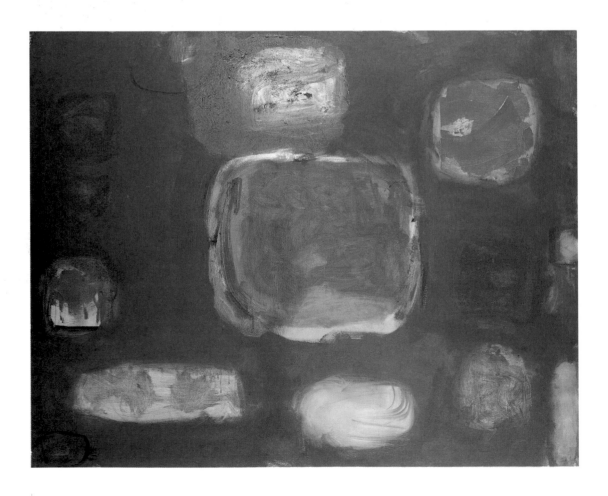

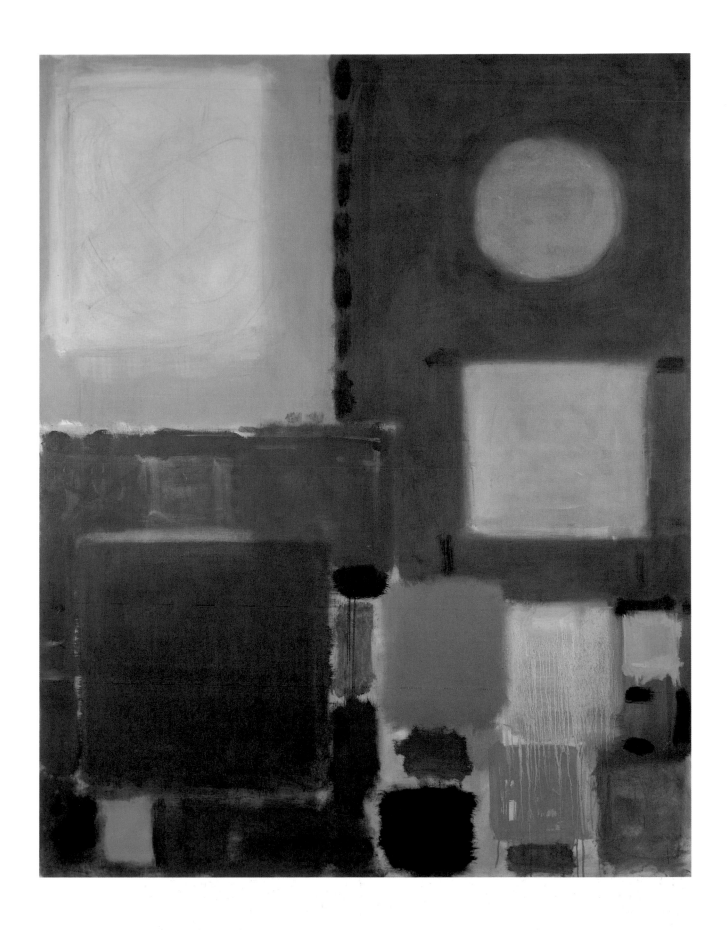

the absence of a dimension in the paintings of four out of the five Americans in the show.' To adapt Hopkins's famous phrase, he might admire, with significant reservations, but he would do otherwise.

Heron's commitment to the idea of the painting as an autonomous object, conterminous with the image it carried, had been confirmed by his idiosyncratic, and somewhat ambivalent, reading of recent American painting. It was this idea that was coherent with the underlying philosophy of his work prior to his move to the abstraction of 1956 and had little to do with any stylistic aspect of the American painting he had seen. Behind it indeed lay the Mallarméan notion that the work might be a means by which the experience of the world, the impress upon the senses and through them upon thought and feeling of the actual, might find an objective expression separable from its specific occasion. It was an idea transmitted through the practice of Braque and Matisse: painting should be concerned not to render phenomena, but to be phenomenal. 'Let us forget things and consider only the relationships between them,' Braque had written; 'the painting is not a mirror reflecting what I experienced while creating it,' wrote Matisse, 'but a powerful object, strong and expressive, which is as novel for me as for anyone else'.

Red Ground was painted in May 1957, within weeks of *Vertical Light: March 1957*, *Scarlet Lemon and Ultramarine* and the two *Horizon* paintings, and in the same month as *Yellow and Black: March 1957*. Having arrived at the decisive simplicity of the stripe Heron moved simultaneously beyond that brilliant device towards a new sort of pictorial complexity. It is an example of the creative dialectic so characteristic of Heron's progress, and whose dynamic oppositions followed one another so rapidly in the crucial three years that separated the arrival at the dramatic abstract screens of the *Verticals* and light-filled brilliance of the *Garden* paintings of early 1956, and the complicated composition and rich colour sonorities of *Black Painting – Red, Brown, Olive: July 1959*. It was a period marked by an extraordinary diversity of invention, but behind its exhilarating stylistic shifts were preoccupations essentially continuous with those that had animated Heron's art for many years, and creative imperatives that made risk inescapable and changes inevitable.

Above all he remained committed to painting as a process of discovery and revelation, a mediation of the artist's relation to the external world of space and light, conducted through the skilled manipulation of matter. A picture is an object charged with the concentrated creative energy of the artist's actions upon it, the artifice of the painter. The history of painting, up to the living present, was the history of technical artifice: this constituted the painterly tradition within which the individual talent must find its place. Painting is an instrumental language, 'built up,' in the words of his friend Roger Hilton, 'not so much for the purposes of representing the visible world as for being an instrument capable of embodying men's inner truths … for expressing one thing in terms of another.' Introducing his retrospective at the ICA, in February 1958, Hilton continued (in terms that Heron would have found absolutely sympathetic): 'This whole vast vocabulary is still available to us painters. … it is a vocabulary that has been so intimately connected with the inner selves of the greatest painters of the past that, if we associate with it and learn to know it, we shall come to understand the truth it reflects. It is only at this stage that we can use it to reflect a truth of our own.' There is behind this a more profound idea of 'influence' than has to do with superficial stylistics; and it explains why it was possible for Heron to admire, as a critic, a painter like Hilton whose subject and manner, whose 'own truths', were so very different from his

own. It is also the key to Heron's critical concentration, in his writing, upon formal considerations: truth is inseparable from the language of its utterance.

Although he remained friendly with Clement Greenberg through this period, Heron would have found confirmation of his deepest misgivings about the direction of American art in Greenberg's summarizing survey 'After Abstract Expressionism', published in *Art International* in October 1962. According to Greenberg, the painting of Newman, Rothko and Still had raised the question: '… what is the ultimate source of value or quality in art?' His answer was emphatic: '… not skill, training or anything else to do with execution or performance, but conception alone. Culture or taste may be a necessary condition of conception, but conception is alone decisive'. What concerns us here is not the validity of this position, but its distance from Heron's: insofar as he was right about the philosophy of American painting, it explains precisely what it was about abstract expressionism that interested Heron, *as a painter*, less and less as he saw more of it. The absolutist emphasis upon the presentation of an 'idea' is just what Heron was beginning to define as the over-riding *weakness* in New York painting. His review in *Arts* of the ICA show of Power's American pictures was followed by a brief note on the Hilton retrospective, which had immediately preceded it in the same place: 'Hilton's starkness has just that sensuous richness, that subtle science of painting, which I find missing in the American painters I have been discussing.' His 'explosive expressionism' was 'tamed by the purely pictorial realities of his extremely varied color and his sense of formal balance – in a word, by his knowledge of, and reverence for, the art of painting'.

Much of what Heron was to discover in painting over the following years is prefigured in *Red Ground: May 1957*. The red ground of the title is, in fact, a translucent wash over the whole of the canvas, creating what is in Heron's work a new kind of all-over colour-space. Into this are brushed a number of floating colour-shapes, arbitrarily placed bands of summary strokes, displaced children of the stripe. Some horizontal, some vertical, these are no longer held into the compositional order of one-way parallels that constitutes the compellingly simple formal device of the stripe paintings. Some of these bands overlap or are imposed across others, most notably in the dark green cross-form at centre right, where the bold horizontal bar intersects a rectangle of downward strokes in a dramatically awkward conjunction. Completely novel is the appearance of soft-edged rectangular planes of colour, nearly but not quite square: these conduct a stately diagonal movement from top left that is rudely cancelled by the dark green horizontal. At upper right and centre left these are accompanied by formally related outriders, small rectangles themselves containing small squarish shapes of different colours.

Red Ground anticipates with a summary simplicity the grave dispositions of the soft-edge colour shapes that are to characterize Heron's paintings for several years. Its visual dynamics are of relations between flat shapes and contrasting textures achieved by vigorous strokes or even washes across the plane, and also of a proposed recessive space, ambiguous and inconsistent. The title of the painting is perhaps something of a misnomer, suggesting that it might be concerned with figure-ground relations; but it was obviously painted fast, as close in the manner of its making to the 'stripe' and 'horizon' paintings as its added complications would allow, and its atmospheric space and flatly-brushed colour-shapes are akin to those in the contemporaneous paintings. Where it differs is in its rhythmic disposition of the independent free-floating shapes. These are not those quasi-figurative, complicated *forms* that Heron had identified in European non-figurative painting, '*nests … lodged within* an all-over non-figurative structure'. They are what they

BROWN GROUND (WITH SOFT RED
AND GREEN): AUGUST 1958 – JULY 1959
Oil on canvas 152.4 × 213.4 cm

BLACK PAINTING – RED, BROWN,
OLIVE: JULY 1959
Oil on canvas 96.5 × 121.9 cm

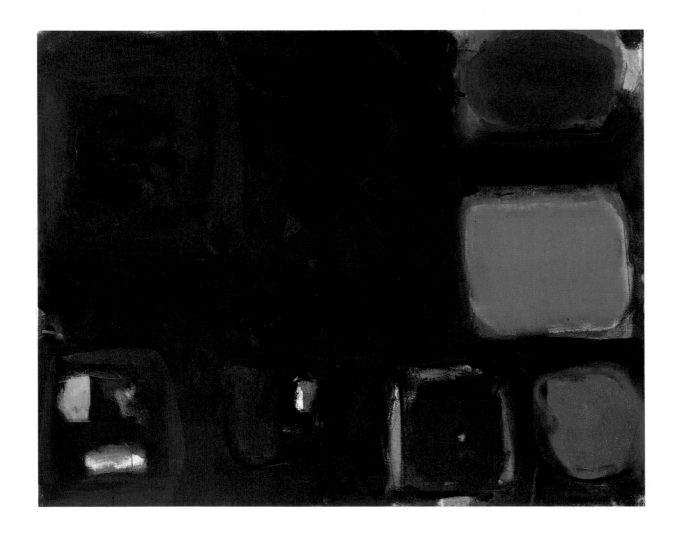

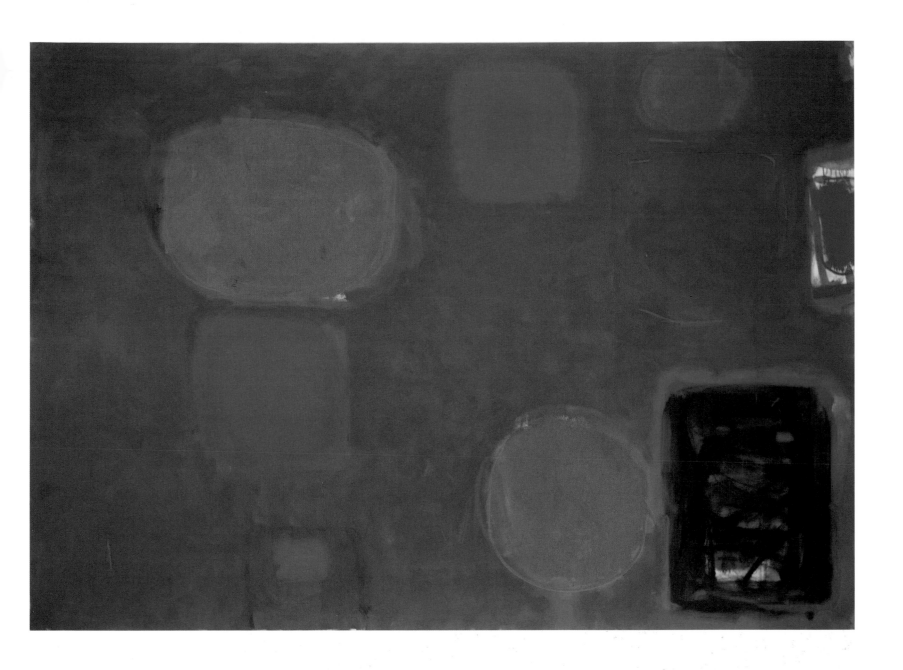

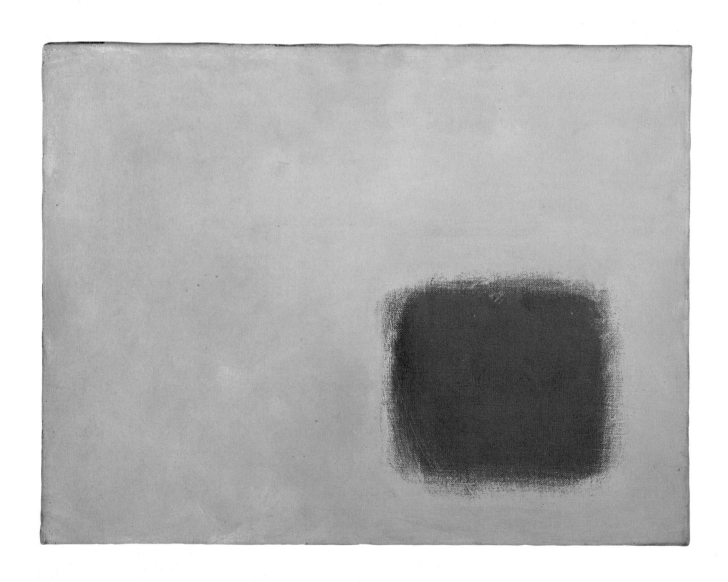

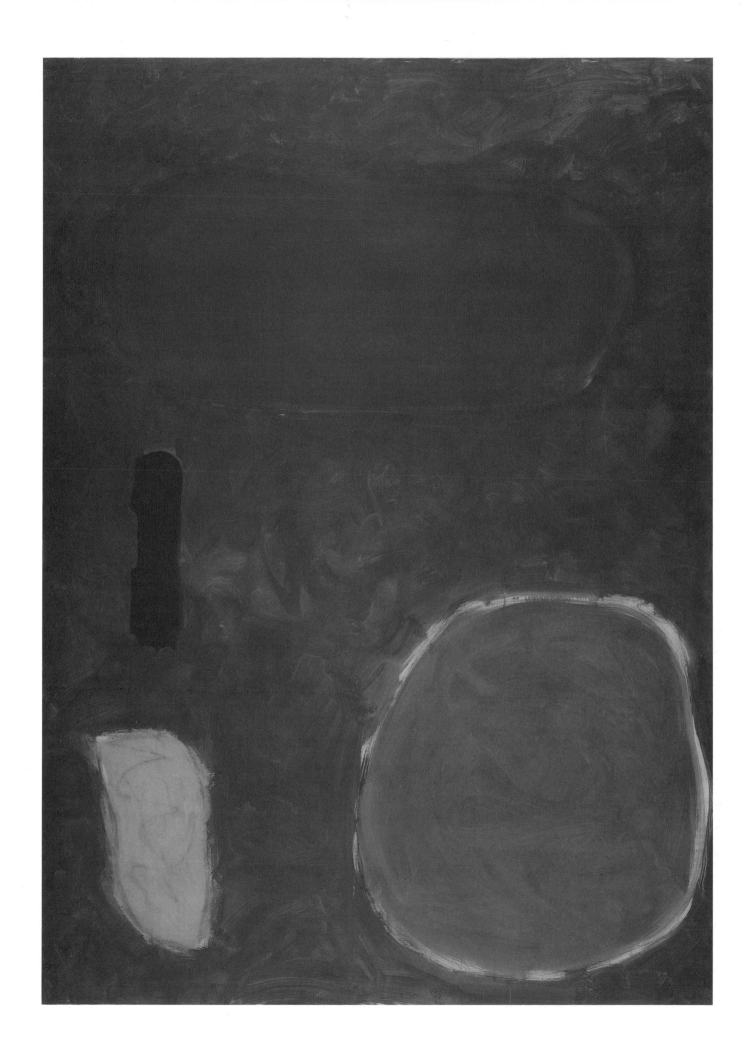

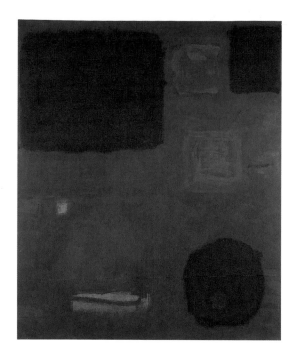

declare themselves to be: paint and colour. A painting is an object in the world, its colour-shapes and their relations with each other responsive to the changing circumambient light. Heron was surprised and delighted to find that as the room in which *Red Ground* hangs darkens at dusk, and colour is sucked out of the reds and the greens, so the violet frame of the small brown rectangle at centre left glows white, like a luminous after-image against the blackening red, a sign, persisting into utter darkness, for the light it has absorbed.

Squares in Deep Cadmium: January 1958 lacks the affecting awkwardness that identifies *Red Ground* as a transitional painting in which not only is an image discovered, but a new *mode* of imagery is intimated. By contrast to *Red Ground* with its slightly jazzy improvisatory air, and its steep vertical double-square format, *Squares in Deep Cadmium* is quietly resolved, its various elements held in an ordered equilibrium within a broader rectangle. There is the hint of an underlying structure of horizontal parallels, which in becoming visible at the centre suggests a perspectival recession to that line, an illusion contradicted by the unmodelled flatness and arbitrary placement of the venetian red squares and the darker shape at bottom right. To complicate spatial matters further, the venetian red rectangular frame at lower left is so lightly brushed that it seems to be fading like a ghost into a deep cadmium space not of the kind that recedes to an horizon but like that experienced in mist or darkness or when we close our eyes; and at upper left, the proximity of the small grey-green square to the purplish shadow beside it on the plane makes it appear to float forward and hang like a pale light to the front of the pictorial space.

This play with two or three distinct types of pictorial space – perspectival, atmospheric, relative – with varying registers of depth and shallowness – was to be a vital aspect of Heron's painting from now on, a functional dynamic in the complex visual music of his art. Colour and the arrangement of colour-shapes; chromatic and tonal variations; the infinitely expressive repertoire of brushwork and over-painting, stroke and mark, impasto, scribble and wash: these were the other elements of a more complex kind of composition. *Cadmium Scarlet: January 1958, Black, Green and Red: February 1958* and *Yellow and Violet Squares in Red: February 1958* can be seen to have developed directly out of the 'stripes', and like *Squares in Deep Cadmium*, to be extending the vocabulary of those paintings by countering the formal simplicities, the uncomplicated stripe *shapes*, with soft rectangles, or what might be described as rectangular *apertures* or windows on to imagined spaces *behind* the surface bands or areas of colour.

In *Cadmium Scarlet* the most dramatic of these openings are to be found piercing the broad sea-green turquoise band over-painted at lower centre, at left as a window, at right as a doorway. The two tones of red cadmium are separated just below this broad band, tempting the eye to read this line of separation as a right-angled meeting point of two planes, as between a floor and a wall. The floating blue rectangle at bottom right, the emphatically brushed intruding rectangle at centre top left, and the pure calligraphic sign of cream yellow enclosing a royal blue square at top right, all work to contradict this reading, proposing other, more local, spatial relations, and insisting, simultaneously, on the pure flatness of the surface. The Matisse of *The Red Studio* is a presence in this work, recalled by the planar colour, its spatial ambiguities and its scatter of motives. Given the intensity of its concentration on the spatial theme, it is not fanciful to see in the blue and red stripe across the centre a version of that Matissean/Bonnardian device of the dividing window sill signalling a transition from one space to another. This device recurs equally emphatically in *Black, Green and Red: February 1958*, a painting in which (as in *Cadmium Scarlet*) the division thus marked between the lower third

and the upper two thirds can be traced back through the 'stripe' paintings to harbour window pictures of the early 1950s. In this painting the light behind the two square 'apertures' in the green band (paler in that at centre right) is the colour of earlier washes left uncovered by successive layers of over-painting. In the paintings of this new phase (all of the paintings discussed here were shown at the 1958 Redfern exhibition) we may discern the first of Heron's many inventive elaborations of the abstract language of Matissean 'signs', whose basic vocabulary was established with the single-stroke/stripe and the aerial turpentine-thinned wash of clear colour in the paintings of early 1957.

Heron's connections with other British painters, with Hilton, Frost and Wynter, and especially Scott, among others, continued to be important to him. Loosely centred on St Ives, but with continuing relations with London-based artists such as Scott and the sculptor F.E. McWilliam, many of whom spent time each year working in West Penwith, these constituted a milieu of friends who shared basic attitudes, though their personal styles were diverse. 'A painting to [these artists] is space and colour and texture, form and image and architecture,' wrote Alan Bowness in his introduction to the exhibition of Heron, Hilton, Frost and Wynter at Waddington's in May 1959, ' – this is its essential reality, and not the green fields or kitchen interiors or multiple self-portraits or whatever it is the English public prefers to see'. In a visual culture that favoured literary illustration, emotive 'realism' or nostalgic pastoralism, these painters and others associated with them (including Nicholson, Pasmore, Lanyon) belonged to 'a team that … can … stand comparison with the 17 Americans whose work was recently shown at the Tate.' Bowness was referring to the exhibition in February and March that year of *The New American Painting*, the first really comprehensive showing in London of the New York School.

There is no written record of Heron's response to that famous show, nor to the major retrospective of Jackson Pollock at the Whitechapel at the end of 1958. It is tempting to suggest that his growing antipathy to what he had described as 'the present world-wide spate of gesticulatory, would-be aggressive forms, both pictorial and sculptural' had contributed to his decision in the late summer of that year to give up critical writing altogether, and resign as London correspondent of *Arts*. Writing of Dubuffet in his final contribution, in October 1958, he laments the absence in 'most "advanced" painting and sculpture of the present time … [of] that passionate calm, that contemplative structural grandeur which distinguish the first-rate from the second-rate in art – no matter of what school or mood'. Favourably comparing Poliakoff to Dubuffet, he wrote of the former's 'stiff and sombre gaiety', and of the 'entirely French' provenance of Poliakoff's 'idiom of very deliberately delineated divisions in the surface of the canvas', deriving ultimately from Synthetic Cubism. Like that of his best French contemporaries (especially Soulages, 'the speed of [whose] strokes was always measured') Poliakoff's painting showed 'no trace of … the too visible energy and speed with which American Action Painting has infected so much contemporary painting …'. Once more, and for the last time for his American audience, Heron was aligning himself temperamentally and critically with Paris, and expressing in remarkably direct language his reservations about the direction of New York painting.

There were more pressing concerns behind Heron's renunciation of criticism than that of a lack of sympathy for the current trends in painting, towards an un-measured 'expressionist' quickness of execution on the one hand (whether its ends were figurative like those Dubuffet, or dramatically abstract like de Kooning's), or the repeated statement of a grand overriding idea or conception on the other.

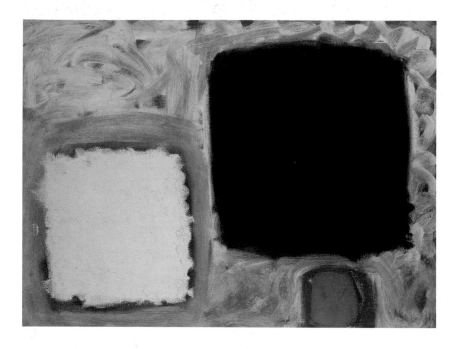

↑ JANUARY YELLOWS (NAPLES AND
 VIOLET): JANUARY 1960
 Oil on canvas 76.2 × 101.6 cm

⇒ SQUARES FLOATING IN BROWN
 (EMERALD, LEMON, VIOLET):
 JANUARY 1960
 Oil on canvas 76.2 × 101.6 cm

↘ BLUE PAINTING – VENETIAN DISC
 AND BLACK COLUMN: MAY 1960
 Oil on canvas 121.9 × 182.9 cm

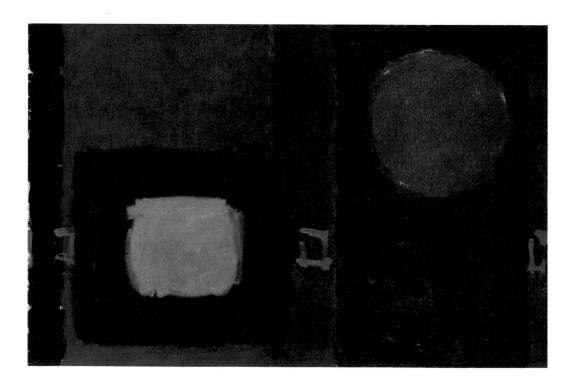

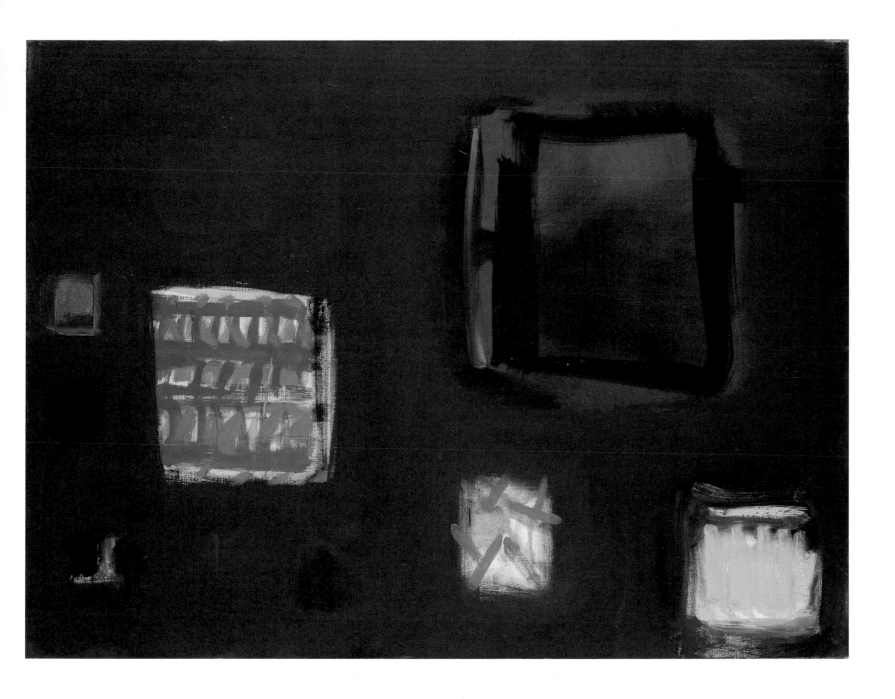

Heron was by nature a celebratory critic, with a rare gift for defining precisely those specificities of technique that distinguished one artist from another, for illuminating comparisons and subtle discriminations. His critical championing of those artists he admired was always based upon an acute visual analysis attuned to the nuances of style and manner that placed an artist within particular histories of modernist painting. The critical reception of his last show at the Redfern, generally so imperceptive and ignorant, had indicated clearly that there was no critic of comparable percipience and knowledge prepared to champion his own work. A sort of watershed had been reached. The gallery's insensitive handling of the show, and its commercial failure, confirmed Heron's decision to leave the Redfern and join Bryan Wynter at Waddington's. Propitiously, it was at just this time, in June 1958, that Ben Nicholson, leaving St Ives to live in Switzerland, made careful arrangements for Heron to inherit his Porthmeor studio.

As the decisive development of his painting through 1958 and 1959 indicates, Heron was not to be put off stride. His criticism, so emphatic and assured, though at times it directly reflected his underlying philosophy as a painter, was never employed in the advocacy of his own work, but it had always seemed difficult for anyone to write of his painting without mentioning his prowess as a critic. 'Your tactical mistake was to write so intelligently about painting – it is *not done* by the real painters – it does not fit in with the public's conception of the painter as a dumb ox.' That, wrote Herbert Read in a letter of December 1958, was Heron's 'problem', one with which, as a creative writer whose poetry had been eclipsed by his critical work, he sympathised deeply.

But having made that mistake you assumed that other painters, or critics on their behalf, would return the compliment. They will do nothing of the sort. The public will never admit that a man can be supreme in more than one art … You may in time live down your intellectual reputation (on condition that you henceforth refrain from emitting anything but vacuous aphorisms)', but meanwhile you must rely on the faith which you have in yourself and your destiny.

Read had written in immediate reply to an angry letter from Heron expressing his disappointment at his and Terry Frost's exclusion from the reproductions selected by Read for his section in *Art Since 1945*. Heron's further response, written on 5 February 1959, expresses a faith in his destiny undaunted by the events of the previous year: 'As for [the] painting itself – it flourishes. Its true place will not forever be obscured by complications concerning my late critical activities …'. It had clearly been a time for change and re-direction:

It is necessary to clear the decks at a time of crisis (in one's affairs). Last August I resigned as London Correspondent of ARTS (N.York) – I turned down an offer to do the London letter for Cimaise [the Paris-based magazine] – *and I decided never again to write criticism.* This is not being gone back upon. Nor will it be – because the total absorption in *painting* somehow *incapacitates* one (more and more I find) for *thinking* about painting in terms of words. I don't want, any more, to *explain;* or to *analyse;* or to *persuade.* I only want to go on creating my images of atmospheric colour – and that's what I'm doing and shall do – even if it means turning this place into a boarding house temporarily.

This did not prove necessary. In the May 1959 mixed exhibition Heron showed the first substantial group of his 'atmospheric' paintings, including the coolly crepuscular *Grey and Yellow (with Circle): October 1958–February 1959*. Later that year *Black Painting – Red, Brown, Olive: July 1959* was awarded the Grand Prize by an international jury at the John Moores' exhibition in Liverpool. These paintings, with the grandly-scaled *Yellow Painting: October 1958–May/June 1959* and *Brown Ground (with Soft Red and Green): August 1958–July 1959* exemplify the move to the

'recomplication of the picture surface' that was first adumbrated in *Red Ground: May 1957*, and could be seen gathering momentum in *Squares in Deep Cadmium: January 1958* at the very beginning of 1958. As the inclusion of composition dates – sometimes of several months – in their titles indicates, these were deeply considered paintings, worked on and set aside, contemplated over time. They are indeed executed with the 'true spontaneity of an infinitely varied tempo', which he had called for in the May 1958 *Arts* article. Time and deliberation are inscribed in these beautiful paintings; they are visible in the ghosts and shadows of shapes submerged by successive layers of over-painting, and in the shimmer at the edges of square and lozenge where colours meet at indeterminate boundaries or merge softly. Time is as much their subject as space and colour.

They have a textural richness and visual sonority that is new to Heron's work, and derives from successive over-painting and a palette that exploits every resource of colour, chromatic and tonal. The final image is the outcome not of predetermined design but of intuitive manipulations of paint, of a kind of collaboration, at once measured in pace and spontaneous in execution, with the material. The colour shapes – 'round-squares', lozenges, soft-edged discs – were often set down only to be engulfed, like islands in a flood or rising tide of colour, to survive only as traces just visible beneath the surface of the irregular areas of predominating colour. Those that remain in the final configuration, their edges indefinite and sometimes surrounded by a halo of light from an even earlier layer of lighter or darker paint, or from an over-lap of layers, are in some cases like those luminous apertures first seen in the earliest pictures of this period; in others, they float on top of or in front of the title colour, being the last-painted patches, the latest shapes to have arrived.

Many years later, in *The Shape of Colour* (1973), Heron described the making of these paintings as a kind of 'juggling' with the soft-edged squares, and remarked the tendency of these shapes to '[edge] up into one of the corners, or [move], almost visibly, along one of the canvas's edges as if drawn by a magnet'. Sometimes the entire picture area is filled with them, floating towards or apart from each other, hovering relative to each other in a shallow space, advancing or receding, but inevitably seeming to move outwards towards the edge of the canvas, and then, potentially, into a space beyond. George Dennison, reviewing Heron's first New York show, remarked this 'implication of continuity and succession in the way the patches of color are cut by the edges of the canvas, so that the whole image seems to have been taken from some larger process.' These paintings present us with images of inconstancy, of forms as impermanent and insubstantial as clouds, whose occupation of space – (of any of those species of space defined above) – is as implicitly provisional as the configurations that cohere in the momentary serenity of a day or night sky. That 'larger process' from which they abstract an entirely non-figurative image is nothing less than the dynamic of those relations, spatial and atmospheric, that constitutes the world of light, saturated with colour, where we live.

In 1960 Heron produced his first one-man show with Waddington's and his first exhibition in New York, at the Bertha Shaefer Gallery. The American critical response was enthusiastic and perceptive. Dennison, in *Arts* (April 1960), saw the connection between Heron's painting and his writings on the New York painters: 'Heron's reviews (in these pages) … were written in such personal terms that one could sense the gathering of his own intentions …'. Like other critics, he was struck by the richness and subtlety of Heron's colour: 'Heron lays his strongest demands upon color; and his most sustained investigations are of its properties – its tensions, vibrations, harmonies, reverberations – especially when the color is suf-

fused with light and is released as much as possible from the function of describing forms.' He was able to discern a crucial distinction: 'Where Rothko arrives at an impersonal and yet lyrical grandeur, Heron develops a personal image; it is expansive and certain of its generalizations, but it is personal in its measured proliferation of detail, and in its concern with modulation and flexibility'. This is both exact and just. For Stuart Preston in the *New York Times*, Heron was 'a juggler, balancing [his specific, squarish shapes] in compositions of momentary equilibrium. Their state of suspended animation gives his pictures their extraordinary lightness despite the positive existence of his forms.'

Inevitably, Heron reacted against the growing complexity of these pictures. *Green Painting with Three Browns (Suppressed Squares): October 1959 – May 1960* and *Squares Floating in Brown (Emerald, Lemon, Violet): January 1960*, in their different ways, signal a change. *Green Painting*, though richly over-painted, has a more even unity of colour and greater simplicity of image than the earlier paintings. Though the green suggests a deep space within which the brown shapes hover at different levels of recession (the suppressed squares adding to this spatial ambiguity), its surface opacity, compromised only by the two small areas of violet shining through from the original under-painting, is very different from the cloudy atmospherics and visual fuzz of the paintings of a year before. The disposition across the plane of these brown forms – and here the term seems again applicable – assumes something of the grave relation of a dance. The squares of *Squares Floating*, in spite of the title, are clearly *windows through* the smoky brown field to patches of primed or earlier-painted canvas. In the cases of the three bright lights from centre left to lower right these have been subsequently marked in a manner that denies a spatial reading and draws attention to the surface.

As always, there is nothing ordered or programmatic about these developments: Heron continued to make paintings using a virtuosic variety of marks and textures, and with varying degrees of compositional complication, in pictures as different from each other as the moodily nocturnal *Alizarine Painting (Orange and Blue): May 1961*, and the chromatically high-pitched *Big Red with Cadmium Green: July 1960*. Although individual works will continue to contradict any generalization about the work at this time, a trend to greater simplicity is nevertheless clearly discernible, with the colour shapes decreasing in number, or assuming the more definite outlines of pictorial forms or figures, and the colour areas within which they are placed becoming more unified in texture and uniform in colour. *Three Blues in Violet (with White): 1961* achieves a textural unity through the overall application of the paint in a busy scribble that defines both violet and blue shapes, and leaves a dark halo at the edges where they meet. The movement towards the elimination from the final image of multiple colour-shapes and complex formal relations culminates in pictures such as the quintessential *Orange Painting (Brown, Ochre and Black): January 1962*, where Heron's habitual tendency towards an asymmetric bunching of elements at the edge (usually at the right) reaches an extreme. Here the three darker toned shapes gleam, paradoxically, like shimmering after-images against the darkness of the sheer orange. In *Big Green with Reds and Violet: December 1962* the great horizontal field is wittily punctured by three patches of colour which tumble, like cloudlets in a potentially infinite sky, down to the lower right. As with all the paintings of this period, it is an image of the perpetually kinetic *equilibrium-in-mobile* of nature. The 'fine deliberateness' of their composition, their instinctive orderings of shape, colour and space, give them the movement and stillness, the gaiety and gravity of a free dance.

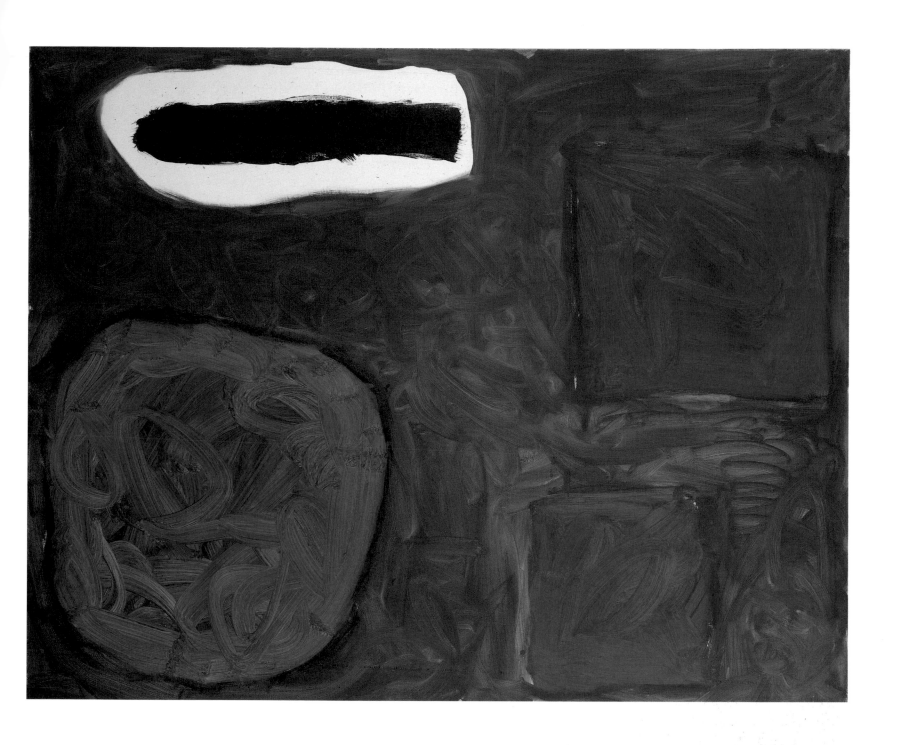

→ ALIZARINE PAINTING (ORANGE AND
BLUE): MAY 1961
Oil on canvas 121.9 × 213.4 cm

↓ CERULEUM SEA: JUNE 1961
Oil on canvas 121.9 × 152.4 cm

→ SMALL AREAS (LIME AND BLUE IN
PALE VIOLET): 10 SEPTEMBER 1962
Oil on canvas 25.4 × 33 cm

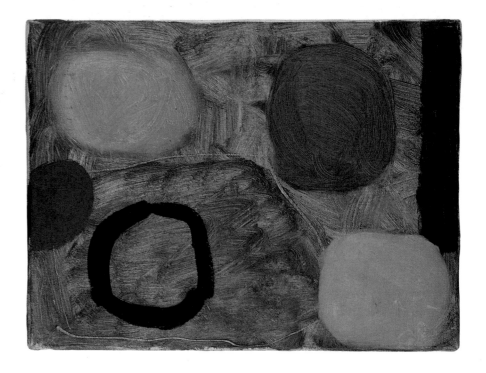

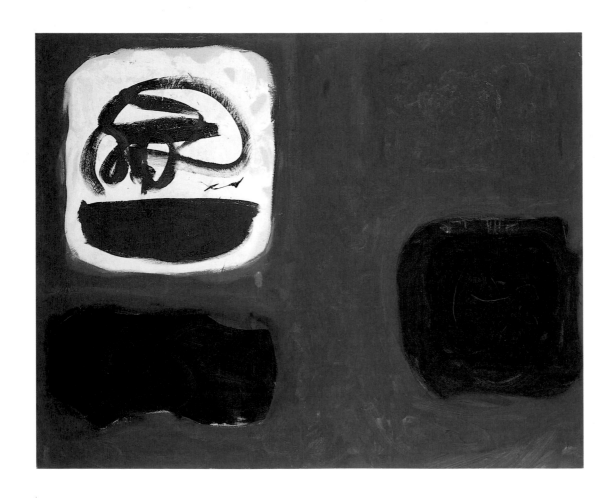

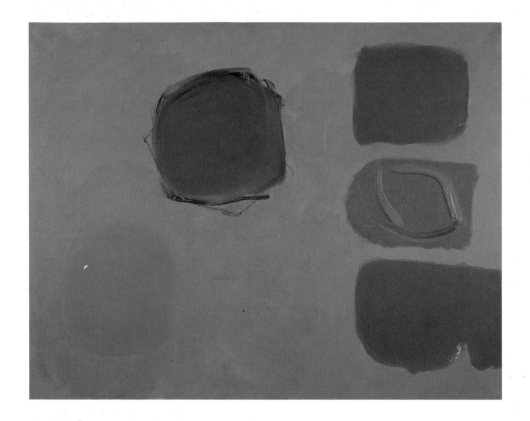

↑ ORANGE (WITH FIVE):
SEPTEMBER 18 1962
Oil on canvas 121.9 × 152.4 cm

→ ORANGE PAINTING (BROWN, OCHRE
AND BLACK): JANUARY 1962
Oil on canvas 121.9 × 152.4 cm

⇒ BLUE PAINTING WITH DISCS:
SEPTEMBER 1962
Oil on canvas 96.5 × 121.9 cm

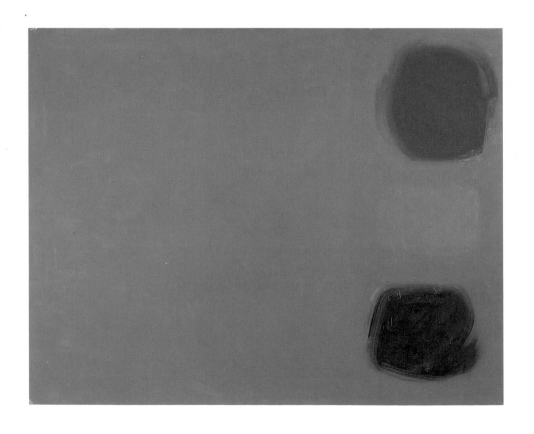

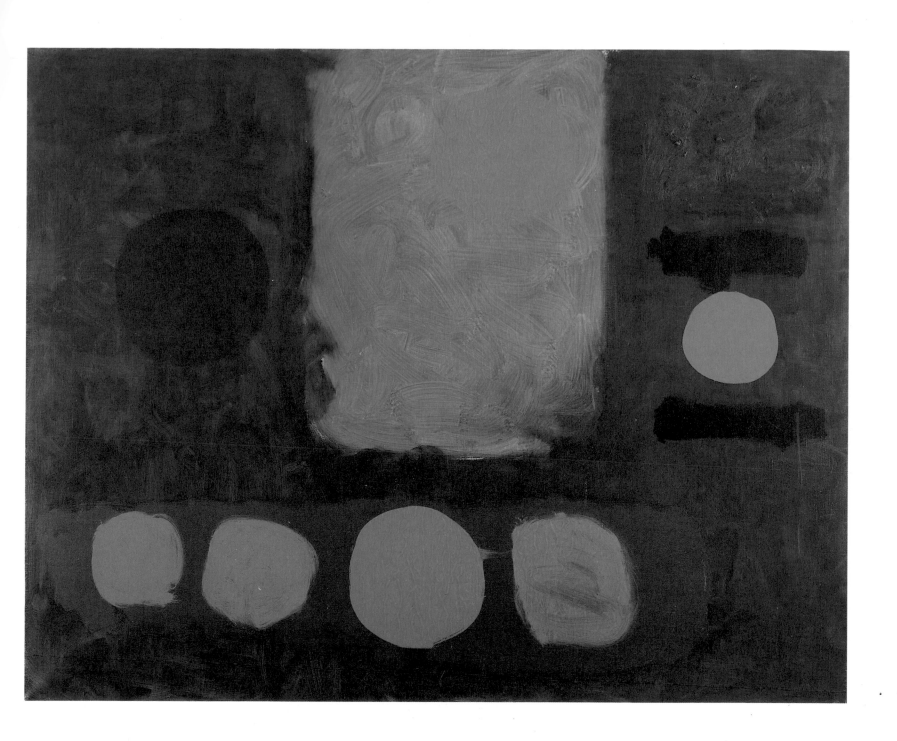

→ TALL PURPLE: SEPTEMBER 1962
 Oil on canvas 182.9 × 76.2 cm

↠ TALL VENETIAN: OCTOBER 1962
 Oil on canvas 182.9 × 76.2 cm

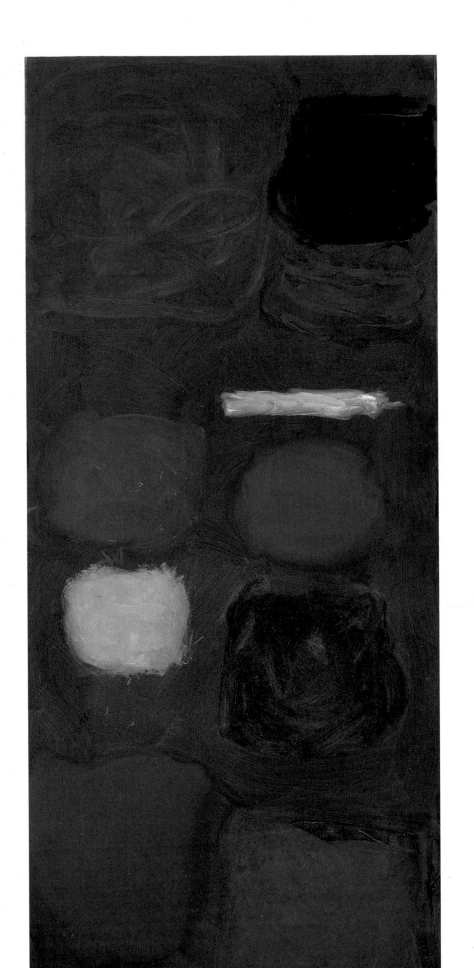

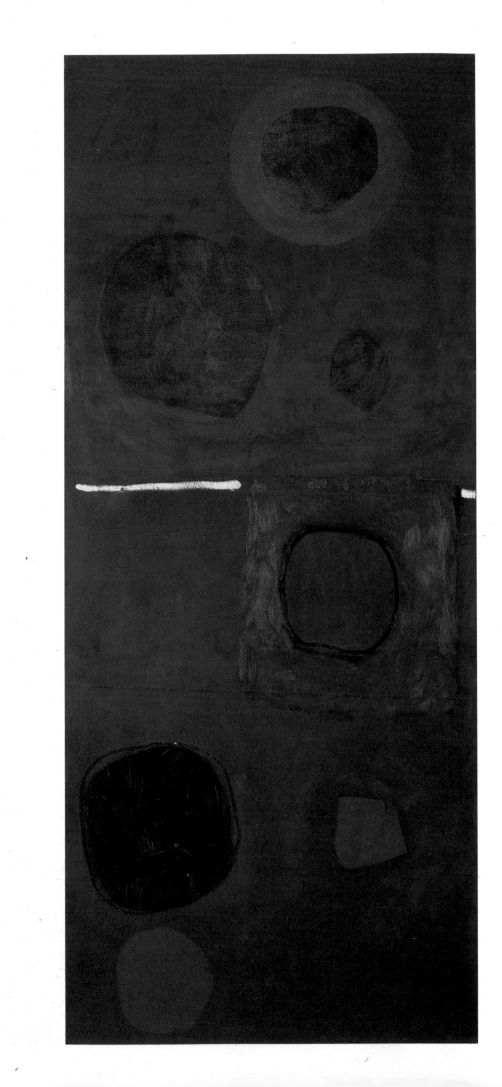

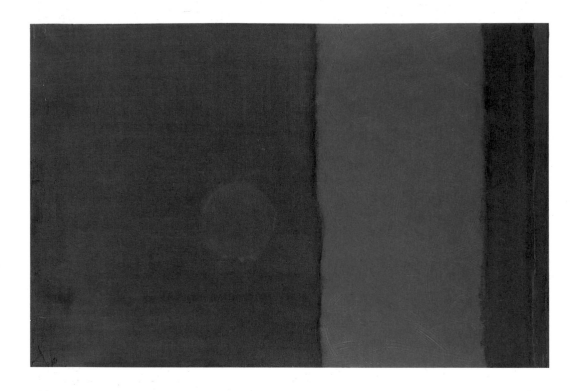

↑ VERTICAL BLUES WITH DISC:
DECEMBER 1962
Oil on canvas 101.6 × 152.4 cm

→ VARIOUS BLUES IN INDIGO:
DECEMBER 1962
Oil on canvas 101.6 × 152.4 cm

» BIG GREEN WITH REDS AND VIOLET:
DECEMBER 1962
Oil on canvas 152.4 × 213.4 cm

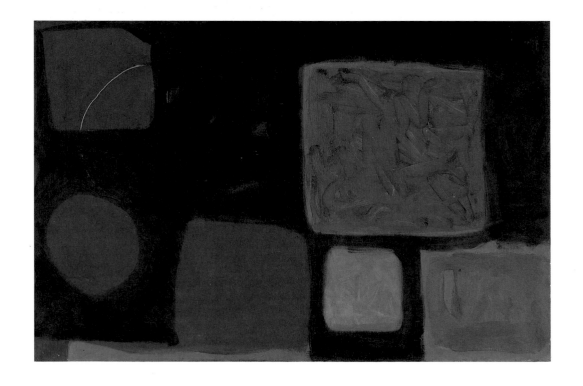

7 IN THE DIRECTION OF COLOUR

1962–77 Exploring the continent

→ ALLOVER REDS, GREEN AND ORANGE:
APRIL 1972 – SEPTEMBER 1974
Detail

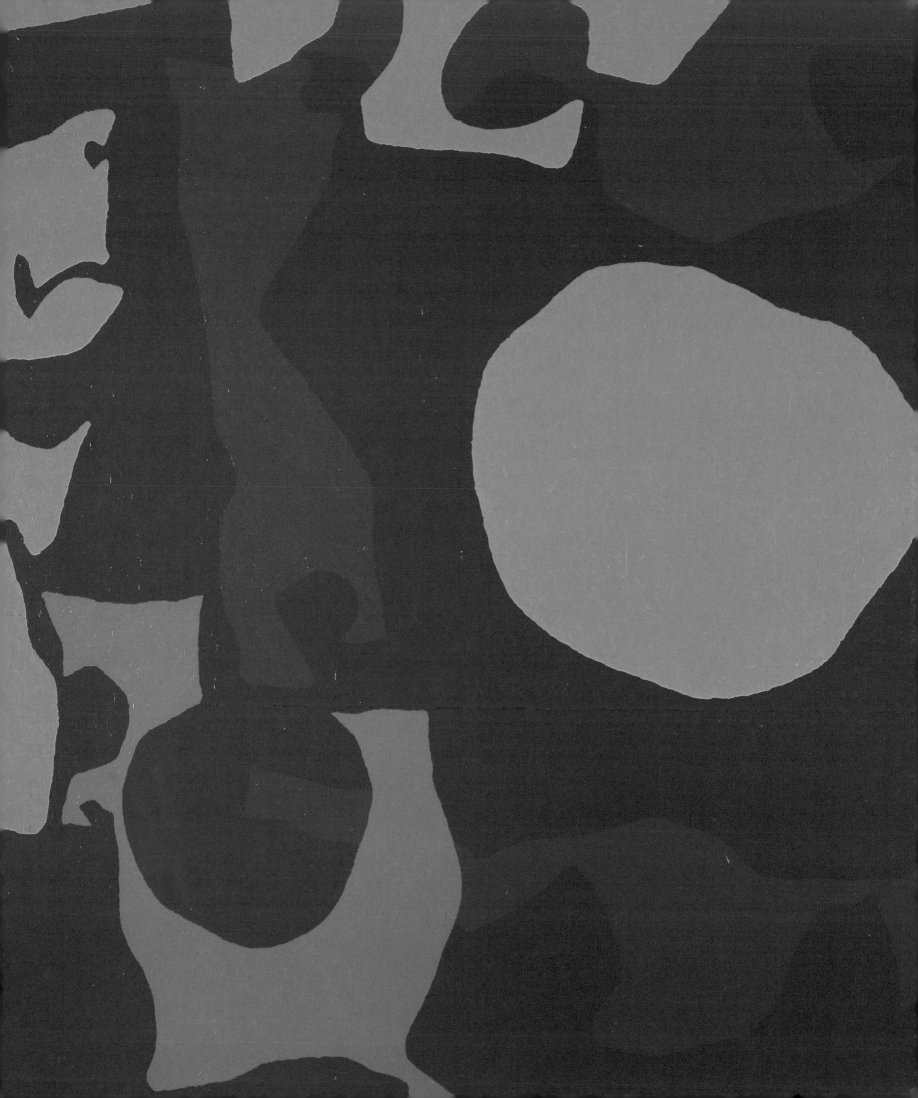

I do not find myself "designing" a canvas: I do not "draw" the lozenge-shaped areas or the soft squares. And these forms are not really "forms" at all, anyway, but simply areas (of soft vermilion? violet? ceruleum? brown ochre?) materializing under my brush when I start to try to saturate the surface of the canvas with, so to speak, varying quantities of this colour or that.' Heron's *A Note on My Painting: 1962,* from which this is taken, was written for the catalogue of his exhibition at the Galerie Charles Lienhard in Zurich in January 1963, and was his first written statement on his own work since the brief note on the painting installed at Lund Humphries in 1958. With a characteristic contrariness, he began almost immediately to draw once more with charcoal directly on to the canvas, mapping out with line the areas which would be subsequently filled in with colour. From a procedure in which he had felt that colour itself determined the actual shapes, or areas, which balanced one another in his painting, he changed suddenly to one in which the composition of the final work was predetermined by a deliberate act of design, and its areas of colour met at boundaries drawn before colour entered the arena. The first of the paintings made in this way was *Rectilinear Reds and Blues: 1963.* Heron has reflected with retrospective insight on this apparently perverse change of practice: '… perhaps this inconsistency was more apparent than real? What I had just said in words, about not drawing or designing, was a fairly accurate comment on what had been happening in my painting *up to that moment*: I now think there's little doubt that, by finally expressing the point in words, I actually de-fused whatever remained of my interest in those soft-edged areas …'.

The new paintings were, in fact, to be concerned with another relational dynamic: that of shapes and areas of colour separated by distinct divisions, whose inter-actions would be direct and juxtapositional. There are still areas of atmospheric colour, but these are delimited and circumscribed, as if seen through windows, or frames, and the overall architecture of paintings as different one from another as *Rectilinear Reds and Blues: 1963*; *Five Discs: 1963*; *Two Vermilions, Orange and Red: September 1964* and *Three Cadmiums: January–April 1964* is of planes arranged on a loose grid across the surface of the canvas. Heron has always insisted that all areas of a painting are equally important to its compositional integrity: even in representa-tional paintings the spaces *between* figurative forms are themselves positive shapes defined by the outlines or edges of the figuration. In his own soft-edge non-figurative paintings of the period 1958–62 the larger areas of a dominant colour were no less shapes than were the lozenges and squares that appeared to float in them.

The development towards a kind of wobbly and imprecisely drawn Nicholson-ian arrangement of rectangles and circles was prompted by Heron's continuing interest in colour interaction, and by a desire to create the more intense optical sensation made possible by an immediate linear border. Heron was working directly with the phenomenal relativity of colour famously remarked by Fromen-tin: 'A colour does not exist in itself since it is, as one knows, modified by the influence of a neighbouring colour. Its quality comes from its surroundings'. This required that for maximum impact upon their neighbours the colours should touch one another without the tonal halo or vagueness of outline of the shapes in paintings as recent as *Orange (With Five): September 18 1962* or *Tall Purple: September 1962*, and that all the shapes in a composition should have a high definition of both colour and outline: '… a colour is most intense when it is delimited,' Heron later wrote in *The Shape of Colour*, 'and the sharper the boundary … the more intense the colour will be.' This drama of colour interaction was intensified in these new pictures by its containment within a notional grid, whose relation to the perfect rectangle defined by the painting's four edges was formally implicit if visually

ironic. (Irony may be defined as the capacity to hold opposites in tension.) Heron's rounded squares and oblongs, lopsided discs and unruly lines have none of Nicholson's ordered exactitude of relation to the canvas edge.

The implication of continuity with the larger process of cosmic relations beyond the canvas edge that gave the image in the earlier paintings an oneiric multi-dimensional spatiality is absent from these paintings. They present us rather with bright surfaces of apollonian brilliance, their configurations of vividly chromatic colour held confined within the theatre of the canvas itself. That is where the drama of ambiguities and contradictions is enacted, as first one area or shape advances or retreats, is perceived as now in front, now behind, another shape or area. The off-centre disposition of shimmering shapes, moving out towards the edge, caught up in an endless dance, has become an asymmetric jigsaw-like decorative fretwork of colour planes. These do not recede one behind the other as in the logically ordered spatial layering of flats in synthetic cubism; the inconsistency of their spatial relations is a purely visual phenomenon, a function of perception. In this respect these paintings differ absolutely in the principle of their operation from the cubist-derived abstractions of Nicholson to which they seem parodically related. Heron's paintings are purely non-figurative inventions of colour and shape, their architectonics visually problematic and arbitrary; Nicholson's are ordered visual propositions, symbolic equivalents for things and places remembered and relations *known* in the mind.

The tendency in Heron's painting at this time was, then, towards an interlocking of colour planes whose edges are irregular, and whose ambiguous spatial relations deny the possibilities of a definitive reading of them as forms in space, since what appears to the eye at one moment to be a figure or a flat shape against a ground appears at the next moment to be an aperture through to a space behind it. The effect is of a pictorially contained, irregular arrangement of colour areas that is essentially ornamental, and which brings any reading irresistibly back to the fact of the flat surface, and the ludic play of the colour shapes across it, foiled by the straight-edged geometric boundary of the canvas rectangle. Nothing could be further from the overlapping forms in space of cubist-derived painting so precisely described by Heron in his writings on Braque.

The affective and conceptual potency of Heron's paintings in the mid-1960s – their capacity to delight and intrigue – is a function of their intrinsic visual dynamics, of the games they invite the eye and the mind to play in the field contained by their physical limits. Their appeal is directly sensational; they have no symbolic burden, they make no deliberate allusions to things in the world, they invite no particular associations. Several years before this Heron had adopted the practice of giving his paintings titles almost always factually descriptive, enumerating specific features (squares or discs), or indicating precisely the names of the colours used in the picture (Heron has always taken a special pleasure in these names). This is not to say that in contemplating these paintings we are not free to find allusive traces or to make our own associations: how could it be otherwise? Colour is inevitably evocative; its intensities and hues are described by terms that have other dimensions of meaning: deep, dark, light, cool, hot; shapes have differing relations of contiguity: they nudge, collide, intrude or invade, hover above or below, envelope; a floating disc recalls sun or moon; a rectangle of colour suggests a window. These images are occasions for memory and recognition; lacking denotation they call forth a language rich in connotations, a language not of the relationship between *things* but of relationships *per se*. In this sense, and in this sense only, the formal relations of colour and shape in these paintings are metaphorical.

Vertical Blues with Disc: December 1962, which was painted shortly before Heron's sudden return to drawn composition in early 1963, has a deliberation of structure that signals a change of direction. It consists of a series of vertical planes, narrowing towards the right, with a roughly brushed dull purple disc, like a pale moon in an ultramarine sky, just lower left of centre. The vibrant opacity of the ultramarine is achieved by a procedure that Heron employed in only one other painting, *Blue Painting: September 1961–September 1962*. This was the repeated brushing with a turps-laden brush of even single strokes, horizontal and vertical in turn, to create a fine 'close-weave' of undifferentiated pure colour, eliminating in the process the uneven translucent shimmer that is characteristic of a blue oil paint applied in a single covering. The brighter blue to the right of this large rectangle is lightly brushed in a washed scribble, the white of the primed canvas visible behind it. The darker blue of the narrower band to the right of that has again been repeatedly wet-brushed to an even opacity, leaving a surface of visibly horizontal strokes. The charcoal-like verticals that separate these bands are actually the dark deposit of pigment carried by the turps to the terminals of the horizontal strokes.

It is clear from the degree of conscious control over both surface effect and pictorial arrangement of *Vertical Blues with Disc* that Heron was already pondering the possibilities of a new mode of composition. But there is very little in the subsequent work that follows the example of this beautiful and mysterious painting, and its ordered geometric modalities are very unusual. (The similarly nocturnal *Blue November Painting: 1963*, and the 1964 gouache *Mysterious Grey: November 23: 1964* – both of which have evocative titles – have similar aspects of composition and colour, and of mood – Heron is a master of the aerial and marine atmospherics of grey, violet and blue.) The fact is that Heron's artistic temperament is impetuous, his decisions quick and intuitive, and his changes of manner and approach as surprising to himself as anyone else. Writing of his own development (after the events) Heron has always concentrated on formal aspects within an elaboration of those key ideas about space and colour that have accompanied his progress into abstraction and thence into the purely non-figurative, non-allusive exploration of colour and light. Passages from one mode to another have usually been signalled by discernible elements in the work preceding the change, by experimental gambits and transitional overlaps.

In retrospect, however, it is possible to discern if not a pattern then at least an interesting recurrence of crises in Heron's life that have coincided with and may have, in one way or another, precipitated specific changes of style. It has been characteristic of Heron's practice from the beginning of his post-war career that periods of intensive creative activity, during which a particular set of visual ideas is explored and worked through exhaustively, are preceded by events of special personal significance or by periods of comparative creative inaction. The end of the war and his marriage to Delia; the move to Eagles Nest; the first summer and autumn in the garden; the decision to give up critical writing in late 1958: each of these events is followed by a distinct stylistic shift and the beginnings of a sustained new manner. The duration of these periods of work varies from a matter of months (as in the case of the *tachiste* garden paintings of 1956) to several years, and they are never self-contained or absolutely unified: neither is their take-off always as dramatically immediate as those of early 1956 and early 1957.

What is of interest here is not the hidden psychology of Heron's artistic evolution, but the visible characteristics of his manner of operation, and the light they throw on his distinctive achievement. Underlying Heron's extraordinary diversities of manner and his mercurial propensity to change has been a remarkable constancy of preoccupation and coherence of artistic purpose. Each new mode is

another procedure for the generation of *images*, and another way of avoiding *symbolism*: 'I hate all symbols in painting: I love, instead, all images … *Images* physically reflect the physical realities of the world surrounding us: but *symbols* are merely linguistic devices invented by men.' (Connoisseurs of the Heronian emphatic will register the extremities of 'hate' and 'love', and notice the insouciance of that 'merely'.) Crisis or inaction alike have been necessary to Heron as the means by which pictorial habit is broken before it codifies into a 'linguistic' convention. Spontaneity, however complex in its operations, must be maintained if painting is to maintain its function as an act of direct realization.

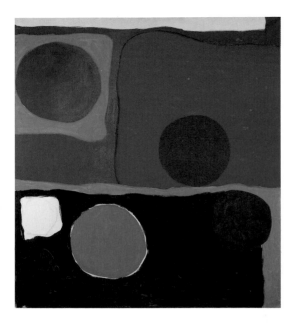

After the opening of Heron's second New York show, in 1962, in a bitterly cold April, he returned to Zennor with hepatitis, and spent the following ten weeks in bed. He did no more painting until the late August, when he began to prepare in earnest for his Zurich exhibition. Paintings of late 1962, such as *Blue Painting with Discs: Orange (with Five)* and *Tall Purple*, (all painted in September), and *Big Green with Reds and Violet: December 1962* are, clearly, stylistically continuous with the work of the previous four years in a way that *Vertical Blues with Disc* is not. But in other paintings shown at Zurich the four-square alignment of distinctly rectangular shapes prefigures elements in the 'design' of the pre-mapped paintings of 1963 and after. Heron had discovered in *painting* the organizing principle behind the configurations he was soon to *draw* on to the primed canvas.

The enforced reflection of the long illness no doubt contributed to Heron's conviction that colour itself was to become the overwhelming concern of his painting in the future. The second paragraph of the published Zurich *Note*, with which this chapter opened, was a comment on his current practice, and related to the procedures by which he arrived at the dispositions of area and shape of his 'atmospheric' paintings. It now seems clear that if he was to fulfil the expectations for the future implicit in the famous first paragraph, then new methods would be required that would more clearly meet the demands for a demonstrative presentation of planar colours and their relations as the primary 'facts' of his painting.

Painting has still a continent left to explore, in the direction of colour (and in no other direction). Painting, like science, cannot discover the same things twice over: it is therefore compelled in those directions which the still undiscovered and the unexplored dictate. It seems obvious to me that we are still only at the beginning of our discovery and enjoyment of the superbly exciting facts of the world of colour. One reels at the colour possibilities now: the varied and contrasting intensities, opacities, transparencies; the seeming density and weight, warmth, coolness, vibrancy; or the superbly inert "dull" colours – such as the marvellously uneventful expanses of the surface of an old green door in the sunlight. Or the terrific zing of a violet vibration … a violent violet flower, with five petals, suspended against the receptive furry green of leaves in a greenhouse! Violent violet cobalt! Certainly I can get a tremendous thrill from suddenly seeing two colours juxtaposed – anywhere, indoors or out (but I am no landscape painter in disguise, incidently).

If this has the falling-over-itself intensity of utterance under the pressure of an internal imperative and almost inexpressible feeling, *Rectilinear Reds and Blues: 1963* makes its vibrant address to the senses with the declarative certainty and visual eloquence of a bright ensign. Its colours, meeting at decisive boundaries, sing against each other with a resonance increased by the constraints imposed by the delimited arena of the canvas, each of the internal rectangles asserting itself in parallel to the dominant coordinates, vertical and horizontal, of the larger rectangle within which it is placed. When Norbert Lynton, writing of Heron's Waddington show in 1963, remarked that Heron 'builds images out of colour', his emphasis upon the architectonic was especially true of paintings like this, and those which were to follow. He continued, 'It may be that … were such a thing feasible, an analysis of

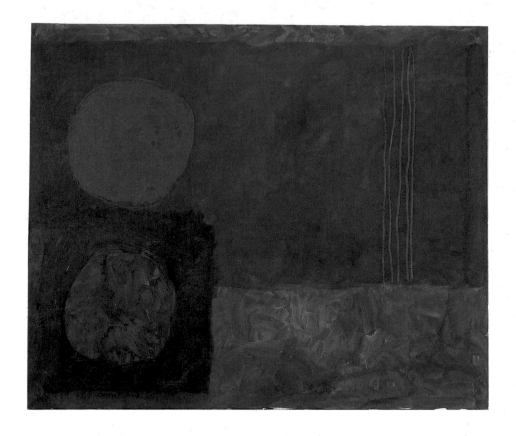

↑　BLUE NOVEMBER PAINTING: 1963
　　Oil on canvas　152.4 × 182.9 cm

→　MYSTERIOUS GREY: NOVEMBER 23: 1964
　　Gouache　44.7 × 68.6 cm

⇥　RECTILINEAR REDS AND BLUES: 1963
　　Oil on canvas　152.4 × 182.9 cm

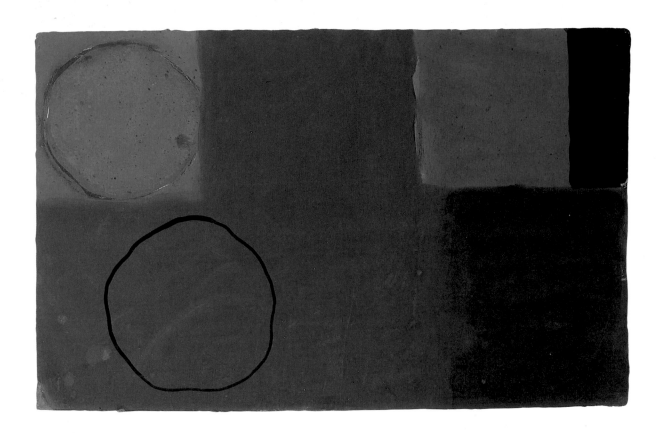

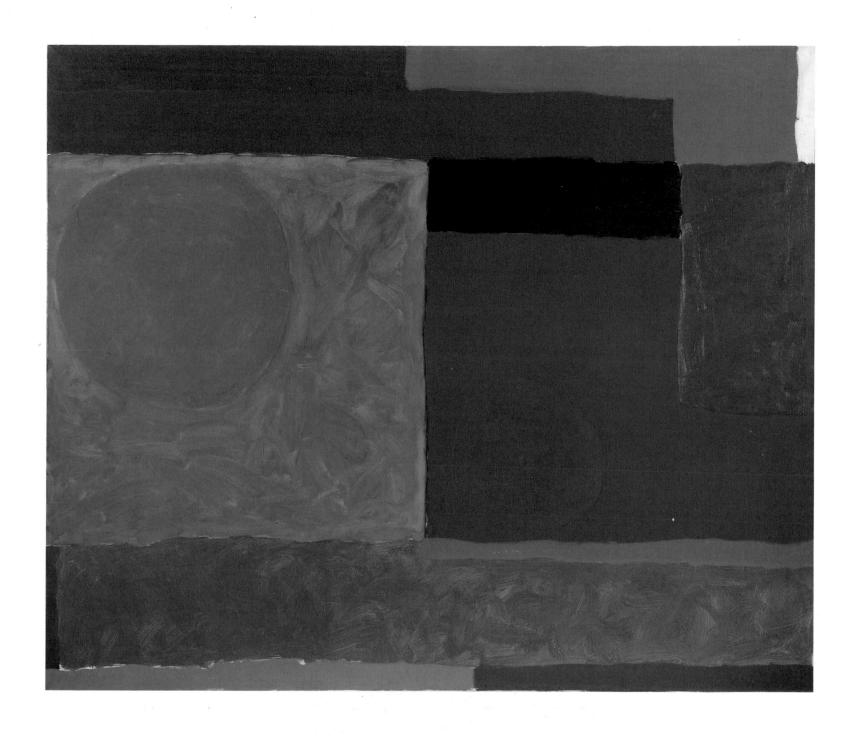

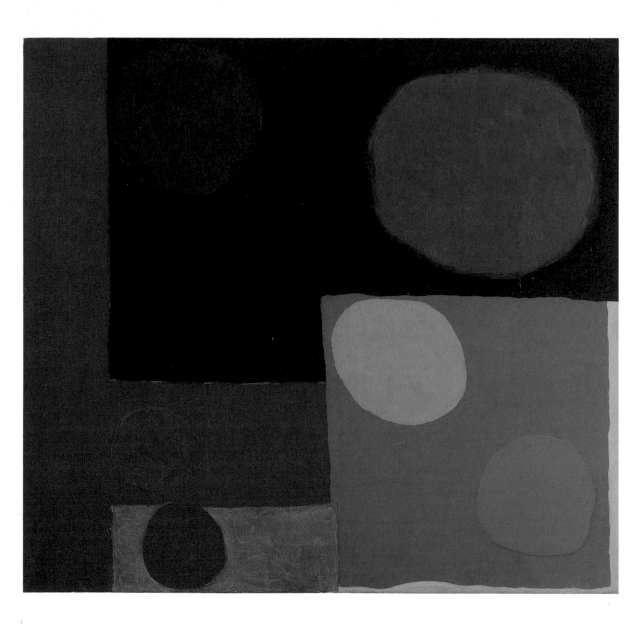

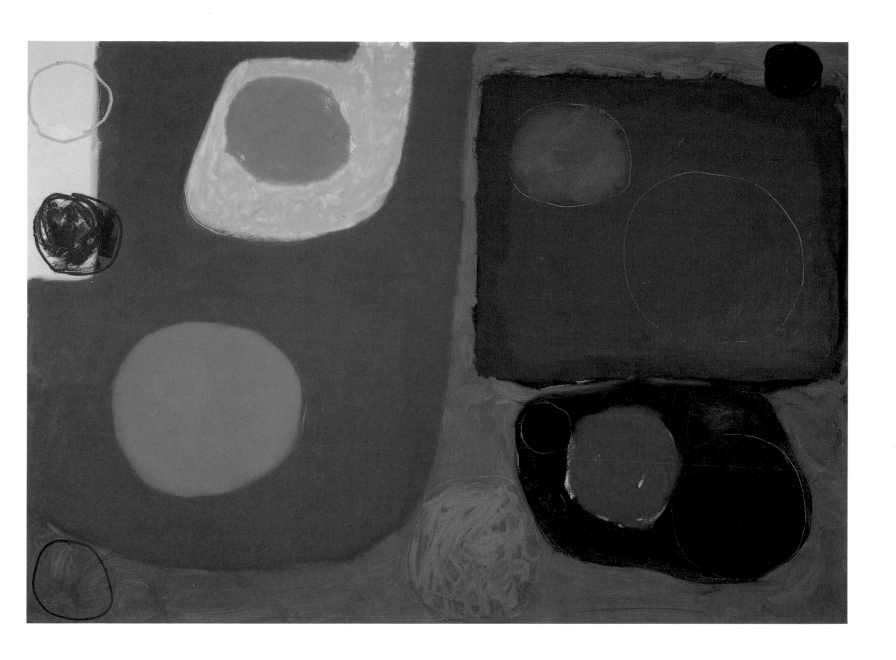

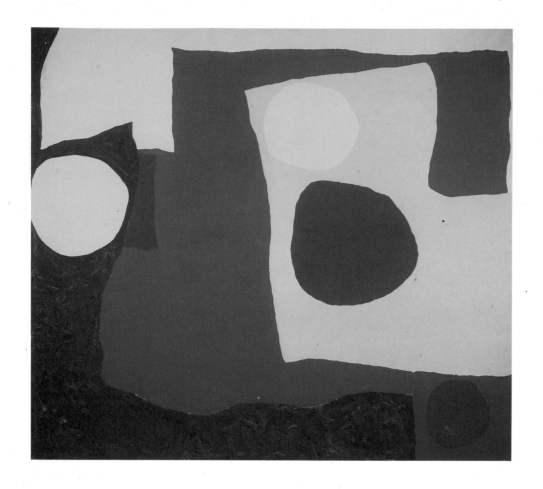

↑ YELLOWS AND REDS WITH VIOLET
 EDGE: APRIL 1965
 Oil on canvas 152.4 × 167.6 cm

→ COMPLICATED REDS, FIVE DISCS:
 MARCH 1965
 Oil on canvas 121.9 × 132.1 cm

⇒ TWO VERMILIONS, ORANGE AND
 RED: SEPTEMBER 1964.
 Oil on canvas 152.4 × 213.4 cm

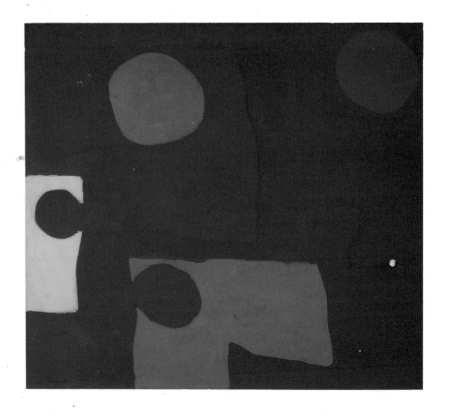

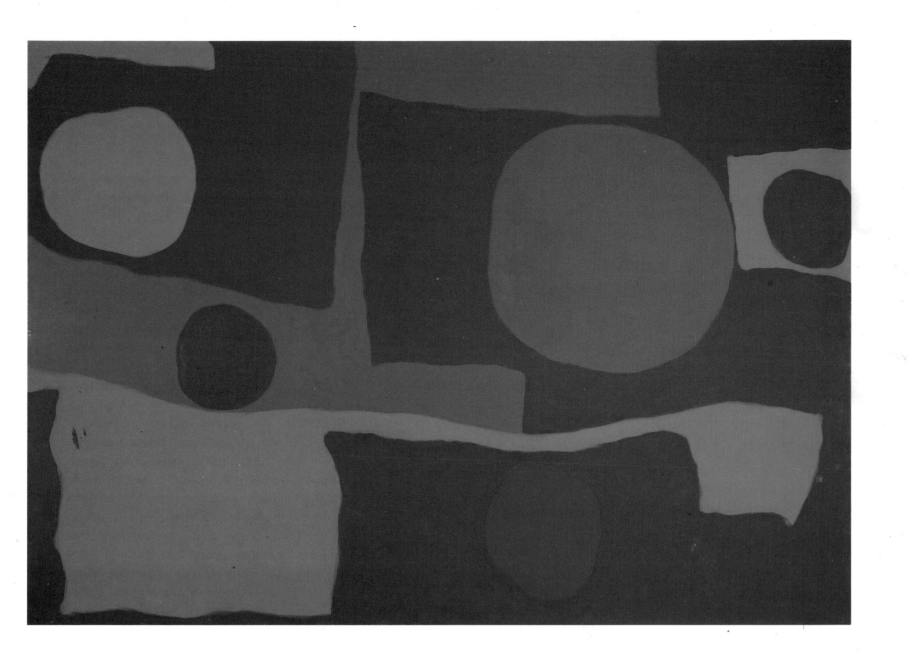

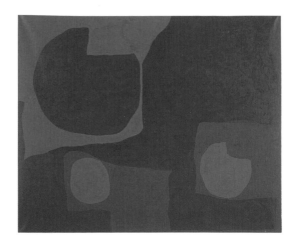

the communicative function of his paintings would show that his forms play as important a role as his colour, but they are in effect, as he says, colour-forms [Lynton is referring to the Lienhard *Note*], and in those paintings that seem to me the best … it is not possible even to distinguish significantly between forms and the colour-fields they inhabit.' Lynton recognized that Heron's purpose, to discover the 'superbly exciting facts of the world of colour', was intrinsic to his compulsion to paint, and that painting was the process by which those compulsively discovered "facts" were made objective: '… his paintings, for all their apparent simplicity, are complexes *expressing themselves* through the disposition of colour and the visible record of its disposing as ductile matter.' [my italics]

The undisputed masterpiece of this period is the pivotal *Fourteen Discs: July 20 1963*, which on account of its problematic oddness remained unexhibited for twenty-two years. This looks both backwards to the spatial atmospherics of the soft-edge paintings of the previous period, and forward to what Heron was to call his 'wobbly hard-edge' paintings of the late 1960s and the 1970s. Even more significantly, it anticipates the more open composition, the looser and more varied handling, and the vital relations of free-floating forms, of paintings of the early 1980s such as *Lemon Disc in Sea Green with Zig-zags: July–December 1982* and *Big Purple Garden Painting: July 1983–June 1984*. In containing so much in terms of both summation and potential it stands alone, a marvellously ludic picture of an unpredictable universe. Many of the 'discs' are in fact sgraffiti circles added after the laying in of the painted surface into which they are inscribed, or drawn round a roughly circular area of loosely scribbled brushwork; the shimmering orange disc in the large 'inert' dull green shape left of centre, like the green floating disc in the pale blue inlet above it, and the dull green one enclosed in the purple boulder shape to lower right, appears to have been 'arrived at' by the loaded brush; the large green, with its harbour inlet at the top, is a decisively drawn shape, 'an uneventful expanse', a dark peninsula into the aerial or aquatic atmospheric blue. Read this marvellously complex image as we like, and project what we may into its forms and their vitally kinetic interplay (the larger forms are centripetal; the discs and circles centrifugal) it insists at all times on its irreducible objectivity as a flat painted surface.

An emphasis on the *structure* of the paintings of the mid-1960s, and on its expressive relation to the pictorial exploration of the possibilities of colour should not be taken to indicate any didactic purpose on Heron's part. His work at this time plays subversively with those geometric forms that have since Pythagorus been seen as signs of an ideal universe parallel to our own. Heron is resolutely materialist, but his philosophy is embodied in his art in terms of exemplification and expressive form, and linked in his mind, significantly, with the physical flatness of the canvas as a reality whose truth must be admitted even when a painter is interested in the representation of figures and objects in illusionistic space. Hence his reverence for Bonnard, Braque and Matisse, and his comparative reservations about Picasso. There is an underlying coherence in this: the joyfully anarchic pictures of the mid-1960s, whose wobbly shapes are like parodic versions of Platonic forms, curvilinear and kinetic rather than straight and still, are indeed compositions of that 'abstract music of interacting form-colour' that he wrote of in his 1947 essay on Bonnard. 'Unlike Ben Nicholson I have never in my life drawn a straight line or a purely circular circle or disc,' he was to write in 1973. 'To my eye, at least, an absolutely straight line or colour edge, and a pure arc or circle, both seem destructive of the flatness of the picture surface: both seem to me to rise up off it, or to sink back too deeply into it – a fact which the logic of Nicholson's own shallow reliefs perhaps bears out?'

The abstract music of such paintings as *Five Discs: 1963*; *Fourteen Discs: July 20 1963*; *Discs Escaping: 1964*; *Yellows and Reds with Violet Edge: April 1965*, and *Three Cadmiums: January–April 1966* offers a complex and subtle pleasure, involving not simply a sensational response to colours and the vibrations between them, but delight at the unruly play of actual forms – physical expanses of pigmented stuff – whose irregularities mock the ordered geometries and constructions of the ideal, and whose visual relations contradict the logics of both perspectival and cubist space. These paintings are among Heron's most exuberantly playful: they are, above all, expressions of delight in the ineluctable modalities of the visible.

In July 1965, at the ICA in London, Heron made a short speech in which for the first time in public he criticized American artistic chauvinism in general and the role played by Clement Greenberg in the critical promotion of American painting in particular. The event caused something of a stir: here was one of the earliest and most eloquent of champions of post-war American abstraction apparently changing his tune with a vengeance. It was in fact the first of a series of vehement attacks on the critical orthodoxy perfectly encapsulated in the opening sentence of Michael Fried's 1965 study of Noland, Olitski and Stella, *Three American Painters*: 'For twenty years or more almost all the best new painting and sculpture has been done in America …'. Heron's campaign against what he perceived as 'a kind of cultural imperialism' began in earnest with an article in *Studio International*, December 1966, entitled 'The ascendancy of London in the sixties' in which he also attacked 'the sheer gutless obsequiousness to the Americans which prevails amongst so many British critics and art pundits', and asserted the living presence in British painting of 'not one, but three generations of painters whose vitality, persistent energy, inventiveness and sheer sensibility is not equalled anywhere else in the world.' Heron was referring to an older generation of established painters that included Ben Nicholson, Ivon Hitchens, Ceri Richards and Victor Pasmore; to that 'middle generation' to which he himself belonged, and of whose work he had written so passionately and persuasively through the mid-1950s; and to the host of brilliant younger painters, figurative and non-figurative, on the contemporary British scene, including John Hoyland, Patrick Caulfield, Harold and Bernard Cohen, and David Hockney.

Heron was at pains in this and subsequent articles for *Studio International* ('A kind of cultural imperialism?' was published in February 1968, and a third piece, 'Two Cultures', in December 1970) to remind his readers that it had been painters of the 'middle generation', Davie, Scott, Lanyon, and himself, as writer as well as painter, who had been quickest off the mark to realise that something important had happened in New York in the late 1940s and early 1950s, and whose own work had most directly registered a creative response: '… by 1950 these Americans [the famous 'first generation' of New York painters] had all arrived … at the large-scale, empty, shallow-space format by which the world knows them: and this precisely was the revolution which we hailed, because it showed the way out of the claustrophobic post-cubist idioms of postwar French painting and led to new concepts of pictorial space. It is precisely because (unlike the French) we British openly availed ourselves of the American discoveries, making them to some extent our own new point of departure, that we have been able now to advance far beyond the American positions of 1950 …'. The Americans, on the other hand, had never really advanced beyond those formats at which they had arrived by 1950: they had achieved 'the extremes of flatness, emptiness and bigness … almost

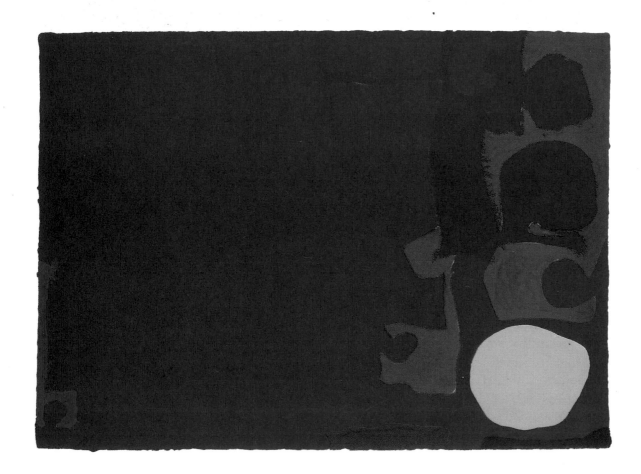

→ CERULEUM AND ULTRA
INTERLOCKED (RED AND BROWN
OVERLAPPED): JULY 1969
Gouache on hand-made paper
59 × 77.8 cm

↓ COBALT WITH RED AND YELLOW:
1968
Gouache on hand-made paper
60.3 × 79 cm

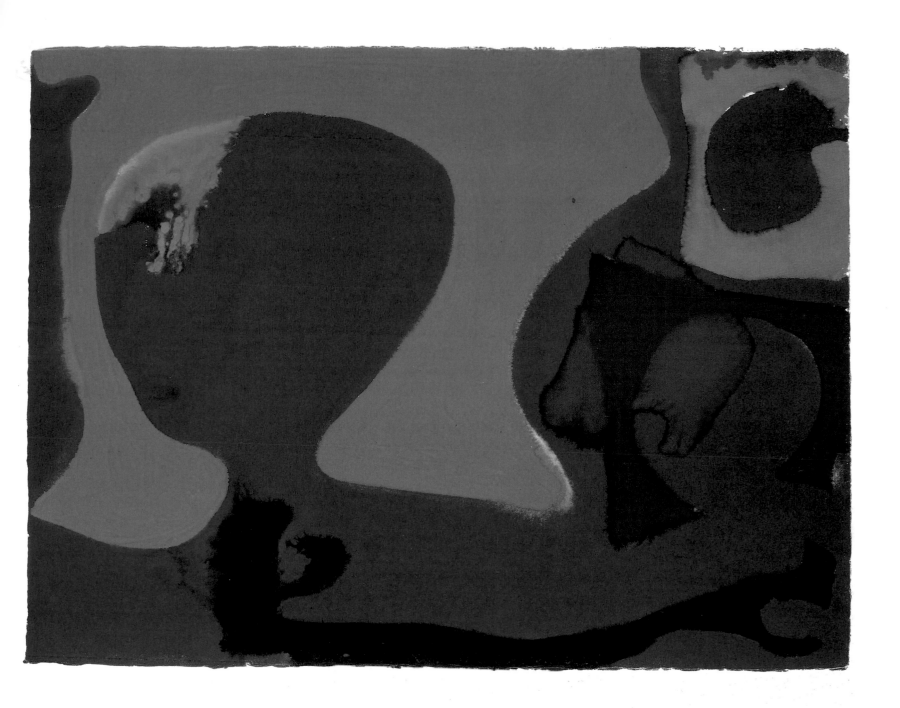

at a bound' and 'gone into production'; they had been unwilling or unable to 'go in the only direction left open to them (i.e. towards some sort of *re-complication* of the picture surface), they have had to stand still.'

Heron justified his assertion of the ascendancy of British painting in the mid-1960s by particular reference to its complexities of texture and composition, and its access to 'European resources of sensibility and instinct'. As British painting had become more technically adventurous and diverse, American painting had become merely academic, its pictorial emptiness arid, the inevitable outcome of its subservience to concept and system. A consequence of this domination of the idea had been its susceptibility to the programmatics of the critical formalism exemplified by Greenberg, elaborated in detailed applications by disciples like Fried, and demonstrated in tendentious publications and exhibitions: 'If ever an academic movement was heralded as the latest manifestation of the *avant garde* that movement was Post Painterly Abstraction.' The widespread preference of American 'post-painterly' painters (not only of the abstract varieties) for pouring, staining, spraying and rolling – for 'methods of applying paint so that it was clinically impersonal, literally dead flat in quality' – was related to their intellectual and systematic purposes; the 'hand-done paintwork' favoured by British painters was expressively effective, vitally complicating the surface, an 'infinitely powerful and subtle means for giving a colour-area its precise spatial function'.

The personal touch – the sensible *facture* – of British painting was functionally related to its persistent commitment to the idea of 'composition' ('a nice, old-fashioned word' Heron had called it in *A Note*): to the resolution, that is to say, of 'asymmetric, unequal, disparate formal ingredients into a state of architectonic harmony'. Heron was exact in his identification of its essential characteristics: nobody had paid more assiduous attention to the specific qualities of the work of his compatriot contemporaries. The intuitive discovery of the image in the act of painting itself, that poetic empiricism that was typical of much of the best British abstract painting of the post-war period, gave it an expressive variety and a range of pictorial invention. This was quite opposite to the centred symmetrical format and the serial and systematic repetition of motif and device that were typical of those American painters of the 1960s so admired by Greenberg for their 'renunciation of virtuosity'. In 1970 at the ICA Heron delivered an extraordinary three-hour polemic, copiously illustrated by slides, entitled 'Symmetry in Painting: An Academic Formula'. To exploit the obvious and exclusively conceptual 'unity' of the symmetrical image, with its 'spuriously powerful presence' was '… to short-circuit the whole pictorial adventure and to funk absolutely all the million risks which attend the fascinating search for new unities in asymmetric and diverse complexity.' The climax of Heron's sustained campaign against the international promotion of American painting, and the pusillanimity and ignorance of British critics who had failed to acknowledge either the quality or the influential originality of the British 'middle generation' painters, was the famous article, spread over three days, in *The Guardian* in October 1974. There he wrote again of the 'overtly ratiocinative' origins of American painting, and its consequent 'mechanicalness' of execution.

'I have myself always believed … in the hand-stroked, hand-scribbled, hand-scrubbed application of paint: putting paint on a flat surface with a brush is just about the greatest possible pleasure I know,' he wrote in 1970. And brushwork was a register of individual sensibility: '… no two artists overlap in their nervous brush-writing.' His own paintings at this time exemplified in an extreme way his commitment to the hand-done surface: Heron was working on an unprecedented

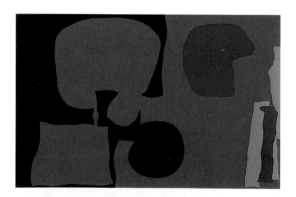

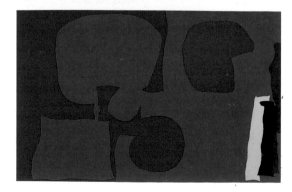

scale; on canvases as wide as thirteen and fifteen feet he was creating areas of up to sixty square feet of intense opaque colour entirely applied with small Chinese water colour brushes. Mixing large bowls of a chosen colour, directly from the tube, with turps and linseed, he committed himself to creating the entire area of a designated colour in a single session, knowing that to stop and start again after a break always left a discernible line, a distracting demarcation in a field whose shimmering intensities and subtle sensuousness had to be continuous: '… one may find one has induced a sort of life or vibration, in itself pretty unanalysable, in an apparently flatly painted, apparently uniformly smooth paint-area by a paint application which vanishes when dry, except that the brush-scribbles remain semi-visible in relief only.' The colours of these areas were chosen on impulse, never in accordance with any preconception of colour relationship or theory of colour relations; Heron's obsession with colour has never extended to any systematic theoretics or experimental research. It begins and ends in the actualities of pleasure: '… in fact there is an intense elation in allowing awareness of colour to flood the mind – and this was clear to me long before Huxley made mescalin famous.'

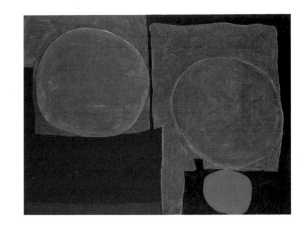

It is a pleasure intensified by the interaction of one colour upon another, by the vital kinaesthetics of colour juxtaposition. Heron's intent was to create these interactions and induce these pleasures by defining the frontiers between colour areas in his paintings with a dramatic precision, and by setting extensive planes against smaller shapes, wide horizontal or steeply vertical sheer fields against enclosures and attenuations, to exploit to the maximum the dynamics of colour relativities. His paintings through this period make their impact upon the senses with an exhilarating physicality, and their titles leave no doubt as to the existential identification of their *subject* with its *objective* realization in the work that confronts and dominates the optical field of the spectator. *Orange in Deep Cadmium with Venetian: 1969*; *Cadmium with Violet, Scarlet, Emerald, Lemon and Venetian: 1969,* and later paintings such as *Emerald in Dark Red with Violet and Blue: February 1972* and *Big Cobalt Violet: May 1972* are grand colour machines whose sheer scale and chromatic vibrancy give them a remarkably powerful presence, and their sensational directness and complexities of optical and spatial effect are utterly original in the manner of their achievement. Their idiosyncratic configurations of brilliant colour constitute a major visual invention: they are images as inextricably linked in our mind's eye with Heron's name and vision as the circles and rhomboids of Nicholson, the rectangular primaries of Mondrian, or the soft-edged colour clouds of Rothko are with those of their authors.

The scale of these paintings is crucial to their impact, and in late 1969 Heron wrote an essay for *Studio International* in which he reflected on this and other aspects of their working. Before considering *Colour in My Painting: 1969*, a remarkable document that remains in some ways the most illuminating statement on his own work, we must return to the summer of 1967, and a disastrous event that had momentous consequences for Heron. Canoeing with Bryan Wynter, for what was the first and the last time, he returned exhausted to the granite quay, and climbing out of the canoe in a rough sea was struck heavily by the now waterlogged craft. Dragging himself on to land he was horrified to see the bones of his lower right leg visibly protruding at right angles with seaweed caught on them. His leg broken badly in four places below the knee, Heron was to be disabled and out of action for over a year. When after some months he had recovered enough to work at all, it was possible only to make gouaches.

It was during this period that Heron discovered those distinctive compositional configurations that were to characterize his painting for the next ten years.

CADMIUM WITH VIOLET, SCARLET,
EMERALD, LEMON AND VENETIAN:
1969
Oil on canvas 198 × 396 cm

ORANGE IN DEEP CADMIUM WITH
VENETIAN: 1969
Oil on canvas 208.3 × 335.3 cm

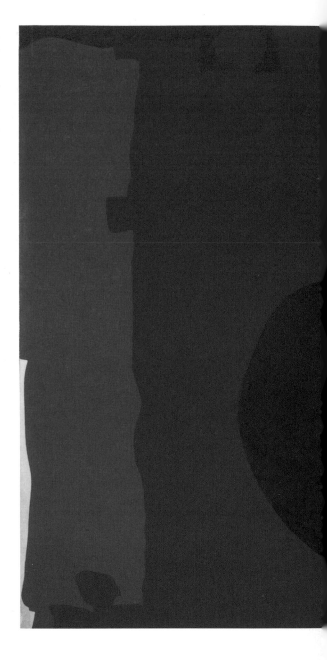

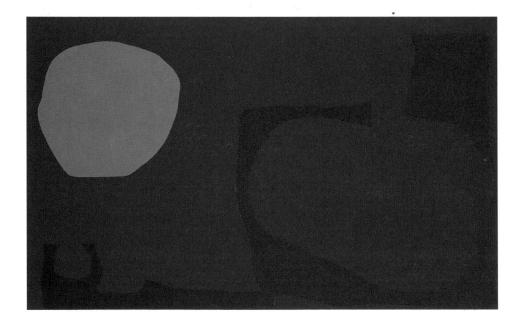

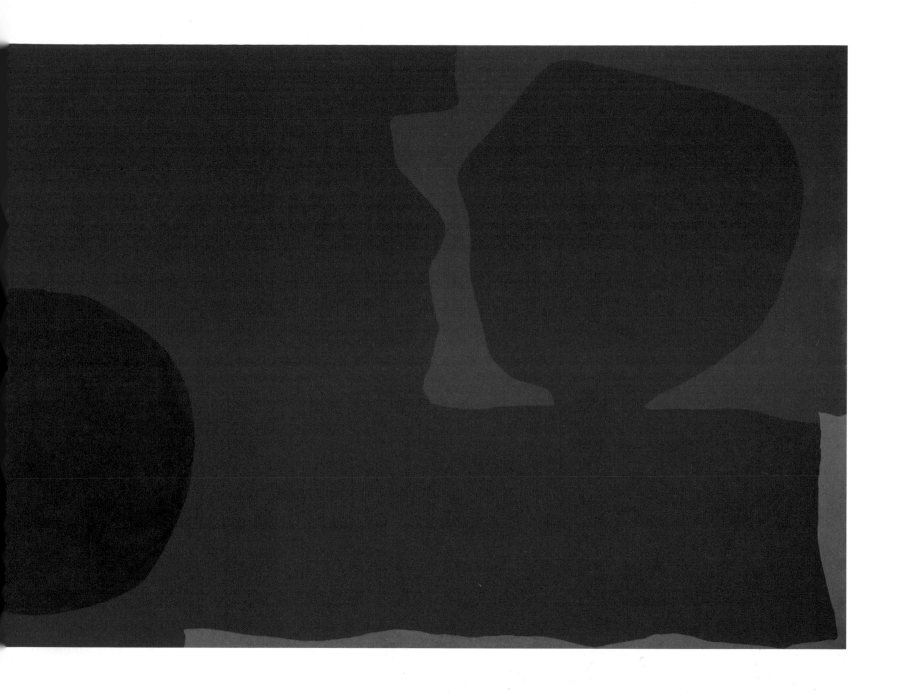

→ RUMBOLD VERTICAL I: EMERALD IN
REDS: FEBRUARY 1970
Oil on canvas 213.4 × 121.9 cm

⇒ RUMBOLD VERTICAL FOUR: GREEN
IN GREEN WITH BLUE AND RED:
SEPTEMBER 1970
Oil on canvas 213.4 × 121.9 cm

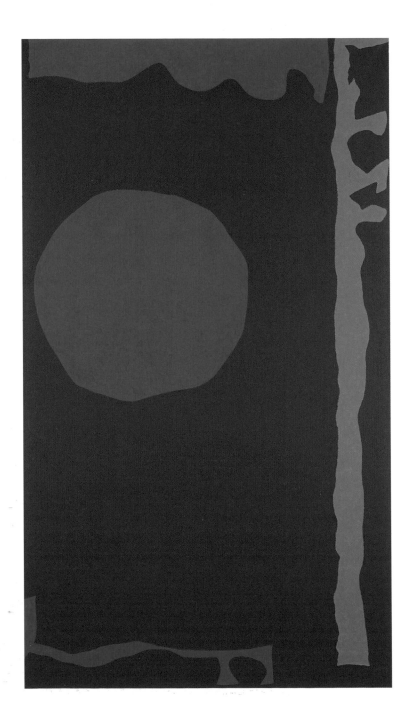

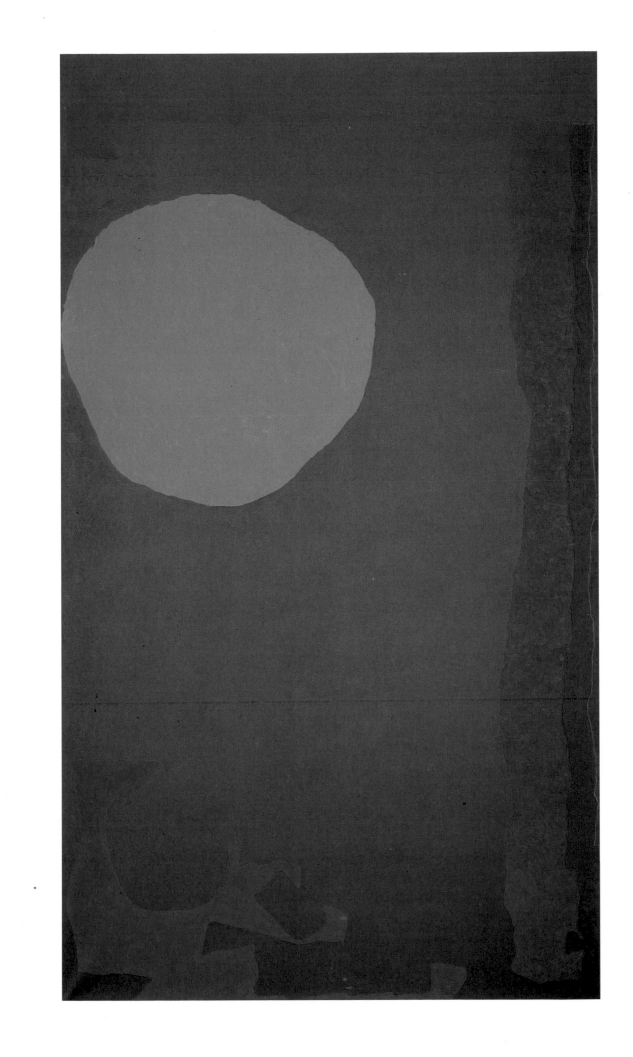

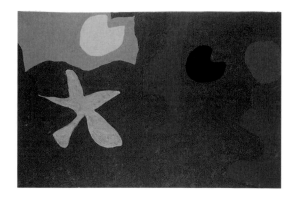

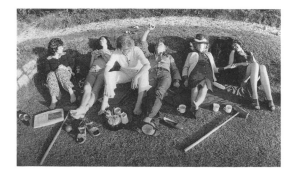

Once again a personal crisis precipitated a significant change of direction. Of course, many of the formal devices of this new pictorial style are anticipated in the paintings of the mid-1960s: the harbour shape, like the negative cut in a jigsaw pattern, or like the circular segment punched out of a bus ticket, which first appeared in *Discs Escaping* in 1964. The familiar discs like great suns low on autumn horizons, refracted through dense atmospheres or shimmering in reflective pools; and the islands, lagoons, bights and isthmuses, inlets and headlands that constitute the topography of these images, like complex coasts seen from the sky, or the intricate littoral geographies of runnel and rockpool and wind-and-water-ruckled expanses of sand: all these elements can be found in the earlier work. So too, the vivid impressions of space in colour, the sense of deep connections between the external world, its light playing across and through things, and these abstract realizations, brilliantly emphatic analogies, can be seen and felt as characteristic of Heron's work since the 'garden paintings' of early 1956.

What has changed is the underlying formal structure of the paintings. The recurrent motives are no longer held within a compositional arrangement based upon an invisible but implied grid, but freely drawn and discovered by an impulsive cartography: 'The only rule I follow while painting is this: I always allow my hand to surprise me,' Heron wrote in the 1969 essay, '(the lines of all the frontiers in my recent paintings are drawn-in in a matter of a few seconds)'. The severely asymmetric intuitive arrangement typical of this new series of paintings can be discerned in the numerous gouaches that Heron made in 1968, small works such as *Cobalt with Red and Yellow: 1968*, in which the fluidity of the medium seemed to lead Heron's visual imagination into the contemplation of new pictorial possibilities. Imaginative scale is not confined by the dimensions of the support (Klee made some of the grandest paintings of the century within the span of inches), and enforced contemplation breeds desire. When Heron was released to paint again he immediately sought to translate the imagined immensities of the gouaches, with their oceanic stretches of saturated spatial colour, into actual magnitudes of luminosity. He was after what he called a 'full emptiness', colour stretched physically to the limit where it still maintained integrity as a component of the image. The maximal sensation created by a vast field of a subtly differentiated pure hue, the optical vibrations generated by colour juxtaposition at linear boundaries, and the dynamic equilibrium of disparate formal elements by which motive and shape oscillate between negative and positive: these were the means to artistic purposes that only oil painting could fulfil.

These were briefly adumbrated in *Colour in My Painting: 1969* which though written retrospective to the first paintings in the new manner, has a passionate immediacy and directness of utterance that comes of being written, nevertheless, out of the heart of the process. Heron was in fact still close to the beginning of the great adventure of his exploration of colour in the 'wobbly hard-edge' manner that was to occupy him until the end of 1977. (He coined the term, in fact, in that 1969 essay.) 'The sensation of space I value', he wrote, 'is one generated by plain opaque surfaces placed at a measurable distance before my face: thus, the contemplation of colour I refer to is something which heightens my accurate awareness of my own physical position in relation to such surfaces, *and to my actual physical environment. Awareness of colour, in my sense, is therefore a means of leading one towards the everyday realities of one's physical environment …*' [my italics]. This stress upon the 'everyday realities' relates to an emphatic contradistinction that Heron, writing at the end of the 1960s, was at pains to make between colour-in-painting and 'the filmy, essentially unsubstantial, transparent, veil-like revolving vapours of

'colour' now universally associated with "the psychedelic"', which he disliked intensely. (It might be added in passing that Heron objected similarly to the disorientating and hallucinatory effects of much Op-Art.) As always, there is in Heron a Matissian predisposition towards the apollonian radiance of the natural world drenched in its natural light: the 'rainbow lights' of psychedelia 'seduce the spectator into a more or less hysterical dreamworld, while the fully conscious concentration upon colour relationships in painting, and upon the sort of spatial illusion *they* generate, is an exercise leading to a real – not an imagined – heightening of the senses.'

In *Colour in My Painting: 1969* Heron provides a description of this vital 'heightening of the senses' that occurs in the real presence of an actual painting such as *Orange in Deep Cadmium with Venetian: 1969*: 'If I stand only eighteen inches away from a fifteen-foot canvas that is uniformly covered in a single shade of red, say, my vision being entirely monopolised by red I shall cease within a mtter of seconds to be *fully conscious* of that red: the redness of that red will not be restored until a fragment of *another* colour is allowed to intrude, setting up a reaction. It is in this interaction between differing colours that our full awareness of any of them lies. So the meeting-lines between areas of colour are utterly crucial to our apprehension of the actual hue of those areas: the linear character of these frontiers cannot avoid changing our sensation of the colour in those areas … *The line changes the colour of the colours on either side of it.*' Heron attributed the sharpening intensity of the sensations of hue induced by chromatic colours of the wobbly hard-edge paintings precisely to the drawn linearities that separated them: the sharper the division, the greater the distorting vibration of colour on either side, whatever those colours might be, and whatever their relations in the traditional theories of the spectrum.

It goes without saying that the immediacy of sensational impact of which he is writing is *only* possible in the actual relation of spectator to painting. The objecthood of the painting, its absolute identification of material and idea, medium and image, is what gives it its unique power, and painting as an art its unique authority. Whether it tends towards the self-defining 'purity' and flatness of Greenberg's reductive version of modernism or to the illusionistic perspective, modelling and chiaroscuro of the many modes of realism, it is the *fact* of painting not the idea it represents that matters in the first place. It is also true, of course, that the demands of making paintings at the scale of those under discussion entailed a physical involvement (actively sought by Heron after the confinement of his disablement the year before) of an extraordinary kind. (Newman's painting of his largest canvases, also undertaken with a sensitive concern for local touch and texture over large single-colour areas, is comparable in this respect, though not in others.) The specific nature of the physical effort involved, and his prolonged proximity to the canvas, engulfed by an expanding visual field of interacting colours as the work moved towards completion, intensified Heron's consciousness of the sheer materiality of paint, and of the subtleties of the space that brushwork itself creates. 'Colour is paint' and 'brushwork is spatial' became watchwords that provided him with the titles of two of the lectures he delivered at the University of Texas at Austin in 1978, when he exhibited over thirty large paintings from the late 1960s through to 1977, the year in which he made the last works in the 'wobbly hard-edge' manner.

The drawing of the shapes and their configurations in these paintings was effected in a matter of seconds, with thin felt-tip pens directly on to the grainy canvas, often after many hours of preparation, and hundreds of small sketches (never transcribed as such on to the canvas). Heron was moving towards the finer line and the sharper division before his accident; the discoveries of shape and the freeing of

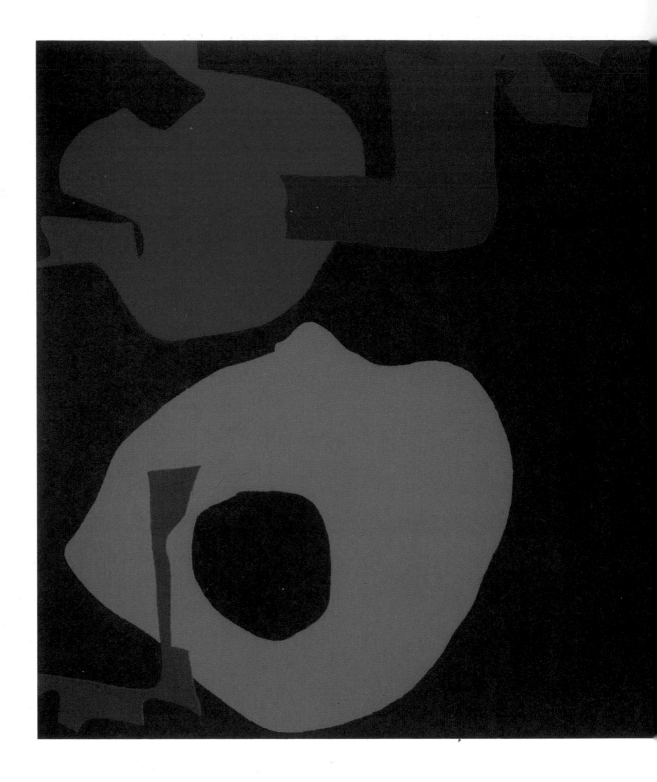

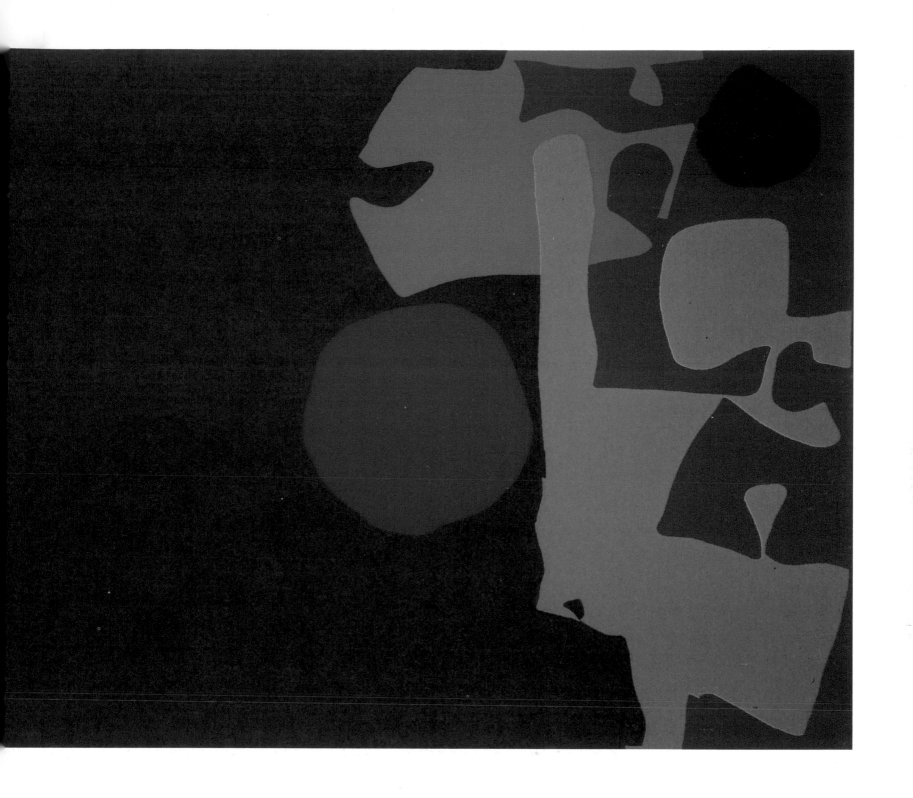

ALLOVER REDS, GREEN AND
ORANGE: APRIL 1972 – SEPTEMBER
1974
Oil on canvas 152.4 × 167.6 cm

COMPLICATED GREEN AND VIOLET:
MARCH 1972
Oil on canvas 182.9 × 305 cm

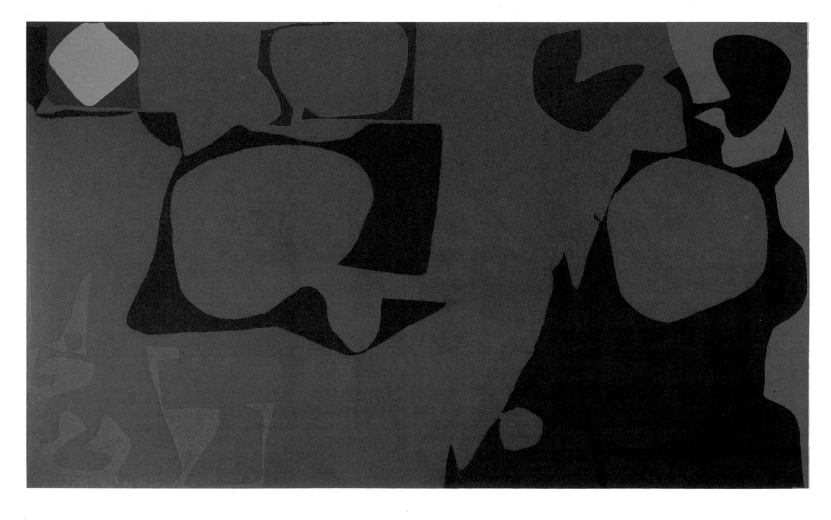

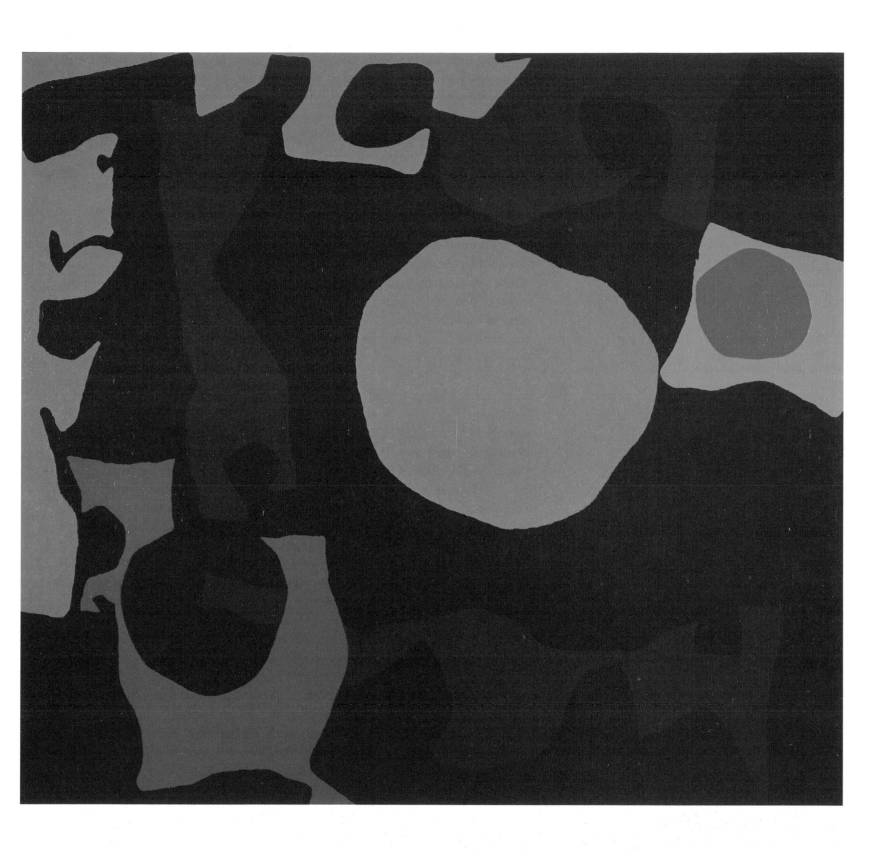

the compositional impulse that the work with gouache brought about confirmed the necessity for the rapid, spontaneous establishment – at one go and as fast as the arm could move across the wide expanse of the primed canvas – of the outlines of projected colour areas. There followed the long slow process of painting in the areas: the covering of surfaces with one luminous skin of brushed pigment, which took as long without break as was necessary to complete, and felt, in Heron words (as so often, topographical), like painting 'up to a further shore'. In the case of *Long Cadmium with Ceruleum in Violet (Boycott): July–November 1977* we have Heron's word that the painting of the cadmium red occupied nine hours of non-stop brushing. (The painting was begun at the moment Geoffrey Boycott stepped up to the wicket in the second test against Australia, for what was to be a match-winning innings: Heron remains a Yorkshireman.)

The paintings of this period are wonderfully diverse, and consistently visually exciting. The earliest, such as *Cadmium with Violet, Scarlet, Emerald, Lemon and Venetian: 1969* and *Orange in Deep Cadmium with Venetian: 1969*, have a striking simplicity of forms, with the suggestion still that the discs and circular harbour shapes are somehow related, as if they were parts of some previous integrity which has been broken up by centrifugal energies, akin to a sort of pictorial continental drift, and set asunder. This is not to suggest that these paintings propose a continuity with the universe beyond the rectangular frame, in the manner suggested of the atmospheric paintings of the late 1950s and early 1960s. The edge elements in these paintings (the scarlet, emerald, lemon and venetian of the former, the venetian of the latter) are constraining, even framing devices, holding the colours tightly within the picture, enforcing the eye to engage with their interactional dynamics, to move back from the edge to the great planes of subtly agitated cadmium. This is true also of the great vertical *Rumbold* paintings of 1970 (so-named after the London street in which Heron borrowed a studio during 1970), where the attenuated wobbly verticals at the right edges contain the eyes movement to keep it returning to the vertical sweep of brilliant red (in *Rumbold Vertical I: Emerald in Reds: February 1970*) or dark green (in *Rumbold Vertical Four: Green in Green with Blue and Red: September 1970*), and maintaining in both cases an ambiguous spatial relation to the discs which hover above centre left, now in front, now behind the red and dark green dominants.

Later paintings in the series become more complex, the number of devices and the spatial relations between them increasing: a tendency that is clearly developing in the significantly titled *Complicated Green and Violet: March 1972* (a painting destroyed in a bush fire near Adelaide some ten years later) and in the magisterial *Big Cobalt Violet: May 1972*. In the former, the distribution of motive and shape is across the plane with strong elements at both top left and bottom right; in the latter the complicated elements occupy the extreme left and right of the canvas, and the eye traverses the violet of the title as between two continents. At bottom left of *Big Cobalt Violet* occurs a distinctive form, as of a pool of colour enclosed within a larger roughly circular shape. Many years later, Heron recognised its close similarity to the configuration of a reflective pool in a rounded granite boulder in the garden of Eagles Nest (see p. 19). So it is that the forms and lucencies of nature assimilated in the course of a daily familiarity, a constant looking at the world, find themselves translated into the signs, devices and colours of art. Titles continue through the 1970s to signal compositional aspects: *Allover Reds, Green and Orange: April 1972–September 1974*, which presents us with the overlapping complexities of a view into a rockpool from above, or the indeterminate layering of leaves, light and shadows which the eye encounters when looking up through the foliage of a

tree; *Complex Greens, Reds and Orange: July 1976–January 1977*, in which there is a dramatic near-vertical division of the green and orange which with the in-set reds and yellows sets up a vibrant visual hum, like that between the differently hued but chromatically identical interior/exterior of a late Matisse, a sensation of deep summer heat and light.

What is true of all the paintings of this entire period, up to and including *Boycott*, is the variety and delicacy of the painted surfaces, changing from colour to colour within paintings, registering in texture the different movements of wrist, catching light like silk, or reflecting it like mother of pearl, saturated and dense in some areas, luminous and shimmering in others. They invite always a shifting physical relation of spectator to surface, a movement into close quarters, a stepping back, a move to right or left: all rewarded by changes of light and colour, magical transformations and sudden changes of emphasis, and by a constant push and pull of the eyes that registers now this colour as forward of that, now behind it, this disc as now a floating form, now a circular aperture to a brilliance or sonority behind the surface.

After a bad start, when the paintings destined for showing were dispatched on a slow boat down the eastern seabord instead of directly to Texas, and arrived at the University a month later than the intended opening, the exhibition at the University of Texas at Austin, in the spring of 1978, was a spectacular presentation of Heron's work from the previous twelve years, including gouaches and screen-prints. It constituted a major exposition of a theme, with extensive variations, and in the accompanying lectures, subsequently published as *The Colour of Colour*, Heron elaborated on the principles of their production, and placed them in the context of his previous work and of his long-standing belief that art is autonomous of social obligation or conscious communicative function. It was a triumph unreviewed and unsung elsewhere. In the heavily pollinated Texas spring, in what is known as the asthma capital of the USA, Heron became seriously ill. He returned to England utterly exhausted, after travelling by car across the States to California, his lung pneumonically infected, and was once again confined to bed for several weeks. Little work was done through the remainder of 1978.

A far greater crisis was to come. In the May of 1979 Delia Heron died suddenly and unexpectedly at Eagles Nest. Patrick was devastated: she had been his constant companion in life and in art; his most perceptive critic and his greatest friend. She had been the vital spirit in the regeneration of Eagles Nest and its miraculous garden. From the time of their first stay there in the summer of 1955, camping in the Edwardian gloom of rooms in which all the floors and woodwork were painted black, unsure about buying it or not, Delia's personality had irradiated the house, her imaginative generosity and magnetic quickness drawing friends into a bright ambit of creative conviviality. For the brilliantly and sometimes turbulently diverse company of artists and writers that made West Penwith a place of quite extraordinary artistic concentration during those years, Eagles Nest was a uniquely magical place, constantly crowded and alive with children, cooking, conversation and celebration. The heart of this domestic animation was Delia. Susanna has writ-ten of another kind of presence, in the garden:

> After she died I glimpsed her hair, grey hair, amongst those high camellias behind
> the walls as she moved along the paths:
> Elusive – there – there, again –
> Going about her business
> Breathing through
> Her hair blowing in little gusts.

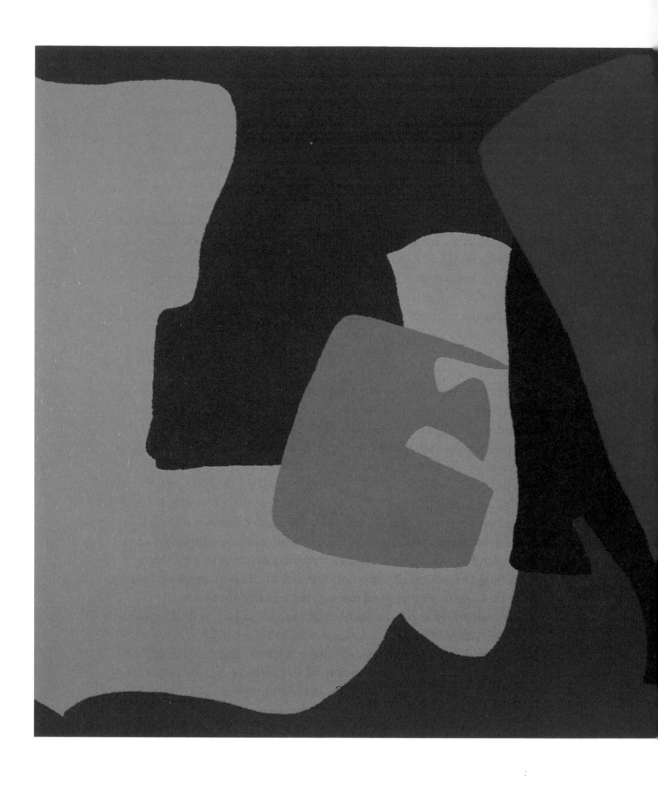

→ LONG CADMIUM WITH CERULEUM IN
VIOLET (BOYCOTT): JULY –
NOVEMBER 1977
Oil on canvas 198 × 396.2 cm

↓ COMPLEX GREENS, REDS AND
ORANGE: JULY 1976 – JANUARY 1977
Oil on canvas 101.6 × 152.4 cm

8 COASTAL LIGHT, FLORAL BRILLIANCE

1978–92 Rendering the world visible

Heron painted little in the year after Delia's death. Indeed there is a prolonged hiatus in his career at this time. The paintings of the late 1960s and the 1970s had demanded to be done, and Heron had submitted himself to a mode of working that was in certain ways uncharacteristic. The daring burst of intuitive drawing by which the unpremeditated boundaries of the colour areas in the big paintings were created was in accord with his natural impulse as an artist: 'It is one of the ecstasies of painting – this independence of the hand from the brain!' But the painstaking brushwork of innumerable strokes, applied in an infinite variety of gestures with small watercolour brushes, the deliberate creation of those saturated planes of subtly agitated colour, worked with such precision of definition at their boundaries, required a conscious discipline of handling that was in some ways unlike Heron's more usual manner of working. He had worked according to rule, committed himself to a process that prohibited certain kinds of spontaneity: the 'ecstasy of painting' that derived from the discovery of what the hand had done independent of the prompting of the brain was denied him.

The procedures brought with them their own subtle pleasures, for maker and spectator alike. Heron has spoken of the intensities of feeling that accompanied the creation of textures across a colour field up to the final filling in of the last colour-area in a picture, and of the unpredictability of the all-over colour interactions until the entire rectangle had been covered. Colours in those paintings hum and pulsate as they meet, and the sheer expanses of a single colour have the shimmer and gleam of a radiantly vital skin: these were among effects that could have been achieved in no other way. Even so, there was a formulaic element, a logic of procedures, that eliminated a whole range of expressively painterly possibilities in the making of the work. In each painting, failure was a real possibility up to the very end of the process, and this in paintings of enormous scale. In these works Heron had explored the continent of colour to one of its extreme limits. Now his life had been changed; and his art must find a new direction.

'When the means of expression have become so refined, so attenuated that their power of expression wears thin,' said Matisse, 'it is necessary to return to the essential principles which made human language. They are, after all, the principles which "go back to the source", which relive, which give us life.' Matisse was talking (in 1936) about the 'courage to return to the purity of the means' that had been the starting point of Fauvism, and the requirement in his own work, at the time of speaking, to return to strong and undiluted colour, 'beautiful blues, reds, yellows …'. In the early 1980s, Heron was looking for a way back from the opposite pole, having gone as far as it might seem possible in the direction of chromatic amplification, where not only relationships within the image but the actual *quantities* of pure hue had increased their intensities of perceptual effect. The unmitigated brilliance of midday induces the longing for the paler, cooler light of early morning, the subtler effects of late afternoon. In short, Heron was gathering courage for a return to 'a purity of means' other than that which saturation and scale had provided. Having made a discovery, and explored its implications at some personal cost – the efforts of the 1970s had exhausted him – he was not predisposed to 'go into production'. As always, it was a crisis in his affairs (this time the greatest of his life) that led to a radical re-definition of purposes.

It was a process that took time. *Scribbled Violet Disc in Venetian with Reds and Emerald: September 1981* signals a move towards a more open aerial colour in the disc of the title and in the lightly scribbled purple at top right, against which the scarlet is silhouetted in a configuration remarkably like that of a Cornish headland against the open sky. The other areas are painted with the fierceness of colour and

opacity of the most extreme 'wobbly hard-edge' paintings of several years before, and have clearly been established by what might be called the 'disappeared drawing' of those earlier paintings. The violet disc, lightly scribbled and translucent, is anticipated by that in *Violet in Mars: July–September 1977*, the penultimate of the pictures made specifically for Texas. In the latter painting the violet is applied with a closer weave of strokes, consistent with Heron's intention at that time to maintain 'a uniform luminosity' over the entire work (an intention upon which Heron elaborated in great detail, incidently, in 'Colour is Paint', the first of the Austin lectures, in relation to this particular painting). But in each case the violet, enclosed in both paintings in a species of venetian, is agitated to an extreme degree, as if already in *Violet in Mars* there were an intimation of impatience with the stark opacities and finesse of handling that characterized the paintings that had preceded it for several years.

Midsummer Reds: July 1982 is a painting unique in Heron's work. Its robust textures and ragged forms, with the exception of the great lemony disc and a couple of smaller shapes, are created entirely by palette-knife. Heron had left behind unity of surface and the careful and programmatic painting-in of quickly drawn areas; in several places the white of the canvas is clearly discernible as a thin white line at the edges where the vigorously knifed paintwork has itself established a colour area or the outline of a form. Once more that latter term seems appropriate in discussion of Heron's work, for the shapes clustered at lower right may be read clearly as a 'nest of forms', overlapping 'figures against a ground'. The directness of attack and quickness of application are those of a painting made without premeditation, with the kind of risk and pleasure so dramatically identified by Heron many years before: 'The quality of vitality in art is something very closely connected with risk, with pure daring. The artist who never feels, as he starts a new picture, that he is tempting madness to envelop him – such an artist is no artist at all'. The artist's mind instructs the hand, but 'suddenly the painter sees the mess that his hand has made of the job he gave it and he finds it is marvellous; and that is the ecstasy'. *Midsummer Reds* is one of those transitional paintings whose dynamic effect is a function of a contained and powerfully felt potentiality; unlike anything else, it is a demonstration that Heron had freed himself finally of the predeterminations and formulae of the 'wobbly hard-edge' style and was on the threshold of a new beginning. With a new-found confidence, he stepped again into the variegated light of the morning garden.

The compositional structure of the earliest of the new-style paintings of the early to mid-1980s, *Violet Disc in Lime Yellow: June – December 1982*; *Lemon Disc in Sea Green with Zig-Zags: July–December 1982* and *Pale Pink and Lemon Painting: November 1982 – May 28 1984* are recognisably continuous with that of certain of the 1970s paintings, especially those later examples (such as *Complex Greens, Reds and Orange: July 1976 – January 1977*) in which the picture surface is divided vertically into two principal colour zones by a diagonal frontier close to centre. In the first two the disc at lower centre left is the major feature, its faintly amorphous square-round shape, focal and dominant, an unmistakeable Heron motive. (In *Pale Pink and Lemon Painting* it features as slightly elongated and angular: a roughly demarcated area of canvas, enclosing a quick yolk of looping lemon scribble.) Equally characteristic is the asymmetric pressing of complex shapes and figures into the extreme right quarter of these pictures. There, with the plainly descriptive titles, the resemblance with the earlier work ends. For these new pictures are painted in a virtuosic variety of brushing techniques, and a directly linear painting-drawing, direct from the tube, has entered the work to add rhythmic accent to the interplay and counter-

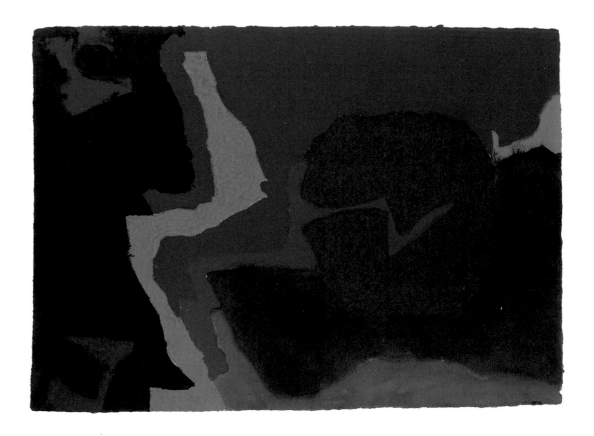

→ MARCH 29: 1982
Gouache on hand-made paper
56.5 × 77.5 cm

↠ SCRIBBLED VIOLET DISC IN
VENETIAN WITH REDS AND
EMERALD: SEPTEMBER 1981
Oil on canvas 96.5 × 121.9 cm

↓ MIDSUMMER REDS: JULY 1982
Oil on canvas 101.6 × 152.4 cm

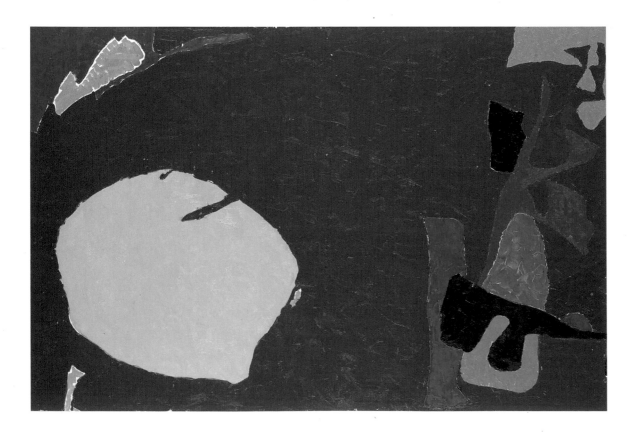

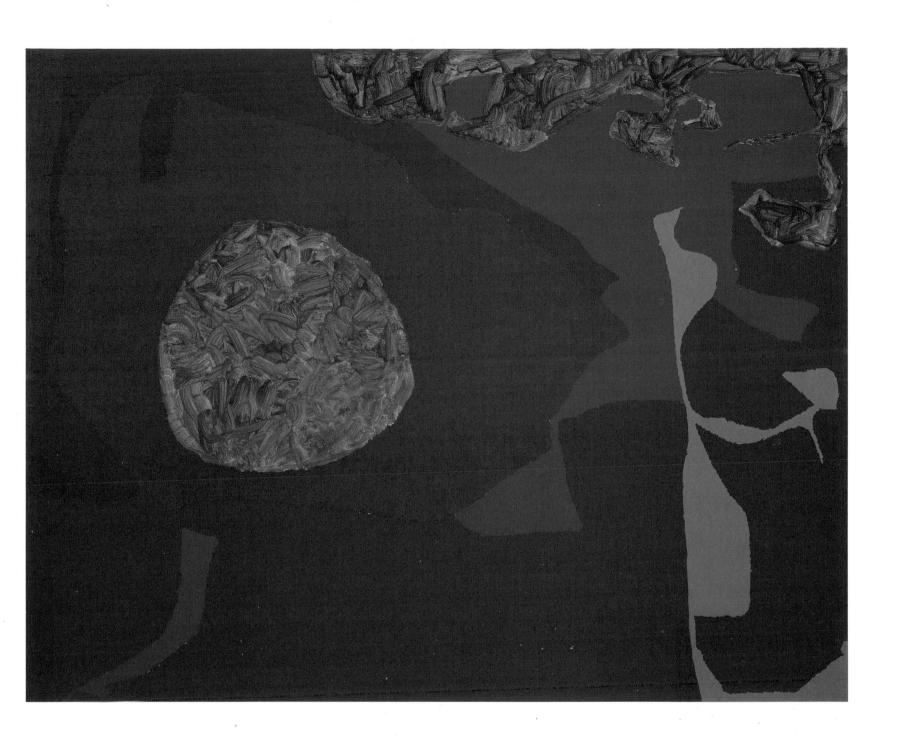

PALE PINK AND LEMON PAINTING:
NOVEMBER 1982 – MAY 28 1984
Oil on canvas 96.5 × 121.9 cm

LEMON DISC IN SEA GREEN WITH
ZIG-ZAGS: JULY – DECEMBER 1982
Oil on canvas 152.4 × 213.4 cm

VIOLET DISC IN LIME YELLOW:
JUNE – DECEMBER 1982
Oil on canvas 152.4 × 213.4 cm

THIN VIOLET IN MID-WINTER
YELLOWS: SEPTEMBER 1982 –
FEBRUARY 1983
Oil on canvas 101.6 × 127 cm

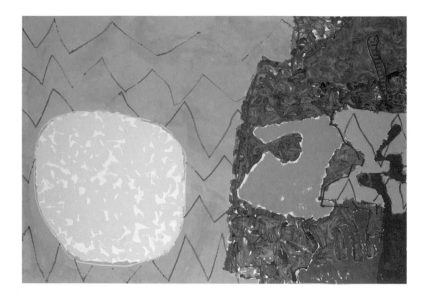

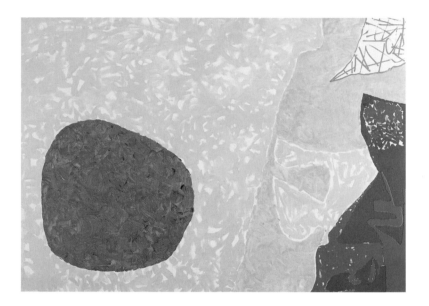

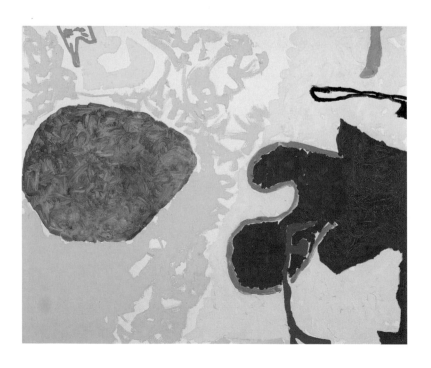

COASTAL LIGHT, FLORAL BRILLIANCE

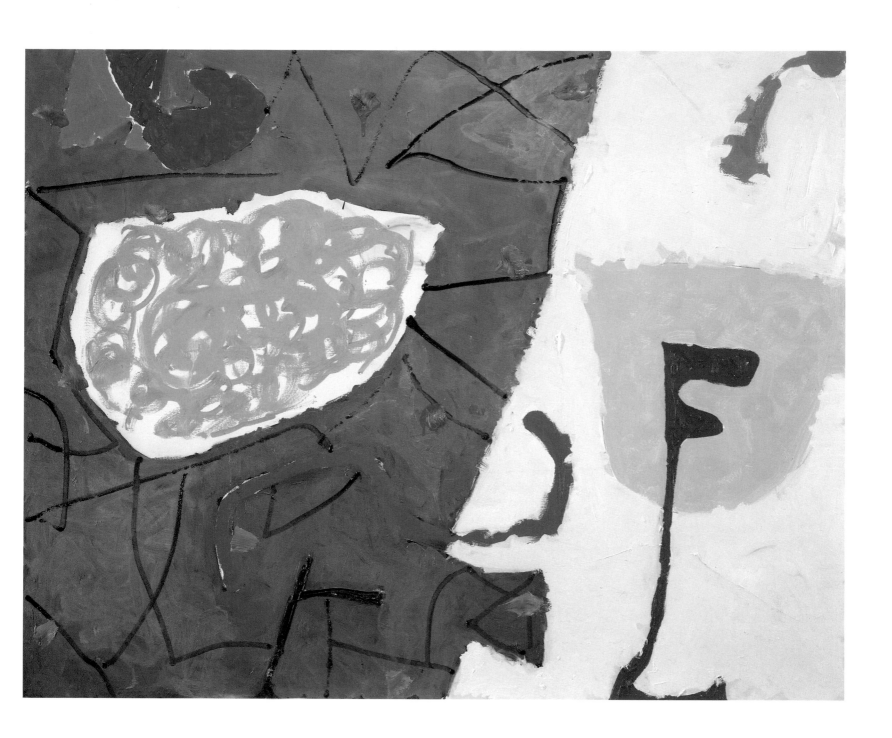

→ GARDEN PAINTING: JUNE 6 1983
 Oil on canvas 50.8 × 60.9 cm

↓ 28 JANUARY: 1983 (MIMOSA)
 Oil on canvas 50.8 × 60.9 cm

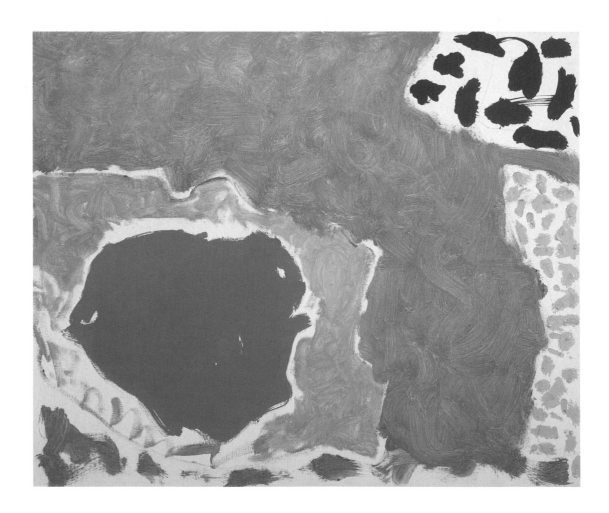

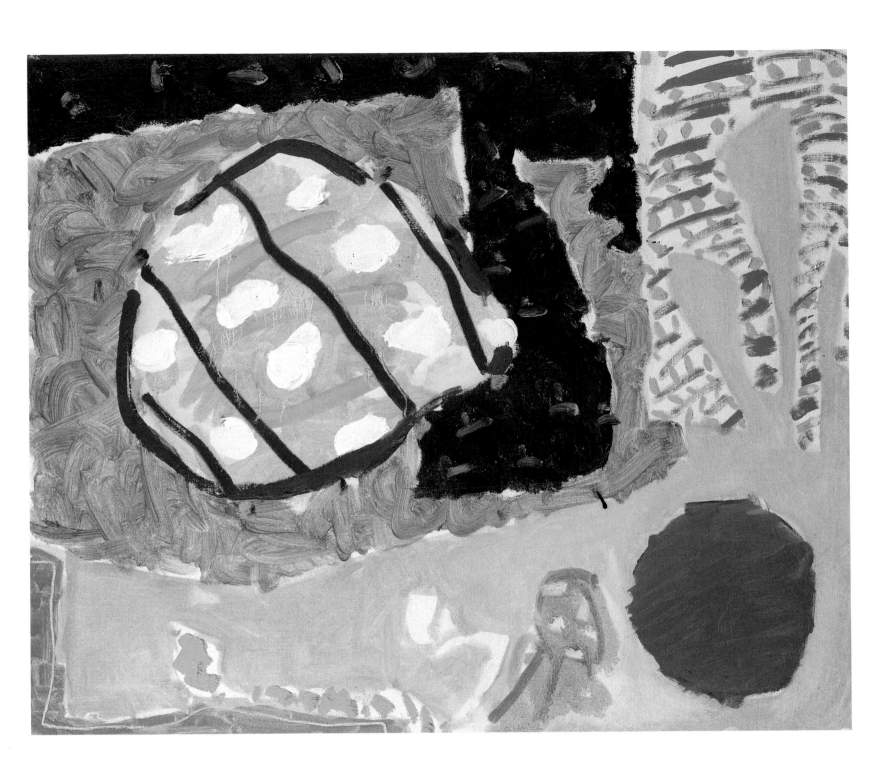

» SCRIBBLED DISC IN DEEP
CERULEUM: FEBRUARY – MAY 1983
Oil on canvas 121.9 × 152.4 cm

↓ AFTERNOON BLUE: JULY 1983
Oil on canvas 198.1 × 274.3 cm

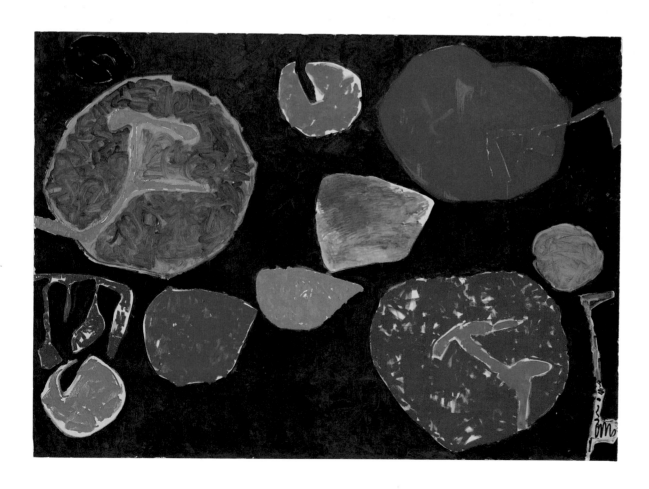

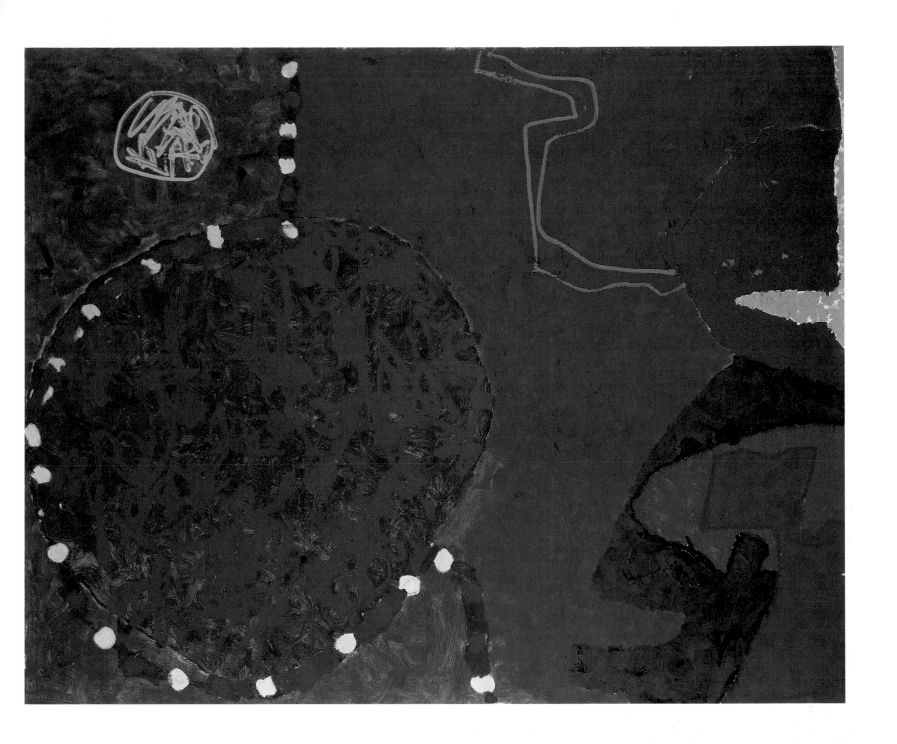

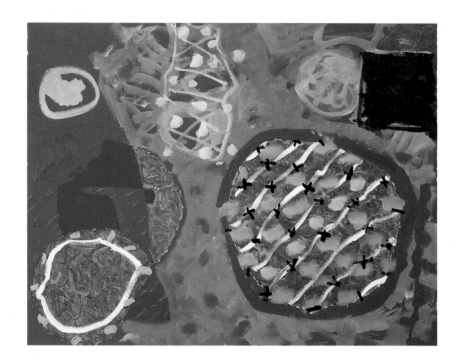

STRIPED AND SPOTTED PURPLE
DISC: 1983 – MAY 29 1984
Oil on canvas 96.5 × 121.9 cm

BIG PURPLE GARDEN PAINTING:
JULY 1983 – JUNE 1984
Oil on canvas 208.3 × 335.3 cm

WHITE, PINK AND SCARLET: JULY 1983
Oil on canvas 121.9 × 213.4 cm

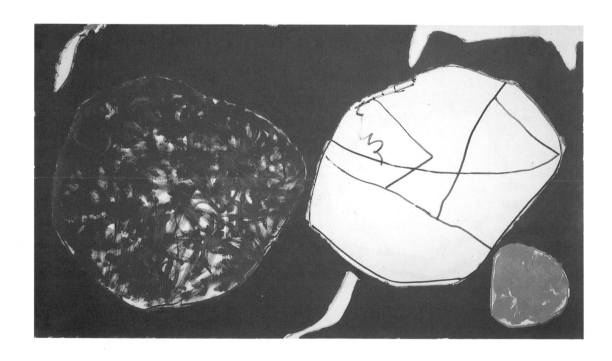

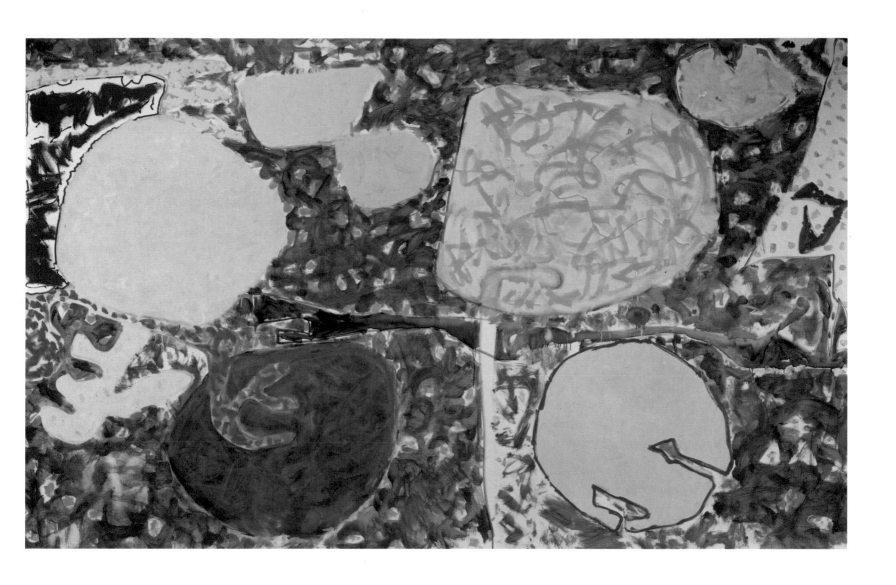

DECEMBER 4: 1983: II
Gouache on hand-made paper
45.5 × 50 cm

DECEMBER 8: 1983: II
Gouache on hand-made paper
34.9 × 50.2 cm

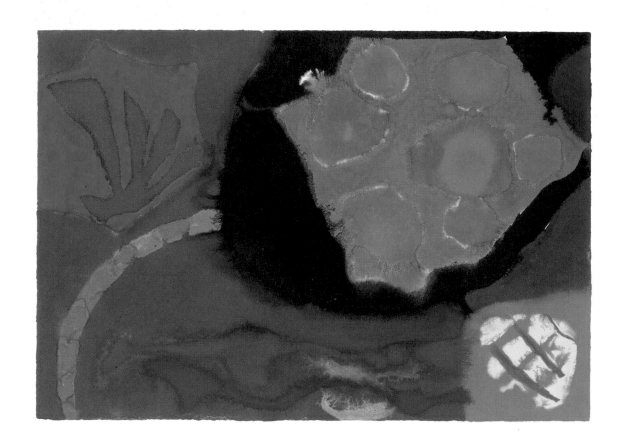

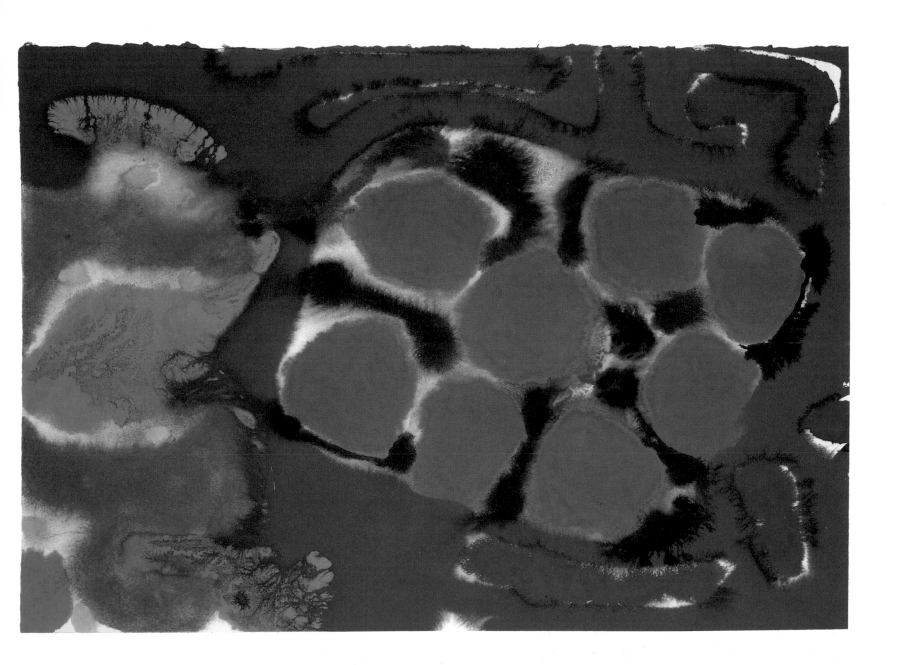

→ RED GARDEN PAINTING: JUNE 3–5 1985
Oil on canvas 208.3 × 335.3 cm

↓ WHITE GARDEN PAINTING: MAY 25 –
JUNE 12 1985
Oil on canvas 208.3 × 457.2 cm

↘ PALE GARDEN PAINTING: JULY –
AUGUST 1984
Oil on canvas 208.3 × 335.3 cm

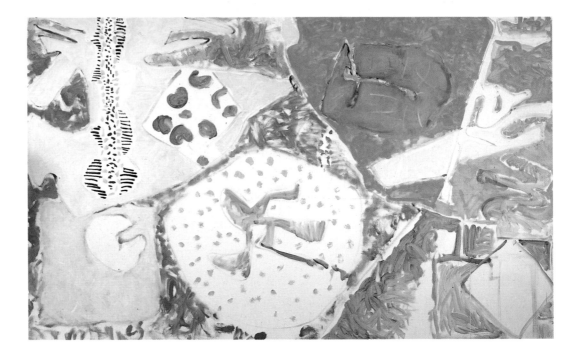

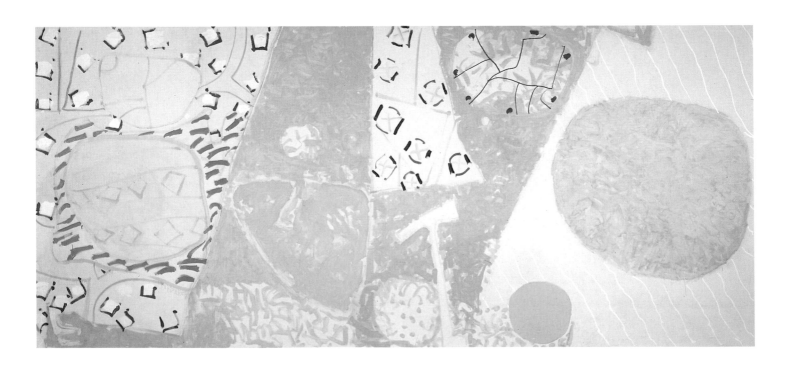

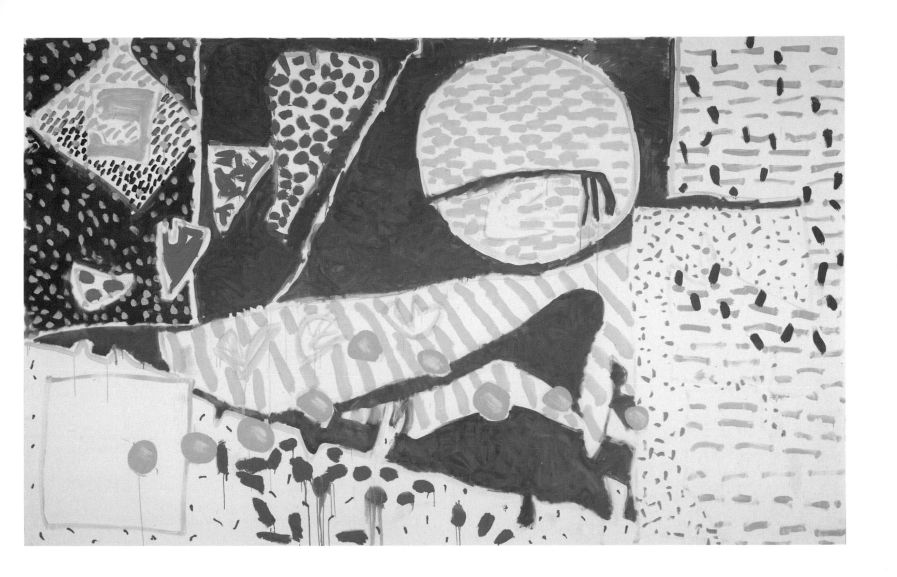

→ SEPTEMBER 18 1986
Gouache on hand-made paper
33 × 46.7 cm

↓ GARDEN PAINTING WITH LEMON:
MAY 1985
Oil on canvas 96.5 × 121.9 cm

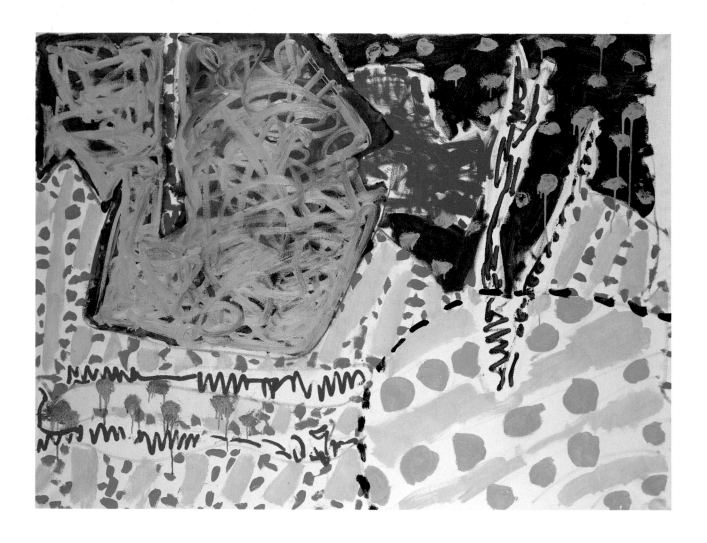

↑ PORTRAIT OF JO GRIMOND III:
SEPTEMBER 4 1986
Oil on canvas 40.6 × 50.8 cm

» Top to bottom
SMALL HOUSE IN THE DORDOGNE:
SEPTEMBER 1982
24.5 × 35.6 cm

FELLO ATKINSON'S SWIMMING POOL
AND WALNUT TREE, DORDOGNE:
SEPTEMBER 1982
24.5 × 35.6 cm

FELLO ATKINSON'S PLATE GLASS
DOOR AND SWIMMING BATH,
DORDOGNE: SEPTEMBER 1982
35.6 × 24.5 cm

BRIDGE AT SADGILL, LONGSLEDDALE,
LAKE DISTRICT: 1983
24.5 × 35.6 cm

All 6B pencil on paper

point of colour areas that are themselves distinctive in texture. These are spell-binding compositions of that complex, and yet brilliantly resolved, 'abstract music of interacting form-colour' that Heron had long before identified in the painting of Bonnard; and like that of Bonnard in Heron's description, '[if] it is abstract it is saturated with the quality of things; even of particular things'.

It is not that representation has made a re-appearance in Heron's painting so much as that the natural light of the external world, and its concomitant diversities of colour and tone, the brightness and shadow of morning and evening, have once more been admitted; and with those atmospherics have entered forms and configurations that we recognize, not as being directly descriptive but, rather, reminiscent of things seen, as being somehow like things we encounter in the light of day. In *Lemon Disc in Sea Green with Zig-zags: July–December 1982*, for example, the colour of the green (as Heron's title conveys) is specifically evocative, and the faintly greenish staining, or clouding, of the pure opaque turquoise and the startling dark green zig-zags irresistibly allude to the indeterminate colour and the rhythmic energy of the sea as it rides into shore. Even as we scan the canvas from left to right, admitting such implications of colour and rhythm, giving play to association, so other aspects of the picture, of facture and colour, confute any literal reading, and whilst offering images to the mind that are congruent with the mood of such a reverie, they deny representation. The stipple of white in the lemon disc, a reflective sparkle achieved by leaving uncovered the white of the primed canvas; the translucency of the purple shore; the reappearance of a pool of the zig-zagged sea-green to extreme right; sudden linear tracings, direct from the tube, of deep blue and crimson; odd rivulets of scarlet and crimson, curved forms of ultramarine and sand-coloured ochre: so many associations, so many contradictions and ambiguities; so allusive the shapes and colours, so self-declarative the paint as substance and texture!

Violet Disc in Lime Yellow: June–December 1982 offers a similar complexly-associative visual music, with its densely brushed dark sun in a stippled field of yellow and its strangely figured forms at extreme right, vividly described by Alan Gouk in a memorable essay on this phase of Heron's work (written for the catalogue of Heron's Barbican Retrospective in 1985):

… the way in which both the ball and its surroundings are brush-painted, the one writhing inwardly up to its serrated edges, the other crazing open, with incisively directional dabs, allows the contained energy of the orb to spread its effect in a continuously pulsing wave right to the four edges of the canvas, carrying the slashed intervention of a pale violet finger, an orange scribbled dagger in the corner, and causing the scurrying Heifetz-fingered creatures at the right-hand corner to set a merry dance, rasping and sawing as in a devil's trill by Paganini.

Gouk is an outstanding non-figurative painter himself, and for all the associative extravagance of this cadenza, he is deeply aware of the purely abstract rigour of Heron's painting even as he allows it to provoke these imaginings. He is playing a language game in which words attempt to describe the effects of an abstract visuality whose components – of form, colour, rhythm and design – refer to but do not describe natural phenomena. It is a modality whose history can be traced through the work of modernists as diverse as Kandinsky and Klee, Miró, Arp, Matisse at his most abstract, and (surprisingly perhaps) Nicholson at his most severe, all of whom invite playful speculation as they dispense delight. Heron's work in this latest decade has a celebratory certainty and insouciant wit that places it within this line, even to the extent that certain paintings may have symbolic resonances of a kind that are far removed from the conscious concerns of their author.

Heron finally threw off the compositional constraints of the 1970s, in paintings

such as *Afternoon Blue: July 1983*, with its amoeba- and chromosome-like forms floating *in perpetuum mobile* in aquatic bliss; *White Pink and Scarlet: July 1983* with its poised opposition of rounded shapes like billowing Chinese lanterns ('... permanent rose tube-squeezings zip into the resilient tambourine-taut white priming in a sort of football lacing,' wrote Gouk, 'while a sonorous rose magenta surrounds it, a flurry of scarlet and a circled orange, to form a stark conspiracy.'); and *Striped and Spotted Purple Disc: 1983–May 29 1984*, with its garish fairground colours and discs pulsating in a crowded atmosphere of hot scarlet clouded into shocking-pink. Paintings like these, shown at Waddingtons in 1983 in his first exhibition of new works since 1977, caused something akin to consternation among an art public that had perhaps forgotten the mercurial and restlessly changing artist of the 1950s and 60s, and had grown accustomed to the distinctive Herons of the 'wobbly hard-edge' style, and to the rhetorical insistence of their author that his work was not to be seen as in any way referential. Gone were the unities of texture and colour pitch; here were paintings, like *Thin Violet in Mid-Winter Yellows: September 1982–February 1983* and *Scribbled Disc in Deep Ceruleum: February–May 1983* that seemed to break every rule. The first posed the thickly-painted violent intrusion of dark red at right, rudely outlined with green, in absolute tonal dissonance to the thinly scribbled violet disc of the title, in a fractured field of broken yellows whose allusion to a daylit coldness was deliberately suggested by the title. The second combined the pure sign of the dotted line with arbitrary doodlings straight from the tube, and the atmospheric nocturnal evocations of deep blue and purple with fierce reds and cool greens.

At the same time as he prepared these latest paintings for the 1983 exhibition Heron was embarked upon *Big Purple Garden Painting: July 1983–June 1984*, the first of the grand garden paintings of the mid-1980s. In these he returned to the aerial clarities and radiant light of those first 'garden paintings' made at Eagles Nest, but with a repertoire of brushwork and mark, a variety of handling and virtuosity of touch, that made possible a more complex music than had ever been possible within the limitations of the *tachiste* manner of those earlier works. Where the 'garden paintings' of 1956 had the virtues of directness and a quick spontaneity, and a brilliance and diversity of colour, these later pictures have an all-over compositional coherence. Where Heron's own species of Tachism dissolved form into a screen of flashing or shimmering strokes, to a highly formalized chordal equivalence of the play of light itself, this later style offers a kinetic complication of a richer and subtler kind, and the impression of light in its variegated play over objects and surfaces. Where the *tachiste* works seem to present the brilliance of a moment, these later garden paintings have a lyrical temporality, in which it is possible to discern rhythms and counter-rhythms, subtleties of repetition and of visual rhyme.

The impression of light! The phrase inevitably recalls Monet, and indeed, in both mood and format, the 'gardens' of 1983 to 1985 have much in common with the late horizontal canvases of the greatest of the Impressionists, and may well have been in some part inspired by memories of them. *Big Purple Garden Painting: July 1983–June 1984*; *Pale Garden Painting: July – August 1984*; *White Garden Painting: May 25 – June 12 1985*, and *Red Garden Painting: June 3–5 1985*, like the late Monet demand a lateral scanning, a process of continuous apprehension that moves across the surface, from left to right and back again as the eye is entranced by the flicker of light, and then, caught by the suggestion of an object or a surface, it perceives suddenly a space like the space of the experienced world, and the eye seems to glide into an

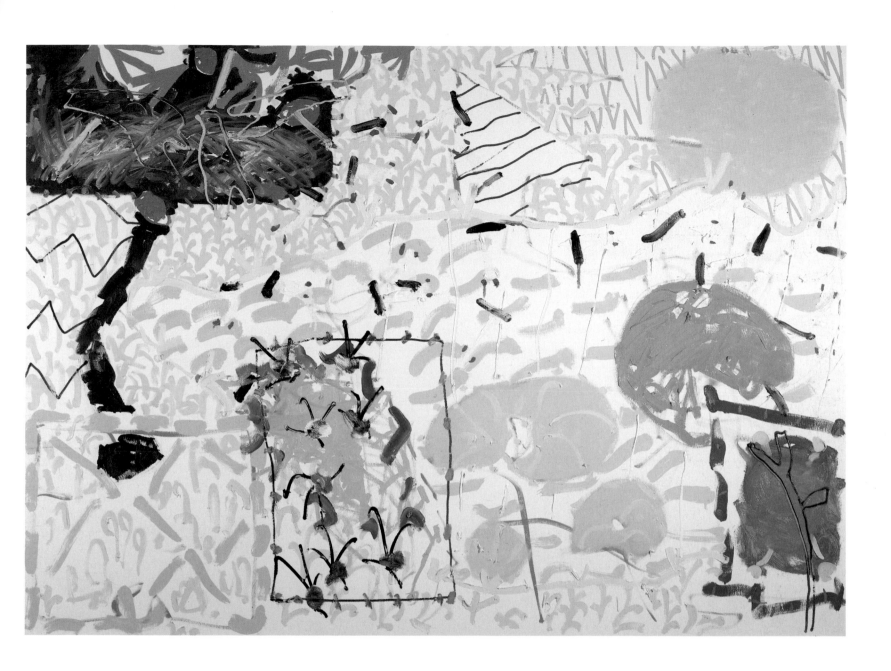

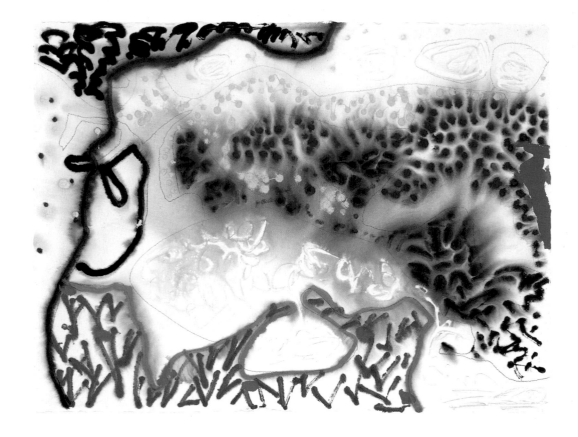

→ SYDNEY: 18 JANUARY: 1990
Gouache on hand-made paper
58.4 × 76.2 cm

⇒ SYDNEY: NOVEMBER 17: 1989: I
Gouache on hand-made paper
58.4 × 76.2 cm

↓ SYDNEY: 19 JANUARY: 1990: I
Gouache on hand-made paper
57.5 × 75 cm

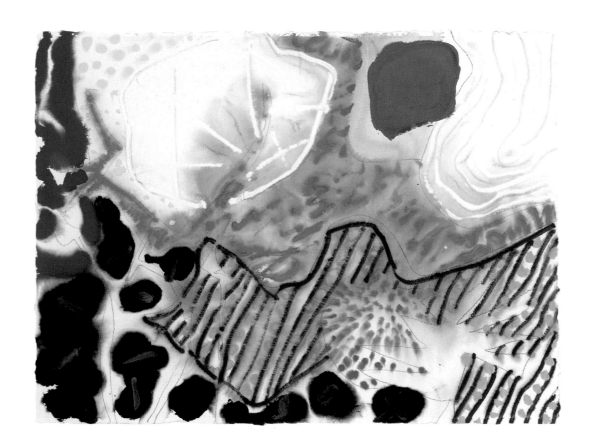

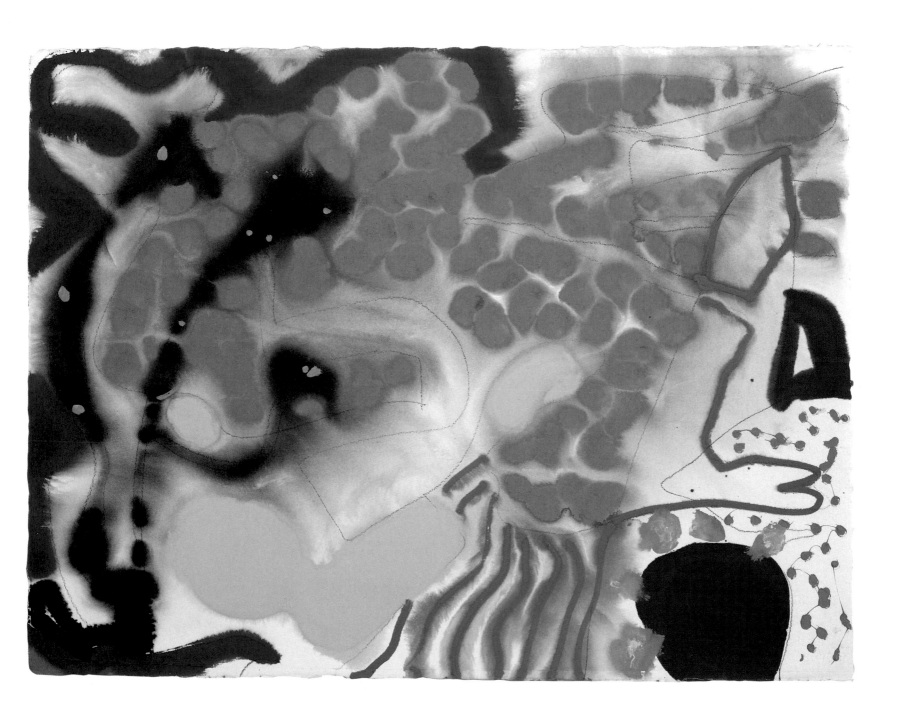

→ SYDNEY GARDEN PAINTING:
 FEBRUARY 1990: II
 Oil on canvas 165.1 × 86.4 cm

⇒ SYDNEY GARDEN PAINTING:
 FEBRUARY 1990: I
 Oil on canvas 165.1 × 86.4 cm

↑ SYDNEY: 29 JANUARY: 1990
Gouache on hand-made paper
58.4 × 76.2 cm

→ SYDNEY: 23 JANUARY: 1990
Gouache on hand-made paper
58.4 × 76.2 cm

↠ SYDNEY: 26 JANUARY: 1990: II
Gouache on hand-made paper
58.4 × 76.2 cm

↘ SYDNEY GARDEN PAINTING:
JANUARY 1990: II
Oil on canvas 152.4 × 213.4 cm

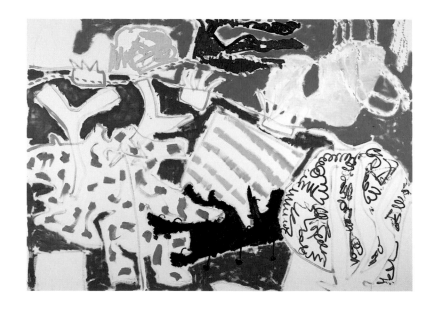

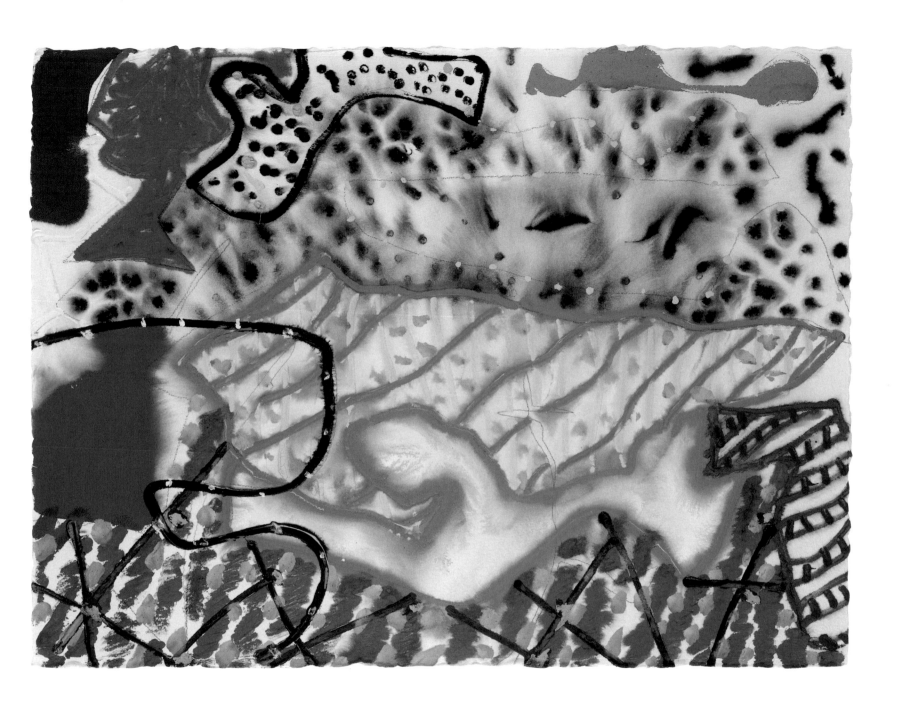

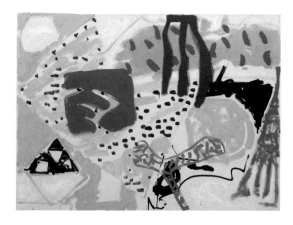

↑ SHARP GARDEN PAINTING: JUNE 1985
Oil on canvas 96.5 × 122 cm

⇒ VERMILION AND ULTRAMARINE:
JUNE 11 1985
Oil on canvas 40.5 × 51 cm

indeterminate distance, potentially infinite. It would not do to push this comparison too far: Heron is resolutely non-figurative, and it is certainly none of his purpose to return in these paintings to direct transcriptions of the natural world, or to seek an equivalent in painting for our perceptions of it. Space in these late Herons is of a radically different kind from that in Monet's late garden and water-lily paintings, for whereas in the latter, space is perceptually continuous and coherent, in the former it is disjunctive and dislocated. Monet's space is that of a nineteenth-century painter (no matter that he lived until 1926); Heron's that of an artist of the late twentieth. Every stroke in Monet, even Monet at his most abstract, has a descriptive purpose; in Heron we are presented with paint as colour, colour as paint. Association and resemblance begin *after* that salient fact.

As our eye encounters *Red Garden Painting: June 3–5 1985*, for instance, it registers first of all the predominance of red, then the brilliance of yellow; the red as an experience of density and hue, the yellow as an experience of broken light, a direct function of its application in dashes and stripes against white. The white light of uncovered primed canvas is the first overwhelming impression. Simultaneously we register the actuality of paint as such, paint as stuff, applied with wet brushes in splotches that run and stain, in quick horizontal parallels of dashes and vertical falls of dots, in strange shapes that divide and attenuate, and formal figures – squares, triangles, diamonds, circles and discs – that have been displaced from the universe of signs and returned to the more primitive existence of shape. All this is the eye's work of seconds. Then the eye and the mind together must try to decipher this complex visual message, that seems at first nothing but an illogical concatenation of colours and light, shape and form. It glances to extreme left and begins the inevitable 'reading' scan, first noticing the strange rectangular enclosure of venetian at top left, with its diamond enclosed, and within that, like a chinese puzzle box, another form; and all round it a scatter of pale touches, like a snowstorm in a child's glass toy. A window perhaps (though the painting has no interior/exterior logic); and that pale violet square below it, a door? a gate? The eye moves right, following the line of violet lozenges that bounce across the lower centre like a ball caught in freeze-frame succession – movement recorded in stillness, like a Muybridge sequence – and becomes aware again of that fractured red field and the great disc, not harshly yellow like the sun, but sparkling like a pool catching sunlight, and then moves on to the open spatialities of the extreme right quarter of the painting, a distant sea receding, light flecked, a scatter of scarlet petals. The logic here is that of memory, of association and reverie: once more we play that game, and at the end of each reading, the game over, we find ourselves once more confronted by the absolute reality of the painting itself, the aesthetic facts of its colours, shapes and textures contained within the rectangle of its four edges.

Each of the garden paintings of the mid-1980s offers such complex visual and associative pleasures. The differences are of mood, itself very much a function of the dominant colour, of the colour *key*, to maintain a musical analogy, of the varieties of space that are evoked, and of the shapes and forms and their resemblances to the things of the known world. The colour forms in these works are never imitative of actual objects, they are always reduced to shapes whose dynamic universe is that of the painting, and placement is arbitrary, the outcome of intuitive and impulsive decisions of the hand as much as of the mind. Unpremeditated by the artist, they are continuously unpredictable in their relations to each other for the spectator, whose eye moves over them, now according to a rhythm they dictate, now freely disposed, glancing now here, now there, catching fresh harmonies of relation, hearing new melodies.

Big Purple Garden Painting July 1983-June 1984, (the most Monet-like of them all) is aquatic and plangent, its great lily-pads floating against a continuous translucent purple wash, glinting with blue: but of course they are not lily-pads, they might just as persuasively be described as balloons, or heavenly bodies, or rocks, or submarine creatures – jellyfish or sea anemonies; and what of those other shapes, tentacular and branching, strange morphologies, stretching out and entering the circular bodies like primitive protoplasma? There are other memories here than of things simply seen. And then the painting returns to its irreducible verticality: it is a joyful play of pure colour and shape, its discs rhyming like repetitions in music, each time subtly different. *White Garden Painting May 25-June 12 1985* and *Pale Garden Painting July-August 1984* are aerial and open in mood. Their cool modulations of pinks and pale violets, and greens and bright lemons evoke the fresh morning light of spring and summer respectively. In the first the colours are brighter, paler, its green and lemon more brilliant, its forms more tentative and potential; in the second the tones are darker, the colour and light less intense, the forms somehow fuller, their florescence achieved. In both we find again that combination of forms and signs – splodge and dot, line and stripe, cross and diamond, tentacle and disc: that marvellous inconsistency of language that gives this series of paintings its extraordinary originality.

What there is of late Monet in this work is a tenuous presence, a matter of mood, that of a celebration of the natural world, rather than of means or purposes. The reservations about the direction of Monet's art that Heron had expressed many years before did not extend to doubts as to his genius. But, recalling Cézanne's famous remark – 'Monet is only an eye. But *what* an eye!' – Heron had written: 'The criticism here [is] that Monet's painting was primarily a superlative record of objective visual sensation, and was too little concerned to translate that sensation into terms of aesthetic emotion.' This was in the course of his discussion of Bonnard's 'underlying abstract "music"'. What is significant here, of course, is that Heron's work in this latest decade is profoundly imbued with the spirit of the later master, though that spirit moves in a way that has little to do with stylistic resemblance. '… Every great painter has his own variety of abstract shapes', Heron wrote (also apropos Bonnard), '… concealed – and often only just concealed – beneath his more or less naturalistic compromise with appearances, beneath a finish that is "like".' We have traced in Heron's own work the persistence of such 'shapes', as he has continuously renegotiated his 'compromise with appearances'. Now in his sixties, he had achieved a contract with the natural world and its objects that allowed him the utmost freedom to create images that derived from the apprehension of resemblances rather than with the imitation of appearances, with feeling as well as seeing: in short to 'translate sensation into terms of aesthetic emotion.'

There is a statement of Bonnard's about his own work, made in conversation with his nephew Charles Terrasse, that is uncannily apposite to Heron's situation in the mid-1980s. It had been quoted by Terrasse in his preface to a catalogue of an extensive exhibition of Bonnard's drawings in 1972, for which Heron had written a long introduction. Few critics had looked for so long or so passionately at Bonnard's drawings as Heron; and as we know, he had grasped earlier than anyone of his generation the essentially abstract qualities in Bonnard's painting that made him an indisputably modern master. Bonnard had said: 'Colour has taken me too far away, and almost unconsciously, I sacrificed form to it. But form truly exists and one cannot arbitrarily and indefinitely transpose it. Because of that I must learn to draw

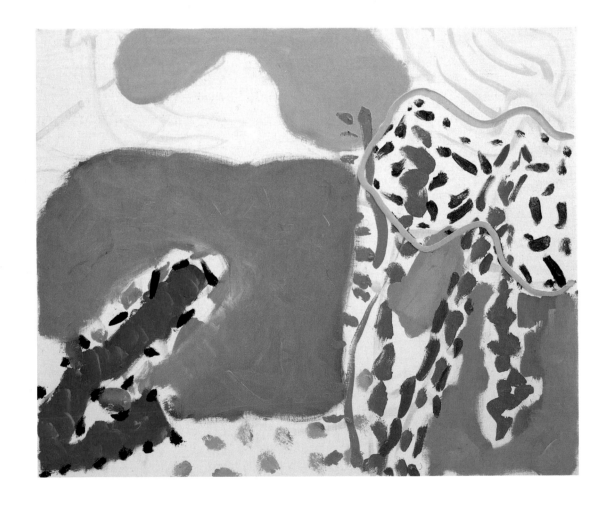

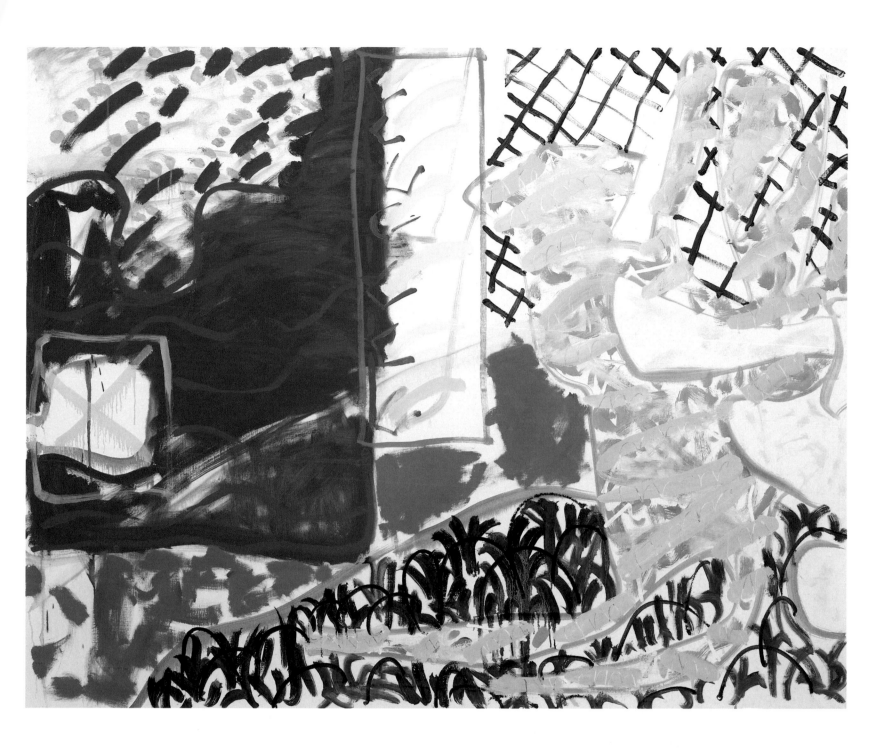

→→ 21 DECEMBER: 1991
Oil on canvas 121.9 × 152.4 cm

↓ 18 DECEMBER: 1991
Oil on canvas 121.9 × 152.4 cm

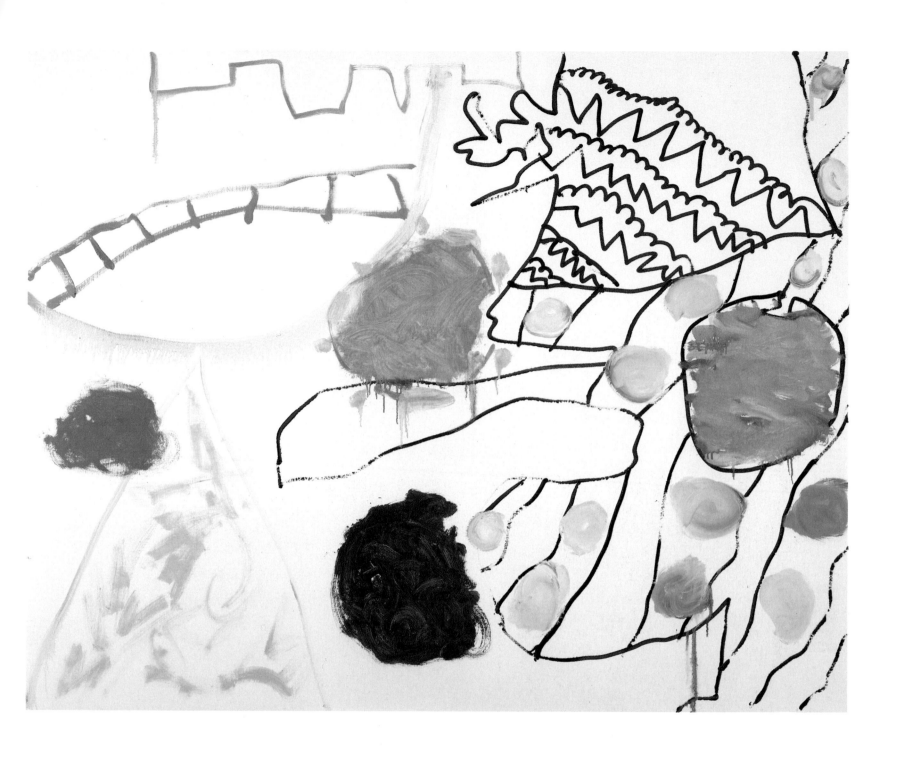

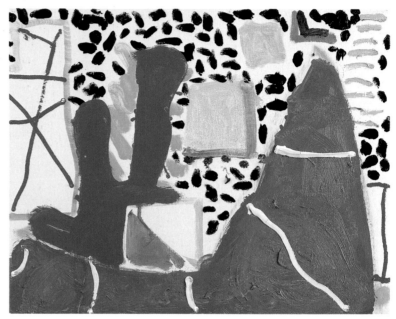

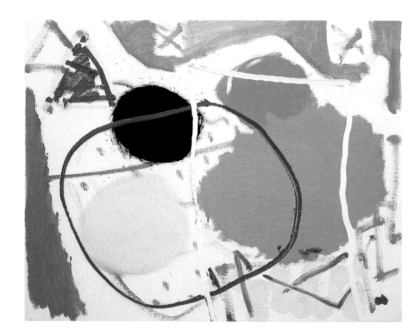

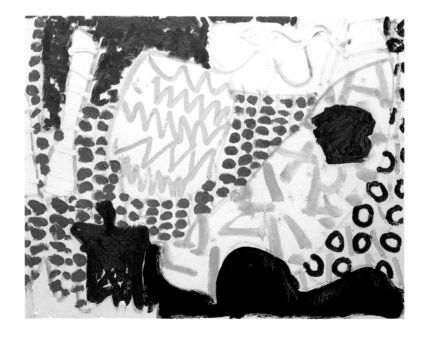

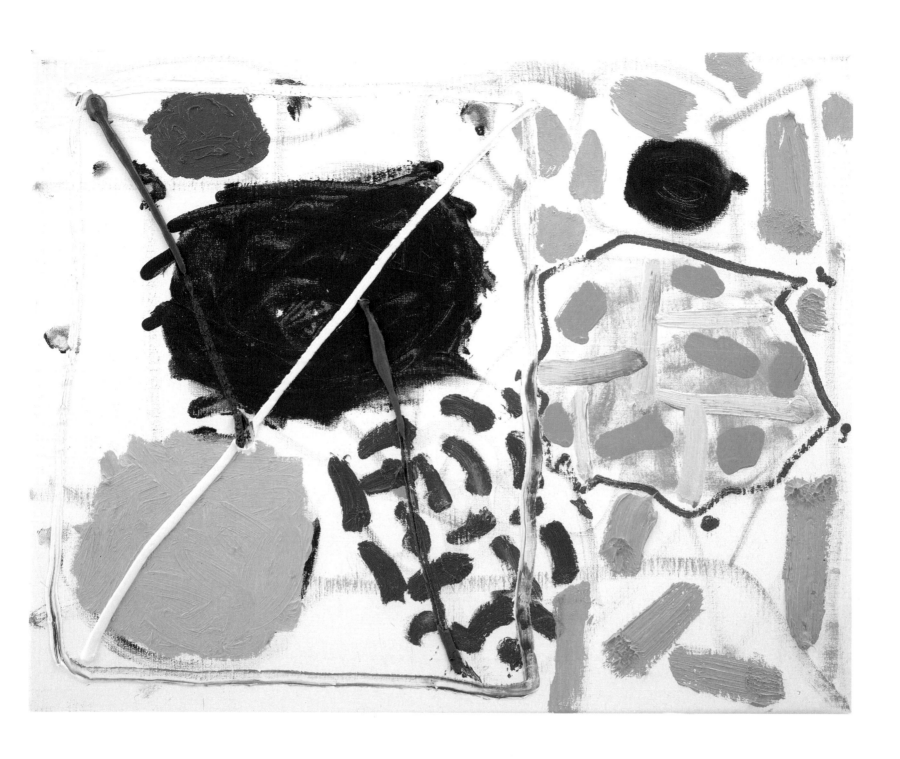

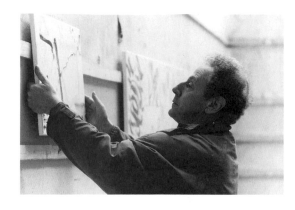

↑ Leslie Waddington at PH's Porthmeor
Studio, St Ives, spring 1992

↗ KH, Leslie Waddington and PH at the
Porthmeor Studio, St Ives, spring 1992

⇒ Top to bottom
HIGHERTOWN, ST MARTINS AND THE
DAY MARK: ISLES OF SCILLY: c.1985
6B pencil on paper 21 × 29.9 cm

GREENHOUSE AT HIGHERTOWN,
ST MARTINS AND THE EASTERN
ISLES: ISLES OF SCILLY:
OCTOBER 1987
6B pencil on paper 18.1 × 26.7 cm

VIEW FROM HIGHERTOWN, ST
MARTINS, TOWARDS TRESCO: ISLES
OF SCILLY: c.1985
6B pencil on paper 21 × 29.9 cm

all over again …'. It was indeed to the language of drawing that Heron returned in the paintings of the later 1980s, a language in which forms returned like nouns, in which *things* are remembered as well as the relationships between them.

Drawing of any kind is a mode of abstraction, and Heron's drawing-in-painting of the last few years has developed its own signs and signals, its own unique remarkings of reality. As with the garden paintings of the mid-1980s it is free of inhibition, and like those paintings it is concerned with the presentation of resemblances rather than with imitation. The distinction may be clarified by reference to what Wallace Stevens, speaking of poetry in terms that apply equally to painting, called 'one of the significant components of the structure of reality – that is to say, the resemblance between things'. His definition repays consideration in relation to Heron's late manner:

… as to the resemblance between things in nature, it should be observed that resemblance constitutes a relation between them, since, in some sense, all things resemble another. Take, for example, a beach extending as far as the eye can reach, bordered, on the one hand, by trees, and, on the other, by the sea. In what sense do the objects in this scene resemble each other? There is enough green in the sea to relate it to the palms. There is enough of the sky reflected in the water to create a resemblance, in some sense, between them. The sand is yellow between the green and the blue. In short, the light alone creates a unity not only in the recedings of the distance, where differences becomes invisible, but also in the contacts of closer sight.

The recognition of resemblance is qualitatively different from the making of comparisons: to say 'this is *like* that' is not to point to that significant relation of which Stevens speaks, the exactitude of which is revealed by art as an aspect of the structure of reality. As Stravinsky remarked: 'These natural sounds suggest music to us, but are not yet themselves music'. That condition of aesthetic abstraction, reality re-constituted, is achieved only by their imaginative transformation at the hands of the artist.

From 5 November 1989 until 28 February 1990, Heron was the guest of the Art Gallery of New South Wales in Sydney as artist-in-residence. This was his third visit to Australia. The first had been back in February 1967, when, at the invitation of Rose Skinner, he had visited Perth in order to judge the Perth Festival all-Australian painting exhibition. He had fallen in love with the continent immediately, entranced by the strangeness of its plant and animal life, by its immensities of space and its clarities of light. In 1973 his exhibition at the splendid Bonython Art Gallery in Sydney led to an invitation to deliver the 6th Power Lecture in Contemporary Art at the Power Institute of Fine Arts at the University of Sydney; this was *The Shape of Colour*. The brightness of the antipodean summer light, and the vivid colours of the flora encountered on his daily walk from his hotel to the studio through the Botanical Gardens inspired Heron to new brilliancies of evocative expression and celebration. His time there was one of the most prolific periods of work in his life, and in sixteen weeks (he managed three times to prolong what was intended as a month's residency) he produced an astonishing forty-six large gouaches and six large paintings. In so doing he established the characteristic linearities and calligraphics of his latest manner, and arrived at a style that combines description with evocation, spatial complexity with decorative verve, and a compositional élan that could come only from an artist whose ecstatic vitality of response to the drenching light and colour of the external world was matched by a masterly virtuosity and insouciance.

After a typical wait of several days, he began with gouache and launched upon an outpouring of topographical abstractions that in their power of evocation and

descriptive truth match any comparable body of landscape work in the medium. What is immediately apparent in these paintings, once the extraordinary versatility of technique and mastery of effects has been registered, is the new frankness with which Heron is prepared to depict the forms and appearance of things, the natural phenomena of light and colour. In *Sydney: November 17: 1989: I* the brilliancies of sunlight on sea, the ribbing of the sandy shore, the glint and gleam and glare of the harbour are unmistakeably realized in the washed blues and purples, the flashes of pink, the sharp saturations of yellows, the orange parallels. Elsewhere the shapes and colours of the jacarandas and other trees in the botanic gardens, the greens of leaf and lawn, the explosive chromatic effulgence of the flowers, the bleached ochres and harsh oranges of the interior scrub are caught in ecstatic concentrations of washes and opacities, scribbles, arabesques and zig-zags.

The first of the large oils were made in December. Where the garden paintings of a few years before had still seemed to work as arrangements of shapes on the surface of the canvas, concatenations of form whose relations within ambiguous space offered possibilities of topographical readings as they simultaneously denied them, these Sydney pictures present a kind of spatial coherence that has to do with a new conceit in the work, and one which persists as an aspect of paintings made as recently as 1992. It is of pictorial space itself as a kind of imaginative topos: the painting itself as an analogic place, with an implicit invitation to the spectator to enter it dynamically, and for the wandering of the eye to enact analogously a physical progress through the garden. This paradisical space is as crowded with fantastic foliage and exotic flora as those earlier botanic gardens created with such absolute conviction by the Le Douanier Rousseau.

In certain cases, as for example *Sydney Garden Painting: December 1989: II* and *Sydney Garden Painting: February 1990: I*, they are entered through a transparent gateway. Earlier edens had been furnished with this perceptual gate: it first occurs in *La Garoup, Cap D'Antibes: 1949*, and is to be found, more significantly, in the unusual *Abstract Garden* of 1956, where it is placed at lower centre, above a railing-like structure. The trails and loops of paint squeezed straight from the tube, and the decorated-circle motives in this painting directly anticipate the paint-drawing of the late paintings, as does the Bonnardian all-over spatiality, and of course the Bonnardian theme. The gate or railing motive is a version also of the window/ balcony that lets on to the sunlit splendours (in Bonnard as in Heron) of garden or sea: a point of entry into the magical space of the painting.

There is an underlying logic to these connections: the earthly paradise that Heron rediscovered in the Sydney paintings is, of course, a country of the heart and mind, a construct of the imagination. It is nothing less than the real world transfigured by what Locke called 'natural light' – the intuitive perception 'into the nature of relations whereby we recognise distinctions and identities, contradictions and entailments' – (Stevens's 'resemblances'!) The garden at Eagles Nest, high above the shining mirror of the sea, had long provided him with an image, and abstract figures within the image (the rounded pool, the square-round boulders, the fractured shadows of branch and leaf, the splintering colour bursts of flowering shrub), and in that blessed spring of 1956 it had inspired him with just such plenitudes of light and colour as those he now experienced in the incandescent light of the Australian summer. He responded to the newness of scene and the release of spirit with a comparable creative outburst.

Of course it is true that familiar Heron shapes continue to inhabit the paintings made in Sydney and after. The disc and the kidney-shape, the strange branching attenuation that had first appeared, writ large, in *March–April: 1975* and again, like an

COASTAL LIGHT, FLORAL BRILLIANCE

→ 20 JUNE: 1992
Oil on canvas 40.6 × 50.8 cm

↠ 13 MARCH: 1992
Oil on canvas 213.4 × 121.9 cm

↓ 4 JUNE: 1992: I
Oil on canvas 50.8 × 60.9 cm

underwater plant with the other odd marine morphologies in *Boycott* in 1977, the odd arbitrary signs, squares, diamonds and triangles, the stripes and zig-zags: all these figures feature. But now they are held in place, as if corralled in space or circumscribed on the plane, by quickly painted lines, now looping, now angular, that recall the linear framework of the figurative paintings of the early 1950s. As in those earlier paintings they perform a dual function, acting as dynamic aspects of a surface design, and as indicators of a coherently imagined spatial relation between things. But in these paintings there is now the added vitality of a restless and virtuosic calligraphy of pure colour, written from the tube with an emphatic quickness of utterance that is the man himself. And what is unified in these late works by these linear devices, this rapid handwriting, is an imagined space no more tenuously attached to remembered actualities than the earliest drawings done from memory, or the figurative paintings made in London, remembering the room at St Ives. Heron has moved through abstraction and an absolute non-figuration to arrive at a new kind of figuration, perhaps that which he had anticipated as early as the note he wrote for *Statements* in 1957: '… I do not … necessarily believe that the future belongs to non-figuration. On the contrary: I believe a brand new figuration will emerge, but emerge *out of* our present non-figurative thought and practice'.

Paintings as diverse as *Sydney Garden Painting: February 1990: II*, with its busy scribble of light, its pathways and beds of dark foliage – pure paint, undisguised; or *27 August: 1991*, with its Bonnardian intensities of heat and colour and its Matissean continuity of interior and exterior; or *13 March: 1992* with its invitation to the spectator to enter its space, walk into the radiance of its garden light; or *10–11 July: 1992* with its magical plants and pebbles – pure lines of paint, exuberant and witty: these are the fruits of an unencumbered spirit, of a visual imagination that will not be constrained by rule or preconception. They are unmistakeably *late* works of a master who no longer gives a damn, and is happy to share his vision with all who are prepared to see the world with his own entranced eye. 'There is a paradox', he wrote in *My Painting Now: 30 August 1987*: 'Painting as such is abstract. Yet the power of that abstraction is its capacity to render the outside world visible …'. From the outset of an extraordinary career conducted with the utmost artistic integrity Heron has made beautiful fictions, themselves, as he is deeply aware, parts of a greater whole, the great work of the world itself, the true world. He has worked always in the spirit of Wallace Stevens's superb injunctions to the poet-artist:

It Must Be Abstract. It Must Change. It Must Give Pleasure.

→ 12 JANUARY – 21 MARCH: 1994
Oil on canvas 96.5 × 121.9 cm

↠ 17 JANUARY – 5 FEBRUARY: 1994
Oil on canvas 182.9 × 243.8 cm

↓ 2–7 APRIL: 1994
Oil on canvas 198.1 × 365.8 cm

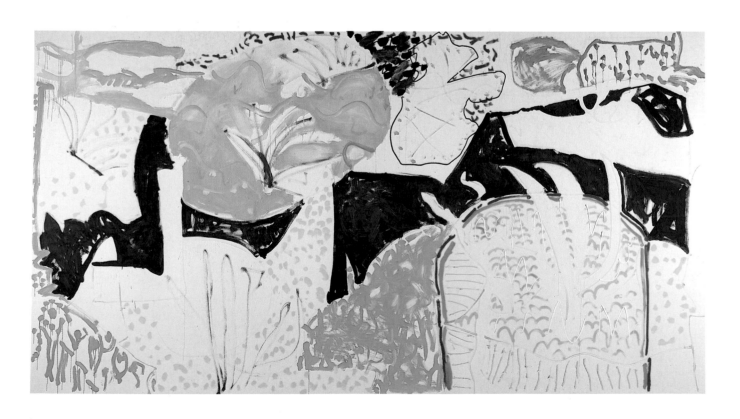

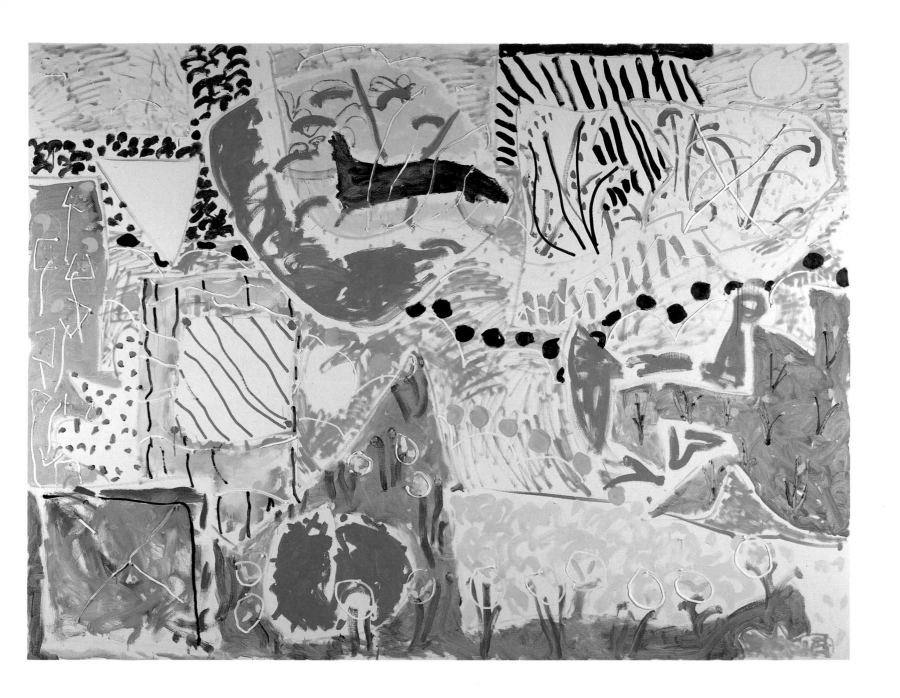

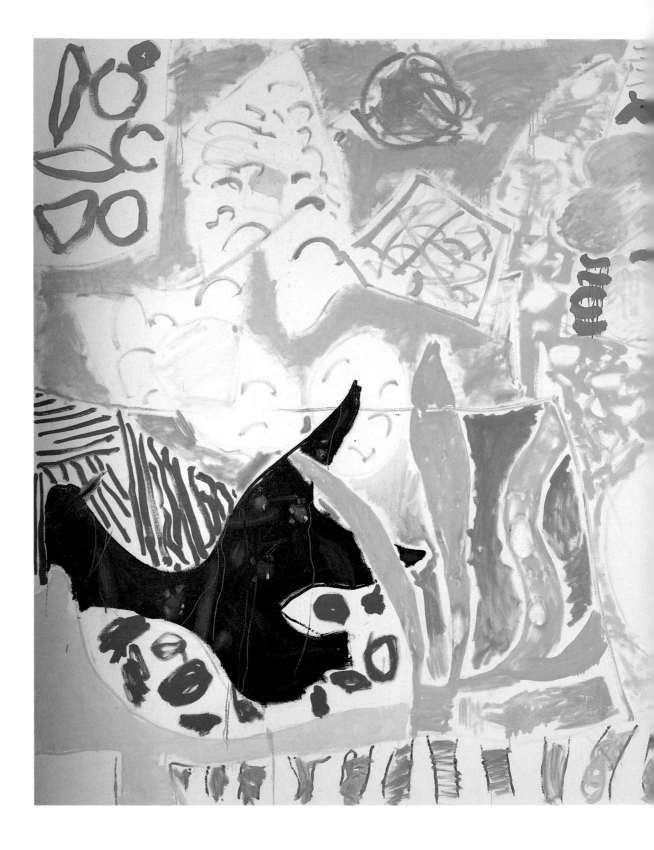

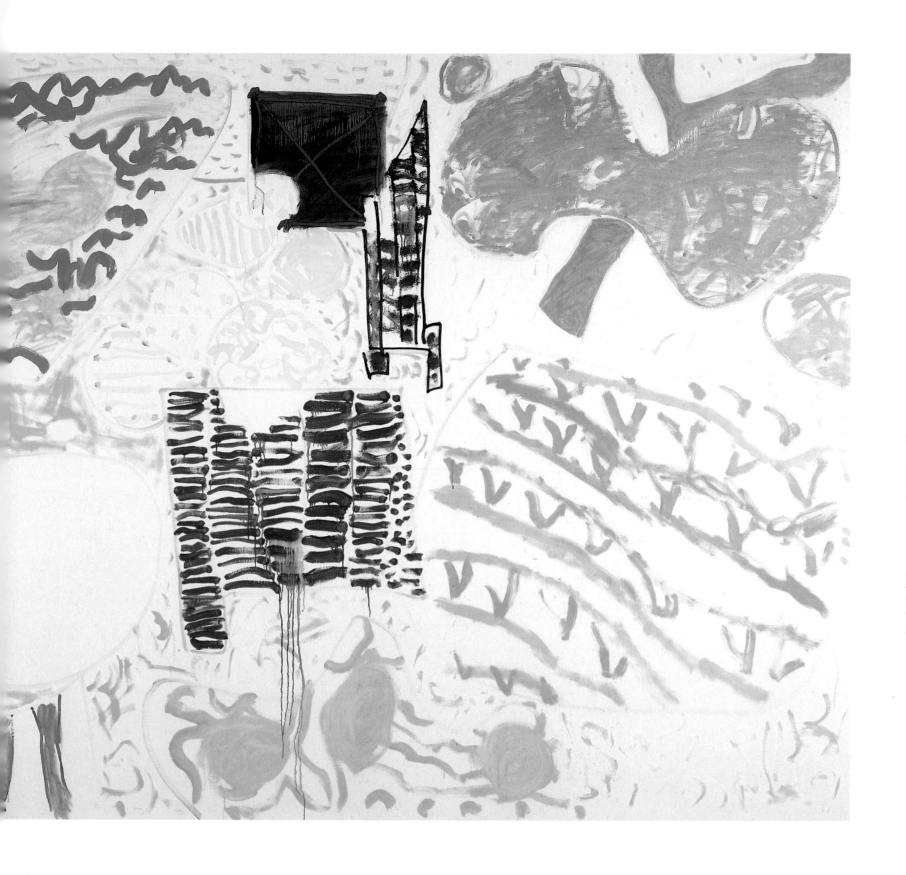

NOTES AND REFERENCES

Abbreviations used in these notes:

CFA: *The Changing Forms of Art* by Patrick Heron, Routledge and Kegan Paul, London, 1955. The edition referred to is the American paperback edition (Noonday Press, New York, 1958).

SC: 'The Shape of Colour', The Sixth Power Lecture in Contemporary Art 1973 by Patrick Heron. Published in *Studio International*, February 1974, (quotations in the text are from this version) and in *Concerning Contemporary Art – The Power Lectures 1968–73,* ed. Bernard Smith, (The Clarendon Press, Oxford, 1974).

CC: *The Colour of Colour* by Patrick Heron (College of Fine Arts, The University of Texas at Austin, 1979). These are the texts of the E. William Doty Lectures in Fine Arts (Third Series) delivered in 1978.

VK: *Patrick Heron* by Vivien Knight (John Taylor in association with Lund Humphries, London, 1988).

CHAPTER 1

p. 8 'A lawn floating in air high above the sea' is Susanna Heron's description, taken from *Shima: Island and Garden*, her lyrical evocation of the garden at Eagles Nest (Abson, London, 1992). Patrick Heron writes of the 'strangely Cubist complexities' of Eagles Nest (VK, p. 15), and of its gardenscape and the landscape of West Penwith 'very nearly the greatest passion of my life' in 'My Painting Now: 30 August 1987' in VK, p. 19.

p. 8 'Seeing is not a passive but an active operation': from 'The Seeing Eye' a symposium in *Journal Forty-Nine of the Society of Industrial Artists* (February 1956), pp. 7–9.

p. 9 'the anciently valid response of the painter …': from 'Pierre Bonnard and Abstraction' in CFA, pp. 116–129. (All further references to Bonnard in this chapter are quoted from this essay.)

p. 9 'It is enough to invent signs': from 'The Path of Colour', Matisse's statement of 1947; reprinted in *Matisse on Art* by Jack D. Flam (Phaidon Press Limited, Oxford, 1973), p. 116.

p. 9 'I love all images and hate all symbols. For me painting deals with images': from 'Colour is Paint' (CC, p. 16); 'Concepts, and also symbols, are the enemies of painting …': from SC, p. 67.

p. 12 Matisse wrote of 'the rehabilitation of the role of colour' etc. in 'The Role and Modalities of Colour' (1945), quoted in Flam (op. cit.), p. 99.

p. 12 'Sensation, revelation': from *Cahier de Georges Braque 1917–47* (Paris,1948). The translation of this and other *Cahier* maxims are by Douglas Cooper, and quoted from *G. Braque*, catalogue of the Arts Council of Great Britain exhibition at the Tate Gallery, London, 1956.

p. 14 William Scott's reflections on the New York painters are from 'Biographical Notes' in *William Scott: Paintings, Drawings and Gouaches 1938–71* (Tate Gallery, London, 1972).

p. 15 Hilton Kramer is quoted from 'The American Juggernaut' in *The New York Times*, 3 January 1971.

p. 17 'the essential element of the mysterious': from the catalogue to *Statements: A review of British abstract art in 1956*, an exhibition organized by Lawrence Alloway at the Institute of Contemporary Arts, London, 1957.

p. 17 Heron's first article, on Ben Nicholson, appeared in *The New English Weekly*, 18 October 1945.

CHAPTER 2

p. 24 Much material relating to the life and career of Tom Heron is drawn from 'Tom Heron: a biographical note' by Patrick Heron, in *The Journal of the Decorative Arts Society 1890–1940*, pp. 34–9, and from the transcript of a taped conversation between Tom Heron and Katharine Heron (1971). I have also drawn on conversations with Patrick Heron, and with Katharine and Susanna Heron, and, here and elsewhere, upon personal letters kindly made available by the family.

p. 25 Eulalie Heron's 'extraordinary family' came originally from Bradford. Her father, Michael Davies, was an uncompromisingly pacifist Unitarian minister, whose windows had been smashed when he preached against the Boer War, and whose son Taliesen (Patrick's uncle, who joined Tom Heron on the staff of Cryséde at St Ives, and became a director of Cresta at Welwyn Garden City) had been imprisoned as a conscientious objector for over three years during the First World War: there was a tradition of radical non-conformism on both sides of Patrick's family. There is a letter from Michael to his grandson on his eleventh birthday which gives a vivid glimpse of his character, morally energetic, tough and tender:

I wonder whether, when you are 70, you will be able to recite 1,050 lines of poetry [Paradise Lost], as I did last Monday, with only one stumble! And I wonder what sort of stuff you are cramming into your memory; and whether you are reading GOOD books or rubbish. And I am wondering how that diminutive body of yours is getting along; and whether that chest of yours is stronger than it used to be. And I am wondering whether you will be a really good man when you are 70, – and how good you will be. Perhaps you have not thought about it yet; but I expect you have, for, of course, so much depends on the foundation … What do you think about things in general, eh?

p. 26 Something of Eulalie's intensity of response to the natural world can be discerned in these extracts from a letter to Patrick, written from Welwyn Garden City in May 1960, shortly after her return from a holiday in the Lake District – 'another to add to the series of happy family times up there'. (The Davies family and Patrick's father had many youthful holidays in the Lakes; and there it was that Tom and Eulalie had spent their honeymoon, and in turn taken their children.)

It is still my Heaven on earth – and now it is all stamped afresh on my inner sight. The mountains are like persons, and it's immensely moving when you see their familiar outlines and masses again, and recall some of the intimate details that climbing them reveals … we were content to sit and look at them – sometimes from the top of a pass – as on Wrynose – or at Blea Tarn where the greater height puts you into closer contact, with Langdale Pikes – you could see into the mountain, instead of looking up at it … The Lakeland gardens were all overflowing with azaleas – frothing and foaming with them – you could see them from right across a valley, or lake – among the greenery – mostly salmon pink and yellow – not so varied or delicate as yours … [and in the garden back at Welwyn Garden City]. The trees have closed in on us, since we left – with their summer barricade of foliage and it's much more difficult to watch the movement of the birds. A wren is nesting in our garden hut over the doorway – beautiful fine funnel shaped nests they make – do you know them?

CHAPTER 3

p. 38 'Submerged Rhythm: *A Potter's Aesthetic*': from CFA, pp. 52–65.

p. 42 'Hills and Faces: Ivon Hitchens and Peter Lanyon': from CFA, pp. 21–39.

p. 43 'certain reflexes of eye, arm and hand …' and 'once we know or can recognize these aims …': from 'Submerged Rhythm' in CFA, pp. 59 and 62.

p. 43 'I have come, with hindsight …': from 'Art is Autonomous' in CC, p.51.

p. 47 T.S. Eliot is quoted from 'Tradition and the Individual Talent' (1919) in *Selected Essays* (Faber & Faber Ltd., London, 1951).

p. 47 Heron's first essay on Braque appeared in *The New English Weekly*, 4 July 1946.

CHAPTER 4

p. 52 'I do not have to distort …': from Braque's *Cahier* (op. cit.).

p. 52 John Richardson's article 'The "Ateliers" of Braque' was published in *The Burlington Magazine*, June 1955.

p. 52 Mallarmé's famous dictum: 'Tout, au monde, existe pour aboutir à un livre …'.

p. 52 'In a typical Braque interior …': from 'The Changing Jug', a broadcast by Heron reprinted in *The Listener*, 25 January 1951, pp. 135–6 and in 'Braque' in CFA, pp. 81–95.

p. 52 'Picasso made the gas stove into a sacred object': Heron in conversation with the author, Spring 1993.

p. 52 Heron's essay, 'Maurice de Vlaminck' was republished in CFA, pp. 130–40.

p. 53 Heron compares Braque with Picasso in 'Braque' in CFA, and writes of Picasso's 'perfect marriage of fantasy and reality' in 'Picasso' in CFA, pp. 96–115.

p. 53 Eliot's concept of the 'objective correlative' is defined in 'Hamlet' (1919) in *Selected Essays* (1951).

p. 53 Cézanne's 'art is a harmony *parallel* to Nature' is quoted by Heron in both his essay on Braque and on Picasso in CFA.

p. 56 Matisse's definition of 'composition' is from 'Notes of a Painter' (1908) in Flam (op. cit.), pp. 35–40.

p. 56 'I paid endless visits …': from 'Art is Autonomous' in CC, p. 49.

p. 56 'As in the music of Bach …': from 'Art is Autonomous' in *The Twentieth Century*, September 1955, pp. 290–7.

p. 57 Paul Valéry defined a poem as 'really a kind of machine for producing a poetic state of mind' in 'Poetry and Abstract Thought', the Zaharoff lecture delivered at Oxford on 1 March 1939, ed. James R. Lawler (Routledge and Kegan Paul, London, 1977), p. 163.

p. 67 'No head, I felt …': from 'The lost portraits of a poet', Heron's account of his essays at the portrayal of Eliot between 1947 and 1949, in *The Guardian*, 24 September 1988.

p. 67 David Sylvester's review appeared in *Art News and Review*, 6 May 1950.

p. 74 'The feeling of a sort of marriage …': from *The Tate Gallery Illustrated Catalogue of Acquisitions 1980–82*, p. 129.

p. 75 'Where does the charm of your paintings of open windows come from?': the question was asked of Matisse in a radio interview in 1942, reprinted in Flam (op. cit.), p. 93.

CHAPTER 5

p. 94 D.H. Lawrence's letters to the Middleton Murrys are dated 24 February and 5 March 1916: from *The Collected Letters of D.H. Lawrence* ed. Harry T. Moore (Heinemann, London, 1962), pp. 436 and 438.

p. 94 'the fact is that all transitions …' and 'the Tachist blobs …': from *The Tate Gallery Illustrated Catalogue of Acquisitions 1980–82*, p. 130.

p. 96 Heron's reports from Paris between 1949 and 1952 for *The New Statesman and Nation* are reprinted in CFA, pp. 264–8.

p. 97 Clive Bell is quoted from 'The Debt to Cézanne' in *Art* (Chatto and Windus Ltd., London, 1914).

p. 97 *Art Since 1945* was published by Thames and Hudson, London, in late 1958.

p. 97 'Here comes London's first exhibition of *tachiste* paintings!': from a conversation with the author, Spring 1993.

p. 99 William Scott is quoted from 'William Scott: Paintings, Drawings and Gouaches' (op. cit.).

p. 104 Valéry wrote that 'History feeds on history' in his 'Foreword' for *Regards sur le monde actuel* (1931); translated and reprinted in *The Outlook for Intelligence*, ed. Jackson Mathews (Harper and Row, New York, 1962), p. 8.

p. 104 'controlled … by a *new* feeling of formal coherence …': from 'Braque at the Zenith' in *Arts (NY)*, February 1957, p. 38.

p. 104 'The only rule I follow …': from 'Colour in my Painting: 1969' by Patrick Heron in EM46 *Patrick Heron: Retrospective*, commissioned by Edward Meneeley for E.S.M Documentations published in New York 1970; reprinted in *Studio International*, December 1969, pp. 204–5; reprinted in exhibition catalogue for *Patrick Heron: Recent paintings, gouaches, screenprints* at Harrogate Festival of Arts and Sciences, 4–15 August 1970; partially reprinted in VK, p. 34.

p. 111 John Berger is quoted from *The New Statesman and Nation*, 16 June 1956; Nevile Wallis from *The Observer*, 10 June 1956; Basil Taylor from *The Spectator*, 15 June 1956.

p. 111 Sam Francis's reply to Bernhard Schultze is quoted by James Johnson Sweeney in his introduction to *Sam Francis*, the catalogue to a retrospective exhibition at the Museum of Fine Arts, Houston, Texas, in 1967.

p. 114 Herbert Read's letter to Heron is published with permission.

p. 114 Alan Bowness is quoted from 'On Patrick Heron's Striped Paintings', his introduction to the catalogue of a retrospective exhibition of paintings 1957–66 at the Museum of Modern Art, Oxford, 1968.

p. 115 Heron's remarks on Monet are from 'the Monet revival' in *Arts (NY)*, November 1957, pp. 20–1.

p. 115 'Seeing is not a passive but an active operation': from *Journal Forty-Nine of the Society of Industrial Arts* (op. cit.).

p. 115 'Delia was the expert …': from 'My Painting Now: 30 August 1987' in VK, p. 15.

p. 115 Will Arnold-Forster's descriptions are quoted from his classic handbook *Shrubs for the Milder Counties* (Country Life Ltd., London, 1948).

p. 118 Susanna Heron is quoted from *Shima: Island and Garden* (op. cit.).

p. 118 Of Heron's many reflections on Eagles Nest, the garden and its environs, the following are notable: 'Heron's Nest' in *Harpers and Queen*, August 1981, pp. 104–5 and 143; articles in *The Sunday Times* magazine, 1 November 1985, *The Times Saturday Review*, 5 January 1991, and *Country Living*, June 1993, pp. 66–7; and, most importantly, 'My Painting Now: 30 August 1987' in VK, p.19.

p. 118 'All day there is the sound of the wind …': from Susanna Heron (op. cit.).

p. 119 'the indispensible means …': from 'Space in Colour', written for the exhibition of that title, selected by Patrick Heron, at the Hanover Gallery, London, in July and August 1953.

p. 119 Matisse's 'The Path of Colour' is reprinted in Flam (op. cit.), p. 116–7.

p. 120 'Here is a country …': Matisse in conversation with André Marchand in Flam (op. cit.), p. 114.

p. 120 'I thought I was making the most extreme paintings …': Heron in conversation with the author, Spring 1993.

p. 121 'Although I think Rothko a very fine colourist indeed …': from *Arts (NY)*, May 1958, pp. 22–3.

p. 121 Extracts from Rothko's interviews with William Seitz (January 1952) and Selden Rodman (1957) are quoted in 'Selected Statements by Mark Rothko', by Bonnie Clearwater in *Mark Rothko 1903–70* (Tate Gallery, London, 1987).

p. 126 Clement Greenberg's essay on Post Painterly Abstraction was published in the catalogue of the exhibition at Los Angeles County Museum of Art in 1964.

p. 127 On the chronology of 'stripe' painting in America, see letters from Gene Davis and Patrick Heron in *Art International*, XIV/4 April 1970 and XIV/7 September 1970 respectively.

p. 127 'the reason why the stripes sufficed …': from 'Colour in My Painting: 1969' (op. cit.).

CHAPTER 6

p. 137 John Russell is quoted from *The Sunday Times*, 2 March 1958; Denys Sutton from *The Financial Times*, 4 March 1958; Nevile Wallis from *The Observer*, 16 March 1958; Guy Clutton-Brock from an unsigned article in *The Times*, 28 February 1958; Andrew Forge from *The Listener*, 27 March 1958.

p. 139 Alan Bowness introduced *Patrick Heron Recent paintings and selected earlier canvases* at the Whitechapel Art Gallery, London, June–July, 1972.

p. 139 Heron's *Arts (NY)* piece on 'five Americans …' was published in May 1958, pp. 22–3; partially reprinted in VK, pp. 32–3.

p. 151 'the painting is not a mirror …': from an extract of a letter from Matisse to his son, Pierre, 1942, in Flam (op. cit.), p. 90.

p. 160 The Grand Prize of £1,000 at the John Moores exhibition in 1959 was awarded by a special international jury for a painting from a selected entry of 25 British and 25 invited French painters.

p. 160 'In pictures like … *Black Painting* …': from SC, p. 71.

p. 161 George Dennison is quoted from *Arts (NY)*, April 1960; Stuart Preston from *The New York Times*, 17 April 1960.

CHAPTER 7

p. 174 'perhaps this inconsistency was more apparent than real …': from SC, p. 72.

p. 174 Fromentin's remark on colour relativity is quoted by Francis Carco in conversation with Matisse (1941) in Flam (op. cit.), p. 88.

p. 177 '*Images* physically reflect the physical realities …': from the second of two paragraphs written for 'A Note on my Painting: 1962', for the Galerie Charles Lienhard catalogue, but omitted from it, and published subsequently by Norbert Lynton as part of his review of Heron's 1963 Waddington exhibition in *Art International* VII/4 April 1963, p. 65

p. 184 'Unlike Ben Nicholson …': from SC, p. 73.

p. 185 *Three American Painters* by Michael Fried was published by Harvard University Press, Cambridge, Mass., in 1965.

p. 188 'If ever an academic movement was heralded …': from 'A kind of cultural imperialism?', *Studio International*, February 1968, pp. 62–4.

p. 188 Heron's 1970 polemic, delivered on 16 December at the Institute of Contemporary Arts, was entitled 'Symmetry in Painting: An Academic Formula'.

p. 188 'To short-circuit the whole pictorial adventure …': from 'Two Cultures' in *Studio International*, December 1970, pp. 240–8; partially reprinted in VK, p. 35.

CHAPTER 8

p. 210 'It is one of the ecstasies of painting …': from 'The Necessity of Distortion in Painting' in CFA, pp. 3–20.

p. 210 'When the means of expression …': from 'The Necessity of Distortion in Painting' (op. cit.).

p. 211 'The quality of vitality in art …': from 'The Necessity of Distortion in Painting' (op. cit.).

p. 239 The catalogue to the exhibition of Bonnard drawings which toured the USA in 1972–3 was published by the American Federation of Arts, New York (1972).

p. 246 Wallace Stevens' definition of 'resemblance' is from the first of 'Three Academic Pieces' in *The Necessary Angel: Essays on reality and the imagination* (Faber & Faber Ltd., London, 1960).

p. 246 Stravinsky's remark is from 'The Phenomenon of Music' in *Poetics of Music*, the Charles Eliot Norton Lectures delivered at Harvard in 1939–40 (Harvard University Press, Cambridge, Mass. and London, 1970).

p. 247 Susanne K. Langer discusses Locke's 'natural light', Lecture 5 in *Problems of Art: Ten Philosophical Lectures* (Routledge and Kegan Paul, London, 1957).

p. 254 Stevens' injunctions are the headings to the three central sections of 'Notes toward a Supreme Fiction' in *Collected Poems* (Faber & Faber Ltd., London, 1955).

ONE-MAN EXHIBITIONS

1947
Redfern Gallery, London
→ Downing's Bookshop, St Ives

1948
Redfern Gallery, London

1950
Redfern Gallery, London
→ Bristol City Art Gallery

1951
Redfern Gallery, London

1952
City Art Gallery, Wakefield; toured to:
University Galleries, Leeds; Bankfield
Museum, Halifax; Scarborough Art Gallery;
Ferens Art Gallery, Hull; Midland Group
Gallery, Nottingham (retrospective;
catalogue with text by Basil Taylor)

1953
Lady Margaret Hall, Oxford
→ II Bienal de São Paulo, Brazil; toured
South America

1954
Redfern Gallery, London

1955
Simon Quinn Gallery, Huddersfield

1956
Redfern Gallery, London

1958
Redfern Gallery, London

1960
Bertha Schaefer Gallery, New York
→ Waddington Galleries, London

1962
Bertha Schaefer Gallery, New York
→ Grinell College, Grinell, Iowa

1963
Waddington Galleries, London
→ Galerie Charles Lienhard, Zurich
(catalogue; text by J.P. Hodin and Patrick
Heron)

1964
Waddington Galleries, London

1965
Bertha Schaefer Gallery, New York
→ Hume Tower, Edinburgh (with Bryan
Wynter)

1965–67
VIII Bienal de São Paulo, (representing
Great Britain with Victor Pasmore); toured
to: Rio de Janeiro, Buenos Aires, Santiago,
Lima, and Caracas (catalogue with text by
Alan Bowness)

1967
Dawson Gallery, Dublin
→ Richard Demarco Gallery, Edinburgh
(retrospective; catalogue with text by
Robert Hughes)
→ Kunstnernes Hus, Oslo (retrospective)
→ Waddington Galleries, London

1968
Museum of Modern Art, Oxford
(retrospective; catalogue with text by Alan
Bowness)
→ Waddington Galleries, London
→ Park Square Art Gallery, Leeds
→ Bear Lane Gallery, Oxford (gouaches
and graphics)

1970
Waddington Fine Arts, Montreal
→ Mazelow Gallery, Toronto
→ Rudy Komon Gallery, Sydney; toured
Australia
→ Waddington Galleries, London
→ Waddington Galleries, London
(graphics)
→ Gallery Caballa, Harrogate Festival of
Arts & Sciences

1972
Whitechapel Art Gallery, London (partial
retrospective; catalogue with text by Alan
Bowness and Patrick Heron)

1973
Waddington Galleries, London (graphics)
→ Hester Van Royen Gallery, London
→ Bonython Art Gallery, Paddington,
New South Wales
→ Midland Art Centre, Birmingham

1974
Skinner Galleries, Perth, Western Australia
→ Prints on Prince Street, New York

1975
Waddington Galleries, London
→ Rutland Gallery, London
→ Festival of Bath

1977
Galerie Le Balcon des Arts, Paris (with
Terry Frost)
→ Waddington & Tooth Galleries, London
(gouaches)

1978
University of Texas at Austin Art Museum
(retrospective; catalogue with text by Alan
Bowness, Patrick Heron and R.C. Kenedy)
→ Bennington College, Vermont
(graphics)

1979
Waddington Galleries, London
→ Oriel Gallery, Cardiff

1981
Riverside Studios, London

1983
Waddington Galleries, London

1984
Abbot Hall Art Gallery, Kendal

1985
Castlefield Art Gallery, Manchester
→ Arcade Gallery, Harrogate
→ Barbican Art Gallery, London
(retrospective; catalogue with text by James
Faure Walker, Alan Gouk and Vivien
Knight)
→ Newlyn Orion Gallery, Cornwall
→ Caledonian Club, Edinburgh (gouaches)

1986
Northern Centre for Contemporary Art,
Sunderland
→ New Grafton Gallery, London (with
Ivon Hitchens)

1987
Waddington Galleries, London

1988
Oxford Gallery, Oxford (gouaches)
→ Chessel Gallery, Moray House College,
Edinburgh
→ Plymouth Art Centre (gouaches)

1989
Jersey Arts Centre, St Helier
→ Waddington Galleries, London (gouache
retrospective)

1990
Art Gallery of New South Wales, Sydney
('Sydney' paintings and gouaches)
→ Rex Irwin, Woollahra, New South
Wales ('Sydney' paintings and gouaches)

1991
Waddington Galleries, London
('Sydney' paintings and gouaches 1989–90
and related works)

1992
Waddington Galleries, London

1994
Camden Arts Centre, London
→ Bodilly Galleries, Cambridge

1995
Arnolfini Gallery, Bristol

GROUP EXHIBITIONS

1949
'Salon de Mai', Paris

1950
'Aspects of British Art', Institute of Contemporary Arts, London
→ 'Five Painters', Bristol City Art Gallery

1951–52
'Sixty Paintings for 51', Manchester City Art Gallery (Festival of Britain); toured to: R.B.A. Galleries, London; Leicester Museum & Art Gallery; Walker Art Gallery, Liverpool; Bristol City Art Gallery; Norwich Castle Museum; Plymouth City Art Gallery; Leeds City Art Gallery; Laing Art Gallery, Newcastle; Glasgow City Art Gallery; Brighton Art Gallery; York City Art Gallery and Harris Art Gallery, Preston
→ '21 Modern British Painters', Vancouver Art Gallery; toured to: Seattle, San José, San Francisco, Salt Lake City and Portland

1953
'Space in Colour', Hanover Gallery, London (exhibition devised by Patrick Heron)
→ 'British Watercolours and Drawings of the XXth Century', Brooklyn Museum, New York

1953–54
'Ten Contemporary British Painters', (British Council); toured to: Gothenburg, Stockholm and Malmö

1954
'British Painting and Sculpture 1954', Whitechapel Art Gallery, London

1954–55
'British Art 1900–1950', Kunstsoreningen, Copenhagen; toured to Kunstnernes Hus, Oslo

1955
'International Exhibition of Painting', Ateneo de Valencia, Venezuela

1955–56
'Six Painters from Cornwall', Montreal Museum of Fine Art; toured to: Vancouver Art Gallery; Art Gallery of Hamilton; Art Gallery of Ontario, Toronto; Elsie Perrin Williams Memorial Art Museum, London, Ontario and Winnipeg Art Gallery

1956
'Critic's Choice', (Sir Herbert Read), Arthur Tooth & Son, London
→ 'Recent Abstract Painting', Whitworth Art Gallery, Manchester

1957
'Statements: a review of British abstract art in 1956', Institute of Contemporary Arts, London
→ 'Peinture Anglaise Contemporaine', Musée des Beaux-Arts, Liège; toured to Galerie Perron, Geneva and Brussels
→ 'La Peinture Britannique Contemporaine', Salle Balzac, Paris
→ 'Dimensions–British Abstract Art 1948–57', O'Hana Gallery, London
→ 'Premio Lissone', Milan
→ 'John Moores Liverpool Exhibition I', Walker Art Gallery, Liverpool

1958
'Abstract Impressionism', Arts Council Gallery, Cambridge; toured to: Arts Council Galleries, London; Laing Art Gallery, Newcastle and Nottingham University
→ 'British Guggenheim Award Paintings', Whitechapel Art Gallery, London
→ 'The Religious Theme', Tate Gallery, London
→ 'British Abstract Painting', Auckland City Art Gallery, New Zealand

1959
'John Moores Liverpool Exhibition II', Walker Art Gallery, Liverpool
→ 'Eleven British Painters', Jefferson Place Gallery, Washington, D.C.
→ 'Four English Middle Generation Painters: Frost, Heron, Hilton, Wynter', Waddington Galleries, London

1960
'Seventh Exposition', Tunis, Tunisia
→ 'British Guggenheim Award Paintings', Royal Watercolour Society Gallery, London

1961
'13 Brittiska Konstnarer', Moderna Museet, Stockholm
→ 'Carnegie International', Carnegie Institute, Pittsburgh, Pennsylvania
→ 'University of Nebraska Annual Exhibition', Lincoln
→ 'Watercolour International', Brooklyn Museum, New York

1961–62
'Arte Britanica na Seculo XX', (British Council), Calouste Gulbenkian Foundation, Lisbon; toured to Oporto and Coimbra

1962
'Six Painters', Waddington Galleries, London
→ 'Pittsburgh International', Carnegie Institute, Pittsburgh, Pennsylvania

1962–3
'British Art Today', San Francisco Museum of Art, California; toured to: Dallas Museum for Contemporary Arts, Texas and Santa Barbara Museum of Art, California

1963
'British Painting in the Sixties', Tate Gallery, London

1963–64
'Contemporary British Painting', (British Council), National Gallery of Canada, Ottawa; toured to: Louisiana Gallery, Copenhagen
→ 'Contemporary British Gouaches', British Council exhibition, Kunstamt Charlottenburg, Berlin; toured Germany

1964
'Painting and Sculpture of a Decade: 54–64', (Calouste Gulbenkian Foundation), Tate Gallery, London

1967
'Recent British Painting', (Collection of Peter Stuyvesant Foundation), Tate Gallery, London; toured to South Africa and Australia

1968
'Works on Paper', Waddington Galleries, London
→ 'Britische Kunst Heute', Kunstverein, Hamburg
→ 'Painting 64–67', Arts Council, London

1970
'Kelpra Prints', Hayward Gallery, London
→ 'British Painting and Sculpture 1960–1970', National Gallery of Art, Washington, D.C.

1972–73
'Decade: Painting, Sculpture and Drawing in Britain 1940–49', Whitechapel Art Gallery, London; toured to: City Art Gallery, Southampton; Public Library, Museum & Art Gallery, Carlisle; D.L.I. Museum & Arts Centre, Durham; City Art Gallery, Manchester; City Art Gallery, Bradford and Museum & Art Gallery, Aberdeen

1973
'First Biennale', Sydney
→ 'Europalia 73, Great Britain: Henry Moore to Gilbert and George', Palais des Beaux-Arts, Brussels

1974
'Some Significant British Artists: 1950–1970', Rutland Gallery, London
→ 'British Painting 74', Hayward Gallery, London

1975
'The British Are Coming', Cordova Museum, Lincoln, Massachusetts

1977
'British Painting 1952–1977', Royal Academy, London
→ 'Cornwall 1945–1955', New Art Centre, London

1977–78
'Color en la Pintura Britanica', (British Council); toured to: Brazil, Argentina, Venezuela, Columbia and Mexico

1979
'Colour 1950–1978', D.L.I. Museum & Arts Centre, Durham

1980
'Hayward Annual', Hayward Gallery, London

1980–81
'Leeds Paintings', Victoria Art Gallery, Bath; toured to: Huddersfield Art Gallery; Herbert Art Gallery & Museum, Coventry; Harris Museum & Art Gallery, Preston; Cooper Gallery, Barnsley; Usher Gallery, Lincoln and Bolton Museum & Art Gallery

1983
'Pintura Britanica Contemporanea', Museo Municipal, Madrid
→ 'Aspects of Modern British Art 1920–1960', Austin/Desmond Fine Art, Ascot

1984
'British Artists' Books 1970–83', Atlantis Gallery, London
→ 'English Contrasts', Artcurial, Paris
→ 'Aspects of Modern British Art II 1910–1965', Austin/Desmond Fine Art, Ascot

1985
'Kunstwerk', Peter Stuyvesant Foundation, Amsterdam, (Silver Jubilee exhibition)
→ 'Printmakers at the Royal College of Art', Barbican Art Gallery, London
→ 'Recalling the Fifties', Serpentine Gallery, London
→ 'St Ives 1939–64', Tate Gallery, London

1986
'Summer Exhibition', Royal Academy, London
→ 'Annual Open Exhibition', Royal West of England Academy, Bristol
→ 'Forty Years of Modern Art 1945–1985', Tate Gallery, London
→ 'Side by Side: Contemporary British and Malaysian Art 1986', (British Council), Balai Seni Lukis, Kuala Lumpur; toured to: Bangkok, Hong Kong and Singapore
→ 'Aspects of Modern British Art IV', Austin/Desmond Fine Art, Ascot

1987
'British Art in the Twentieth Century: The Modern Movement', Royal Academy, London; toured to Staatsgalerie, Stuttgart
→ '2D/3D – Art and Craft Made and Designed for the Twentieth Century', Laing Art Gallery, Newcastle; toured to Northern Centre for Contemporary Art, Sunderland
→ 'Works on Paper', Waddington Galleries, London
→ 'British & European Paintings and Drawings', Redfern Gallery, London
→ 'John Moores Liverpool Exhibition 15', Walker Art Gallery, Liverpool
→ 'Small is Beautiful', Angela Flowers Gallery, London

1988
'The Best of Modern British Art', Austin/Desmond Fine Art, London
→ 'St Ives Revisited', Angela Flowers (Ireland), County Cork
→ 'St Ives', New Art Centre, London
→ 'Post-War British Abstract Art', Austin/Desmond Fine Art, London
→ 'Twentieth Century Works', Waddington Galleries, London

1988–89
'Paintings and Sculpture', Francis Graham-Dixon Gallery, London
→ 'The Presence of Painting', Mappin Art Gallery, Sheffield; toured to: Hatton Gallery, Newcastle; Ikon Gallery, Birmingham and Harris Museum & Art Gallery, Preston
→ '100 Years of Art in Britain', Leeds City Art Gallery

1989
'The Bridge Between the East and the West, St Ives, its Climate and Art', Hyogo Prefectural Museum of Fine Art, Kobe; toured to: Kamakura and Tokyo
→ 'British Abstract Art 1950–1960', Tadema Gallery, London
→ 'Post-War British Prints', Austin/Desmond Fine Art, London
→ 'The Day Book Picture Show', Usher Gallery, Lincoln
→ 'St Ives 1919–1989', Beaux Arts Gallery, Bath
→ 'From Prism to Paintbox', Oriel Gallery, Clwyd

1989–90
'Picturing People', (British Council); toured to: Kuala Lumpur, Hong Kong and Harare

1990
'Spring Exhibition: 20th Century British Paintings, Watercolours, Drawings and Ceramics', Redfern Gallery, London
→ 'Three Ways', Royal College of Art/British Council exhibition; toured to: Magyar Kepzomuveszeti, Budapest; Istvankiraly, Székesehérvár and Pécs, Hungary
→ 'Summer Show', Waterman Fine Art, London

1990–1
'Colour in Modern Painting', Stoke-on-Trent Museum and Art Gallery

1990–2
'Festival of Fifty-one: Paintings and Sculpture of 1951 from the Arts Council Collection', Royal Festival Hall, London; toured to: Norwich, Cambridge, Brighton, Hull, Plymouth, Stockport, Bath and Lincoln

1991
'British Art from 1930', Waddington Galleries, London
→ 'British Artists', Waterman Fine Art, London
→ 'Work from the Seventies', Galerij Cotthem, Ostend
→ 'Abstraction', Waddington Galleries, London

1992
'The Poetic Trace; Aspects of British Abstraction since 1945', Adelson Galleries, New York
→ 'Collection Fondation Peter Stuyvesant – l'Art Actif', Ecole Nationale Supérieure des Beaux-Arts, Paris

1992–3
'New Beginnings: Post-War British Art from the Collection of Ken Powell', Scottish National Gallery of Modern Art, Edinburgh; toured to Courtauld Institute Galleries, London

1993
Inaugural exhibition, Tate Gallery St Ives; thereafter changing selection of works by Patrick Heron in showings of the collection

1993–4
'Herbert Read – A British Vision of World Art', Leeds City Art Gallery

1994
'Castlefield Gallery – Tenth Anniversary Exhibition', Castlefield Gallery and Whitworth Art Gallery, Manchester
→ 'The Constructed Space: Painting, Sculpture and Verse Commemorating the Poet W. S. Graham', Manor House, Castle Yard, Ilkeley

PUBLIC COLLECTIONS

AUSTRALIA:
Adelaide: Art Gallery of South Australia
Brisbane: Queensland Art Gallery
Perth: Art Gallery of Western Australia
Sydney:
 Art Gallery of New South Wales
 Power Gallery of Contemporary Art, Sydney University

CANADA:
London, ON: London Art Gallery
Montreal, PQ:
 Musée d'Art Contemporain de Montréal
 Museum of Fine Arts
Toronto, ON: Art Gallery of Ontario
Vancouver, BC: Vancouver Art Gallery

EIRE:
Galway: University of Galway

GREAT BRITAIN:
Aberdeen: Aberdeen Art Gallery
Bedford: Cecil Higgins Art Gallery
Belfast: C.E.M.A.
Bristol: Bristol City Art Gallery
Cambridge: Fitzwilliam Museum
Canterbury: Eliot College, University of Kent
Cardiff: National Museum of Wales
Chichester: Bishop Otter College
Eastbourne: Towner Art Gallery
Edinburgh:
 Scottish National Gallery of Modern Art
 Scottish National Portrait Gallery
Exeter:
 Cornwall House, Exeter University
 Exeter Art Gallery
Kendal: Abbot Hall Art Gallery
Leeds: Leeds City Art Gallery
Leicester: Leicestershire Education Committee
London:
 Arts Council of Great Britain
 British Broadcasting Corporation
 British Council
 British Museum
 Contemporary Art Society
 Calouste Gulbenkian Foundation
 National Portrait Gallery
 Peter Stuyvesant Foundation
 Shell-Mex Limited
 Tate Gallery
 Victoria and Albert Museum
Manchester:
 Granada Television
 Manchester City Art Gallery (Rutherston Collection)
Newcastle: Hatton Art Gallery, Newcastle University
Norwich: Norwich Castle Museum
Oldham: Oldham Art Gallery
Oxford:
 Lady Margaret Hall
 Merton College
 New College
 Nuffield College
 Pembroke College
 St John's College
Plymouth: Plymouth City Art Gallery
Southampton: Southampton Art Gallery
Stirling: University of Stirling
Wakefield: Wakefield City Art Gallery
Warwick: University of Warwick

BIOGRAPHICAL DETAILS

JAPAN:
Kogawa Prefecture: Ohnishi Museum
Tokyo: Setagaya Art Museum

THE NETHERLANDS:
Amsterdam: Peter Stuyvesant Foundation
Rotterdam: Boymans-van Beuningen
 Museum

PORTUGAL:
Lisbon: Fundaçao Calouste Gulbenkian

USA:
Ann Arbor, MI: Museum of Art, University
 of Michigan
Austin, TX: University of Texas at Austin
 Art Museum
Buffalo, NY: Albright-Knox Art Gallery
Los Angeles, CA: Frederick R. Weisman
 Foundation
New Haven, CT: Yale Center for British
 Art
New York, NY: Brooklyn Museum
Northampton, MA: Smith College
 Museum of Art,
Pittsburgh, PA: Carnegie Institute
Toledo, OH: Toledo Museum of Art

1920
Born in Headingley, Leeds, Yorkshire,
30 January

1925–29
Lived near Newlyn, and Lelant, Zennor and
St Ives, Cornwall, before moving to
Welwyn Garden City, Hertfordshire,
September 1929

1934
Designed first silk square for Cresta Silks

1937–39
Part-time student at Slade School of Fine
Art, London

1940–44
Agricultural labourer, Cambridge and
Welwyn Garden City

1944–45
Assistant at Bernard Leach's pottery, St Ives

1945
Moved to Holland Park, London, after
marriage to Delia Reiss; resumed painting

1945–47
Art Critic for *The New English Weekly*
Annual visits to St Ives, until 1954

1947
First one-man exhibition
Series of talks on contemporary art
commissioned by BBC Third Programme
→ Became art critic for *The New Statesman
and Nation* (until 1950; further contributions
to 1955)

1950–54
Occasional reviews in *Art News & Review*

1953–56
Taught at Central School of Arts and Crafts,
London

1955
Became London correspondent for *Arts
Digest* (later *Arts*), New York

1956
Moved to his present home at Eagles Nest,
Zennor, Cornwall

1958
Resigned from *Arts* (New York)
Took over Ben Nicholson's studio at
Porthmeor, St Ives
→ Mural panel installed in London offices
of Percy Lund Humphries

1959
Awarded Grand Prize (International Jury)
in 2nd John Moores Liverpool Exhibition,
Walker Art Gallery

1965
Awarded Silver Medal at VIII Bienal de
São Paulo; lectured in São Paulo, Brasilia
and Rio de Janeiro

1967
Visited Australia, lecturing in Perth and
Sydney

1973
'The Shape of Colour', Power Lecture in
Contemporary Art, delivered in Sydney,
Brisbane, Canberra, Melbourne, Adelaide
and Perth

1977
New Year's Honours List; created C.B.E.

1978
'The Colour of Colour', E. William Doty
Lectures in Fine Arts, delivered at
University of Texas at Austin

→ Patrick and Delia Heron made honorary
citizens of Texas by order of the Secretary
of State for Texas
→ *The Shapes of Colour: 1943–1978,* book of
screenprints, Kelpra Editions, Waddington
and Tooths Graphics

1979
Commissioned to design two carpets for
foyer of the Cavendish Hotel, London

1980–87
Trustee of the Tate Gallery, London

1981
Commissioned to design tapestry for
University of Galway, Eire

1982
Hon. D. Litt., University of Exeter

1983
Appeared in *Patrick Heron*, BBC TV
Omnibus film, directed by Colin Nears,
13 March

1985
Appeared in *Painting the Warmth of the Sun*,
a TSW production for Channel 4, directed
by Kevin Crooks, 7, 8 & 9 April

1986
Hon. D. Litt., University of Kent
→ Appeared in *South Bank Show: Patrick
Heron*, an LWT production, directed by
John Read, 9 February

1987
Hon. Doctorate, Royal College of Art,
London

1988
Visited Moscow and Leningrad on behalf
of the Tate Gallery, London

1989
Hon. Ph.D. CNAA, Winchester School
of Art
→ Visited Japan to lecture at the opening of
'St Ives' exhibition, Setagaya Art Museum,
Tokyo
→ Made second visit to Moscow and
Leningrad on behalf of the Tate Gallery,
London

1989–90
Artist-in-Residence, Art Gallery of
New South Wales, Sydney. Made over
50 paintings in the Gallery's studio

1990–93
Two tapestries made from Sydney gouaches
by Victorian Tapestry Workshop,
Melbourne

1991
Visiting Artist, International Art Workshop
at Teschemakers Conference Centre, near
Oamaru, North Otago, New Zealand
→ Honorary FRIBA
→ Designed nine silk banners for Tate
Gallery Bookshop, London

1992
Designed coloured glass window for Tate
Gallery St Ives (official opening June 1993)
→ Designed three silk banners for Chelsea
and Westminster Hospital, London (height
58 feet)
→ Designed kneeler to encircle Henry
Moore altar at St Stephen Walbrook,
London

1993
Honorary Fellow of Bretton Hall College,
University of Leeds

ADAMS, BRUCE
'In Control of Colours', *The Sunday Telegraph* (Sydney), 24 June 1973

ALLEY, RONALD
'Patrick Heron, The development of a painter', *Studio International*, July/August 1967

BONE, STEPHEN
'Coloured Stripes and Cubist Art: Redfern Exhibitions', *The Manchester Guardian*, 26 February 1958

BORLASE, NANCY
'Brilliant Use of Colour, Form', *The Bulletin* (Sydney), 30 June 1973

BOWNESS, ALAN
'Form and Content', *The Observer*, 11 September 1955
→ Introduction to exhibition catalogue of VIII Bienal de São Paolo, British Council, London 1965
→ 'On Patrick Heron's Striped Paintings', introduction to exhibition catalogue *Patrick Heron: a Retrospective Exhibition of Paintings 1957–66*, Museum of Modern Art, Oxford, 1968
→ Introduction to exhibition catalogue *Patrick Heron: Recent Paintings and Selected Earlier Canvases*, Whitechapel Art Gallery, London, June-July 1972
→ Introduction to exhibition catalogue *Paintings by Patrick Heron 1965–77*, University of Texas at Austin Art Museum, 1978, pp. 9–12

BROOK, DONALD
'Victims of a U.S. Hardsell?', *Nation Review* (Sydney), 6–12 July 1973

BURROWS, CARLYLE
'Heron Has Debut', *The New York Herald Tribune*, 17 April 1960

CHECKLAND, SARAH JANE
'A Painter's Craft', *The Times*, 6 July 1985

COCHRANE, PETER
Interview: 'Reprieve from the handbag-wielding warrior', *The Sydney Morning Herald*, 26 December 1989

COHEN, DAVID
'Patrick Heron', *Modern Painters*, vol.1, no.2, Summer 1988, p. 94
→ 'Patrick Heron: The Courage of Conviction', *Artline*, vol.5, no.6, Winter 1991–2, pp. 16–17
→ 'William Gear and Patrick Heron', *Modern Painters*, Autumn 1992, pp. 95–7

CORK, RICHARD
'Serene', *The Listener*, 29 August 1985

CROOKSTON, PETER
'A Childhood: Patrick Heron', *The Times*, 5 January 1991

DENNISON, GEORGE
'Month in Review', *Arts* (*NY*), April 1960

DYER, RICHARD
'Patrick Heron at Waddington Galleries', *City Limits*, 10–17 September 1992, p. 20

ELLMANN, LUCY
'Controlling the Paint', *TLS*, 9 August 1985

FAURE WALKER, JAMES
'Patrick Heron', *Artscribe*, no.31, October 1981
→ 'Patrick Heron: the 1970s' in exhibition catalogue *Patrick Heron*, Barbican Art Gallery, London, July-September 1985, pp. 13–17

FAURE WALKER, JAMES, with BRANDON TAYLOR
'Patrick Heron Interviewed by James Faure Walker & Brandon Taylor', *Artscribe*, no.2, Spring 1976, pp. 1–5

FEAVER, WILLIAM
'Zing and Buzz', *The Observer*, 25 July 1985

FULLER, PETER
'Patrick Heron', *Art Monthly*, no.50, October 1981
→ 'The Innocent Eye', *Artscribe*, no.54, September/October 1985
→ 'Britain and America: A Special Relationship?', *Modern Painters*, Summer 1989, vol.2, no.2, pp. 4–5

GARLAKE, MARGARET
'Patrick Heron at Waddingtons', *Art Monthly*, October 1983

GOODING, MEL
Introduction to exhibition catalogue *The Poetic Trace; Aspects of British Abstraction since 1945*, Adelson Galleries, New York, May/June 1992

GORDON PORTEUS, HUGH
'Patrick Heron', *The New English Weekly*, 23 October 1947

GOUK, ALAN
'Patrick Heron I', *Artscribe*, no.34, March 1982, pp.40–54
→ 'Patrick Heron II', *Artscribe*, no.35, June 1982, pp. 32–43
→ 'Recent Paintings' in exhibition catalogue *Patrick Heron*, Barbican Art Gallery, London, July-September 1985, pp. 18–24

HILTON, TIM
'The wild west show', *The Guardian*, 3 April 1991
→ 'Everything in the garden is lovely', *The Guardian*, 10 September 1992

HODIN, J.P
'Patrick Heron', *Quadrum II*, Brussels, 1961
→ 'The Development of Patrick Heron's Art', introduction to exhibition catalogue *Patrick Heron*, Galerie Charles Lienhard, Zurich, January 1963

HUGHES, ROBERT
'Colour Standing up Alone', *The Observer*, 14 May 1967
→ Introduction to exhibition catalogue *Retrospective: Patrick Heron*, Richard Demarco Gallery, Edinburgh, June-July 1967

KENEDY, R.C.
'Patrick Heron – Abstract Impressionist', essay in exhibition catalogue *Paintings by Patrick Heron 1965–77*, University of Texas at Austin Art Museum, 1978, pp.34–40

KNIGHT, VIVIEN
'The Pursuit of Colour' in exhibition catalogue *Patrick Heron*, Barbican Art Gallery, London, July-September 1985, pp.5–12
→ *Patrick Heron*, edited and with an introduction by Vivien Knight, John Taylor in association with Lund Humphries, London, 1988

KRAMER, HILTON
'The American Juggernaut', *The New York Times*, 3 January 1971
→ 'Patrick Heron's Art on View in London', *The New York Times*, 11 July 1972

KUSPIT, DONALD
'St Ives – Setagaya Art Museum, Tokyo', *Artforum International*, December 1989, p. 156

LAMBERT, HELEN
'U.K.'s Patrick Heron, U.S.'s Paul Jenkins', *The New York Herald Tribune*, 6 March 1963

LEWIS, ADRIAN
'British Avant-Garde Painting 1945–56', *Artscribe*, no.35, June 1982

LILLINGTON, DAVID
'Patrick Heron', *Artscribe*, no.77, September/October 1989, pp. 10–12
→ 'Colour Code', *Time Out*, 3–10 April 1991

LYNN, ELWYN
The Weekend Australian, 6–7 January 1990
→ 'Patrick Heron: an artist in full bloom', *The Weekend Australian*, 20–1 January 1990

LYNTON, NORBERT
'London Letter', *Art International*, 25 April 1963
→ 'Heron Exhibition', *The Guardian*, 19 May 1967

McDONALD, JOHN
'One man against the U.S. onslaught', *The Sydney Morning Herald*, 13 January 1990, p. 66

McGRATH, SANDRA
'Colour is the Medium and the Message', *The Australian*, 23 June 1973

McNAY, MICHAEL
'Heron's Nest', *The Guardian*, 21 June 1972
→ 'Star with the Stripes', *The Guardian*, 23 July 1985

MENEELEY, EDWARD and CHRISTOPHER DE MARIGNY
EM46, Patrick Heron Retrospective, E.S.M. Documentations, New York, 1970

MORTIMER, RAYMOND
'Art Critics in a Fix: and a Painter on some Modern Masters', *The Sunday Times*, 18 September 1955

NICKLIN, LENORE
'The Interlocking Artist', *The Sydney Morning Herald*, 15 June 1973

PRESTON, STUART
'An English Modern', *The New York Times*, 17 April 1960

ROBERTSON, BRYAN with JOHN RUSSELL AND LORD SNOWDON
Private View, Nelson, London 1965

RUSSELL TAYLOR, JOHN
'High Flying Heron', *The Times Preview*, 4–10 September 1981

RUSSELL, JOHN
'The Novel and the New', *The Sunday Times*, 2 March 1958
→ 'Heron Aloft', *The Sunday Times*, 13 December 1959

SPURLING, HILARY
'East End Flame Thrower', *The Observer*, 25 June 1972

STOREY, DAVID
'Towards Colour', *The New Statesman*, 8 March 1963

SYLVESTER, DAVID
'Patrick Heron', *Art News & Review*, 6 May 1950
→ 'Portrait of the Artist no.85 Patrick Heron' *Art News and Review*, 3 May 1952

TAYLOR, BASIL
'Patrick Heron', *The New Statesman and Nation*, 6 May 1950
→ Introduction to exhibition catalogue *Retrospective Exhibition of Paintings and Drawings by Patrick Heron*, Wakefield City Art Gallery, April 1952, and tour
→ 'Space in Colour', *The Times*, 26 July 1953
→ 'The Painter as Critic', BBC Third Programme, review of *The Changing Forms of Art*, 14 September 1955

THOMAS, DANIEL
'Artist's Passion for Colour', *The Sydney Morning Herald*, 21 June 1973

THOMAS, LAURIE
'Stirred by a Wobbly Hard-Edger', *The Australian*, 16 June 1973
→ 'Through the Critic's Eyes Darkly', *The Australian*, 30 June 1973

WILSON, ANDREW
'Late Herons, Early Hockneys', *Galleries*, April 1991
→ 'Patrick Heron at Waddington Galleries', *Art Monthly*, no.160, October 1992, p. 23

ANONYMOUS

'Space in Colour: Mr Patrick Heron's New Pictures', *The Times*, 19 June 1956

'Painter as Critic', *TLS*, 6 July 1956

'The Spectrum on Canvas, Mr Patrick Heron's New Paintings', *The Times*, 28 February 1958

'Preoccupation with Colour, Mr Patrick Heron's New Paintings', *The Times*, 29 November 1960

SELECTED WRITINGS AND LECTURES BY THE ARTIST

Abbreviations: *NEW: The New English Weekly*; *NS&N: The New Statesman and Nation*

1945
'Ben Nicholson', *NEW*, 18 October, p. 46

1946
'Picasso', *NEW*, 10 January, pp. 124–5
→ 'Paul Klee 1879–1940', *NEW*, 21 February, pp. 186–7
→ 'Cézanne at the Tate', *NEW*, 30 May, p. 70
→ 'Braque', *NEW*, 4 July, pp. 118–19
→ 'New Sculpture (and sculptor's drawings)' [Henry Moore and Barbara Hepworth], *NEW*, 31 October, pp. 28–9

1947
'Bonnard –Vuillard–Sickert', *World Review*, June, pp. 48–54
→ 'The Ethics of Mr Herbert Read' [book review of *Annals of Innocence and Experience* by Herbert Read], *NEW*, 31 July, pp. 139–40
→ 'Matthew Smith, Craxton and Freud', *NS&N*, 8 November, p. 368
→ 'Van Gogh at the Tate', *NS&N*, 27 December, pp. 507–8

1949
'Reality for the Painter', *NS&N*, 16 April, p. 378
→ 'Paris: Summer, 1949', *NS&N*, 16 July, pp. 67–8
→ 'Salon de Mai Vᵉ' [Matisse's last canvases], *NS&N*, 30 July, pp. 122–3
→ 'Adrian Ryan and Peter Lanyon', *NS&N*, 15 October, pp. 422–3
→ 'The Necessity of Distortion in Painting', lecture at Leeds University, 24 October

1950
'Space in French Landscape', *NS&N*, 4 February, p. 128
→ 'Picasso in Provence', *Art News and Review*, 2 December, p. 2

1951
'The Changing Jug' [text of BBC Third Programme talk], *The Listener*, 25 January, pp. 135–6
→ 'Bonnard and Visual Reality', *NS&N*, 24 November, pp. 588–9

1952
'A Master Potter's Aesthetic' [book review of *A Potter's Portfolio* by Bernard Leach] *NS&N*, 2 February, pp. 130 and 132
→ 'Art's Scientific Credentials' [book review of *The Philosophy of Modern Art* by Herbert Read], *NS&N*, 29 March, pp. 378 and 380
→ 'Paintings by Roger Hilton at Gimpel Fils', *NS&N*, 24 June, p. 771
→ 'Pottery and Painting' lecture at International Conference of Craftsmen in Pottery & Textiles at Dartington Hall, July

1953
'Space in Painting and Architecture', Architects' Year Book V, January, pp. 19–26
→ 'Fruit or Thorn?', *NS&N*, 24 January, p. 92
→ 'Mexico', *NS&N*, 14 March, pp. 292 and 294
→ 'Picasso in Rome', *NS&N*, 16 May, pp. 576–7
→ 'William Scott', *NS&N*, 20 June, pp. 730–1
→ 'Braque', *NS&N*, 27 June, pp. 772 and 774
→ 'Space in Colour', introduction to exhibition catalogue, Hanover Gallery, London, July–August [exhibition devised by PH]

1954
'Artists missing from the Tate' [letter], *NS&N*, 25 December, pp. 855–6

1955
'Inspiration for the painter', *NS&N*, 1 January, pp. 6–7
→ *The Changing Forms of Art*, Routledge and Kegan Paul, London; paperback edition Noonday Press, New York, 1958
→ *Ivon Hitchens*, Penguin Modern Painters, London
→ 'Space in Color', *Arts Digest (NY)*, 15 March, pp. 8–11
→ 'Barbara Hepworth – Carver', *Arts Digest (NY)*, 1 July, pp. 23–4 and 30

1956
→ 'Peter Lanyon', *Arts (NY)*, February, pp. 33–7
→ 'The Americans at the Tate Gallery', *Arts (NY)*, March, pp. 15–17
→ 'London' [Renoir], *Arts (NY)*, August, pp. 11–12

'Is Cézanne Still Alive?' *Arts (NY)*, October, pp. 26–29
→ 'London' [John Wells, Bryan Wynter], *Arts (NY)*, November, pp. 15 and 73

1957
'Note', in exhibition catalogue *Statements: a review of British abstract art in 1956*, Institute of Contemporary Arts, London, January–February
→ 'Braque at the Zenith', *Arts (NY)*, February, pp. 34–8
→ 'Introducing Roger Hilton', *Arts (NY)*, May, pp. 22–6
→ 'London' [the Monet revival], *Arts (NY)*, November, pp. 20–1

1958
'Derain Reconsidered', *Arts (NY)*, January, pp. 26–9
→ 'London' [five Americans at the ICA], *Arts (NY)*, May, pp. 22–3
→ 'London' [Degas, Picasso], *Arts (NY)*, June, pp. 16–17
→ *Braque* [introduction and commentaries] Faber Gallery, London

1963
'A Note on My Painting: 1962', introduction to exhibition catalogue *Patrick Heron*, Galerie Charles Lienhard, Zurich, January

1966
'Bonnard in 1966', introduction to exhibition catalogue, *Bonnard: 1867–1947, Drawings, Gouaches, Watercolours*, Victor Waddington, London, September/October.
→ 'The Ascendancy of London in the Sixties', *Studio International*, December, pp. 280–1

1968
'A Kind of Cultural Imperialism?', *Studio International*, February, pp. 62–4

1969
'Colour in My Painting: 1969', *Studio International*, December, pp. 204–5

1970
Letter [*Vertical Light: March 1957*], *Art International*, XIV/7, 20 September, pp. 79–80
→ 'Two Cultures', *Studio International*, December, pp. 240–8
→ *Symmetry in Painting: An Academic Formula*, lecture at Institute of Contemporary Arts, London, 16 December

1971
'Murder of the Art Schools', *The Guardian*, 12 October

1972
'Colour and abstraction in the drawings of Bonnard', introduction to exhibition catalogue *Bonnard Drawings, 1893–1946*, American Federation of Arts, New York, and tour
→ 'Notes on my painting: 1953–1972', introduction to exhibition catalogue *Patrick Heron – recent paintings amd selected earlier canvases*, Whitechapel Art Gallery, London, June–July
→ 'Matisse and Aragon' [review of Louis Aragon, *Henri Matisse: a novel*, vols. 1 and 2, trans. Jean Stewart], *The New Statesman*, 1 December, pp. 828–30

1973
'Picasso – the end of an age' [obituary], *The Guardian*, 8 April

1974
'The Shape of Colour', *Studio International*, February, pp. 65–75, reprinted in *Concerning Contemporary Art, The Power Lectures 1968–73*, ed. Bernard Smith (Clarendon Press, Oxford)
→ 'The British Influence on New York', *The Guardian*, 10, 11, 12 October

1976
Bryan Wynter 1915–75. Introduction to memorial exhibition catalogue, Hayward Gallery, London, August

1978
'Notes on My Painting: 1953–1973', contribution to exhibition catalogue, *Paintings by Patrick Heron: 1965–1977*, The University of Texas at Austin Art Museum, March-May, pp. 13–24

1979
The Colour of Colour, E. William Doty Lectures in Fine Arts, First Series 1978, College of Fine Arts, University of Texas at Austin

1985
'A note on my gouaches', accompanying text to exhibition *Patrick Heron Gouaches* at the Caledonian Club, Edinburgh, November

1986
'Blue Cranes in the Sky' [Richard Rogers' Lloyds Building], *Architectural Review*, October, pp. 57–8

1988
'My Painting Now: 30 August 1987', and 'Selected Writings by Patrick Heron in *Patrick Heron*, Vivien Knight (John Taylor in association with Lund Humphries, London), pp. 15–20, and 21–38
→ 'Late Picasso at the Tate Gallery', *Modern Painters*, Summer 1988, vol.1, no.2, pp. 6–10
→ 'The long portraits of a poet', [Patrick Heron's account of painting his portraits of T.S. Eliot], *The Guardian*, 24 September

1988/9
'What was wrong with Gauguin', *Modern Painters*, Winter 1988, vol.1, no.4, pp. 7–11 [transcript of BBC Radio 3 talk]

1989
'Prunella Clough', introduction to exhibition catalogue *Prunella Clough, recent paintings, 1980–89*, Annely Juda Fine Art, London, April–May

1991
'A note on the Sydney paintings', text to accompany exhibition *Sydney Paintings and Gouaches 1989–90*, Waddington Galleries, London, March/April
→ 'How blind bureaucracy is destroying Britain's Art Schools', *The Guardian*, 7 November

1993
'Late Matisse', *Modern Painters*, Spring, pp. 10–19

1994
'Constable: Spatial Colour in the Drawings', one of the introductory essays to the catalogue for the exhibition *Constable, A Master Draughtsman*, Dulwich Picture Gallery, July-October

Plus numerous articles on conservation and the landscape

LIST OF WORKS

List of works reproduced
Where no location is given, works are
from the Heron family collection

Page numbers in *italic* refer to illustrations